Mac OS X for

Photographers

The Digital Workflow series from Focal Press

The Digital Workflow series offers clear, highly-illustrated, in-depth, practical guides to each part of the digital workflow process. They help photographers and digital image makers to work faster, work smarter and create great images. The focus is on what the working photographer and digital image maker actually need to know to get the job done.

This series is answering readers' calls to create books that offer clear, no-nonsense advice, with lots of explanatory images, but don't stint on explaining *why* a certain approach is suggested. The authors in this series – all professional photographers and image makers – look at the context in which you are working, whether you are a wedding photographer shooting 1000s of jpegs a week or a fine artist working on a single Raw file.

The huge explosion in the amount of tools available to photographers and digital image makers – as new cameras and software arrives on the market – has made choosing and using equipment an exciting, but risk-filled venture. The Digital Workflow series helps you find a path through digital workflow, tailored just for you.

Series Editor: Richard Earney

Richard Earney is an award-winning Graphic Designer for Print and Web Design and Coding. He is a beta tester for Adobe Photoshop Lightroom and Photoshop, and is an expert on digital workflow. He has been a keen photographer for over 30 years and is a Licentiate of the Royal Photographic Society. He can be found at http://www.method-photo.co.uk.

Other titles in the series

Canon DSLR: The Ultimate Photographer's Guide

Mac OS X for Photographers

Optimized image workflow for the Mac user

Rod Wynne-Powell

AMSTERDAM • BOSTON • HEIDELBERG • LONDON • NEW YORK • OXFORD
PARIS • SAN DIEGO • SAN FRANCISCO • SINGAPORE • SYDNEY • TOKYO
Focal Press is an imprint of Elsevier

ELSEVIER

Focal Press is an imprint of Elsevier
Linacre House, Jordan Hill, Oxford OX2 8DP, UK
30 Corporate Drive, Suite 400, Burlington, MA 01803, USA

First edition 2008

Notice
No responsibility is assumed by the publisher for any injury and/or damage to persons
or property as a matter of products liability, negligence or otherwise, or from any use
or operation of any methods, products, instructions or ideas contained in the material
herein

British Library Cataloguing in Publication Data
A catalogue record for this book is available from the British Library

Library of Congress Cataloging-in-Publication Data
A catalog record for this book is available from the Library of Congress

ISBN: 978-0-24-052027-8

For information on all Focal Press publications
visit our website at www.focalpress.com

Printed and bound in Canada

08 09 10 11 11 10 9 8 7 6 5 4 3 2 1

Working together to grow
libraries in developing countries

www.elsevier.com | www.bookaid.org | www.sabre.org

ELSEVIER BOOK AID International Sabre Foundation

CONTENTS

CHAPTER 2

CHAPTER 3

CHAPTER 4

CHAPTER 5

CHAPTER 6

CHAPTER 7

Introduction

Many photographers use the Macintosh platform on which to work. Up to Mac OS 9, there was little difficulty in finding help from colleagues for any mishaps that may have occurred. Then along came Mac OS X! A new breed of operating system, whose underpinnings were those of an established academic and business system known as Unix. It took a while for many to make the change.

The point at which most felt able to upgrade was with the launch of 10.2 (Jaguar) and the restoration of some of the missing features from Mac OS 9. By 10.2.8, early adopters had convinced many of the rest of Mac users it was time to make the jump.

By now, most users have upgraded to either Panther or Tiger (10.3 and 10.4), but as you read this, Apple will have launched 10.5 known as Leopard. The backbone of this book is therefore based on Tiger, with the new workflow features that Leopard brings.

I will major on those changes which have a bearing on the way photographers can gain benefit, either from simplification or new features.

Stability

Early versions suffered some freezes, crashes and what are known as 'kernel panics' – the equivalent of system crashes in Mac OS 9 and earlier. Escape meant a total loss of all unsaved files! By version 10.2.8 this situation had all but disappeared. It is probably fair to say that kernel panics were often the case of third-party programming errors, due to the constant revisions to the system, consequently there were frequent updates to most of the major applications. By Tiger, 10.4.2 in particular, kernel panics were rare.

The main programs in use by photographers are largely very stable, and the top one, Photoshop, is probably the most stable of all Mac programs.

This is not to say that nothing can go wrong, but stability is something you can now expect when using a Mac with Tiger or Leopard. If not, you can probably work on the assumption that it is your personal kit that has the problem. Useful information on avoiding kernel panics can be found at the X Lab:

 http://tinyurl.com/9jt9r

Fig. 0.1 Mac OS X 'Tiger'.

Mac OS X is a mature operating system for Apple Macintosh computers, preserving much of what was in the preceding versions, or taking it to new levels of convenience as the underlying hardware power and speed increased. I am therefore writing about the very latest stage in this process as much as what came before. It follows that I should cover all aspects from the simple and obvious, to the more complex, so, as photographers, you can make the most of what Macs offer.

Macs do not operate in isolation, they have copied from other systems as much as being copied themselves, but I do firmly believe that they lead more than follow. This is never more so than in ease of use. Computing is a complex task – Mac OS X, and, in its latest update, 'Leopard', aims to make your life easier; my role is to be your guide.

Photographers familiar with Macs will find the transition to 10.5 a welcome step that improves upon simplicity and speed, with a few minor style changes to the appearance. For newcomers or switchers from Microsoft Windows™, the chapter on underlying architecture will be essential reading. This book provides you with information on how to keep your Mac running sweetly and swiftly with simple maintenance routines, and pointers to resources available when something goes awry.

Every photographer works in their own way and each has subtly different peripheral devices hung on the back (or front) of their machines. Some will work with their digital cameras tethered, some will make their captures on a variety of memory cards. Yet others will take conventionally on film, in the form of either negatives or transparencies which they then scan. The scanning could be either with an in-house scanner or one at a bureau.

My concern in the writing of this book is what happens when you are at your computer. I will cover the ways to use the Mac that will ensure you a trouble free life, and the confidence you made the right decision in your choice of Mac and Mac OS X.

I will cover the implications of the choice of hardware and its specification, and routine procedures for maintenance. I will also describe additional software you might consider to assist in this maintenance. I will describe how to obtain updates from Apple themselves in the form of System Software and Security Updates. I will also describe a few resources that offer further technical

support, opportunities for learning, and communicating with your peers. One such resource is help with Color Management, and I will provide pointers to the resources currently available either as works of reference or specialist companies.

The pitfalls encountered by those working directly with digital capture, and those whose starting point is a scan, will also be covered. Also, since Photoshop is the most prevalent of all software, aspects that improve workflow will be discussed in some detail.

As the end result of all your effort having taken the photographs, will often be different, the various output methods and associated equipment will be discussed along with image storage and retrieval.

Mac OS X – Unix

Apple is both a hardware and software company affording it many architectural advantages. In 1996 Steve Jobs, returned to Apple from NeXT, a company he had formed. The company had some interesting products; a newer operating system, NEXTSTEP for one, on which Mac OS X is modelled, which is itself based on the Mach Kernel with source code from BSD Unix. Darwin is the Open Source core of Mac OS X, meaning that independent developers can add and correct elements beneath the surface to improve and advance the operating system. It is modular with other important modules built on top, such as the PDF-based graphics engine Quartz, Core Audio, Core Imaging and Core Video. Leopard now introduces Core Animation; this allows developers to use ready-made code to add otherwise complex animations.

'Core' technologies are well exploited by Apple in providing their own application software, such as iLife, iWork, Preview, and Front Row. This means that Macintosh computers can cover all the common tasks users are likely to need – word processing in Pages, spreadsheets in Numbers, presentations in Keynote, handling images in iPhoto and Preview, music in iTunes and GarageBand, and now video and DVD with Final Cut Pro. I will try to cover the operating system aspects that are the primary interest of photographers, either directly, or when using third-party software, in particular, Adobe Photoshop, Bridge and the rest of the Creative Suite, not forgetting Aperture and Lightroom.

Fig. 0.2 Mac OS X 'Leopard'.

5

Chip change – The Intel Macs

In 2005 Steve Jobs announced that by 2007, all Macintosh computers would be powered by Central Processors from Intel rather than IBM and Motorola (or rather as it became – Freescale) – he explained it would still be the same operating system – Mac OS X. For five years he had maintained development of a parallel Intel version of Mac OS X. The final prompt for the dramatic switch was when the PowerBook range was unable to use G5 processors because of excessive heat, whereas Intel promised cooler running dual-core processors and a sound future roadmap.

The prophecy was realized ahead of schedule; by August of 2006. Also arriving earlier than forecast, came the MacBook, MacBook Pro and the MacPro. There were two versions of Mac OS X 10.4.7; one for each of the processors. Leopard is Universal, a Fat Binary, working for either CPU.

Apple further confounded the markets and pundits by bringing out a Public Beta version of 'Boot Camp' – software that enables these new machines to run Windows XP and Vista natively, and also announced that Leopard, will have this built-in, however it will not offer support for Windows, or bundle it with its machines. Apple hopes this decision will attract more people to the Mac platform because uniquely, one machine can boot into both operating systems.

Parallels and VM Ware have virtualisation software which does not require rebooting. This software allows the use of other operating systems beyond Microsoft Windows™, such as the several Unix variants, Ubuntu and Red Hat etc.

Despite the CPU change to Intel, Apple retains the very powerful advantage of control over both the hardware and software, making tight integration easier. They should also be able to maintain their high level of security, immunity against virus attacks, and other malware. Do not be complacent though, this situation could always change for the worse, as the adoption of Mac OS X increases.

To expand on something mentioned earlier, this book will not delve too deeply into the subject of Color Management, neither will it be ignored.

Software upgrades

Apple have kept their word in terms of the current Tiger incremental upgrades, whether for PowerPC or Intel chips, there has been a simultaneous release; however, not unnaturally, the Firmware upgrades for each chip have been separate.

Boot Camp has had the drivers for various devices upgraded during the Tiger lifecycle, and judging from published figures, this does seemed to have helped keep Mac users loyal and added some PC users to the fold.

'Rosetta'

Rosetta, from Transitive Technology, is the software that Apple uses to allow programs written for PowerPC chips to run on Intel Macs. All the major applications, Quark Xpress, The Creative Suite, Final Cut Pro, Aperture and Lightroom are Universal, making the transition between CPUs even less painful.

For really in-depth coverage there are numerous very good books entirely devoted to the subject from well-known and respected authors such as the late Bruce Fraser and Dan Margulis, both of whom I highly recommend. Some of what Color Management involves will be discussed; this book will provide a basis, but also point the reader to those skilled practitioners, their books or websites. Apple's tight integration allows ColorSync to underpin the handling of color for all aspects of your Mac.

Apple has adopted Industry standard components, architecture, and peripheral interfaces. When you couple this with good build quality, it is easy to understand why so many photographers choose the Mac.

Later chapters will cover aspects such as how to get the most out of printers for Mac OS X, where to seek professional advice on matters relating to Macs. And, in this increasingly technical environment, how much help you can get directly from the inbuilt software of your Mac.

This book describes how you integrate your workflow in a studio; network to other computers in your organization; communicate your images to your clients, in both the early stages, and after selection has taken place, and, how you finish that work. You will need to protect yourself from mishaps, and establish an archive of your work. No single book, nor person, can supply all the answers. I shall make it as easy as possible to find answers that relate directly or indirectly to how a photographer can make the most from the power that Mac OS X offers, either from my own involvement and experience, or from organizations and individuals with whom I have come into contact. I know of many rich resources, and I shall use the following chapters to pass these on to a wider audience. I hope you will find inspiration from the enthusiasm I have for digital image making, manipulation, and Mac OS X.

Digital photography is littered with buzzwords and technical terms, I have used the more commonly accepted ones, to keep things informal as well as informed. Where I felt that understanding the terminology was peripheral, they are in either the Glossary or Appendix. So if a term is used in the text, but not explained, try visiting the Glossary. There are also some fuller explanations than some of those given in the sidebars.

Computers and memory

Computers are dependent upon memory to use for the processing of information, its subsequent storage, and for storing the programs that manipulate the data.

Memory therefore appears as Random Access Memory (RAM) some of which may be onboard the CPU itself, where the complex processing is handled and in current Macs this can be up to 16 GB. It is volatile, in that it is lost when the computer is switched off. Memory chips are not only rated by their capacity but the speed at which they can handle the data.

This memory can be extended onto hard disks as what is known as Virtual Memory and in the case of some programs can be called 'Scratch Disk' space. Hard disk memory is most effective when in large contiguous areas of free space, and is less efficient when fragmented. Provided hard disks are not overfilled, Mac OS X will try to keep this fragmentation down in the course of use.

Non-volatile memory; memory that is not lost between starts is often known as 'firmware', and can contain such static information as the Date and Time.

The overall computing speed is therefore affected by the speed at which data can be written and read to disk, the amount of RAM present, its speed and the speed of the links between all of these components — the bus speed.

There are times when it is necessary for specific user information to be entered into a path or a description: I have used italicised text where that is the case; such as 'User', 'Current Application', or 'Macintosh HD'.

System change – 10.4 to10.5

Apple's change from Tiger to Leopard is simply a version change from the 10.4 series to 10.5 series; the System is Universal, in that the code is written to operate similarly on both the former PowerPC chips and the latest Intel chips. Naturally there are some features which the older chips are unable to handle. The Intel chips are faster and run cooler.

This duality will not last forever; there will come a point when the numbers of users on the older chips are too small to justify continued support, and when you consider that Apple uses these new chips across their entire range, you can see that Apple and third-party developers who support the Mac platform will be making the transition from Universal binary to a single Intel binary sooner rather than later.

The chips are likely to all have multiple cores very soon, and the programs that need the speed and processing power will make it uneconomic for you to keep a PowerPC going for too much longer. Photographers are the very people clamouring for greater speed and power, so expect them to respect your wishes!

In Leopard the most important new features are Time Machine, a new means to implement backing up; Spaces, which allows you to work in a more compartmentalised way by grouping applications to individual Desktop areas, so there is less clutter, as each Space only contains those applications you need at any one time; and then there are changes to the Finder, Spotlight and Safari. Finder has the extra Flow view and Quick Look to aid visual identification of files, and Spotlight is both more efficient and makes better use of the available space.

Many of these smaller changes are helpful to photographers and anyone involved with images. In Safari, when you have used several tabs, you can hold the mouse over a tab and a thumbnail view of that page will shortly appear beneath your cursor.

In Finder, clicking the Space bar on a selected item opens the file in Quick Look; as does choosing Quick Look in the contextual menu. Without actually opening Preview, it seems to be using the same code to bring up a small window into which a preview appears. Click the double arrows to fill your screen, or you can send it to iPhoto (see the circled icons in Fig. 0.5 overleaf).

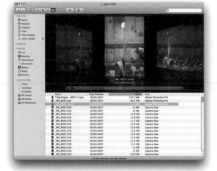

Fig. 0.3 Leopard's new Finder window view – Flow view, featuring horizontal scrolling through the image previews. Note the linking between the image selected and the highlighted file in the list below the image pane.

Fig. 0.4 Time Machine takes over the entire screen area, displaying repeats of your selected window back through time. You can either use the timeline on the right or the arrows, to reach the backed up data you want to restore.

Spotlight has been improved both in ways it searches and how they are displayed, as can be seen from the two screenshots; less space is taken up by the categorisation of the search, by having these lists behind buttons along the top of the dialog box.

Apple has made considerable changes to Leopard beneath the surface, but has tried to ensure good continuity with earlier versions, with appropriate changes that either simplify or extend the overall functionality.

It should therefore not be a culture shock to those familiar with the Macintosh experience, and it should be easier for those new to the platform.

One example is that the User Interface is now scalable: by that is meant, it will adapt to the size of screen much better than it has in the past. Notice newer Dock icons and their quality.

In many areas the bit depth has been increased, providing extra accuracy in areas that benefit photographers.

Screen Sharing is an innovation which could enhance the experience a client has within your environment by being able to view what you are doing remotely, in another part of your studio.

Photo: Tim Howarth

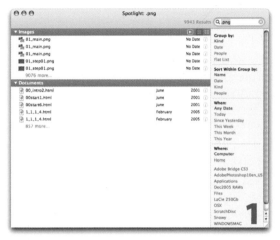

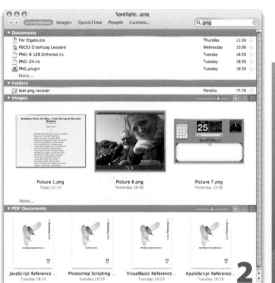

Fig. 0.5 Image **1** shows the window displayed when you click 'Show All (. . .)' using Tiger. Below that, **2** is a search in Leopard. Greater space is afforded the search results in Leopard, as opposed to Tiger's right-hand pane. **3** is an example file as shown by Quick Look, with the icons to go full-screen, and to open in iPhoto, respectively.

The System Architecture

The defining characteristic of Mac OS X is the overall consistency from the system, through all the application programs you might load onto your Mac. The obvious similarity of operations is retained, which means you rapidly gain familiarity with where you expect to find things. Though you do have to get to know where they are in the first place!

Learning about the Mac interface is not as daunting as sitting in the cockpit of a Jumbo jet, although to some it may seem so, on first acquaintance.

This chapter will hopefully pilot you through the general layout and the controls, what they mean, what they do, and the settings you need to make, so the Mac is able to become the ideal companion for your camera, lens and lighting equipment.

The advent of Mac OS X heralded a change from a proprietary operating system on Macs, to a new Mac-like front end to an existing multi-user system, that was also multi-tasking and multi-threaded.

What does all that mean?

Notable Leopard innovations

Overall, the look and feel is less fussy, gone is the brushed metal look, in has come a clean interpretation of pseudo 3D. There is a new view within Finder windows that originates from iTunes' Coverflow, and this can aid photographers and designers to locate images.

The Dock also has a means of displaying the contents of a folder as a 'Stack' – either as a fan for small groups, or as a grid for larger numbers of images. It can be set manually or left to the system to decide.

The engine driving Preview is used to offer Quick Look, which provides similar functionality, using the Space bar.

Screen Sharing offers interesting possibilities to a photographic studio by allowing a client to be at a different Mac from the photographer, yet glimpse what is going on at the Capture Mac.

Spaces allows the user to group applications for specific tasks thereby only seeing one group at a time. An example might be to create one space for Word , Excel and Mail, with another comprising Lightroom, Bridge, Photoshop and InDesign, and another with iTunes, Skype and Safari.

Each space can then be invoked either from the menu bar or Control and the relevant number or arrow key.

Time Machine is a novel way to make Backup more of an integral part of general workflow, but it should be remembered this needs saving to a substantial-sized separate drive.

Fig. 1.1 A fan stack rising from the Leopard Dock.

Multi-user

Multi-user means that more than one person can use the machine in individual ways that retain the privacy for each person who logs in. Logging in brings both advantages and disadvantages – having to log in when you are the sole user can be a nuisance; but, if you are prepared to sacrifice ultimate security, you can set the Mac to log in automatically.

You can create a separate User account for assistants and accounts and admin staff, and only load Microsoft Office and an accountancy package there. If this user is your bookkeeper, he/she will have no need for CaptureShop, DreamWeaver and Photoshop, likewise your assistants will have no need for access to Excel and Sage. You can control this by allocating users their user names and passwords, and I would suggest that you re-allocate the passwords regularly.

Users can be given limitations such as being only able to read what is available to them, but unable to alter or erase them.

Multi-tasking

Means that you can run more than one program simultaneously, with the central processor dividing the time it gives to each regularly, but with the frontmost task being given a higher priority. An added advantage of Mac OS X's pre-emptive multi-tasking is that each program runs in its own protected memory space, so that should it crash, it does not bring another program down at the same time or crash the entire system.

Multi-threading

This is the simultaneous processing of different tasks within one program, and within different programs can all take a proportion of the processor's time, giving the illusion that these all take place simultaneously. This activity is known as time-slicing.

Time-slicing

The end result of time-slicing is that you do not have to wait for one thing to finish before starting something else, you can set several things off at once and all will take some processor time and complete more quickly.

This means that several up-and-running programs can all interact with each other, on what to you may seem a single task, but is in fact a series of actions being taken so far, then handing off to another application and getting the information back in a new form before passing it to another program, and so on, till you are given the end-result.

You can see this in action at startup – you could keep opening one program after another, and they will all start loading and coming online according to how much each has to load into RAM. The more complex the program the longer this will take, but once one is available, you can start using it even though some other programs may not have finished loading. The others will continue to get themselves ready in the background. If you regularly use Photoshop, you can make it a Startup Item in System Preferences/Accounts, so you can start working immediately.

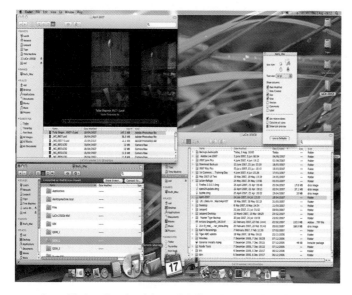

Fig. 1.2 Leopard Desktop. Note the subtle rounded effects, the new 3D Dock, the Flow View of a window and the new default Desktop background image.

Activity monitor

A combination of more processing power from the Central Processing Unit (CPU) and multi-tasking allows the Mac to carry out numerous background tasks to keep everything running sweetly, without you ever knowing they are happening. There are times when it would be handy to know just what is going on behind your back, and the system does provide a helpful application for this purpose called the Activity Monitor. This will be discussed in the chapter on maintenance.

Normally, I would consider the Activity Monitor 'Geeky', but it can sometimes be a handy indicator even for the non-technical user. In its default view it shows the underlying tasks it is carrying out on your behalf. If you feel a period of activity seems to be somewhat tardy, a glimpse here might provide some answers.

If you see an application you are using now has an alert in red explaining it is not responding, this may well be that the program has either frozen or crashed.

Fig. 1.3 Activity Monitor's display is updated frequently, displaying the relative amounts of processor, memory and disk usage that is taking place at the time.

The Mac OS X Tiger and Leopard interfaces

I have no reservations when saying that Tiger is the minimum system for Mac-using professional photographers. In addition to all the ways your photographic workflow is improved by the manner in which Tiger works, it is a prerequisite level for both Aperture and Lightroom; Leopard, simply goes further.

Although only some features are new, I am going to treat the interface as if all of it is a new entity. Even though you might be the only user of your machine, it may well be worth creating more than one user, making one with full Administrator privileges, and the other as a standard user. Generally this is done when you first set up your machine, but you can do it after the event. The Administrator, or Admin for short, has the privilege, once the password has been entered and authenticated, to alter everything within your system. With that power, it is very easy to wreak havoc as well as make everything work at its optimum, so take care to guard the Admin password.

Accounts Preference Pane

You create users in the Accounts pane of System Preferences. These you reach either via the Apple menu, or the Dock if its icon is present there. Choose Accounts (two heads in silhouette). You will get a window with a pane on the left with the names of Users, and the right-hand side can have four different views according to the tab selected and highlighted; the default tab displayed is Password (See Fig. 1.5).

To add a user, first ensure that the padlock icon at the bottom left is open. If it isn't then you will need your Admin password to open it. Once it is open, you click the plus sign, just above the padlock, which will automatically move to the Password tab and open a blank form. Fill this in and decide on a password. Try to avoid making this too obvious to others, and if you are giving another person Administrator privileges, then make sure you know it! You can have more than one Admin user which may be useful in times of trouble. You can choose an image for the user, and set limitations for those not already given Admin permission. Admin users are designated by checking the box at the bottom of the Security tab which says 'Allow user to administer this computer'.

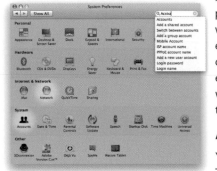

Fig. 1.4 System Preferences in the default view, but showing the Search facility being used to find possible alternative preference panes highlighted that contain references to Accounts. Note also the Tooltip showing the context.

System Preferences Palette

You can look at Systems Preferences palette in two different ways, either by category, or with their icons alphabetically. The default setting is by categories and is probably the clearest. This is the equivalent of Control Panels in Mac OS 9 and earlier.

The Dock

The Dock is the repository for aliases of the programs you use frequently up to a divider line, beyond this line you can put folders and files, and it is where you will now find your Wastebasket/Trash. I will discuss the Dock in more detail later in the chapter.

Fast User Switching

If there are to be more users on your computer than yourself, then setting Fast User Switching, by clicking first onto Login Options, and checking the last item in the pane on the right, means one user doesn't have to log out to allow another to log in. This helps make the transition from one account to another much smoother. The initial transition will take some time, whilst the Mac creates the new user's Home directory. However, once logged in, the subsequent changes will be reasonably fast. The logged in user's name will appear in the top right of your screen.

To change user, simply click on this name to see the list of other users and let go; you will then be asked for the relevant user password. A word of caution with regards to passwords – do keep track of the Users and their Passwords; I would suggest you do not allow other users the choice of changing passwords without your knowledge. Security is a double-edged sword, lose a password and you lose access to the data just as surely as someone actually deleting it!

This applies even more strongly to the use of FileVault found in the Security pane.

Fig. 1.6 The current User's name appears in the Menu bar, when Fast User Switching is set; clicking on the name brings down a dialog displaying any others.

FileVault

I do not recommend using FileVault unless you have major security issues as you could potentially lose everything in some circumstances, such as forgetting your passwords, because your Home folder will have been encrypted. You will need a very robust backup system in such circumstances, so you should use FileVault with caution.

Fig. 1.5 Creating the initial Admin User is simply part of the System Installation process, but opening the Accounts tab in System Preferences as in 1, and clicking the plus, will allow you to add another user. Clicking Login Options brings up 2, where you can refine your options. Do remember to Unlock! And Lock later!

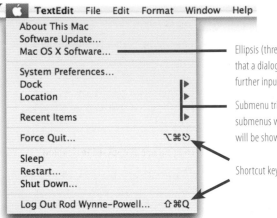

Ellipsis (three dots) — indicates that a dialog box requiring further input will be opened

Submenu triangles — indicate submenus with further options will be shown

Shortcut key combinations

Fig. 1.7 The Apple logo and each of the textual headings drop down to reveal menus of choices; much of this structure is seen in every Mac application.

Apple menu

In the above screenshot you will see that the right-hand column contains Reveal triangles, which when clicked will display other lists; these are submenus sometimes described as flyout menus. You will see similar triangles in Finder windows, to the left of folders, however, these do not flip downwards, they remain static.

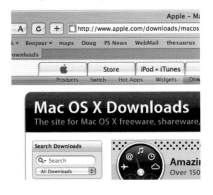

Fig. 1.8 Clicking on 'MacOS X Software...' brings you to the Apple Downloads page in your default Browser.

Menu Bar – Left-hand side

The Apple Menu is where you find **Sleep**, **Shutdown**, **Restart** and **Log Out**, and reach **System Preferences**. You can alter the **Dock**, your Network **Location** and view **Recent Items** from all Applications. Also you can contact Apple for **System Updates**. From a button marked **More Info...** in the **About This Mac** window, you reach **Apple System Profiler** with details of your computer's hardware and software, their versions and specifications, information you may need when diagnosing problems.

Some items within the list have shortcuts that are displayed in iconic form, showing the combination of keys that will activate the same command without you having to go to the menu itself. It is well worth learning some of the more common ones as this will save you time. Items that are followed by an ellipsis (...) indicate you will see a dialog box using the shortcut shown. Using the Shift key with the Apple menu will allow you to click on **Force Quit** the *Current Application* without a dialog box, and this is confirmed by the name of that application appearing after the **Force Quit...** Do not be confused by the shortcut seemingly having the added Shift key; it appears, simply to indicate the key you pressed. If you hold the Option/Alt key the ellipsis after the current user's name also disappears, indicating logout will occur also without a further dialog box.

Mac OS X Software connects you to an Apple Downloads page, shown to the left in Safari.

System Preferences is the equivalent of Control Panels in Mac OS 9 and earlier. (*I go into each of the ones meaningful to photographers later, in greater detail.*)

Dock lists its own preferences as to where it can be placed and how it functions. Consider adding frequently used items to the Dock, as folders. Leopard displays these 'stacks' in a fan or grid.

Recent Items is divided into Applications, Documents and Servers, offering yet another way in which you can work more efficiently. At the bottom is a **Clear Menu** Command.

Force Quit… is used to exit an otherwise non-responsive program; a click alone brings up a dialog, listing all the live programs, with the frozen one highlighted in red. Hold down Shift and this becomes Force Quit the *Current Application*; click it to quit instantly, without a dialog box.

In earlier Mac systems you invoked **Sleep**, **Restart** and **Shut Down** from the Special menu; Mac OS X does this from the Apple menu. On a Desktop machine, a single click of the Power button will put your Mac to sleep, on a laptop you will be presented with a dialog box asking if you wish to put the computer to **Restart, Sleep, Cancel,** or **Shut Down**.

Logout *User* will exit Mac OS X, and require a user to log back in.

Application Menu is the next heading, Finder being the default; it will always name the frontmost program – the one you are in.

File menu contains the **Open** and **Save** commands, and items such as **Import**, **Export** and **Place**, as well as the Print related items such as **Page Setup** and **File Info…**

Edit contains **Cut**, **Copy**, **Paste**, selection commands, and **Undo**, sometimes **Redo**, and often the **Find** and **Search** commands.

Window may well list any open windows owned by the frontmost application, possibly with commands for tidying up the window arrangement or tiling them to show multiple windows at once. **Help** will invoke either your default **Browser** or **Help Viewer**.

Other common or specific menu items may appear between **Edit** and **Window**, but their positions are more fluid than the ones named here.

Location

These items are preset settings for your Network, and though you can reach them via System Preferences, this is quicker, since it lists the presets. In addition it is also another way to reach the Network Preference pane itself, it is separated by a divider and resides at the bottom of the menu.

Logging out as opposed to sleeping

If you want to leave your computer switched on, but keep it safe from prying eyes, log out rather than put the computer to sleep – it will require the password to pick up where you left off.

Alternatively, you can specify that a password is required when waking up. However, you may find this tedious. This option is set by checking the box in the Security pane of System Preferences.

The Mac will display the default desktop image with a login screen as shown below.

Fig. 1.9 This is the login screen which will require the relevant password to get back into Mac OS X, or you can close down, or Sleep the Mac.

Note

I have explained about how to reach Apple System Profiler later in this chapter.

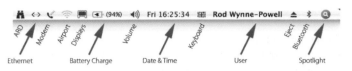

Fig. 1.10 You can Command+click most of these items and drag them to other positions along the menu bar.

Useful notes

Should you ever have difficulty loading the Adobe Creative Suite or any individual member of the Suite, then take a look in Date and Time and see what is set as your Time Zone – if the location is set incorrectly this can sometimes cause problems.

The Character Palette is hidden under the National Flag, whose main purpose is to select the keyboard you are using, can be very useful for finding obscure characters in a font, for such purposes as the copyright symbol – I have shown it below to select the escape key motif.

Having found the character you want, single click the enlarged version, or double-click the one in the grid, to place it in your document.

If the flag is not present, open the International preference pane in System Preferences and open the Input tab to choose Character palette.

Fig. 1.11 The Character palette opened from the National Flag icon in the menu bar: select the symbol or character in the larger window, and it appears in the box beneath Character Info.

Menu Bar – Right-hand side

I have shown the menu bar as it appears on my PowerBook. The only icon in a fixed position is **Spotlight**; all the rest can be Command+dragged to new positions. I should really refer to order, rather than position, because each takes up its own width, so position is relative to others, not fixed.

The items I have here are:

- Apple Remote Desktop
- Ethernet
- Modem
- Airport
- Displays
- Battery Charge
- Volume
- Date & Time
- The User
- Eject button
- Bluetooth

The majority provide single-click access to their respective System Preference controls, so give particularly speedy access to settings. If Fast User Switching is enabled, then clicking your User name will reveal those who have User folders on that Mac, and each can login from here. As they authenticate, the screen will revolve, bringing their environment to the fore. The Eject key can be useful for those without that key on their keyboard.

These icons, described as Status Icons, are often placed in the menu bar upon installation of the application; you can remove them simply by Command+dragging them away from the menu bar and letting go (*watch and listen!*).

Finder Window structure

The Finder and Application window constructions are very similar, with the Title bar giving the name. If you hold down the Command key, on the Title itself, the pathway is shown and can be used when clicked to navigate back up through the folders.

The Appearance preference pane controls the color of the window frames, and the blobs become color 'Traffic lights' when a style other than Graphite is selected. However to aid color evaluation, I recommend you use Graphite.

To alter individual aspects of your windows, select the View menu, where you can alter the font and type size. The mode, whether Icon, List, Column or Flow view, is altered in the Title bar, as shown here in the top window which is in Column view. I have selected the Focal Press folder, which is located on the hard drive called 'Files', and have selected the image file called 'Wooden flowers_3887.tif'. In the lower image note the Volumes panel has disappeared, as well as the busy Title bar. Those were various items I Command+dragged there for fast access; they only ever appear when the full view is selected.

Customising the Title bar

Control+click on the Title bar and Select Customize for all the regular items, or drag something from the window to the Title bar area; doing this requires patience as the wait for the plus icon to appear is lengthy.

Command+click and drag to either reposition an existing icon. To remove an icon, simply drag it off the Title bar.

Fig. 1.13 You can Command+click these items and drag them to other positions along the menu bar.

The lozenge (arrowed) toggles the window's Toolbar on and off. The command is also available in the main toolbar, from the View menu.

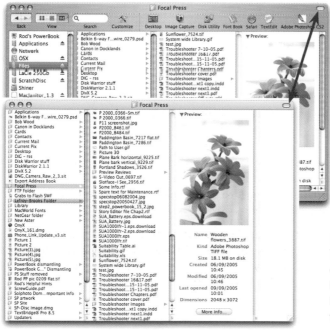

Fig. 1.12 Finder Windows showing some of the structure. The three circular buttons at the top left of a window designate Close window, Minimize window, and Toggle last size of the window. The lower, compact window has been toggled by clicking the lozenge at the top right, in the Title bar.

Finder Window features – The Views

There are different views to display the contents of a folder in Finder. They are: as Icons, as a Hierarchical List, or in Columns, again hierarchically, and now Flow view in Leopard.

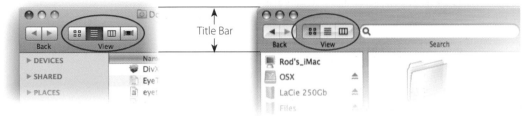

Fig. 1.14 Above the word 'View' in a Finder window are icons for Leopard and Tiger's different ways you can look at a folder's contents.

Leopard's Flow View

With the increase in the power of the latest Macs, and the newer underlying 'Core' technologies, Apple has felt it can now implement a far more graphical view for the display of images in particular. This new view is tightly linked to a List view, so that it is possible to search out images both visually and by filenames.

The images scroll by fanning horizontally, but lock individual images square on centrally when stopped. The images are rendered on the fly, so the higher resolution may take a little longer to appear, especially for large RAW files.

The differences between each of these views is not arbitrary: each provides advantages at varying stages in your workflow, and time spent learning about the nuances of each will be rewarding. Obviously the first stage of choosing which view you use is simply a click away, but there is much more that may not be quite so apparent. You can structure the data you store entirely to suit the way you work, and the nature of your business. I shall explain the structure and the possibilities, and leave you to decide which suit you best.

The natural computer structure presently is top down, with your Startup hard disk, which holds Mac OS X, at the top. You will notice that Mac OS X has done some ordering, both for itself and yourself. I believe that where possible, you keep the System items as they are, and recommend that for any computer you can add separate additional hard drives, you do so. Firstly, there is the Startup disk. This disk which contains the operating System, Mac OS X, is generally found at the top right of your Desktop screen, in the environment known as Finder. Double-click that icon to open a window showing you its contents.

Initially all you will see are a series of folders, four of which have special icons: Applications, Library, System and Users. The two of most concern are Applications and Users. Programs stored in the former will be available to every user on your Mac. If you open Users you will see another special icon, named using your short User name with a house icon – this is your Home folder, it contains data that is dedicated to you, when you are logged in; it is not available to others when they are logged in as the user.

Finder Window features – Icon View

Icon view is ideal for viewing a single folder of images, provided you are seeing thumbnails of those images, not simply generic icons for the application that created them. Folders within a folder are known as 'nested'. Double-click one to delve deeper and see its contents.

A single click will highlight any item, this allows you to use context-sensitive help using the Control key (or right mouse-clicking if you have a multi button mouse). In either case you get a clue from the cursor change to the black arrow, with a list icon to its right (I hear it described as a ladder!). Whilst holding down, you get a list of options available to you at that juncture.

Double-clicking opens a file or folder; or runs an Application. To select more than one item, click and drag around the items you plan to select, or hold the Command key down as you click on other items beyond the first. Shift or Command+click on any selected item/s to deselect it. If you have separate groups of items to select, you can drag around one group, then hold down Shift while you select others. Why select several items at a time? To open several together, or to move or copy them to a new location (which might even be the Trash). Or, it could be to drop them on a program icon in the Dock or another folder – all would then open in that program. This technique is ideal when you want to open say a JPEG created in Photoshop, in Preview or Safari. In the following pages I show the differences between folders in the other views.

Cursor actions

Mouse over
> Hover over an item. Can sometimes trigger a response of some sort

Mouse down
> When you click and keep pressing down

Mouse up
> An action can be triggered as you release the mouse

Single click
> A single quick down and up, highlights an item, ready for a command to be applied to the focus of your attention

Double-click
> What it says! Initiates an action, such as 'Open', or makes a text selection

Triple, or more clicks
> Carries out an extension of the earlier action

Action of modifiers

Command
> Often used to initiate a specific command without recourse to a menu. Extend the function of a simple command. Add discontiguous items to a selection. Can be used to default to an important key, such as the Move tool

Option/Alt
> Often provides the opposite action – a toggle. Subtracts from a selection. Sometimes a drawing constraint

Shift
> Capitalise text. Add to a selection, often continuously Constrain rotation or resizing to fixed values

Control
> Provides a contextual menu. Or, apply a constraint

Leopard note

There is a useful addition, accessed via the View menu, 'Show Path View'. This opens up a bar along the window bottom, showing the path to your selected item in all four overall Finder views. When too long it shrinks the leftmost items to icons.

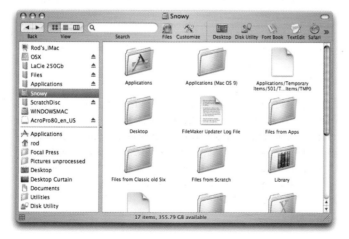

Fig. 1.15 Icon view shows just one level of folders and files.

List and Column Views

It is worth noting that neither the order nor categories displayed as columns in both List and Column views is set in stone.

You decide which categories are shown using the View menu, and highlight the column header for the order in which the sort is carried out. You can position the columns set by dragging the column header along to the position that suits. The Ascending/Descending Sort order for the column is defined by the header's triangle indicated in Fig. 1.16.

You can also alter the width by dragging the divider line between the columns, but in List view this is at the top, and in Column view this is at the bottom of the window.

Built-in Spotlight searching

The magnifying glass icon designates a search field, and this brings the power of Spotlight to bear in helping you whilst using a Finder window. Once you have entered a character into the search field a new line appears below the Title bar offering you the range of categories and locations you can use to carry out your search.

As the search starts, another row appears with the search criteria and the results populate the relevant categories defined within Spotlight's Preference pane. Click an item to select it and the path to its location is displayed in a line along the bottom of the window.

If you double-click on a found item, if it is a folder, your window will display its contents, if a file it will open it.

In the case of the result being a folder, the search bar will disappear, reverting to a standard Finder Window.

For a fuller description of Spotlight and Flow View, look later in this chapter.

Note – Leopard's Flow View

Flow view is effectively a visual extension of List view, offering a three-dimensional horizontal fan view of files' image content, linked to the listed items below.

Finder Window features – List View

List view allows you to look at one folder's contents, yet open nested folders within that folder. If those subfolders also contain folders, they also open within the same window. You can open or close all nested subfolders by Option-clicking the reveal triangle.

Fig. 1.16 List View can show more levels, but in this case, I have not clicked on the gray reveal triangle.

Fig. 1.17 Still in List View showing more levels. In this case, because I have clicked on the reveal triangles. If I had Option-clicked the triangle, all of the folders within that folder would also open to display their contents.

Finder Window features – Column View

List view does offer a good idea of the pathway to files and folders but sometimes it is not entirely clear exactly what is in any one folder – this is where Column view helps - each column represents the contents of an entire folder, in a scrollable column.

Fig. 1.18 Column View shows the levels horizontally, with a subfolder occupying the next column each time.

The icons used to show the different modes in which you can view a Finder window, only tell half the story. Each view offers subtly different ways for you to either find the item you seek or find something more about that item. It allows you to structure the way you store your images. You can impose order by applying a similar filing system to that which existed when taking negatives and transparencies.

Imagine you have a series of folders that are named by client. Within the client folder, there might be more than one department commissioning you. Within that folder might be a series of project or dated folders with the relevant shoot images within those. Add in metadata stored in the images themselves, and you have the makings of a sound overall structure.

There are a host of changes you can make to display and sort that information; select them from 'Show View Options' within the View menu. Changes you make can apply to just that window, or all subsequent ones, using the radio buttons at the top of the dialog box. Some items in this box appear in the Context menu when Control+clicking the bottom of the Title bar.

Fig. 1.19 Above are Tiger's context-related View palette windows, alongside is the Flow view palette in Leopard, all show the options available to tailor the window contents for each case.

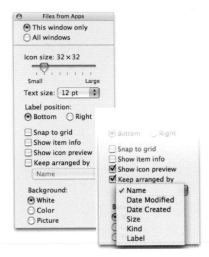

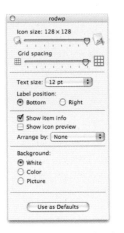

The View Menu – Icon View

When you choose View from the Menu bar, first decide whether the settings are to apply to just the current folder or to all subsequently created folders as well. The items shown is based upon your choice of Display View. Icon view has controls for their size, how they are laid out, the amount of detail given, whether the filename covers one line or two, the position of the filename relative to the icon, and also the type of background.

The icon size you can have ranges from 16 pixels square up to 128 pixels, the Font size for the filenames ranges from 10 to 16 pt. Icons can snap to an invisible grid or remain loose, allowing you to make ad hoc clusters; you can also have them arranged by any one of six criteria automatically. Lastly, you can choose to make the background either a flat color of your choice or even a picture. The latter is handy for window backgrounds on a CD.

In the window below take note that the scrollbar at the base indicates a small number of items exist beyond the window – there is only one more, found by noting the total shown by the status info below the scrollbar. The size of the scroll tab is dynamic and represents the visible proportion of the whole.

Fig. 1.21 The View menu that displays for the icon view of a folder's contents. And the five alternative ways in which you can keep your items organised within any window in this View.

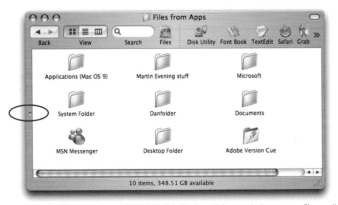

Fig. 1.22 Subtle changes have been made to the same window in Leopard.

Fig. 1.20 The View menu for the Icon view of the Finder window, and what you see. The small dot indicates this column can be dragged to the right to reveal the various mounted volumes, and Favorites.

The View Menu – List View

In View options you can alter both the font and icon sizes, but remember, making these large, limits the number of items visible in the window.

You decide which columns appear via the View options, but changing their order or column width is done within the Finder window itself, by dragging the headers or the dividers at the top.

Checking the size box only offers a column showing file sizes as opposed to folder sizes. The very last checkbox, (Calculate all sizes) ensures folder sizes are shown. Just remember this has a very adverse effect on speed. The most common reason for needing to know folder sizes is when trying to fill CDs or DVDs.

Relative dates show the current day as Today, and the previous day as Yesterday, rather than the date, which is often quicker when dealing with short term file finding.

Another advantage that Mac OS X brought to the Finder, taken from Windows, was that you can copy and paste files and folders from different folders, a process that is still not particularly well-known among many Mac users.

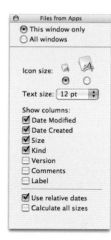

Fig. 1.24 Although you can make the icons larger, it is really only beneficial when you have custom previews, and even then the benefits are small, because you end up having to scroll more to see all the items. This is where using Flow View in Leopard is useful.

Tip

To get an idea of how the contents of a folder is growing when adding files or folders, the trick is to hold down the Option key as well as the Command key +I keys – the window will stay open and keep a running total as you keep putting in more files or folders; the size calculation is almost instantaneous.

Note

In List View, holding the Option/Alt key down when opening a folder will open any subfolders, with the converse, that closing a folder with Option/Alt held down will close each subfolder, this saves a lot of individual clicking!

Tip

When copying or moving you can keep 'drilling down' through the hierarchy to reach the folder you need – just keep holding the dragged item over the folder, soon it will open (you can move to another folder within that one; and so on, till you reach your destination). A plus sign appears alongside the cursor during this action.

Fig. 1.23 Although I have narrowed this window for the book, the name column is purposely wide in List view to allow me to see full filenames when opening folders within folders within folders, I rarely need columns for the last three options. Relative dates can be helpful.

Tip

If you are in a hurry, and the system is still building the preview, click in the blank area of the Preview column and move the cursor around and you will see a small transparent view of your image. This is often enough when looking to see what an image might be.

Fig. 1.26 The sparse View Options box for Column Views of Finder windows.

Tip

If the image in Flow View is still not large enough, use the general way to view images in Leopard Finder windows – select the file then hit the Space bar – this invokes Quick Look, where if that view is still not large enough, you can zoom it to fill the screen!

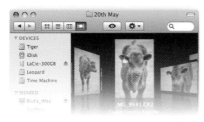

Fig. 1.27 Flow View icon the fourth shown above and alongside the full Flow View showing the linked list beneath the scrolling images.

The View Menu – Column View

Column view has only three options in the View menu, the most likely to concern a photographer is Show preview column. However, for complex layered files, this can be slow. Column view always displays its content in alphabetical order preceded, if any are present, by numerical file or folder names.

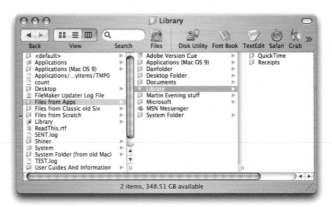

Fig. 1.25 Column view has fewer options, since it is a very simplistic way of displaying the contents of folders and the path to a file.Click a folder on the left-hand side column and its contents appear in the next column, if you click a folder in that, another column opens to its right, and so on, until you reach the item.

Flow View – Leopard only

This may seem like Eye Candy, but for scanning images in a folder quickly, I think most will find this handy. There are no View menu options – you can either use the picture window to scroll through, or jump straight into the linked List view beneath.

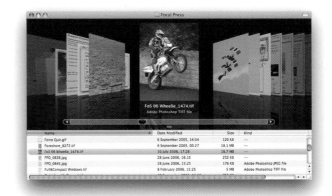

Drag and Drop & Copy and Paste

Any reorganization in one volume can simply involve moving a file or folder from one location to another, so if you click and drag an item from one folder to another on the same volume, the pointers to the file or folder are simply altered. At the user level it has simply been moved. Hold the Option/Alt key as you drag when you need a copy in the same volume.

Copy will always leave the original in place, so from a speedier workflow standpoint, Drag and Drop is more efficient. When the transfer takes place between two different volumes, the effect is the same for both methods..

If you open two windows for the transaction, then the process is easier whichever method you choose. Also if you make a mistake, Undo is available in Finder, which is a less well-known feature.

If you want to open a folder into a new window whilst closing the current one, then hold down the Option/Alt key as you double-click. If you want to retain the existing, but open a new window, then hold down the Command key as you double-click.

The quick way to rename a folder or file, is select the Item, then hit Enter/Return; the entire filename highlights, ready for editing.

When trying to copy an item or items into a closed folder whilst dragging, hover over the folder with the cursor, and shortly it will open. If you need to go deeper, into another folder, keep holding and hovering, and this will also open. Still faster – hit the Space bar to avoid the pause, and drag out of the opened window to close it without having to let go of whatever you are dragging. This action is known as 'drilling down' – let go (drop) the item when you have reached the destination. This works whether you are in the same or a different volume.

Lastly, when Apple changed the shortcut key for creating a new (Untitled) folder, you also had to hold down the Shift key – **Command+Shift+N**. The old key combo gave us a new window at the root of your startup disk which can be a useful starting point; so add **Command+N** to your armoury of shortcuts.

Incidentally, although this is the default, you can alter this setting – go to Preferences when in Finder and make your own choice; it is in the General tab, which is the first one.

File and Folder reorganisation

The Finder environment where you are looking at how files and folders have been created and are stored, is also very much an editing space, you can move files and folders around in several ways; you can drag and drop, or you can copy and paste. You can also duplicate or remove items, and generally reorganise your storage. You can open new windows, even of the same folder, and have one in Icon view , the other in List or Column view; this makes moving files around that much easier.

Note

A useful point to bear in mind when using the Drag 'n' Drop method to move and copy files around your hard drives, is what to do when you realize you have made a mistake, and say picked up the wrong file or folder. Don't panic and drop it off at the first folder that comes to hand – just go back to the starting folder and drop it on its Title bar, or back on itself if that is still visible.

Remember also that if the copying operation has started, you can cancel that in the dialog box, and in some cases use Undo, if the operation has completed.

If you are regularly copying items from one folder to another, think ahead and open both the start and destination folders into accessible parts of your screen, and in the most apt view, Icon, List, Column or Flow.

Automator, which is included with the System, can help you create Workflows to aid in simplifying repetitive tasks. Ben Long of Complete Digital Photography has created an excellent series of Automator action scripts for Photoshop (see Resources, Chapter 5).

Title bar features

Mac OS X has evolved its interface from years of development, and hides much of its power and complexity just below the surface. The title bar is an excellent example. The Title bar not only gives you the folder name, but by Command+clicking on the name, you can trace the pathway back to the parent volume. This might be your main hard disk, an internal/external one, or on removable media such as a CD or DVD. Let go along this path and that folder opens.

Title bars exist for Finder and applications windows, and share certain similarities, but Finder windows' Title bars can be customized to provide navigation arrows and, where various shortcut icons have been attached, should the window be too short to accommodate them, arrowheads appear to inform you of the hidden items.

Also, the history of your Finder window changes are stored, so if your window has the arrows shown in Fig. 1.28 C, you can move backwards and possibly forwards to the last folder you visited.

Fig. 1.28

A Finder window Title bar, showing where the file is.

B Application window Title bar, showing its location.

C Finder window Title bar showing Navigation arrows on the left and twin arrowheads to show there are hidden items — click and hold to display the rest of them.

Finder Window – Title bar

The pathway revealed in a Finder window's Title bar is dynamic, in that you can step back through the hierarchy, letting go at a higher level; your window will remain the same size, but the contents will now show the items present within the newly chosen folder. The view may well change and conform to the earlier view for that folder, so you could have started in Icon view, but when moving back you could find the contents is shown in a List or Column view.

The Title bar of an application window like Photoshop is similarly dynamic – Command+click and letting go along the path opens that folder. The icon to the left of the filename is only full-strength if the file has been saved; once there are unsaved changes, the icon is grayed-out, and no longer active.

You can click and drag this proxy icon to another folder in the same volume, or copy it to another volume, by dragging the icon to the destination folder: the destination folder must be visible in some way. Effectively you are working in the Finder for these operations. Note, when the icon is grayed-out, the file with unsaved changes is busy, and therefore cannot be moved.

If you want to move a copy of the saved image then hold down the Option/Alt key and the copy can be created wherever you drop the dragged icon, be it the Desktop or an open folder. This can be a considerable timesaver with some forward planning, especially if you have multiple monitors, by allowing you to save two versions in separate locations.

A folder's Title bar can be customized to add Favorites and Navigation arrows, by Control+clicking anywhere in the lower half of the Title bar; this will bring up a contextual menu, or you can choose Customize from the View menu. You use this by dragging an icon from the dialog box into position on the Title bar. By adding the cogwheel icon to the Toolbar, your access via the Control or right+click is obviated!

You can also add folders, files and applications by Command+Dragging them to the Title bar, or dragging and hovering over the Title bar till the plus sign appears alongside the cursor. To remove any item, Command+drag away from the Title bar and let go; it will disappear in a puff of simulated smoke!

Application Windows

Windows within an application have very similar features, in that they have similar controls for sizing minimising and closing. The circular buttons have one additional telltale – a dot appears within the first button when the file has unsaved changes, and the proxy icon to the left of the name is dimmed giving the same message. Once saved it is full-strength, and then can be clicked and dragged to change its parent location, or Command+clicked to reveal the parent hierarchy.

Fig. 1.29 The Customize sheet showing all the items that you can add to the Title bar of your windows.

Other Finder Window features

At the bottom of a Finder window is status information, showing you the amount of free space on your volume, how many items in the folder, or the number selected.

Fig. 1.30 A Finder window in Column View with the Status info for the folder, and the default File Info available for a selected file. Note also the 'More Info' button at the bottom for this item. Clicking this brings up the fuller Get Info box shown in Fig. 1.31.

When a window is too small to display its entire contents, scrollbars appear, and a tab bar shows the amount of hidden information by its size relative to the scroll area – the smaller the tab, the greater amount hidden from view. Click and drag the tab to scroll smoothly. You can jump a window-full at a time in a very full window, by clicking in the areas beyond the tab, or scroll slowly using the arrows. Within a folder in a Finder window, you can type the initial letters quickly to move towards the file.

If you want to do something to a file or folder you have to select it. A selection is denoted by highlighting the item, and you choose the color of this highlighting in Appearance in System Preferences. To select more than one item, you can very often click and drag over the area in Icon view, or Command+click one item after another, or click on one and then Shift+click the last in a sequence, and all between will become selected. You could then deselect individual items by Command+clicking those you wanted removed.

You can differentiate items, or associate groups by color coding, using labels: you select those and go to the File menu to choose a color to apply, or you can hold the Control key on those selected and applying the color from the Contextual menu.

Fig. 1.31 Clicking on the 'More Info' button indicated in Fig 1.30 brings up this separate File Info window. Command+I in Finder has the same effect.

File Info

As I mentioned earlier, there is a button at the bottom of the Info palette that I have ringed in Fig. 1.30 that reads 'More Info...' – clicking this button gives you the same dialog box as the File/Get Info or Command+I in the Finder, as seen in Fig. 1.32 shown to the right.

It has a series of divisions which supplies a wealth of metadata information about the selected file.

- It shows you some of the camera's EXIF data
- It allows you to show or hide the extension
- It gives you a list of possible applications with which to open the file, and you can choose this to be a global change for all similar files, by clicking Change All
- It gives you a preview of the file
- It also lists the Ownership and Permissions. To make any changes here will require you to open the padlock (ringed in red) which is done by clicking on it, then supplying your Admin password

Each time you see a small right-facing triangle, this means there is more information to be found if you click it, when it will point downwards and disclose its contents.

I have closed some to keep the screenshot from overflowing the page! I have not yet discussed Spotlight, the system search engine, but much of the data contained here is used by Spotlight to search for files in new ways.

You can use this panel to lock a file against deletion, or create a Stationery pad; in both cases you can open the file but you cannot save over it, you must save it elsewhere, or under a different name. Using Stationery Pad appends the word 'copy' to the existing name, whereas clicking 'Locked' retains the same name by default, allowing you use the same name, but in a different location.

If you have used this panel to decide which file to open, handily, double-clicking the Preview will open the file for you.

A .psd file which has layers will list the layers in the Info box, and Spotlight can find this in a search. Layers in a .tif file do not show.

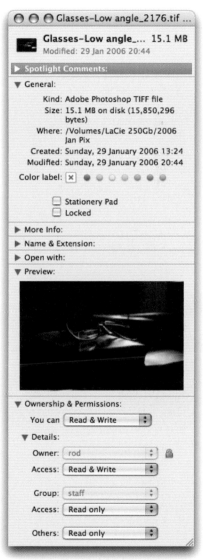

Fig. 1.32 Here are the boxes that were not shown in Fig. 1.31. Note the Color Labels, and the checkboxes for Locking a file or creating a Stationery Pad.

Making adjustments to windows

The View menu holds many Mac window adjustments, but much can be done directly to help either the viewing, sorting, categorisation, prioritisation, or the searching, within windows.

You can lock icons to a hidden grid in Icon view, which keeps things tidy; you can arrange according to name, date or size, each having their own particular advantages. In List view you can alter the sort order from ascending to descending, whether that be by alphabet, age related to creation or modification of the file; you can group according to whether they are files or folders, or categorise by Kind, so all the Photoshop documents are together, and all the JPEGs and TIFFs are segregated.

You decide what information appears in the windows, and in what order. In Icon view you can display the pixel sizes as well as the filename. In List and Column view, how wide the columns are, how large the icons are, and you can reorder the columns, by dragging them to where you need them. If Date Created is more important than when it was Modified Last, then make sure that it is present using the View menu, and drag it into position.

All these settings affect the efficiency of your workflow, so use the opportunity to fine tune how Mac OS X works for you.

This is the pixel size displayed when you check the Item Info box in the dialog box from the View menu.

This image file has been labelled either from the contextual menu or Get Info dialog box.

Fig. 1.33 Full size thumbnails in Icon view with 10 pt type and Item Info turned on.

List View does not show previews of image files, just tiny thumbnails, but is a very efficient way of viewing files when sorting. Column view on the other hand does, but takes a lot of screen room to show deeply nested files and the hierarchy.

This denotes the Sort order – Ascending or descending.

Click on a divider at the top until the cursor changes to this to indicate you can drag the line to a new position, narrowing or widening a column.

This slider tab is small, because it is indicating that far more items are hidden, than are shown in the window; both above and below this point.

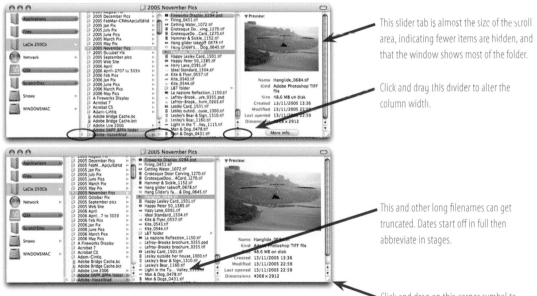

Fig. 1.34 In List view, you can select a different Header by which to sort, in this case by Date Modified.

This slider tab is almost the size of the scroll area, indicating fewer items are hidden, and that the window shows most of the folder.

Click and drag this divider to alter the column width.

This and other long filenames can get truncated. Dates start off in full then abbreviate in stages.

Click and drag on this corner symbol to resize the window.

Fig. 1.35 Folder viewed in Column view mode, showing varied column widths and truncated filenames. The Preview expands to fill the space until it reaches a maximum.

Apple System Profiler (ASP)

In the course of discussions with practising photographers I have found that when they were using Mac OS 9 and earlier, they knew how to check out how much RAM they had, what speed of processor, or what their hardware spec. was, and the reason was simply because Apple System Profiler was reasonably visible, as it was present in the Apple menu. With Mac OS X, many seem to believe that it has been deeply buried in the bowels of the System. The reality is that it is not so deeply buried. It has also been substantially extended, and is a well-structured list that can be viewed expanded or collapsed, and is far more comprehensive than ever before.

It is still accessible from the Apple menu, but not directly. At the top of the Apple menu is 'About This Mac', and when this panel comes up, it has two buttons, one which connects you to Software Updates via your internet connection, and below it simply has a button, marked 'More Info...' This leads you to Apple System Profiler.

Help for the forgetful

When you are busy or get distracted, or an assistant did some work, and failed to let you know the filename he/she gave to a piece of retouching, Recent Items can be your lifeline!

It lists individual Files, Applications and Servers.

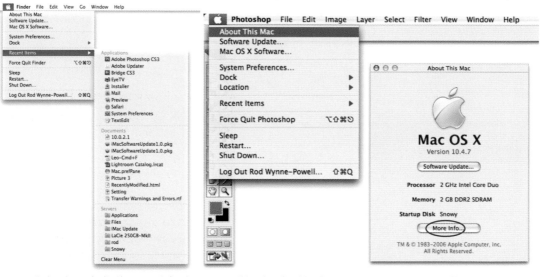

Fig. 1.37 Neglected it may be, but I have certainly found a use for this list!

Fig. 1.36 Although not listed directly in the Apple menu, Apple System Profiler is only one click further than before - just click 'More Info'.

Apple System Profiler is now laid out in a style that closely resembles a Finder window with a series of headings: Hardware, Network and Software. Each item in the list will open to show its details in the main window. In the View menu are three levels of Preview: I set level three, which has all the log reports.

This comprehensive list becomes extremely useful when trying to diagnose problems. When something intractable goes wrong with your machine, and the technician asks you what version of software or firmware you are using, the answer is likely to be found here. You can find logs that report specific faults which may help in tracing why something has failed. You can save the entire contents to a file, and even send this to Apple, or another software or hardware vendor, for them to help remotely diagnose any problem you might be having.

If an application to crashes, it comes up with an offer to inform Apple. Don't be afraid to fill in the details of what happened – the more Apple can learn as to what goes wrong, the better it will be for all users. Apple System Profiler produces this report, and your added comments could well help them diagnose the cause.

Fig. 1.38 When you click on 'More Info' Apple System Profiler opens at Hardware, and the main panel then lists all the information it can glean from whatever item you select. Here I have opened at Applications, and I can tell at a glance whether a program is running Native or under Rosetta, as well as its version.

Fault diagnosis by the User

Some faults you may be able to diagnose for yourself, such as why a USB printer is not functioning.

Apple System Profiler should be your first port of call. Under normal circumstances, once your printer is connected and switched on, ASP should list it, it will have sensed its connection and interrogated it, to learn its interface, and get a handle on what it offers and what protocols it supports. If it does not appear, then change the connecting lead, and try again.

If you have a suspect USB lead linking the printer to the machine, and the machine does not appear, yet when you substitute the lead it does, you can presume you have a faulty USB lead.

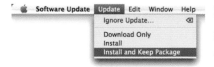

Fig. 1.40 Once you have selected Software Update, you can go here, rather than the 'Install *n* item/s', so that you retain the files you download.

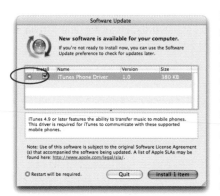

Fig. 1.41 If you highlight an item in the list, a brief description is given in the lower pane. If your item requires you to restart your Mac to load a particular item, this will be flagged in the left-hand column.

Tip

A helpful trick prior to any upgrade is to Select All in Library, and give them a unique colored label. After the upgrade, those Library items unlabelled must have been added by the upgrade, select these and label these a different unique color and remove the other label completely. In the unlikely situation where you do need to revert and you have taken my advice to retain earlier updates, take a look in receipts and remove the last two, and any of the most recently color labelled. Then search out the penultimate upgrade download, and run it again.

Software Update

Like Apple System Profiler, Software Update is also found in the Apple Menu. The observant among you will have noted that you can also reach it via the About this Mac panel, but you are one click closer going direct from the Apple menu itself. If you have a broadband connection, then keeping up to date with your operating system is made really easily from here.

In addition to the short description of each component, there are sometimes links provided that offer greater detail online. If you are concerned about what is being updated, I suggest you check out sites like **www.macintouch.com** to read expert comments and other users' experiences. These can occasionally be invaluable, although in the main, it is perfectly safe to run the updates.

What happens when you select Software Update... and log into Apple is that your Receipts folder is searched and the software notes the relevant versions against its database, and offers you all those for which an update exists for your machine.

It is also possible to initiate the update in System Preferences by clicking 'Check Now', but the real function here is to schedule automatic updates on a regular basis. You can also read the log of all the installed updates in this pane.

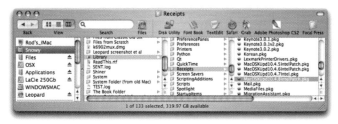

Fig. 1.39 The system pathway to Receipts, showing a few recent system download packages.

As I mentioned briefly earlier, you can schedule checks for Updates: this is done from Software Update's Preferences, shown below. You can also check on other recently installed updates by clicking the second tab in this window, as shown in Fig. 1.43.

For the reasons mentioned earlier about retaining installed updates, I am loathe to schedule updates automatically, and although inherently an early adopter of software, look on the Web for any additional user feedback on software updates.

In Leopard, Apple is considering allowing third-parties to provide their software updates via this same method.

Apple Security, Firmware, and Software Updates

Apple uses the same mechanism for updating Security patches, Firmware upgrades and iLife and others of its proprietary software, such as Aperture. In these cases, it obviously notes the validity of the loaded software it finds before the download proceeds. But it should be remembered that such downloads are purely maintenance releases, any paid for items are only available from the the Apple website, as there is no payment mechanism through Software Update.

In Leopard, Apple has taken things a stage further, and working with Hewlett-Packard has tested the facility to supply updates to Printer Drivers using this mechanism.

Fig. 1.42 You can set a regular schedule of these updates if it suits.

Fig. 1.43 Here is a list of previously updated and installed items.

Libraries – Why are there no fewer than three?

Here is a way to look at where the Libraries are in terms of the computer hierarchy:

Fig. 1.44 There is a minimum of three Library folders, one that is available to all users, which is the first. Then there is the one in the folder called System, and one in each User's Home folder. The Operating System has exclusive use of the one in System, Applications can store and access items either in the Main Library or the User's Libraries.

I have called the main hard disk 'Macintosh HD'; and it may well be that, I suggest you give it another name, especially if you have more than one Mac. Too many times I have visited studios with a network of different Macs, all have been named 'Macintosh HD'! And they have been living with the confusion!

By all means look at each of these libraries to see what items are where, but once items have been placed in their respective folders it is a bad idea to start shuffling them around. This will lead to applications losing the pathway to the items, and either corrupting something, or simply crashing.

I advocate adding an extra drive to most systems so that each can perform discrete operations such as store the System and Applications, store Images, Text documents, and Diagnostic software. This makes it far easier to diagnose problems, backup to other media such as CDs and DVDs, and for each team member in a studio to know where to file things, or to find them.

System level and User level Libraries

Mac OS X has three levels of Library to store items needed by the System and Applications; the main one is available to all Users, including the System. System has a dedicated one, and each user has their own private Library.

Typically, Libraries store Preferences, Application Support files, Fonts, Dictionaries, Startup Items, and the like.

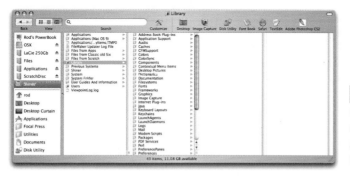

MAIN LIBRARY

Fig. 1.45 Library folders contain many component files that applications need such as their Preferences, Preference panes, Fonts, Keychains, and the like.

SYSTEM LIBRARY

Fig 1.46 Here is the System level Library – available to all users, though used exclusively by the System.

USER'S LIBRARY

Fig 1.47 Here is the User level Library – available only to the specific user.

Apple Macintosh default folders

The operating system creates some folders which can segregate your work, such as Documents and Pictures, but ironically it then can create desktop clutter by saving all screenshots you might make to the Desktop! (You can create a script and folder action to obviate this). In making any suggestions as to how you organise the saving of your files, I would not presume to offer anything more than some general hints.

The most important is try to make it mirror the way that you work your standard studio filing system. If you have a client/project/number system, then follow a similar system, using nested folders on the computer, and if it helps, then print out the contents of your folders for storing as a printed copy – using a screengrab. There is also a Shareware software called 'Print Window' from Searchware Solutions.

Obviously, there are basic items which all users need to access, such as your color settings and ColorSync profiles; these should all be stored at the top level (shown in blue in Fig. 1.45).

'Trash the Prefs!'

One old adage for curing problems with errant programs was 'Trash the Prefs – then start the program again and it'll rebuild them'. 'But', I hear you say, 'in Mac OS X we don't have Prefs' – Yes, we do! They are simply named differently, and they will become easier to sort, since they come with the owner's name attached! See the sidebar note to the left.

Preferences

Many Preference files come in the form: 'com.xxx.yyy.plist' – where xxx is the publisher, and yyy is the application.

So for Photoshop you will see: 'com.adobe.Photoshop.plist'

This structure is consistent for other applications, making it far easier to find the files that relate to particular programs.

Fig. 1.48 Preferences are stored in the Preferences folder within Library; many are in the .plist form.

Understanding where things go – and why?

There are reserved places for certain items, and these include specific folders for Applications and for certain components of programs that need to reside in specific places. For this reason, it is good practice to not start renaming or moving folders that exist from when the Operating System was loaded or updated. Why? Because the System may need them, and not finding them could create a problem where none existed before. This applies equally to other applications.

Libraries are a classic example, and as I discussed earlier, you will find that there is more than one Library. Mac OS X is a multiuser system, and each user could have differing levels of access. These levels are known as privileges. The Root level user is often called Superuser, and has access to all the low-level system routines, and for the most part, the photographer will not need to make changes to the system at this level. If it becomes necessary you will need to use an application called Terminal to enter sudo commands, and this is not an area for the fainthearted, making mistakes here can be fatal to your Mac! (Remember that name – Terminal?!)

When you install an application and you are asked for your password (authentication) this operation is the graphical equivalent of '**sudo**'.

If every user of your machine requires access to a program, then the Applications folder and Library that are immediately visible when you have double-clicked a hard disk icon in Finder, is where the relevant files need to go. If a program that is only to be used by one user (the photographer say, rather than an assistant) then it could be placed in a specific User folder. Be aware that some Applications won't work properly if moved from the Applications folder.

The User folder is named as your short User name by default, and is also known as your Home Folder. You can have an Applications folder and Library here that will store programs that only you can access, as other users will not have the correct privileges.

Obviously, there are basic items which all users need to access, such as your color settings and ColorSync profiles; these should all be stored at the top level.

Sudo

This is a Unix command for Super User do – it temporarily offers you Admin privileges. It may often be used in what are known as 'shell scripts', which on a Mac are handled by Terminal, an application found in the Applications/Utilities menu.

Note

A point worth mentioning here is that if you have a second or third drive, keeping data off your startup disk will keep it from clogging up. For instance the Creative Suite programs can all be stored on other disks except for Bridge, which you are forced to load to your startup disk. Adobe Camera Raw also has a special location, since it can be used by other members of the suite other than Photoshop.

Dock Positioning

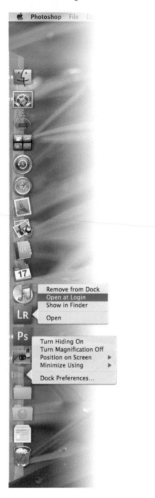

Fig. 1.50 Control+click and hold your cursor on the divider line within the Dock, to choose where the Dock is displayed – shown here set on the left.

The Dock

The Dock is a repository for applications, folders and files that you use often. It is also home to the Wastebasket or Trash, which incidentally metamorphoses to become the Eject button once you highlight a disk, CD, DVD or disk image, and start to drag the disk in its direction!

Where you place the Dock, and whether you have it remain permanently available or be hidden until your cursor approaches, is entirely up to you.

You can place the Dock either at the bottom, the default position, or on either side. The Dock stores aliases of applications one side of the divider line and folders and files the other, along with the Wastebasket.

You can move anything you will be using frequently to the Dock, and it will create the alias; similarly, you can remove any item by simply dragging it from the Dock – it will disappear immediately in a simulated puff of smoke! If you do remove any of these icons, your application/folder still remains intact, *as it is only the alias being discarded, not the item itself.*

You can minimize any Window to the Files side of the Dock divide, by clicking the minimize button (middle of the three) at the top left of its window. A single click on the docked icon restores it. There are snags involved here, **Command+Tab** to an application with a minimized window does not maximize it – if that is an issue, hide the application (often **Command+H**), and **Command+Tab** will work as expected.

Standard applications set as Login Items to load hidden, will respond correctly to Command+Tab.

Docked items like windows can rise fluidly as if from Aladdin's Lamp. If you want to watch the Genie Effect slowly, hold the Shift key and click a docked folder or Photoshop file.

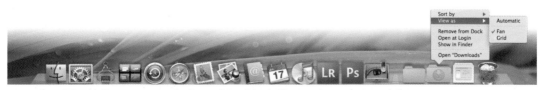

Fig. 1.49 If you click and hold your cursor on an icon here, or Ctrl + click + hold, you get the same options, only faster.

The Dock Preferences

One click on a docked application will start it up, a click on a file will launch the appropriate program and open within it, or if it is already live, will open the document. If you keep holding a Dock icon, a contextual menu will appear offering to Show in Finder as a minimum, or if the application is open, will offer Close and possibly Force Quit. If you also hold down the Control key, this will happen quicker, as the Mac does not have to think about whether to open the file or folder or whether you wish to make a different choice.

You will find certain preferences for the Dock directly in the Apple menu, or from there to the System Preferences Dock item. These will allow you to choose the Dock position, resize the icons to suit, alter the amount the icons magnify as you pass over them, and also whether you hide it until your cursor approaches the edge of the screen. I prefer to place it at the bottom of the screen permanently visible, fairly small, with minimal magnification, because I find if the enlargement of the icon is too great, it becomes difficult click on the right program; it becomes a moving target.

When the Dock is visible, an alternative way to resize it is to click and drag on the divider line between the Applications and the Files. Control+Click on this line and you also reach some Preferences directly; or the Dock Preferences, from the bottom of the menu which appears.

When a docked file or folder opens there are two styles for this: Scale or Genie Effect. Your choice can be made through these Preferences. OnyX provides another more mundane option.

Hidden interface features

Apple has hidden some other options that control the behavior of the Dock, and there are several third-party developers who have produced software that unlocks these hidden features – one such is OnyX. This program offers new ways of aligning the Dock, such as icons ranged from the left or right when placed at the bottom, or ranged from the top or bottom when placed on either side.

Fig. 1.52 This shows the additional Dock alignments available using OnyX.

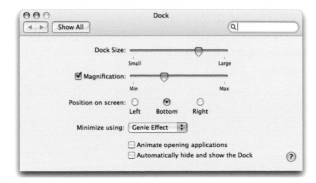

Fig. 1.51 You can find these Preferences for your Dock from the Apple menu, but as you can see in the next screenshot, there are some hidden options that OnyX unlocks for you.

Placement of the Dock

Where you place the Dock, and whether you choose to have it either remain permanently available or be hidden until your cursor approaches, is entirely up to you.

You will notice there is a divider towards the right end (if in its default position, along the bottom of your screen) to separate Applications from Files and Folders; this also carries the Wastebasket or Trash. Clicking on this line and dragging to the right or upwards increases the Dock size, and left and downwards reduces it.

It is handy to keep your Applications folder and possibly Utilities folder in the Dock so they can be accessed easily. Control+clicking on a folder will display its contents, or hold for slightly longer with no modifier key, to do the same, only slower.

Leopard introduces a more graphic way to access the contents of a folder held in the Dock. This feature is a **Stack**, and it can be viewed in two ways; either as a fan of single items, or as a grid.

You may either decide yourself how the contents are displayed, or set it to choose automatically based upon the number of files present.

In Tiger, you can make selections from docked folders in different ways: you can click once and let go, the menu will remain, and you click on the item; or you can hold the key and move through the folder then let go. The method you choose is down to what works for you. Leopard, with its stacks feature, presents the fan or grid statically and a further click on an individual item either opens or runs the item directly.

Client Work folders or Current Project folders benefit from being placed in Favorites, where they are immediately available in Open and Save As... dialogs in applications, whereas folders containing regularly used items are a better candidate fror storage within the Dock.

The Sidebar now has Headers as opposed to the single divider line. Favorites in Tiger is now Places in Leopard.

It is a shame that the term 'Stacks' describes so many disparate activities in the applications like Aperture, Photoshop, Bridge, Lightroom and now Mac OS X Leopard!

Fig. 1.53 In the top screenshot, of the Open dialog in Photoshop, the Client folder 'ICON Demos' had been placed in Favorites, so was immediately available. In the lower screenshot, you can see that if you Command+click on the lower of the two List buttons, the current folder, that the folder itself is nested far deeper; within 'LaCie 250Gb' on Rod's PowerBook' – showing clearly how using the Favorites is beneficial.

Fig. 1.54 When a Leopard Stack rises as a fan from the Dock there is the arrow shown here at the top, which will open the folder from where it is located, any item beneath can be clicked to either open or run.

Switching between Open Applications

If you hold the Command key whilst tapping the Tab key and releasing, you can move to any other open application. Initially all are represented only by their icons, but as one is highlighted, the program name appears beneath.

The first icon is your current program, the second is highlighted and was your last visited one, and if you let go, that program will come to the front. So, a single tap will simply be a toggle between two open programs. Further tapping will then move along from left to right, and when you let go, the highlighted icon will bring that program to the front. Moving backwards is achieved by **Command+tilde** key(~).

You can also choose to mouse along to any icon, and let go on the program you wish to select. Adding the Shift key will move backwards if that proves to be quicker to reach the program you want, but it is far simpler to switch from the Tab key to the tilde (~) key to go back, whilst still keeping the Command key held down.

A further tip worth bearing in mind is that whilst still holding the Command key, once you have arrived at a particular program tapping Q will Quit that program; this is especially useful if you need to quit several programs in quick succession.

Your Current program. Let go here, and this program will come to the front.

Fig. 1.55 Here are the icons for the five currently open applications which appear across the middle of your screen, when you hold down the Command key and tap the Tab key.

Finder navigation

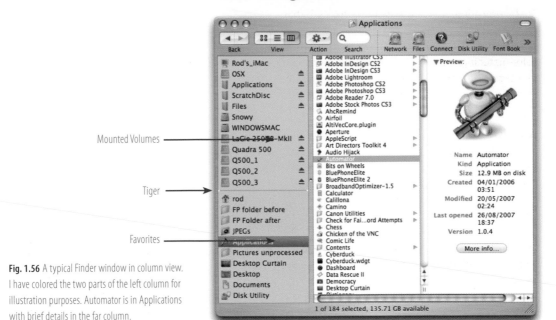

Mounted Volumes

Tiger

Favorites

Fig. 1.56 A typical Finder window in column view. I have colored the two parts of the left column for illustration purposes. Automator is in Applications with brief details in the far column.

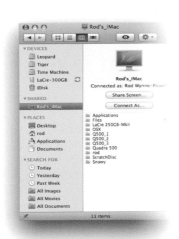

Fig. 1.57 The Leopard sidebar with descriptive headers for the new sections - **Devices** is obvious, **Shared** is for networked Volumes, **Places** is Favorites and **Search For** stores Smart Folders.

Mounted Volumes can be internal and external hard drives, removable drives, CD and DVDs and disk images. These will remain above the divider line in this window.

Favorites are generally aliases of folders, though they can be files; placed here they are readily available from within Open and Save dialog boxes. They can be changed to meet your needs – just drag an item from the columns on the right or from another Finder window, into this area, or select the folder and click **Command+T**. Favorites becomes **Places** in Leopard.

Whilst working on a project, one easy way for you to keep returning to the client's folder, is to add the folder to Favorites when in the Finder. Then, every time you either go to Open or Save As... in the application, the client's folder will be present.

For this reason you should consider creating these favorites right at the start. Create say, a 'Carnival 2008' folder and a 'Finals' folder, and drag them from your 'Client' folder to the left-hand pane of the Finder window, below the divider line ('Places' in Leopard), and let go. Once that project is over, drag those folder aliases from Favorites, and add in the next ones.

Faster access to oft-used folders

So the procedure to follow when you get a job that involves numerous photos, each requiring some attention and being used for differing processes, such as client approval, selection, color-matching, cleaning up, cutting out from a background, montaging, printing from your in-house Inkjet printer, handing over to a bureau, a repro house, or printer, *phew!* – should all start in Finder.

When you know what a job entails, create the folders you will need in the requisite places. I am assuming that the initial captures will simply be added to an ongoing folder that is effectively your initial archive. The first folder for the Project will be the Client folder, which again may already exist; if so, within that folder you can create an overall Job folder, and within that one you can then create possibly three new folders: a Pre Selects folder with all the shots deemed worth a look, an Edits Folder and a Finals Folder. Within the Finals folder you might also create two others: JPEGs and TIFFs. If you select Pre Selects, Edits and Finals, then click and drag these to Favorites, they are ready to use within Photoshop's File Open/Save dialog boxes directly.*

Note

There are two ways in which you can gain swifter access to files and folders, one is by making them favorites, by dragging them to below the divider line in the leftmost column of a Finder window. (See Fig. 1.56 overleaf)

The second is to either go to the Dock when an Application is open and choose 'Keep in Dock', or to drag the application's name/icon from its Finder window to the Dock.

(Once in the Dock, an icon can be dragged into any position that suits you0).

Remember

Finder window Title bars can also store favorites, as seen in Fig. 1.58 (see also pages 26 and 27).

*Note

Aperture, Lightroom and iPhoto can impose their own structures in conjunction with Finder's folders for this scenario, but this does not negate the use of Places/Favorites as a means of speedy access from within applications.

Fig. 1.58 In the Finder, **1** shows dragging each of the folders into Favorites, so that in **2**, using File/Open in Photoshop, the three folders are immediately there, regardless of where within the hierarchy the Open dialog box is on entry. When going to File/Save in Photoshop, the situation is the same.

Finding frequently used Files and Folders

I have shown how Favorites can be used for holding Folders in a handy place for easy access. I have used this method whilst taking screenshots for this book as shown in Fig. 1.58.

Note

When you open an application for the first time its icon will appear at the divider end of the Applications side of the Dock. Open programs in the Dock show a black triangle beneath their icons in Tiger and a blue glowing dot like an LED in Leopard.

Files and Folders arrive in the Dock the other side of the Divider Line, either by minimising a Finder window, or by dragging a file or folder to this side of the Dock.

In Tiger, if you click a folder in the Dock, it will open fully to the Desktop, if you click and hold, it will open vertically from the Dock icon. Also, it will remain open allowing you to scroll until you make your choice. In Leopard, a folder opens as a Stack in either Fan or Grid form, and stays open till you next click either on one of the items, the arrow at the top, or the Desktop. You can choose the order of the items displayed, via the contextual menu, by Control clicking or a right mouse-click.

Fig. 1.59 Here is the view I get when importing files from the Focal Press folder, I do not need to know where the actual folder is – its alias is there straightaway.

Favorites/Places favors Open and Save functions from within an application like Photoshop.

The Dock can serve a similar function if you minimize folders to it. Imagine you have a current work folder with work in progress, you reach the end of the day and wish to save a copy of all that work to a removable disk where there is a backup folder. If you keep a minimized copy of each window, you can click on the former, make a selection, copy (**Command+C**), minimize that folder; it returns to the Dock, then click on the destination folder, when it opens paste (**Command+V**) and the copy proceeds. When you finish the project, both aliases can be dragged from the Dock. Remember these icons are all only aliases, so by removing them, your folders remain in place and intact, as only the alias is being discarded, but in the meantime they have earned their keep.

Navigating menus

There are two different ways to navigate menus: you can click once and let go – the menu remains open and you click on the item you need; or, you can hold the key down and follow the triangle through each folder till you reach the item you need. Choose the method that works for you. I use both methods from time to time, but find that holding down is faster.

In Tiger a similar methodology allowed you to scroll through a list of the enclosed items from a folder in the Dock, and follow nested folders as shown in Fig. 1.60. However, Leopard offers a graphic means of searching a single folder, but leaves list searching to the standard Finder windows.

Multiple selections

Within folders you can navigate using the keyboard, either alphabetically, or using **Tab** to go forwards and **Shift+Tab** to go backwards, also alphabetically. When in icon view you can also use the Arrow keys. Icon view also has some other ways for selecting files: you can select a series of items that you marquee, which means all the items that are within or touched by the marquee are selected, you can select individual items and add them to a selection by **Command+clicking** them, or if they are already part of a selected group you deselect them.

This concept of continuous selection using the shift key to select items is augmented by the idea that in a List view, you can click on the first item in a series you wish to select, move to the end of the series and **Shift+click**; all the items between will now be selected. Conversely, using the Command key (⌘/⌘) selects, or deselects individual items, so you can add individual items to an existing selection, or, having selected the entire folder contents, you can deselect singletons, by **Command+clicking** those few.

Once selected, files can be opened, by double-clicking the selected items, choosing File/Open from the menu bar, or the shortcut **Command+O**.

Fig. 1.60 Placing folders such as your Applications or Utilities in the Dock can make them simpler to access. Leopard takes this a stage further with Stacks.

Fig. 1.61 Shift+Command+click and select an additional item to add it to your initial selection.

System Preferences

In Mac OS 9 and on Windows machines you can find Control Panels. In Mac OS X they do live on – but in System Preferences. They can be accessed from the Apple menu, or from the Dock.

The individual items are known as Preference panes, and are stored in the System's private Library. Third-party items, however, are stored in the main System Library, as 'PreferencePanes', and these are shown as 'Other' at the bottom row of the default setting of the System Preferences window.

This default view shows the preference items displayed in categories, as Personal, Hardware, Internet & Network, System and Other (see Fig. 1.63).

In the following pages is a runthrough of those panes most likely to have an impact on a photographer's workflow. I would not normally simply go from item to item in a list, but in this case it is the most useful way. The Personal category has some pertinent photographic settings related to judgement of color and file location, so do take a close look at these.

Fig. 1.62 Once you have System Preferences up, every item is available to view alphabetically from the View menu in the main menu bar.

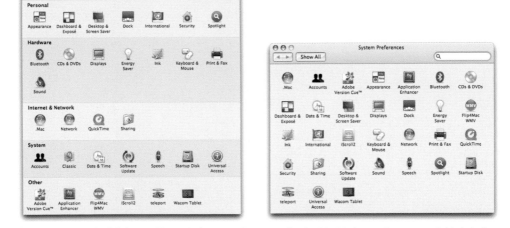

Fig. 1.63 On the left above is the default view of System Preferences in categories, and on the right, it is shown as icons, arranged alphabetically.

Apple has a further trick up its sleeve, that may have been the origin of Apple's naming its search engine. If you know what you need to do, but have no idea which pane has those controls, then all you do is type in words that describe what it is you want to do, into the Search box at the top right. It uses Spotlight in a very graphic way by darkening the whole palette and then highlighting those panes that could be what you want.

Just like using Spotlight for your system wide searching, it begins its search immediately you start typing. In the example I show, I had intended to type in the word 'highlight'. By the time I had typed 'high' it had shown three possible panes in which to look. In addition it displayed a tooltip box that indicated something of the source content, which gave me a clue as to which might be the pane I was needing.

It also indicates the likely relevance by the highlight's sharpness.

With the introduction of Leopard, Spotlight, which debuted in Tiger, has matured and it is far more efficient in the way it carries out its searches, so it will be one of the first topics to be discussed.

Note

The System Preferences icon has changed and it now matches the one to be found on the iPhone.

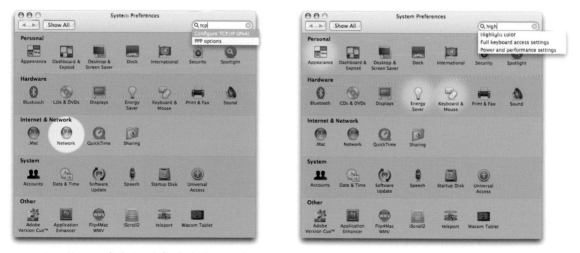

Fig. 1.64 It would seem as if only the Help files for the System Preferences are being targeted. Another observation is that when there are a greater number of results, the spotlight is softer, as you can see from the right-hand screen. In the left-hand screen, choosing Configure TCP/IP from the drop down menu of suggestions, immediately highlighted only Network, and crisply, because it has total relevance.

Appearance

As color judgement is such a high priority for photographers, it is really handy that Appearance is the first pane. My suggestion is you set Appearance to Graphite, with all the other settings to suit your particular needs. It is important when making color assessments that there are as few distractions as possible, and that you try to work in controlled and stable lighting environments.

Within Photoshop, if you do not fill the window with your image, the surround defaults to R, G and B values of 192, you can change this to a value of your own choice. Do this by selecting a Foreground color, choose the Paintbucket and Shift+click in the outer area to flood fill your pasteboard with the chosen foreground color.

One viewing mode when using Photoshop CS2 is arrived at by hitting F: this mode clears the distraction of the Finder, and isolates one image from any other open ones. A major benefit of this mode is that when bounding boxes or paths go into this area, you can reach them even at high magnifications. In Photoshop CS3, you have to hit F one more time for this mode.

If you are using a CRT screen, then beyond considering limiting distracting colors, you should look at Energy Saver at this time, because ideally, you should try to keep a CRT screen running consistently, for accurate color and exposure assessment.

The other items in Appearance that can help are the scrollbar settings. I find that grouping both arrows together really does help in moving around zoomed-in images. Setting the 'Click in the Scroll bar' to jump a page, means it moves a whole screen, making dustbusting in Photoshop so much more accurate, because you move logically all over your image by this method, this is similar to using the Page Down key.

Dashboard

This can be accessed either from the Dock or often the **F12** key. Dashboard thus far is of peripheral interest: it contains 'Widgets' – mini-applications many with links to some of your existing applications. Some may be useful to you, though none seem aimed specifically at photographers. Exposé on the other hand definitely can improve your workflow.

Photoshop CS3 update notice

There is a new screen display feature in Photoshop CS3, so cycling using F gives you more options and you can set these up to suit your preferred way of working - hitting F just once from the standard mode only changes the surround to lose other programs and images, so you can make this any shade you like, but only when you hit F again, can you move beyond the image boundaries.

Fig. 1.65 Here is a chance to take as much color out of your working environment so you can make accurate assessments of your images.

Exposé

Exposé uses the function keys by default; see your Mac's Exposé pane in System Preferences to see which these are (they are not the same on all models). I find **F9** and **F11** to be of the most use, as detailed below, using the most commonly defined keys.

F9 Fits all windows to your screen/s. Allowing you to find hidden windows.

F10 Fits Application windows to screen.

F11 Clears all your open windows aside to reveal your Desktop beneath – I find this to be extremely useful, and use this feature frequently.

F12 Dashboard, which can also be invoked from the Dashboard icon in the Dock, displays Widgets, small applications.

Fig. 1.66 Exposé's F9 has brought all my open windows on the main screen forward in miniature. I have then hovered over the Macintouch page, shown highlighted in green, and the banner shows the title in this instance, though generally, it will be the folder or filename.

Desktop & Screen Saver

If you plan to be absent for a lengthy period use the Hot Corner facility to turn the screen saver on explicitly. If security is an issue during temporary absences, then you can set a preference for awaking from Sleep and exiting your Screen Saver only by entering your Password, but, this is done from the Security pane, not, as you might expect, from here.

Tip

If you use Exposé regularly and want to get more speed after the first use, instead of simply clicking the relevant Function Key, click and hold; this does not require a second click to get you back, as, when you release the key it exits Exposé!

Spaces – often F8

Spaces is a new feature in Leopard whereby you can segregate application windows into multiple desktops. Setting up is done within the Exposé pane, after enabling Spaces and opening the Spaces tab. You add the programs and which Space they are to open up in. If you have several windows open in one space and wish to move one to another, this is done by dragging from one and dropping in the other after **F8** has been invoked.

Interestingly the Exposé feature has spawned a useful third-party tool called 'Mouseposé' that temporarily highlights where your cursor is, in much the same way as the search feature in System Preferences; the difference is that the spotlighted area is hard-edged.

Fig. 1.67 Desktop color is rarely a problem, so I opt for this blue, as I often use full-screen mode in Photoshop, or a minimal surround of gray or black.

Spotlight

Found at the top right of your screen, it is the successor to Find File, the Macintosh search engine. It searches metadata to supply the results of your searches. You do need to make some decisions of your own here to ensure that it gives the answers you seek.

Open System Preferences, Highlight Spotlight. In the Search Results tab (Fig. 1.68) you will see that it allows you to restrict and reorder your search criteria. Reordering is straightforward, you click on a heading and drag it into a new position in the list. Uncheck any irrelevant criteria.

You should also note that there are two distinct ways to carry out your searches. You can search from here, or use the **Command+F** shortcut, which uses a Finder window as the search and results display. Also, as an extension to that method, you can create Smart Folders that dynamically retain the results for later reuse.

Before you can really benefit from Spotlight, you need to have allowed it time to complete its indexing of your various volumes. Those of you who remember earlier content-related searching on the Mac, fear not, Spotlight is not so slow!

There are two checkboxes to consider at the bottom, especially if you use the default keys for resizing images in Photoshop. Changes to avoid the clash can be made either here or within Photoshop; I uncheck both, and use the Menu bar Spotlight icon.

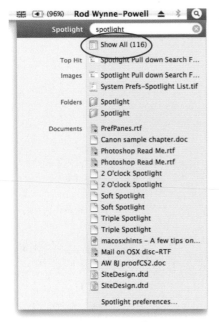

Fig. 1.69 Spotlight starts its search almost immediately the first character is entered. Click 'Show All' for the window below.

Fig. 1.70 The right-hand pane of the Results of a Spotlight search shows one of the many reasons Spotlight is so powerful. Note the How, When and Where of how it sorts the results of its searches.

Fig. 1.68 In this tab drag items into your order of priority, selecting only those categories you need. Exclude volumes or folders using the Privacy Tab, by dragging folders into its window.

The other way to search is to use Finder's File menu, or the shortcut **Command+F**. This invokes a special folder window with the search criteria along the top of the window area. These define where to search, and the plus and minus icons on the right-hand end allow you to edit criteria to refine your search.

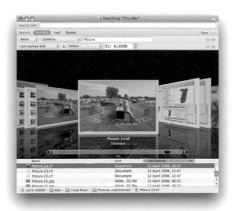

Fig. 1.71 You can also search using the Command+F shortcut.

The Save button can then be used to save your results and name it for future use – anything you create that meets the criteria set, will be added to your folder. It is now a Smart Folder. To create a new Smart Folder, hold the Option key down and the Save button will become 'Save As…' – this allows you to give it a new name.

How might you use this functionality? A useful search I use is to locate all files containing 'Picture' in the name, so that I can gather together a host of screenshots. A Smart folder is distinguished by a black cogwheel within the folder icon. When opened there is a button marked Edit; click to bring back the search fields that will allow you to check or redefine your search.

Fig. 1.73 You can search in Mail using either Spotlight or Google.

Spotlight accessibility

Spotlight is available within Mail, and other Mac applications, so for instance if you are searching for a file to attach to an email to your client, highlight your search text and hold the Control key down on the search slot in Mail and choose Spotlight for the search. Incidentally, as you can see in Fig. 1.73, you can search Google or the system dictionary from within Mail as well, using the context sensitive menu.

You can use Spotlight to search within an Automator Workflow to carry out a series of steps automatically, and even use Automator within Photoshop.

Lightroom and Aperture, both of which are driven by metadata, may well provide what Spotlight and Automator promise, but a system level operation has the potential to work faster. I have shown Tiger's Spotlight, in Leopard, you even get Dictionary definitions when you search.

Fig. 1.72 You can create a Smart Folder using the search results. The search criteria are editable.

Bluetooth

This is a standard which was initiated by Ericsson, IBM, Intel, Nokia and Toshiba as a means of communicating wirelessly simply, between devices such as phones and PDAs. It has a very short range, typically only communicating up to about 5 to 10 metres, and operates in the 2.4 GHz band. It was designed to overcome the inherent problems of Infrared links for the same purpose.

There are now mice and keyboards, thereby keeping cable clutter to a minimum, but Bluetooth mice tend to be heavier due to the necessity for batteries.

Some keyboard functionality is lost since Bluetooth is not initialised till late in the Startup process, therefore such a keyboard, or mouse is not seen till late in that process – holding down a Bluetooth mouse will not eject a CD at startup, for example.

Fig. 1.74 Apple's Wireless Mighty Mouse: it is a multi-button mouse with a tiny scroll button, that operates horizontally, vertically and diagonally, which is very handy when zoomed in within Photoshop. Without a modifier key, it can be used for zooming in and out; add the Option/Alt key for panning around an image.

Bluetooth

I make good use of Bluetooth for synchronising data between a PDA, my phone and Address Book on my PowerBook. I have also tried using a Bluetooth headset with Skype for conducting conversations between clients and myself, as we both look at the work on our own screens.

Setting up a device is fairly straightforward, and rather than provide step-by-step instructions, I think it better to describe the principles; then, any steps you take will make more sense. Firstly, remote devices may draw a fair amount from their batteries, so take this into consideration.

Setting up Bluetooth devices to communicate depends initially on one device doing the transmitting and the other being in a mode that makes it 'discoverable'. Once a device is discovered (and there may be more than one device in the vicinity!) it is listed, and you are asked to choose it. A codeword is then generated, and the other device displays a statement such as 'Device whatever wishes to pair with you, please confirm password'. If you enter this correctly then the pairing goes ahead, and you can save this pairing. Sometimes a new password may well be required for each pairing occasion.

Bluetooth devices fall into different groups with slightly differing needs and therefore the Bluetooth specification defines different device profiles. So, make sure that your device has the correct profile loaded, to ensure compatibilty, so it can therefore pair successfully. One of Bluetooth's opening screens lists different categories of equipment: these relate to the various Bluetooth profiles. Some manufacturers appear to create better profiles for their equipment than others, so check carefully.

Cordless mice and keyboards are generally very straightforward to set up. Other devices may well vary; you may sometimes have to do web searches to obtain updates from the manufacturers. These could involve firmware changes for phones and PDAs. Bluetooth mice and keyboards each have batteries and the charge state can be checked in the **Keyboard & Mouse pane**.

Bluetooth – Setting up a connection

Fig. 1.75 Choose your category of device to start the process of discovery and pairing.

Fig. 1.76 Bluetooth Preference pane and its options.

Fig. 1.77 Once you have paired your device with the Mac, it is listed for future use.

Fig. 1.78 Once you have paired a cordless mouse, or keyboard with your Mac, you can check the battery status in the Bluetooth tab of the Keyboard & Mouse pane.

CDs & DVDs

Here you choose a series of automatic responses to the insertion of media, which can save time. For example, I very rarely use the system software for burning CDs and DVDs, I use Toast – it is really speedy for Toast to be opened the moment I insert a blank disk. Likewise, if I insert a music CD, iTunes is opened. Your choices may vary, you can also choose Ignore!

Fig. 1.79 Save time – set this up, so your Mac knows what to do when you insert a blank CD/DVD.

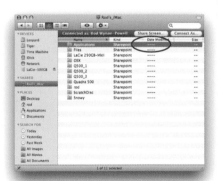

Fig. 1.80 Leopard has a new feature called Screen Sharing, which shows up when you select a shared computer on your network. As can also be seen here, it has another benefit, it shows the other attached disks for that Mac, without you having to mount them.

Note

It is unlikely you will be able to calibrate both monitors to match each other, and therefore both match your output, so always match your output to your main calibrated screen.

Displays

Displays is where you can create your monitor profile or check the settings, and thus you may wish to visit reasonably frequently, in which case check the box within Displays to place the icon in the menu bar permanently. If you have more than one monitor, this where you set them up. The second monitor can exactly mirror the main one, or extend your work area by spanning the monitors, allowing you to work in Photoshop with all your palettes open on one screen, whilst your image fills the main one.

As a photographer, using a laptop, please do not be tempted to check the box marked 'Automatically adjust brightness as ambient light changes' – just ensure that you calibrate your monitor at levels that are fairly constant. Try to maintain neutral color and subdued ambient light in your environment, when doing color critical work.

When you have two monitors, the Displays pane appears on both individually. The 'Gather Windows' button in this dialog box brings both panes to the one main screen.

If you are using two monitors, only the main one will have an Arrangement tab. It is here that the transition between the two screens is set up by dragging an image of the subsidiary screen to a suitable position along one or other edge (see Fig. 1.81). You can also drag the image of the menu bar to the other monitor, which makes that monitor become the main one, with all the menu items.

If you have a laptop attached back at the studio to a larger screen, this would allow you to get the benefit of a wider Palette Dock in Photoshop. In Photoshop CS2, it may be the only way to see the Palette Dock at all, if the screen is below 1024 x 768.

After a period when the computer has been asleep, one monitor in a two-monitor setup can occasionally not wake up. Clicking Detect Displays will generally force the system to restart the monitor selection process and find the errant monitor. If it doesn't then if it is the external monitor that remains doggedly asleep, then put the computer into Sleep mode, remove the connection, wait a few seconds and refit the cable. If this also fails, then do a Restart. Unless you have a major fault, everything will be fine.

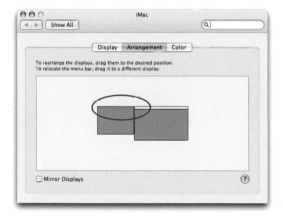

Fig. 1.81 Here, I have clicked and dragged the secondary monitor to the right of the main monitor; the main monitor remains static, and initially has the menu bar shown at its top, though it can be dragged across to the other.

Fig. 1.82 If you have a second monitor attached, then it will show a similar dialog, but without 'Arrangement'. I find it useful to check the box to have the Display preference pane available in the menu bar.

Note

Although there are only nine screenshots here, they are here to aid familiarity, as there are more screens than this. You just follow the sequence through. If you are unsure, there is always the 'Go Back' button. These two pages should give you confidence to apply these settings if you are not using a hardware calibration tool such as Eye 1 Monitor 2 (which offers far greater accuracy).

Using the Color Tab, it is possible to run through an in-built Calibrate and profile procedure. This will do at a pinch, but for enhanced accuracy I strongly recommend that a hardware calibration device is used. These are discussed in Chapter 6.

Open Displays, either from the menu bar at the top, or from System Preferences in the Apple menu, to take the steps to calibrate your monitor screen. Set Gamma to 2.2 despite the 1.8 comment, and Native Whitepoint for flat-screens, and name the profile with a date.

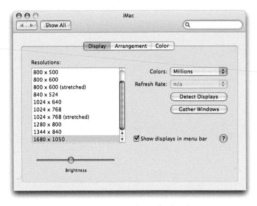

Fig. 1.83 The initial Displays screen that is displayed on your main monitor – the Arrangement tab appears when you have more than one monitor connected.

Fig. 1.84 When you click the Color tab, the Calibrate button appears.

Fig. 1.85 The calibration procedure starts from here, tick the checkbox for Expert Mode.

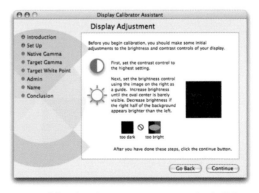

Fig. 1.86 Follow the various steps to setup your monitor, I will show only the first of a series in the following screenshots.

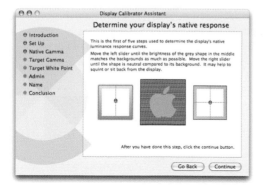

Fig. 1.87 Make the adjustments that are requested.

Fig. 1.88 Set the gamma to 2.2 – yes, even on Macs.

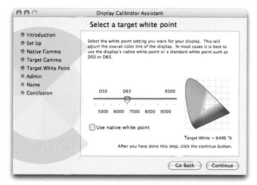

Fig. 1.89 Next set the White point – 6500°k is the generally accepted value here.

Fig. 1.90 In most instances allow all users access to the settings you have just made.

Note

The steps indicated apply in the main to the steps for CRT monitors, many flatscreens will have far less to control.

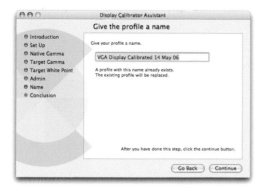

Fig. 1.91 Here is where you are now saving these settings that will become your monitor profile.

Photographers need to have confidence that the exposures and colors they sought to capture digitally, consistently match what they caught with their cameras, what they see on screen, and what they produce on paper, and reasonably reliably, on the Web. Achieving these aims comes under the umbrella term Color Management, something essential for professional photographers. Mac operating systems have long had system level, system wide, color control using ColorSync.

In relation to Displays and to help understand more about Color Workspaces, it is worth looking at the ColorSync Utility, in particular at the Profiles tab. It will allow you to choose a Color Workspace, then bring in say your printer's profile and see how the two relate. It may also help you to relate sRGB to Adobe RGB (1998). You can rotate the graphs in 3D to understand what will reproduce and what will not (see Figs. 1.92 & 1.94).

In Fig. 1.94 I have held the Adobe RGB (1998) workspace profile for comparison with the Epson 1270 Heavyweight Matte profile, which shows that there are some deep blues which are beyond the gamut of the Adobe RGB workspace, and so this is something I should note when printing to this paper.

Note

As a photographer you need to understand why your monitors need to be calibrated; to ensure all your color assessments are made in a controlled environment. Your monitor profile plays its part, and that is what Color Management is all about. Although this book will provide a sound basis, this complex subject can be studied in greater depth elsewhere. I point you to skilled practitioners and some of their books, or websites, in the Resources and Color Management chapters.

Fig. 1.93 Opening a profile in ColorSync Utility will furnish you with information about your profile, but a degree in Color Science may be necessary to learn anything from it!

Fig. 1.92 Compare profiles in this utility to learn more about Color Gamuts, and how one relates to another. You can use this to show whether colors in one colorspace gamut are reproducible in another.

ColorSync Utility

It is worth a digression to take a look at the ColorSync Utility to be found in the Utilities folder. I suggest you just play with what you find there, as some of it may then make much more sense.

Select the Profiles tab, then Adobe RGB (1998) in the left-hand pane. The graph you see is a 3D representation of all the colors that are in that color workspace (shown in LAB by default). Click and drag the hand to move this 'chunk'* of colors around to see the range of colors available.

Now go into the pull down menu and select 'Hold for comparison', and go back to the menu again and chose a CMYK print space. The graph will now show a white outline of the total space, and those CMYK colors not available will extend out of this volume, in full color.

Use the Option key and drag vertically to resize. The Control key or right+click gives you the options.

Rotate and zoom around, and you will begin to understand what happens to colors in different color workspaces. Note the axes for the exposure between White and Black, and how deep colors go out of gamut.

*For 'chunk' read gamut!

Note

It is not really advisable to alter any information presented were you to Click 'Open Profile', but there is considerable information there, which might prove useful to a technician. If you are suffering from a damaged ICC profile — you may be able to repair the profile yourself in the ColorSync Utility.

Fig. 1.94 This shows the holding of Adobe RGB (1998) for comparison, then selecting Euroscale Coated v2 and then rotating around the axis to show the rich greens that would be beyond the Adobe RGB (1998) gamut. This is one reason why this standard has been superseded by FOGRA 27.

Energy Saver

As I mentioned earlier, allowing a CRT display to sleep can affect the reliance you place upon your color assessments of the monitor, as it needs time to reach a stable level. There is another consideration, which I explain in a later chapter, with regards to putting your computer to sleep at night. If you do this you prevent a system function from carrying out some routine maintenance (see Chapter 3).

You can decide when your monitor sleeps explicitly, by taking advantage of a feature that exists in the Desktop and Screen Saver pane that allows you to move your cursor to a designated corner of the screen to sleep the monitor. These are known as Hot Corners.

This preference pane senses your type of Mac, Desktop or Laptop, and also whether you are connected to an Uninterruptible Power Supply, and offers the relevant options, hence my showing a PowerBook dialog box.

Uninterruptible Power Supplies (UPS)

If you are using a UPS unit, Energy Saver will detect this and open further options for its control — see Chapter 2, page 127 for details.

Fig. 1.95 My suggestion is to only use a hot corner to dim the backlight of the screen, and you do this in Desktop & Screen Saver.

Keyboard & Mouse

The sensitivity and speed at which your keyboard, mouse (and trackpad, in the case of a laptop) are all setup here, and are entirely a matter of personal taste. From a photographer's standpoint, the only two tabs likely to be of value are the Bluetooth and Keyboard Shortcuts tabs. If you ever need to acquaint yourself with keyboard shortcuts, these can all be studied in the last tab of this pane, and more importantly if any clash, you can disable or reassign them from here. The list is very comprehensive.

Tip

Shortcut clashes can be resolved in several places. Spotlight is one such just mentioned on page 54, within Photoshop itself is another and here within the Keyboard Shortcuts tab within the Keyboard & Mouse Preference pane.

The choice is very much a personal one based upon your own priorities.

Fig. 1.96 In the Bluetooth pane of Keyboard & Mouse, you can check the state of the batteries in both these devices, whether a Bluetooth icon appears in the Main menu bar, and whether connected Bluetooth devices will wake your computer from sleep.

Fig. 1.97 You can use this list to remind yourself of useful keyboard shortcuts, disable or reassign those that clash or you do not need. A warning alert will appear if you try to overwrite an existing assignment.

Print & Fax

This pane appears to be little more than the front end to Printer Setup Utility, which I advise people to keep in their Dock for easy access. You can set the defaults for Printer, Paper Size and Printer Sharing here. Obviously, if you are using your computer to fax, then those controls are here also, but with a Broadband connection, I rarely come across anyone using this facility from their Mac. The printer features will be discussed in Chapter 7.

Tip

When needing to quickly zoom into the screen image when working or more importantly when presenting, it is handy to be able to zoom using the scroll ball on the Mighty Mouse. To do this check the box marked' Zoom using scroll ball while holding', and set a modifier key. You can also decide how the screen moves in relation to your cursor, under Options, but I find the defaults are fine. I use the Control key as this seems intuitive.

Sound

The Sound pane gives you the opportunity to setup different volumes for the system alerts and general sound output from say iChat, which you might use when discussing shoot details with your clients or Art Directors. Third-party software, such as Skype, may well have their own preference settings.

Other functions here are the various alert sounds themselves and which devices are to be used for Input and Output.

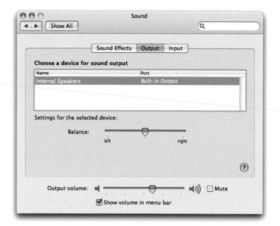

Fig. 1.98 In the first tab, you can choose the Alert sound that informs without irritating you.

Fig. 1.99 The Output port changes from internal speakers to headphones when they are plugged in, and you have both Balance and Output volume controls.

Fig. 1.100 The Output volume slider remains, the Input volume slider replaces Balance, and there is also an Input level meter.

.Mac

.Mac is an Apple Account that provides its members with a disk storage area called iDisk, which you can use as offline backup, or to host your website. The Sync tab employs iSync to synchronise your archived data, and HomePage offers you webspace, so that you can publish your images to the Internet. Your .Mac account comes with 10 GB of overall space for Mail, iCal, Address Book and Webspace, with the option to purchase more.

.Mac membership comes in a 60-day free trial, and this gives you an iChat name which can be useful, especially as you do not lose this, even if you decide not to join at the end of the 60 days. iChat AV takes advantage of the iSight camera built into most recent Macs, to give you live video contact with other members.

iDisk, your personal disk space, can be synchronised with a version on your hard disk, so that you can work offline, then later resynchronise with what is held on the server.

By keeping Mail synchronised with your iDisk, you can access your email from any other computer. You can publish personalised websites with HomePage, which has links from iPhoto and Aperture.

iDisk

This area on Apple servers can be accessed by others via the Internet using a web browser or free software from Apple for Windows XP users: iDisk Utility for Windows.

Mac users can use the Go menu in Finder for either accessing their own or others iDisks. There are three options: your own iDisk, another's iDisk or another's Public folder.

Using iDisk's Preferences, you can add a password to protect the security of your iDisk.

Note

To get the most up-to-date information on what is on offer for the .Mac Service visit Apple's website.

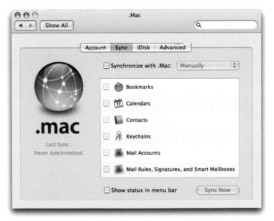

Fig. 1.101 The entry screen before signing up, with the opportunity to upgrade after the initial free period. This is also the log in screen, with tabs leading to the other features of the service such as iDisk.

Fig. 1.102 Here are the applications that can be synchronised with your .Mac account on Apple's servers using iSync.

Select the iDisk tab when you need to purchase further disk space; from this pane, you can start the synchronising operation in either direction. This can be done either automatically, by sensing when an update has taken place, or at times of your own choosing by leaving the radio button set to Manually.

iChat AV is a system level facility that you can use to both talk to and view other Mac users when online, and you use .Mac membership as the means of obtaining a user name for this service. You can also use an AOL (America Online) username to make use of iChat for linking business or family members together for video conferencing. Once you have registered for the trial period of .Mac, if you decide aginst becoming a fully paid up member, you do not lose the user name, so you can at least carry on using the iChat facility. In terms of popularity Skype has made a greater impact using what is known technically as Voice over IP (VOIP); it is constantly adding to the facilities it offers with Voicemail and the ability to communicate directly with landlines.

Either of these services give great sound quality, and allow good communication between photographers and their clients if both are at their computers and have broadband connections.

Fig. 1.103 Once you have joined .Mac, the amount of free and used space, is shown in the top section of the pane. The middle pane allows you to sync with your iDisk, and the bottom pane defines how other users can interact with your Public Folder.

Fig. 1.104 You are not limited to syncing with just a single computer, you simply register the additional computers to allow others you may have, to all keep in sync with each other.

Network Preferences

It is likely this component of System Preferences is visited regularly, hence why it is available from the Apple menu, at the bottom of the Location drop down menu. A Location is simply a preset with previously assigned settings, to make it simpler for you to switch from one to another.

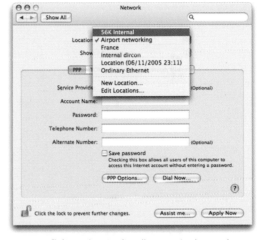

Fig. 1.105 The Network pane shows all the various ports available, and the order in which the system manages them. You can click and drag each item into a different position in the list.

Fig. 1.106 Clicking on Location, lists all your previously created settings, and it is where you create any new ones.

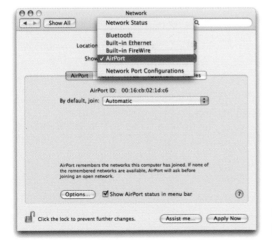

Note

I have shown the series of dialog boxes you would encounter in Tiger, as what has happened in Leopard is that more settings are made automatically and often if the user is upgrading from an existing Mac, the chances are the settings have all been transferred intact.

In Leopard, the level of complexity shown here and in Chapter 8, has been hidden behind the Advanced button, which when clicked reveals much the same controls in the form of a sheet which drops from the Title bar of the pane.

Fig. 1.107 Each of the possible networking options is displayed by selecting from 'Show'.

Fig. 1.108 In the Network Preference pane, highlight the AppleTalk tab then click 'Make AppleTalk Active'.

Fig. 1.109 Set 'Using DHCP' in the TCP/IP tab will automatically generate IP addresses for your network.

Fig. 1.110 Personal File Sharing has been turned on by hitting 'Start' it now changes to 'Stop'.

Network

Ethernet is probably the most important aspect of what is set up in this Preference pane, and before entering any information or making any changes, you should connect your machines using Cat5E cables preferably from an Ethernet switch or hub.

Some switches contain one port designated slightly differently from the others, if this is so, then connect this one to your main computer. If they are the same, then use any ones you like.

From the start, Macs have incorporated a means to network to other Macs, now known as AppleTalk. It is still in use on the latest models and is the simplest form of network – it largely sets itself up, once you have turned it on. This is done by clicking a checkbox from the AppleTalk tab, found when showing either Airport or Built-in Ethernet. Until you check this box, all on that page is grayed out, but once ticked, the Configure option becomes available. However, I suggest you go no further than ticking the 'Make AppleTalk Active' box if you are using AppleTalk.

There are some hidden benefits from using AppleTalk rather than Ethernet, and one is that you should find that each Mac creates its own address, checks for duplication, and if there is, it keeps creating another, until it is unique. This means any connected computer can see all the others, allowing you to login and share files between each other, in a way known as Peer-to-Peer networking. All you need do is open the Sharing Preference Pane, turn on Personal File Sharing on any of the connected Macs, then others can log in with a User name and password.

Sharing is enabled in the Sharing Preference pane, by pressing the button marked Start, after highlighting Personal File Sharing in the left-hand panel. AppleTalk lives happily alongside Ethernet networking and is more than adequate for many a studio. The only other prerequisite is that in the TCP/IP tab of Network you set the very top item (Configure IPv4) to Using DHCP. Once these settings have been made, click Apply Now.

If, when you are setting up an Ethernet network, numbers in a series look like this: 169.254.x.x and you have not made AppleTalk active, then this is a self-assigned number and may well not work with Ethernet; it should have a number in the series 192.168.x.x or 10.0.0.x(see Chapter 8 for Ethernet networking details).

Sharing – Services

I have jumped over QuickTime for the moment since Sharing links with Network.

The settings made here are very much tied in with those made in Network. You can choose a really meaningful or esoteric name for each Mac in the studio network – Camera, Edit, Design, Portable – Tom, Dick, Harry, Kylie!

The Services tab is where you can make decisions as to what parts of your system are available to outsiders. The outsider could be yourself, if for example you wanted to log into your computer from elsewhere. This might involve FTP and Remote Login, possibly even Apple Remote Desktop. You are allowing the opening of doors, known as ports. Each one you tick is the same as if you highlighted it, and then clicked Start.

Each Mac's Sharing Preference pane controls all the ways it allows access to various means of communicating with that Mac. Every Service is handled separately by ticking it in the left-hand window, and clicking 'Start'. In the example to the right, provided the PC has a correct name and password, you have opened your Mac to them for Windows Sharing. You decide when setting up that User in the Accounts Preference pane, the level of access they have to your machine.

You can tick each of the items in the list that you wish to share, and then click 'Start' in the same way as Personal File Sharing. Most items are obvious, but FTP means File Transfer Protocol, and XGrid is a system whereby your computer can link with others to form a larger virtual computer, generally for scientific purposes. Apple provides a short description of each as you highlight them.

The middle tab provides you with a system-level protective Firewall (see overleaf for fuller description) to block incoming signals from the Internet entering your computer through your ports; when turned on it closes them all, except for those you explicitly open in the list within the scrollable window.

Fig. 1.111 When you turn on Windows Sharing this allows you to transfer files between a Windows PC and the Mac. Sharing is also the pane where you can alter the Computer Name from the the Network's point of view.

Fig. 1.112 Apple includes a simple Firewall in Mac OS X, but more often than not, you will have a Firewall built into your Router, and this is in the ideal position to exclude unwanted access to your computer from outsiders.

Note

Do not be tempted to turn on both this Firewall and the one in your router. This would lead to problems.

Leopard's Firewall is Application specific, which will open up further options.

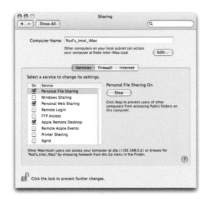

Fig. 1.113 Personal File Sharing and Personal Web Sharing are on, as well Apple Remote Desktop.

Personal File Sharing

Even if you are physically connected to other computers in a network, if Personal Sharing is not ticked, then nothing will be available to any of them – the port is closed. Access to individual folders can still be altered once this has been opened. That access is defined at the bottom of the Get Info box under Ownership & Permissions (see Fig. 1.114).

As Administrator, you can see that in the case of this Image I have both Read and Write Access, but others can only read this file. If I clicked on the padlock icon and gave my name and password, I could change the access to No Access, and in which case, any other network user would be unable to load this file, even though I may have shared the volume it was on.

You may wish to take file sharing a stage further if your Mac at base is on broadband, and you are on location. You may want to send images you have taken, back to your base, this can be done using FTP (File Transfer Protocol). You would need to setup your base machine beforehand by ticking FTP Access, and preferably having only a single folder open to receive your files. For added security, you could create a new user and a separate password. When working away, you could also check the Remote Login box so that you can use a facility called SSH (Secure Shell) to connect and work with that machine, but you will be working somewhat blind, since you will be using the application called Terminal (found in Applications/Utilities). This may be no hindrance if you are only uploading files to your base machine, or retrieving something from a known location on your drive/s. A more sophisticated means to do this is to have Apple Remote Desktop installed on both machines, so that you open an exact copy of what is on your remote machine in a window on the screen in front of you, in which case make sure you check Apple Remote Desktop in Sharing.

Fig. 1.114 In the case of this image file, I have total access, but others have Read Only access, which means they cannot edit it.

Windows Sharing

The last two services that a photographer might find meaningful are Windows Sharing and Printer Sharing. You may well be using a Windows PC for your admin and accounts functions, and need the occasional connection to your Macs; you will have to do some setting up on both machines.

Start at the Windows PC. Decide which folder or folders are to be shared. This could even be a new and separate folder; a drop box for items to be shared.

Right-click on this folder to obtain 'Sharing and Security', where you will use Network Setup Wizard to deal with that end of the connection. If in any doubt, run through 'checklist for creating a Network'. You will likely to have to create a Workgroup, to which the Windows machine will belong. The last page presents a summary of the settings, before you apply them.

On the Mac, you will have to enable the User accounts who wish to share, and take note of the IP address the Windows machine needs to use to connect. This is done in the Sharing Preference pane, where you tick 'Windows Sharing'; this brings up 'Enable Accounts' (see Fig. 1.115 on right).

Click this to bring down a sheet with checkboxes against each User's Account. Tick those relevant; you will have to authenticate yourself by user name and password, then click 'Done'.

To initiate the connection from the Mac, go to Finder, hold down the Command key and click K (Connect to Server, from the Go menu), in the text entry box type 'smb://' followed by either the name of the computer or its IP address); from there, after authentication, another window opens to show the shared folders in a button list.

In the case shown, there was only one, the Home folder, using the User's short name. Hitting OK mounted that as a Network volume on the Desktop, allowing two-way working between the two computers. The second was a Mac with Windows XP running under Boot Camp.

Note

Do remember to create the User's account in the Accounts pane of System Preferences.

Fig. 1.115 Check Windows Sharing to start the operation.

Fig. 1.116 Click 'Enable Accounts' to bring down the sheet shown here, where you decide which accounts have access.

Fig. 1.117 Using Command+K in Finder and typing: smb://l24 brought up the Authentication request, allowing me to see the User's Home folder.

Fig. 1.118 Selecting the folder you wish to share, and right-clicking to select 'Sharing and Security' brings you this dialog box.

Fig. 1.119 'My Network Places' shows the shared Mac folder, and its Home folder.

Linking Macs to Windows PCs requires some preliminary setting up on both sides, and although not to dissimilar, the terminology does vary. The principle is that you create a folder on the PC, and right click to get its properties where you choose 'Sharing and Security'.

Choose 'Share this folder on the network'. Once the computers are connected via Ethernet, the PC should be available to Finder on the Mac via Go/Connect to Server.

Back on the Mac, you go to the 'Go' menu from Finder – it is in the menu bar. Choose 'Connect to Server' (**Command+K** from Finder). In the window which follows, I generally suggest you click on 'Browse', which will take you to a standard browser window showing Network, under which will appear all the various shared items on your network; the name you gave the Windows Workgroup should be there. Click on it and there should appear a globe in a cube icon with the word 'Connect' beneath. You will then be asked for your user name and password, and offered any volumes attached to that computer – tick those of interest to mount them on your desktop.

As an alternative to using Browse, you can type in: 'smb://Computer Name or the IP address', and hit OK. After that you are presented with the selection of shared folders on that computer. Although there is a button for you to authenticate again, it should not be necessary – just click the OK.

There is an option to add your user name and password to your Keychain, by checking the box at the bottom. It is well worth selecting this option as it will save you time in the long run. Click 'OK' and you are connected to the shared folder or folders on the Windows PC.

Once you have established a connection to any server, it can be accessed subsequently from Recent Servers in the Apple menu, or in Leopard, from a Finder window's sidebar beneath the 'Shared' header.

Apple has built in a simple Firewall to protect against the evil intentions of intruders to your Mac, who might want to gain access to your personal details, or to disrupt your computer by taking it over to send out undesirable emails to all those in your address book. It is activated from the Sharing Preference pane.

Access to your Mac is by Ports, and a Firewall starts essentially by closing all ports; then you only open those you need. An additional form of protection is to use a different address given to the outside world than you use internally: this method is known as Network Address Translation (NAT). Mac OS X Firewall only uses the first strategy; opening only those ports you designate. For this reason, it is a sound idea to consider additional third-party NAT protection. 'Flying Buttress' - formerly 'Brickhouse' is a good donationware example, and many ADSL and cable routers offer NAT as part of their packages.

If you do use a third-party Firewall either as a separate entity or a component within an ADSL or cable router, then do not use this Apple one as well. Two Firewalls are not better than one in this instance, it merely creates confusion. The other ports you are likely to want to open are Windows Sharing if you need to connect to a Windows PC and FTP Access if you need to have clients send you files, or collect files from you.

If you have .Mac and use iDisk, this complexity is bypassed as it simply appears as another disk volume.

If you plan on using Apple's built-in Apache Web server, then you may need to open Personal Web Sharing, but bear in mind ideally you need a fixed, not a dynamically changing IP address from your ISP.

Should you need to login and upload files from a remote location, your base machine will need to be: permanently on, be set for Remote Login, to wake from sleep for network activity, and above all, be very secure!

Fig. 1.120 Initially a Firewall closes all the ports, then allows you to choose which ports are to be opened, and in the tooltip, warns you to only open your file sharing ports here. So, if you use this Apple firewall, do not open 'Personal File Sharing' in the Services tab. The tooltips for this Preference pane are particularly informative, as can be seen here.

Internet

When you have created a network of computers, this does not mean that immediately everything on one computer is available to everyone else who happens to be on the same network. Each computer has the ability to decide who can see what. The two components are firstly, who can see the computer, the second is which items on that computer are available. Lastly, you as Administrator of a particular computer can decide whether a file can be edited. This is decided by Permissions: you can let either groups or individuals, Read or Write files.

In the Services tab, you were able to control which Services could be shared; in the Internet tab, you can control whether your Internet connection is shared and through which connection this is made to other Macs in the network.

If you have a USB broadband connection you may not be able to share the Internet connection, whereas with Ethernet and Wireless connection you should have no problems. Many ADSL and Cable modems feature built-in switches or routers, and some have combined Wireless Gateways, making it very easy to share the Internet amongst several computers, and form the basis of a network.

I have changed this name from its default. Here is the best way to get over the Gotcha involving several 'Macintosh HD's!

Fig. 1.121 In this screen as shown you would be allowing your Internet connection from Airport to be distributed to anyone on your wired Ethernet network, once you click Start – the button would then change to Stop. To ensure that only the Adminstrator can change your settings, finish by clicking the padlock closed.

QuickTime

QuickTime forms the basis of much of what the Mac is able to do in terms of graphics and sound, and this is done in the depths of the system. It is used to compress and decompress JPEGs, handles digital video, animation, text and panoramas, yet after possibly only viewing its preferences once when you first get a Mac, the only noticeable user interaction you have is when you use the QuickTime Player.

QuickTime has the capability to stream video – that is, receive simultaneously and output to screen, which proves ideal for Web uses, and enhanced Podcasts.

QuickTime Player and iTunes use QuickTime for both audio and video.

QuickTime Pro

QuickTime comes in two flavors, the second being the Pro version which is a paid for upgrade, and extends some features of Player, but its real strength is in editing where it provides an extensive array of tools for those wanting to create movies and immersive panoramas, or add/remove sound to existing movies.

The creation and editing features, normally enabled by the purchase of a licence key are available to some video editing programs like Final Cut Studio, and Apple entices you with the opening screen of the QuickTime Preference pane (see also page 79).

Fig. 1.122 Tick the boxes you need for the Web.

Fig. 1.123 Load new Codecs and Update here.

Fig. 1.124 Set your connection speed here.

Fig. 1.125 Kiosk mode limits your controls.

Most of the settings in this pane are subjective, or specific to your setup, such as your connection speed. Unless you are producing QuickTime movies, videos or panoramas, I see no need for the Pro key, and you should note that Apple do not provide upgrade pricing but do require you to buy a new key with each QuickTime or major System upgrade.

I tend not to have movies start automatically, but like to cache them. Keep this to a minimum – if you set this to its maximum, then you may well need the 'Empty Download Cache' button.

The speed you set for streaming is also dependent upon outside factors beyond the nominal speed you have purchased, so you may need to set this speed conservatively, and not enable Instant-On.

If you have a fast connection, then you may benefit from enabling this feature and adjusting the delay to suit. If you have added a third-party synthesizer, then you can choose this in place of the default.

Fig. 1.126 Typically, when you open QuickTime Player, Apple displays a series of trailers that can be purchased and viewed in QuickTime.

Advanced relates to the QuickTime plug-in and I would suggest you leave Transport set to Automatic, but if you are behind a Firewall, you can set different ports, by choosing Custom.

In the Advanced tab (Fig. 1.125 on the previous page) you can choose 'Enable kiosk mode' to limit the controls available to a user within your browser.

MIME types relate filetypes to plug ins, and the list is editable. Media keys may be needed if files are encrypted and you will need to obtain the key from the Content owner, and then add it to the list. It may well be a good safeguard to take a screenshot of this, in case you need to reinstate these.

Fig. 1.127 This is a screengrab of a short animation created in 3D Studio Max by Dan Wynne-Powell, from some Photoshop and Illustrator files I use as training material, showing in QuickTime Player.

QuickTime Player

The Player application will play movies, interactive QuickTime VR panoramas, sound files, and open many files such as JPEGs. It can be used as the default application to handle audio and video in web browsers such as Apple's Safari.

QuickTime Pro

Apple has embedded more functionality within QuickTime for the creation and editing of sound, video and interactivity, but these features remain locked until you purchase a key to unlock them.

Also, the model Apple uses with regards upgrading means that at certain stages of the standard upgrade cycle, your previous code will cease to operate. If you need the added functionality for the creation of QuickTime VR and movies, then read the upgrade notes carefully before you proceed. For this reason I would certainly not schedule automatic software upgrades once you have purchased a key, in case you are caught out. Downgrading to a previous version is not necessarily a straightforward process, so do your updating manually once you are sure of the ramifications, by reading any available information online.

The Update tab has an 'Install…' button that takes you to a page on the Apple site offering third-party plug-ins for standard and Pro versions of QuickTime (see Fig. 1.129).

Fig. 1.129 Select the Update tab, and click Install… and you will be taken to the Apple website page where you can see several third-party components and links to their respective sites .

Fig. 1.128 Click the Buy QuickTime Pro button to get your key.

Keychain

Apple has tried to make Mac OS X safe yet not restrictive, and one of the ways it has done this is to institute a system called Keychain. There are numerous times when working on a Mac that you want some form of security, so you can create a password to restrict access – obviously there are different levels of security. Your bank details are far too personal to leave unsecured, and certainly you do not want to be using the same password as the studio for access to clients' image folders. By the same token you do not want to have to keep having to type all of the less important ones in every time you use them. So you store them in a Keychain, so that the computer is aware of them, and if you have checked a box which says 'Remember Password', the System checks who the user is and responds accordingly.

Normally, therefore you do not see the work of the Keychain, but there are times when you might forget a particular password, and need to find out what you set. To do this you go to Keychain Access in the Utilities folder, inside Applications.

The window shown below displays a list of all the various occasions where passwords are required to access certain information, both on your Mac or networks to which you connect. Likewise when you visit secure websites to either view or download files.

Note

It may well be advisable to have a different password for access to your Keychain, due to the sensitivity of the information it contains.

Fig. 1.130 The main window of Keychain Access, listing the instances of all your secure transactions saved to your Keychain. Click Show Keychains to view other Keychains.

Although by default, the window is set to show 'All Items', below that you can view each category separately, which can simplify your task. If you select any item in the list, brief details appear in the top pane of the window. If you either double-click the entry or highlight it and click the 'i' symbol along the bottom edge, you will get further information. If you are the Administrator, you can click on Show Password, if you have forgotten it, and if necessary add a hint for yourself in the Comment field within the Attributes pane.

You can have more than one keychain, and the keychains hold various certificates to validate information or data that you receive. The certificates are electronic signatures used to verify that the data you are receiving is coming from a trusted source.

When you are using Apple's Software Update a certificate is involved to ensure you are receiving this data from a secure and validated source. Obviously this is vital as this is the main mechanism to receive both System Upgrades and Security Updates, direct from Apple. These ensure that the integrity of your system is maintained. When checking these certificates you can look at their expiry date, since they should all be dated.

You and others can create your own digital signatures and certificates, but when accepting a private certificate, ensure they can be trusted. Large global organizations tend to have signatures validated by independent bodies to ensure security.

Fig. 1.131 If you have forgotten the password for this Network, and you are the Administrator, then click 'Show Password', and authenticate yourself, stating whether you want access always or just this instance.

Fig. 1.132 The Access Control tab will show how you get to set the access to this network.

Accounts

The Accounts pane deals with the creation of Users, their associated passwords and privileges, and with Login Items. The Admin User will need to authenticate him/her self before adding to or altering the various options. For purely diagnostic purposes, it can be handy to create an additional Administrator account. The reason is that the account will have default preferences, and is likely to be unaffected by the same situation that in some way may have corrupted the true Admin Account at the time you are trying to troubleshoot.

If you click Login Options at the bottom of the left-hand side panel, you will see the dialog box on the right above. If you check the box to set automatic login, this will avoid having to login each time you start your machine, but you do lose a measure of security. If you have more than one user, then there may be no gain, if the other user has to switch at startup.

If you do want to give a small amount of extra security, you could ask only for a Name and Password, by clicking the lower radio button for how you display the Login window, rather than give half the game away listing the users.

Fig. 1.133 When you open Accounts, you'll see four tabs, the two of concern are Password and Login Items.

Fig. 1.134 Once you unlock the padlock and click Login Options, these are what you can set.

Accounts – Login Items

If you have several programs you need all the time, you can add these as Login Items, so they are immediately available - if this Mac is always used for Photoshop, in the Login Items, click the plus sign to bring up the system file browser, then locate Photoshop and click 'Add'. In the case of Photoshop, there will be no need to tick the Hide column, but if you also wanted InDesign or Illustrator to be open in the background, then place a tick against it in the Hide column, and it would be open, ready for when you need it.

I have not brought up Parental Controls, since I feel it would be out of context in this book! Whether you feel a picture of the user/s is appropriate is entirely down to personal preference, but I suppose with most of the Macs now sporting iSight cameras built-in, it is certainly no hardship to use it to grab shots for this purpose. If Apple were to have a small face recognition program built in, then this could well be an additional security measure!

I do come across studios where no passwords are used, and I do feel this is foolhardy: a disgruntled employee or unwanted visitor might well then take advantage, and could well destroy all your hard work, so please lock down after making any settings here in particular, so that the Admin user name and password must be used to carry out all alterations at this level.

Note

I am often surprised to learn that some Photoshop users are unaware of Bridge, and those who are aware, do not realize it can be loaded automatically when Photoshop is opened.

So for those who would like to have access to Bridge as well as Photoshop with the minimum of fuss, open Photoshop's Preferences and in the General tab, tick the very first box in the Options section.

If you have Photoshop listed as one of your login items to open at Startup, you will now have both programs open and ready to go.

In Leopard, you could even assign Photoshop to Space 1, and Bridge to Space 2, so that you keep each entirely separate as far as screen layouts go, and to flick between, simply use Control plus the arrow keys.

Fig. 1.135 Use the plus sign to add new items at Login, and the minus to remove any you no longer need. I have ticked those items that can remain hidden, some permanently, others only till needed.

Date & Time

It may seem trivial to mention this pane, but it is well worth having the correct local time, so that if your clients are in a different time zone, you can use Dashboard to have a clock running at their time. Overseas clients appreciate your knowing whether it is early morning or close of play, when you call!

Having the correct time can also have a critical effect when doing backups, so do try to ensure that your time settings are kept up to date. Some pre-release software may well be time-bombed (purposely made to cease to function either by a certain date, or after a period of time related to when first installed).

If you ever find that the date at a restart is showing a year in the 1970s, then this may well have been caused by a crash, or by your internal battery that would normally be retaining your volatile memory, failing. Replace that battery as soon as possible in such a case, or you might find your machine will not even start up. That memory stores what is known as Parameter RAM or PRAM for short, and the data held there is what configures your computer at startup, and holds your Date and Time Information.

PRAM batteries are generally Lithium of some sort, and often in half AA size, held in a cradle on the motherboard, nearby will likely be a small reset button, which you may need to press if the battery ever got too low before it was changed.

One option you may well prefer to set if on an always-on broadband connection is to use an Internet clock which will then set both Date and Time automatically. If you do, then simply check the box at the top left of Date & Time and select the Time Zone to the right.

The format of your displays of both time and date can also be altered to suit; in particular, the different ways the Americans and Europeans order their calendars. The British use day before month, whereas the Americans refer to the month before the day, when using numbers. One advantage this has is it lends itself better to the hierarchical storage of information for databases.

Tip

Do you ever miss having the date visible in the Menu bar? And find yourself having to check this out by clicking on the time displayed?

You are only a copy and paste away – just open International, which is simply a matter of clicking on the flag in the menu bar if this is visible, or by opening System Preferences to select its pane.

Choose the Formats tab, and in Dates, hit the Customize button, and set to Medium or Long for Show. Drag the Day and Month to the editing field then copy both to the Clipboard, cancel out of that box, then Open Customize for Times, select Medium or Long again, and paste into the editing field, then OK the box, and exit International - you will now see the fuller Date and Time in the Menu bar.

Fig. 1.136 Rather than rely on the Mac's internal clock, which can drift; provided you are connected to the Internet, you can link to one of three Atomic clocks.

Image Capture

Photographers will know that iPhoto comes with Mac OS X, as well as Preview, but very few are aware that attaching a camera or Card Reader that seems to try to open iPhoto is not specifically a function of iPhoto, but of a small program called Image Capture, and not only does it intercept cameras and cards, but also scanners.

If you do not plan to use iPhoto in any way, it may not be clear as to how you prevent this unwarranted action. You will find Image Capture in Applications, and if you go to its preferences, you can change the defaults to open the program of your choice (or none at all!) and into a location that you specify, rather than on your startup disk, in the Pictures folder.

Therein lies another personal bugbear of mine: I do not like to see so many items automatically being stored on the startup disk. I am constantly recommending that photographers ensure they have more than one disk, also, preferably to load a working system to that disk together with a few diagnostic programs such as TechTool Pro, Disk Warrior, Drive Genius, and Data Rescue.

Where possible try to ensure as much of your data is saved or loaded to disks other than your System Startup Disk.

Once you have set preferences for Image Capture, it can be left to work unattended, and once you get its window up, you can divert the images either to the last used folder or to any recent one, or use 'Other' to allow you to browse and create a new folder and save your images there.

Fig. 1.138 Above are the preference settings; Apple obviously want you to open iPhoto, but once you locate these preferences, it is simple enough to point it elsewhere.

Fig. 1.139 Clicking on Options opens the sheet you see here, where you may wish to choose an ICC profile that corresponds to your camera's workspace.

Fig. 1.137 Download Some... offers you the opportunity to cull images before downloading.

Startup Disk

This pane lists all the available bootable drives that you have connected, whether fixed or removable. If you have installed Boot Camp, it will also show up a bootable Windows partition! Boot Camp is the program that allows the Intel-based Macs to boot into and run Windows directly. This facility is incorporated into Apple's latest operating system, 10.5.x, codenamed Leopard.

Apple has also made Target Disk Mode more discoverable by having a button perform what used to be done by holding down the T key whilst starting or restarting your computer. The old procedure is still operable, and what you do is connect the two Macs using a Firewire cable, the machine you wish to be running the system you boot up normally, and when this is up and running you hold down the T key on the Mac whose hard drive is all you want to see. Then hit the Power button and keep holding the T key till a large Firewire logo starts to gently bounce around your screen. A short while after that your hard disk from that machine will mount on the desktop of the other as just another hard disk volume.

The way suggested when you use the button is to connect to the other machine, the host, then restart your currently live machine into Target Disk Mode. The difference between the two procedures is that you are restarting from a live machine when using the button, whereas you would be starting from cold using the T key method.

If you want to start up from another attached disk that has a valid System on, from cold, then hold down the Option/Alt key at Startup as you hit the Power button, and keep the key down till you see a screen (blue on a PowerPC, silver on an Intel) with a series of the bootable drives, showing up as hard drive images with their names beneath. Click on the required one, and this will highlight on a PowerPC Mac, then you click the right-facing arrow, or, if it is an Intel Mac an arrow will appear beneath your chosen drive, which you then click (see Fig. 1.142 on the facing page).

Different systems

You may have different levels of operating system on different disk volumes, and the version will appear alongside the volume's name, as shown in Fig. 1.140 below, Startup Disk will even show a Boot Camp volume for Windows.

There are times when additional information is required beyond the version number; this is the build number. Hovering the cursor over the volume name to display the ToolTip is the only way to find this information here in the Startup Disk Preference pane.

Fig. 1.140 Any connected drives that have bootable systems installed, will appear in the window, select one and close the box, or press the button to restart immediately.

Note

When using a drive in Target Disk Mode, it should ideally be the only externally connected drive. If you have difficulty, and you are faced with trying to use Firewire Target Disk Mode and there are other drives connected, I find that I can succeed by starting the Mac in this mode with a Firewire lead connected, then connecting this to the host machine.

Startup Disk – Target Disk Mode

Something that may not have been apparent to many, is that you can boot from the system on the Mac that is in Target Disk Mode. On the Mac whose hard drive you want to start from, you hold the T key down and press the Power button.

The hard drive will start up, and the Mac will 'bong', and after a short while the Firewire logo will appear and start to gently bounce around the screen. This indicates that to all intents and purposes, this Mac is no more than a hard drive. It is now in Target Disk Mode.

So long as the System is compatible with the Mac you wish to start up, and the Firewire connection to this other Mac is made, hold down the Option key and press its power button. Keep it held down till you see the two drive icons. On the screen, now select the drive that is in Target Disk mode, by clicking on the arrow beneath it. Your machine will now boot from this drive.

My comment about compatible systems refers to both the machines having PowerPC CPUs or both being Intel-based Macs – you will not be able to run an Intel Mac using PowerPC Mac OS X.

Do bear in mind that you may not have exactly the same drivers and software as the original drive, but this procedure can often be a lifesaving one, if the other drive has failed or is corrupted in some way. Another point to note is that most people think of this procedure as being a way to see a PowerBook or iBook's drive on a G4 or G5 tower, but it is more than that, any recent Mac can take advantage of this technique. You can use this method as a means of copying files between two Macs, when you have a Firewire cable but no Ethernet one, or when you have a failing machine that won't boot up, but has some vital images on it.

The images on PowerMacs are orange icons on blue, whereas the Intel-based Macs are silver on gray.

Starting up from a different disk

When you have not changed your startup disk in the Preference pane, and you need to start from cold and restart using a different disk, the way to do this is to hold down the Option/Alt key till you see all the drives which contain bootable systems, once all the icons for those drives have appeared in a line across the middle of your screen, make your selection and click the arrow that faces right on PowerMacs, or the upward arrow on the Intel-based Macs.

Fig. 1.141 Above is what the screen looks like in Target Disk Mode on the Intel Macs.

Fig. 1.142 This is the screen as it appears on the Intel Macs when starting up whilst holding down the Option/Alt key until you see various drive icons arranged across the center of your screen.

Universal Access

This pane is devoted primarily to those who need to have special assistance from the System, through enhancements to the keyboard, mouse, cursors, or sound levels.

There are some features which can be useful to anyone, at some time or other – the first is in the second tab, Hearing. If you are in a noisy environment, the flash of your screen could be a handy additional alert. So, check the box marked 'Flash the screen, when an alert sound occurs'. The second is at the bottom of the Mouse tab – there is a slider that enlarges the cursor. Use this one with care, since a larger arrow is fine, but an enlarged text insertion cursor is rather less helpful, as this slider control treats both styles of cursor equally.

Fig. 1.143 Though primarily for those in need of special assistance, there are functions that the able-bodied amongst us might also find useful.

Partitioning a drive

The need for partitioning your primary hard disk is not a high priority, since there is little to gain, but partitioning other disks can serve valid purposes in segmenting your data. An example would be keeping a partition entirely free for Photoshop scratch disk purposes.

You will need Disk Utility to create partitions on a hard disk, and you can find this in the Utilities folder within the Applications folder.

Both the Applications folder and the Utilities folder can be opened from the Finder, via shortcuts – **Shift+Command+A** for Applications, and to reach Utilities – **Shift+Command+U**.

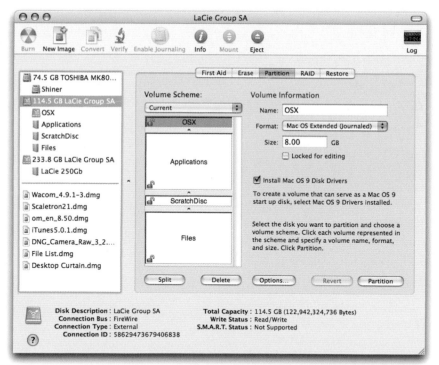

Fig. 1.144 This is the Partition tab in Disk Utility, and shows a drive with four partitions set up. There is a subtly different partitioning scheme in Intel Macs, with other options for different formatting, but HFS+ and journaling on is your best option. Do not attempt to change the size of partitions which already contain data, as the operation will erase everything, unless you are using Apple's Boot Camp live partitioning.

Users' Home folders

I have mentioned at the start of this chapter, that Mac OS X is multi-user, what that means on any one machine is that more than one user can log in. Each has a Home folder and settings, which can differ from each other. Each user can have applications unique to that user. Work can be passed between users via a shared folder called 'Public' in each user's Home folder. Often there is a folder called 'Drop Box' inside this one, and on the owner's computer the Permissions for that folder may well be set to 'Write Only', so files can be added by anyone, though nobody but the owner can see the contents.

When connecting Macs in a network, you are quite likely to see an entry for both the startup hard drive for that computer, connected hard drives and the main User Directory. Exactly what is shown will relate directly to what has been set on that Mac, and that is something you can decide when you set up the network, using a combination of the settings you make in the Sharing Preference pane of System Preferences, and individual volumes, folders, and files, using the Ownership and Permissions section at the bottom of the Get Info window.

This chapter has been very much about what is in the System, not necessarily exactly how it fits into the working environment. Chapter 8, which goes into detail about setting up networks, should be read in conjunction with what has been written in this chapter, and given you an appreciation of the components and structure of Mac OS X. Although there is much complexity in this operating system, the more you learn about it, the more you will be able to second guess how to tackle something new – much of what you will encounter is very intuitive.

In Chapter 5, I go into the resources available to you to learn more, some of which is an inherent part of the system. Remember, unless you save a change or overwrite something, you can generally explore and experiment, safe in the knowledge you are not going to destroy anything. This is even truer if you use Time Machine in Leopard, just go back in time, and copy it!

Two useful things to remember are Undo, for which there is a key combination, **Command+Z**, and the **Escape key**, both these can help you out of tight corners! As can **Command+.** (fullstop/period).

Fig. 1.145 This user is a generic Network user, with as you see a Public folder and within that, a Drop Box.

Fig. 1.146 Selecting the 'nuser' Public folder shows that this restricts the owner of this box to Read only, which means the user is working on a copy, and thus the original remains intact.

What is happening?

Once you have been using your Mac for a while, you develop a sixth sense as to when it is slowing down. Heed this; you are probably correct.

Ask yourself whether what you are doing is burdening the system. Do you have a lot of programs open? Is the picture you're working on very much larger than normal, does it have more layers? If there is nothing untoward there, have you changed any settings recently, or loaded a new program, updated the system, or added a new peripheral? Any of these may give rise to a slowdown.

A more scientific way to check is to open Activity Monitor from the Utilities folder, and watch what is happening here. Can you see the program you felt was sluggish in the list – is it in red, saying program X is not responding? Or, is it at the top of the %CPU column showing close to 100% or simply very high, but no changes are occurring?

Although there are times when the item is red, showing a 'not responding' message, yet the program is still running, it may be simply temporarily overtaxed, but generally, the red text means that program has crashed. Highlight it in the window and click 'Quit Process', this may throw up another dialog box, asking you to Force Quit – click on OK. You can generally simply reopen the program and continue – it will not have affected any other.

If this persists, then you should consider locating the program's Preference file and dragging it to the trash. This file is in Library/Preferences and will mainly be in the form:

com.*Publisher.Program*.plist

So for Photoshop it would take the form:

com.adobe.Photoshop.plist

Or Canon's software:

com.canon.Digital Photo Professional.plist

In almost all cases these .plist files are reconstructed by the host program the next time they are opened, thereby only losing your settings, but **beware** – unstored Actions in Photoshop can be lost, as they are temporarily located here.

Fig. 1.147 Activity Monitor, this could help you decide whether your machine is in an endless loop, or simply temporarily tied up, carrying out a background task.

Note

Although I often recommend that .plist files are fairly safe to trash, do not immediately empty the Trash, close the program, and reopen it to recreate a new Preference file, if there is no change and you have several settings specific to your use of that program, then drag the former file over the new and say 'yes' to overwriting the newer file.

Tip

Because there are a number of settings worth making to Photoshop, once you are happy with your settings, make a copy of the Photoshop.plist file and store it somewhere safely in a folder marked 'PS Backup' for example. Then closing Photoshop and dragging this file over the dodgy one, should get you up and running swiftly. And with Photoshop, save Action Sets and NOT in the Default Set!

Fig. 1.148 Something like this image will fill your screen in Tiger, and means you have experienced a kernel panic.
At the time of writing a description from Apple of what this means can be found at:
<http://docs.info.apple.com/article2.html?artnum=106227>
Another useful URL is: <http://docs.info.apple.com/article.html?artnum=25392>.
The '<' and '>' are present only to denote the full length of the text string you have to enter. This is worth remembering when copying and pasting URL from within a mail program to a web browser.

Note

From a practical standpoint if you are faced with the dire situation of several programs crashing for no apparent reason, or you experience the extremely rare, kernel panics; then back up whatever data you can, *before* attempting to find the cause.

If you have a wrist strap (to avoid static electricity), and the confidence, then, because it is a simple task, check your RAM – *whilst the computer is off.* Check their seating, then try removing them, and replacing one at a time (or pairs in some instances), until either you find a faulty chip, or you eliminate this as a cause.

If the fault remains, next try booting from the original Mac system disks and check using Disk Utility. You could also consider creating another User, to see whether this returns normality.

Should all this fail, it is time to consider third-party tools or calling a professional.

What can go wrong?

This chapter has been all about how to set things up and get things to work, but, however unlikely it has now become, it is always handy to know what can happen that is untoward, and how to get out of those situations without doing any damage.

Do get into the habit of emptying the trash, as this takes up unnecessary hard disk space, and can cause unnecessary fragmentation of your free space, and a possible slowdown.

Below, I explain some terms you might come across.

The Mac freezes or hangs

When the mouse does not move the cursor, or the cursor changes to the spinning multi-colored ball, or watch, and this state seems endless.

Crash

Your cursor disappears and nothing works.

Kernel panic

The screen becomes overlaid with an image like that shown to the left, or goes a veiled gray with an alert in several languages, that tells you to restart your machine. Once again everything is totally unresponsive. You have no option but to restart.

The above three are worst case scenarios

For the more technically inclined, if you can access other programs, but not the one on which you were working, then open Activity Monitor application, found in Applications/Utilities. In this you may well spot a background process that is in an endless loop, if so its entry may well be in red. It could simply be taking a large part of the processor time temporarily. In that case, be patient.

One such activity is indexing. Spotlight, Apple's search tool, on first launching, or sometimes after a system update, needs to index all the data on your volumes. On large volumes this can take a while; however, once indexing is over, normal speed will return. Similarly, the initial saving of your data in Leopard's Time Machine will take some time, but after that, its incremental backups happen in the background and will not disturb you.

When something does go wrong...

1. Do NOT panic

2. Note what was done last or recently

3. Decide on what to do

4. If you can, save whatever you are working on

5. If the cursor has frozen, can it be a loose connection? Check your mouse lead and connection

6. Do keyboard shortcuts allow you to see other programs? (**Command+Tab**)

7. If they do, and you return to the original, can you move the cursor again?

8. Exit the program by using **Command+Q** or by **Command+Option/Alt+esc** (the Quit and Force Quit shortcuts)

9. Restart holding down the Command and ctrl keys and clicking the Power button, or hold the Power button down till the Mac closes, and Restart

10. That alone may cure the problem, but consider some of the diagnostic steps I suggest elsewhere in this chapter

11. If you suspect a hardware fault, you may find an Apple-supplied Hardware test CD came with your computer; use this to check things out

Please note

I cannot stress point 1 strongly enough, do not press everything in sight; you could make things far worse – step away, pause for thought, and think out your alternatives, and possible consequences. You may be pleasantly surprised that things are not as bad as you feared.

It could be a wake-up call for considering a Back up Strategy – have you been saving as often as possible, could you be doing more to protect yourself?

You may also be surprised at how resilient the Mac and its operating system are!

Leopard note

If you have Leopard, and you want to be confident that your files are safe, I highly recommend that you buy a large hard drive that you dedicate to Time Machine, Mac's new system tool for keeping track of all you do. Once Time Machine is set up, this chore can go to the back of your mind, and you can concentrate on the exciting and creative stuff.

Hardware Implications

Not all photographers need the fastest computer on the planet, nor the latest piece of gear to hit the streets! Neither will you necessarily have the wherewithal for the totally optimal kit. However, there are ways to help you get equipment that does the job reliably and efficiently. For this to happen, you need to understand how to specify the equipment, decide what limitations are acceptable, and which will lead to problems.

It helps therefore to ask yourself a series of searching questions. Questions whose answers help in defining your requirements.

All these have a bearing on your choice of equipment, involving individual interactions that raise further issues.

Ultimately, only you can make those decisions according to your circumstances, and the nature of your work.

The all new range of Intel Macs

Less than a year after Steve Jobs announced the proposed change from the PowerPC Chip manufacturers to Intel, Apple completed the transfer of the entire range when he announced at the Worldwide Developers Conference, that the flagship professional Desktop machine and the server model, the XServe, were now Intel-powered.

Many photographers held off purchasing their hardware upgrades, due in part because the major software players had not upgraded the major packages such as Photoshop, Quark Xpress and InDesign. Quark, although later than forecast, were the first past the post, with Adobe following in the Spring of 2007, with Creative Suite 3.

Does this render all your hardware obsolete? No. The clue to why this is so lies in the name given to the new software – Universal Binary. All the programs have been written so that PowerPCs are capable of running them. Those who purchased the new hardware early will find themselves no longer running using 'Rosetta', but fully natively with the new software, and will welcome the speed boost.

Fig. 2.1 The new Tower Mac Pro, note the Firewire 800 port and extra USB 2.0 slot on the front.

Time Machine

Regular backing up can hardly be overstated. Apple, with its latest operating System, Leopard, is fully aware that a very small percentage of people do actually use any automated system of backing up, and so provide a new system-level means that allows a user to look back in time to restore work that might have been deleted two days previously.

There is a slider that can be dragged back through time and your Mac will be as it was back then. Do remember it will take up a fair chunk of hard disk space to accomplish.

Bearing in mind you have four drive bays, you could consider dedicating one drive for Time Machine backup.

Speed of operation in isolation is no longer an issue; the concerns from now are related to looking at the bottlenecks. Cameras are taking ever larger image files, and with the rise in the use of digital SLRs, the quantity has also increased. Storage space has become a high priority. Though here, hard drives have improved in capacity without a major price hike, and due to increased popularity of portable computers, rotational speeds for laptop drives in the 2.5 in size has risen. 7200 rpm drives bring a welcome speed gain.

Cameras relying on memory cards are now being offered card capacities of 16 gigabytes, which brings both benefits and a concern over storing so many eggs in one basket. So far reports on reliability are good, but I advise caution. My suggestion in such cases if on location, is you adopt a regime involving the backup of the filled card, and not erase that card till you are back at base, and have verified your location backup is readable on your base machine.

Intel Macs and Xserves

The supplying of Universal binaries for applications and the operating system means that despite Apple no longer making PowerPC machines, you are in no way penalised if you continue using yours. When you do make the change, you will not be disappointed, invariably the Intel Mac will run the native applications far faster.

The G5 tower especially in dual processor form was no slouch, and will still perform well, but the PowerBooks will be outpaced because the MacBook and MacBook Pro speed boost is considerable. The connectivity of the newer machines has also improved with generally more connectors available – take the Mac Pro as an example, it sports two USB 2.0 ports, Firewire 800 and 400 from the front, in addition to the ports on the rear.

Only the larger studios have considered servers, but I think the need for servers is going to increase in the next few years as photographers find the quantity of images and their increased size exerts pressure to store them more efficiently and provide a secure online means of access without burdening individual machines.

Fig. 2.2 The front view of the Intel Xserve.

Fig. 2.3 Two Intel Xserves and the XServe Raid in the Server Rack assembly.

(Images on these pages courtesy of Apple)

Efficient networking has already become a concern, and wireless connectivity is a really neat way to avoid trailing cables around a busy studio. Most come as standard on the new machines. It is not uncommon to find a studio with a wireless network, which gives greater flexibility without adding to the inevitable cable clutter created by studio lighting. It will however be slower.

Shooting wirelessly in a studio so far seems to be a higher priority with Nikon than Canon, but I can see this gradually making an impact. I gained an insight into this with a demonstration for Adobe Live 2006 with Philip Sowels of Future Publishing, where he shot wirelessly, and I captured the images on a G5 in Lightroom and Bridge to then do some retouching.

A relatively recent storage option is NAS –Network Attached Storage. The hard disk is connected to the network, and therefore available as a central repository for all on the network, but without the overhead of a server. This is a less expensive alternative to servers in studios. However, some applications such as Lightroom are not yet fully compatible with NAS.

Using but not shooting digital

Many photographer still prefer to shoot on transparency or negative and then scan the resultant film, and this can be for any number of differing reasons, not the least being that their clients prefer and understand that medium.

Increasingly though many choose not to go outside for their scans, preferring to retain control by buying scanners and learning how to achieve the standard they want in-house, thereby maintaining control over both cost and quality.

If they want and need near drum-quality scans many turn to the Flextight range of scanners, now made by the Hasselblad company.

Fig. 2.4 A typical high quality scanner favored by professional photographers because of its small footprint, excellent FlexColor software, and its ease of use. This is the 848 model. (*Courtesy of Hasselblad*)

One size does not fit all

Photography and photographers do not come in neat packages.

Are you shooting film in the camera and scanning, or shooting digitally?

One pigeonhole might be that you work primarily from a studio, another might be that you largely work on location. Equally, you could do vehicle work or fashion, and both the above could apply. The clientele you supply or the style of your work may define the equipment you need or choose to use. Where you are located may also define what you use, this could now be defined by purely external limitations such as whether you are in an area served by Broadband. Also, either your budget, or the budgets of your clients may limit or define your choices.

Yet other factors can influence the level of investment you make, such as whether you use a lab or bureau to outsource your work, or how much of the technology you understand or are prepared to invest in learning. Turnaround time defined by the market segment may also be a critical factor in determining whether you invest heavily yourself, or whether you hand off your work at an early stage to a trusted supplier. Whether you employ assistants that are both computer and photography literate will have a bearing too.

Within a studio environment, there are considerations such as desktop machines versus laptops, and this brings in communications, which in turn brings up wired Ethernet versus a wireless network. Do you use Digital SLRs or medium format View cameras with digital backs – the ramifications are too complex to offer complete answers. Is it safe to say 'Buy the biggest, fastest, newest Mac at the earliest opportunity'? or would the more prudent approach be – 'If it aint broke, don't fix it'? The answer lies somewhere between – the technology is still moving swiftly forwards. You are now able to use your Mac and Photoshop, Aperture and Lightroom to work on images in ways that once were done by specialists operating seriously large and expensive kit – you took the 'trannies', then they were put on 'The System'! Nowadays that power can reside in a 24 inch Intel iMac Core 2 Duo and some fast external hard disks! Or even a laptop such as the 17 inch MacBook Pro, linked to a larger external monitor.

State of play

We are in interesting times. In one way things have settled down and Mac OS X has bedded in, but in another we are in a state of flux. Much of the equipment we currently use, both the cameras and the computers, are all very capable. But running parallel, we have two programs, Aperture and Lightroom, which operate very differently. We have an entirely new chip driving all of the Macs, with a new operating system driving it, and the earlier Macs.

The cameras provide ever larger file sizes, so much so that this is showing up the limitations of many of the lenses we found acceptable in the days of film. Our assessment of exposure and color balance has had to be revised. For those shooting digitally as opposed to shooting on film and scanning, the boundaries defining the completion of our responsibilities has shifted and blurred.

Where do we stop? Do we supply digital data files? What size do we need? What resolution? Do we retouch? Do we bring in freelance assistants? Do we bring in specialist retouchers? Do we supply RGB or CMYK files? Do we supply prints? Do we supply proofs? Do we use a bureau to print our files to photographic paper? Do we put smaller images up on a website for the client to approve? Do we send our files to to the client? Do we put them up on the web, and ask the client to download them at their convenience? Do we backup to other hard drives, or onto DVD or CD? Do we add metadata tags to all our files? Do we keyword all our images? Do we shoot for Picture Libraries for stock purposes? Do we need a network? Do we have a wireless network? Do we need a server? Do we buy in training for ourselves and our staff? Then, how do we advertise or communicate our services? Is there a professional body to which we could belong that would help us? How many of our clients ask us to shoot on film?

Are there any firm answers? Of course not. Only you know exactly where you would like to stop; you know your comfort zone, all I can do is pose the questions for which you will need to find answers, and point you in the general direction. One overall question is whether you feel happy being an early adopter, pioneer or pathfinder, or whether you would rather be more conservative. Fortunately there is a place for both.

Questions, questions...

This page is full of questions, which must seem odd for a book supposedly published to provide answers, but the point I make is that asking the *right* questions leads you towards the answers, and what I have done is pose some of those questions.

One of the jobs I do is to make myself available at various venues to field questions from professional and amateur photographers in relation to digital photography, and in the course of answering questions put *to* me, I find myself asking almost as many questions of my interrogators!

Hardware decisions – MacBook & MacBook Pro

When I first wrote this section, I spent considerable time creating a table that attempted to crystallise the features, costs and benefits of buying various Macs as they related to photographers of different disciplines, and locations. Even though vague, I thought it helpful – that was until Apple started to bring out the Intel-powered Macs!

I now realize that it has become far too complex to build a simplistic table. Here is an improved approach: I shall try to point up the links you need to make between your work and the tools on offer.

I shall start with a photographer working in a small studio with a mix of work on location and in the studio. You need to ask yourself whether, if you got a portable machine, you would use it on location, or whether it would be best used for client presentations, and the means to work at home as well as the studio. If it seems likely you would use it for both as well as back in the studio, linking it to a larger monitor and studio-bound desktop machines, then aim for a MacBook Pro. Also, go for the optional extras of the better video card, the faster rotational speed drive (7200 rpm) and max out the memory to 4 GB of RAM.

Let me explain the thinking behind this decision, because it will help you to work out nuances that might make you modify your own decision. First – why the MacBook Pro? There would appear to be ways to save money by going for a MacBook. My reasoning was the video card options – you can do so much more in Photoshop, and when connected to a second and large monitor when working in the studio, it does not lose part of its system RAM to the video card, and the higher spec. models can drive an additional Cinema Display screen up to the 30 inch.

The scope for alternative decisions vary at the top and bottom of the range, at the low end, whilst retaining the RAM, there is the base machine at a slightly slower clock speed of the CPU (Central Processor Unit). At the top end is the addition of the faster Firewire 800, and the larger screen of the 17 inch model. The points to bear in mind then, are: would a high-spec. MacBook be a better option at the low end, or are you sacrificing portability on location with the extra bulk of a MacBook Pro?

Some observations

The 17 inch MacBook Pro and the later 15 inch models have Firewire 800, which means your external hard drives can benefit from the extra speed, but the size of the 17 inch model makes it less useful as a true portable for use on a train or in an aircraft. It does however make an excellent machine as a portable desktop machine, as it can power the 30 inch Cinema Display in addition to its own large screen.

The 24 inch iMac with Core2 Duo chip is an excellent workhorse for those on tighter budgets, which sports Firewire 800 in addition to Firewire 400.

Any decision you make will be based on the ways you work when away from base, and realistically whether a pre-existing iBook is more than adequate when shooting on location, and the likely number of occasions you make presentations to clients.

If an older laptop can at least run Tiger, then Aperture and Lightroom although slow, could still be used in the field.

iMac & Mac Pro

You may have purchased new hardware prior to the introduction of the various Intel-based Macs, in which case, you may be wondering whether you even need to buy any of the latest machines. Certainly, many of the machines now reaching the end of the line are very capable, and will all run the latest Tiger operating system, in which case, a hasty change is not essential, but something I have learned as generally an early adopter, is that experience of the advances has helped me make future buying decisions with greater confidence. I have been able to better understand the trends.

Digital cameras have been improving rapidly, image file sizes have been going up, all adding to the photographer's burden of storage and speedy viewing of the images taken. The move to capturing RAW data from the cameras has been also hotting up with programs like Capture One, Aperture and Lightroom making it possible to seriously consider making the shooting of RAW images *the* way to go. This makes the power of older Macs seem puny compared to the potential some of the Intel kit offers. The application programs to take advantage of the new processors was slow to arrive; they needed to be rewritten with new code and, to retain market share needed to also cater for PowerPC Macs, so for these versions they needed to have two codings. This gave us a new buzzword – 'Universal'.

The new Macs are fast, but only impressively so when running native applications, or when you have not been right up to date, and are leapfrogging the last crop of PowerPC Macs. October 2007 saw a new Mac operating system – 'Leopard', this promises to be more productive, with some interesting and useful new features for photographers.

Desktop Macs almost seem to describe only the iMacs, due to the sheer bulk of the Mac Pro and the earlier G5 tower, but 'Underdesk' is unlikey to catch on! So Desktop will have to include the Mac Pro – this can sport dual quad core processors, 16 GB RAM, two optical drives, and up to four internal hard disks, possibly with terabyte drives, RAID cards and all the various bus connections, Firewire 800 & 400, USB 2.0 and Gigabit Ethernet, and the option to add anything that is connected by PCI-Express. Airport Extreme and Bluetooth are optional.

Multiple processors

The Intel chips are adding yet more jargon for us – the general principle is certainly that the more processors the more powerful the computer, but it must also be remembered that the software needs to have been written to take advantage of the facility, so very often, the theory lags behind the practicality. So watch out for hype!

Core Duo means that the single chip has two microprocessors at its core, the Core 2 Duo has two such chips in tandem, a quad-core has four microprocessors, and so on . . .

Core 2 Duo iMac

The second generation of Intel chipped iMacs are faster, and can definitely be classed a fully professional tool, especially when you consider the 24 inch model which can take up to 4 GB of RAM, has a fast video card and Firewire 800, Airport Extreme and Bluetooth.

Up to 8 core Mac Pro

The Mac Pro which no longer needs the extra fans of the G5 for cooling, now offers up to four internal hard drives, two optical drives a choice of several video cards and can take up to 16 GB of RAM.

Where do MacBooks come into the equation when it comes to the buying of new Mac gear? They certainly do more than simply replace the iBooks. They are faster, and seem aimed more to professional users than consumers, which may mean a change of direction is being signalled for consumers in the Mac range of portables, possibly what journalists probably might describe as sub-notebooks. I make this observation based on the rise in the minimum screen size to 13.5 inches in the MacBook, and the raising of the entry level in pricing; both militate against the the consumer, a market I am quite sure Apple are not about to leave – so a product gap exists, and Nature abhors a vacuum! Which professionals are most likely to benefit from MacBooks then, photographers must come high on the list for Location use replacing those iBooks, and as lightweight presenters using Keynote, PowerPoint and possibly web-based galleries of images.

What of the 17 inch MacBook Pro? – Occasional away-from-base use, often a very good alternative to a desktop machine, especially when linked to a second monitor, a very good presenter, and a machine that can be taken away from the studio at the end of the day for obvious security reasons.

The Intel iMacs represent great value machines, though on my wish list would be a support allowing a height adjustment and the provision of a second internal hard drive.

The G5 remains a worthy machine for driving larger screens, store countless image files, and run several RAM-hungry applications, because these are Macs that support the fastest video cards, multiple internal hard drives and up to 16 GB of RAM.

Lastly, there is the Mac Mini. This machine can fit into a photographic studio in several ways. Size and cost make it a fair choice for your reception desk or office, it will also do well as your internet machine or even a music center if you like a studio with sound. You could also set it up as a printer server; it would also work well alongside a scanner, linked to your other Macs via Airport or a wired network. Although in itself it is compact, to be functional it requires a keyboard and screen, so it is less use than a small laptop when considering its use as a capture station for a tethered digital camera. The iBook, PowerBook, MacBook score better in this context.

A note about RAM

In the G5 and Mac Pro the memory card DIMMs need to be installed in pairs, so do take note of this when considering the purchase of memory. As a general rule try to buy your memory at the time of purchase to avoid having to remove existing memory before you can add larger capacity chips.

The Intel Macs

Mac Pro and 30 inch Cinema Display

MacBook Pro

MacBook

iMac family

Mac Mini and Remote

Fig. 2.5 The Intel-based Macintosh range. *(Courtesy of Apple)*

G5 PowerMac tower.

G4 iBook

G4 PowerBook

The PowerMac family

Mac Mini and Remote Control

G4 eMac

The Flatscreen G5 iMac

Fig. 2.6 The PowerPC-based Macintosh range. *(Courtesy of Apple)*

Apple Inc

Apple manufactures hardware and publishes software

It is this integration that is the strength of the Mac platform. It is far easier to tailor the operating system to the hardware, where there is this level of control over the end product. It has meant that the useful life of most Macs far exceeds that of comparable PCs running Windows, so your Return on Investment (ROI) is high. It can mean that what was once your high-end editing machine, could replace a lesser machine further down your equipment chain, operating as a backup filestore, or something even more mundane. In many cases you can still run the latest operating system on that old box.

Initial Capture

At Capture, especially when in a tethered situation, the essential need is for an accurate calibrated monitor, ultimate speed can be foregone, since it will be the Capture software and your involvement with lighting and arranging that takes time. Your kit needs to be close to the camera, but does not get in the way. If you have a large studio, then it may be possible that you can set up a tower and flat screen, with an Ethernet or wireless link to your editing machine, but if space is limited, you could use a 17 or even 20 inch iMac, or a laptop and Airport. Thus you avoid trailing leads and the need for a separate monitor screen. The integral keyboard of a laptop is handy too.

Whichever computer you use at the Capture stage, this machine could well be equipped with external Firewire Drives, so that another alternative to either Ethernet or Airport networking could be to simply upload the chosen images to a folder, and at suitable times disconnect the drive and simply plug it into your editing machine, and copy the entire folder across directly. You will now have a backup copy remaining on this external drive, in addition to those transferred.

Later, you could archive this again, before deleting it and using it again as the Capture drive. Meanwhile another external drive takes over where the first left off. Establishing a sound backup procedure like this one, is a safety precaution you'll never regret. At the Editing station, Leopard can simplify your task, by using Time Machine to keep track of your work.

Older but not obsolete

I am mentioning this again, to emphasize one major difference between Macs and other PCs. Invariably each new revision in the PC world has lessened the grip earlier hardware has had on the operating system, rendering something obsolete, or calling for new drivers, whereas the ability for older Macs to run subsequent revisions of Mac software has been heartwarming.

Although all the equipment on the facing page has been superseded, all of them can run Mac OS X Tiger. The pressure therefore to upgrade comes not from obsolescence, but a desire just to work faster or more simply. They will all just as likely all run **Leopard**!

Using a digital SLR

When you are shooting using a digital single lens reflex (dSLR) camera, you can likely work in an even simpler manner, by shooting directly to a memory card, that every so often, either you or an assistant slots into a card reader to offload directly to a desktop machine, in which case your speediest route is via Firewire. There are now even Firewire 800 Card Readers. The two memory card types in most professional use are the Compact Flash, and the SD Card.

Fig. 2.7 A Fast Card Reader using Firewire 800.

Studio still life work – The capture station

By that I mean table top work, such as jewellery, shoe and clothing shots, catalogue style work involving crockery, cutlery, glassware, food and drinks and toys, as opposed to fashion.

The reason for stating that the capture machine for such work need not be the fastest, is simply that provided it is not actually slow, it is the capture software and your other activities that take the major amount of your time when involved in this work.

There may well be time constraints and deadlines, but setting up and experimentation take up a greater amount of the time than waiting for the computer, so you can often forego a desktop machine in favor of a laptop, or iMac with flatscreen LCD. Here I would suggest the PowerBook, MacBook Pro or MacBook with their better screens, rather than the iBook which might be a choice for location work, due to its rugged plastic case, lighter weight, smaller size and lower cost.

The keyboard is essential, because you will be using it to manipulate the curves, type in names and so on. If it were a separate item this could be an issue from a stability aspect as much as space, so laptops combining a keyboard and monitor in just one firm and compact location will tend to be more practical. A Bluetooth keyboard and mouse could minimize the spaghetti of cables in the likely tight space close to the camera.

Communication to another part of the studio where either you or an assistant is perhaps assembling a page design, or doing cutouts, can be accomplished by a number of means. Airport is possibly the most convenient, since it obviates trailing cables to trip the unwary. However, this may not be the quickest choice when dealing with either a large quantity, or large sizes of images. The options are Ethernet, or the simple process of unplugging a hard drive and carrying it across the room to plug it into the Editing Mac. Firewire and USB 2.0 drives make this option viable due to their being 'hot-swappable'. The important point is to remember to eject the drive at the Desktop, by either dragging the icon to the trash, or clicking the Eject symbol alongside the drive name in the Finder Window. Failure to take this step will result in your being admonished with a dialog box warning that your data could become compromised, and suggesting you reconnect it.

Hot swapping notes

USB 2.0 and Firewire 400 & 800 are hot-swappable – but that does not mean you can simply unplug them and plug them in elsewhere, Mac OS X likes to be informed! In a Finder window the drives are shown with an Eject symbol to their right for all except the Startup disk. You must click this and wait till the named drive disappears from view, only then you can safely detach the drive.

Even here there is a proviso – if the drive is powered, then turn this off before removing the Firewire or USB 2.0 lead. By way of example if you are using earlier LaCie d2 drives that feature a blue light, this is a switch – press this to turn it off, then detach to the data cable, Firewire or USB 2.0 (later versions do have a switch).

If you forget, and you are alerted that the drive has not been correctly removed, do put it back and follow the correct procedure. Most times this will not have done any harm, but for safety's sake, power down properly at the earliest suitable time and restart. You might also consider running the FSCK – File System Check feature described in Chapter 3.

A capture and editing setup

This example is of a still-life being shot in the Terry Trott studio using a G4 Mac to edit and cut out images for one of their catalogue clients. He now has Intel MacPros!

Note the use of the mirrored second monitor to assist in setting up. All the critical work involving composition, exposure and color balance is done at the movable console.

Processing power

Dual Processors bring great advantages to using Photoshop, and the new crop of dual core, dual processors from the Intel lineup also greatly improve the speed you can achieve in Photoshop. As will Leopard with the new Flow view, and Quick Look.

However, the real gains come with the Intel Macs running fully native code: Creative Suite CS3 is a Universal Binary, so will work on both new and old Macs, but the newer machines really shine with their extra RAM as well as CPU speed.

Photo: Terry Trott

Fig. 2.8 Table top work in Terry Trott's studio using a Sinar Digital Camera back, CaptureShop, G4 Tower, and LaCie monitor.

Studio editing station – PPC G5 or Mac Pro

Here is where you need raw power; this is the computer which is likely to be doing all the grunt work. You will be pushing around both large quantities and large numbers of files, and maybe also doing numerous other tasks involving more than simply working in Photoshop. You will need to be working with scanners, DVD/CD writers, external hard drives, routers, digitising tablets, databases, word processors, page layout and web programs, and the Internet – this is MacPro and PowerMac territory.

The G5 and MacPro towers with dual-core and quad processors make considerable improvements to speed in Photoshop, and the possibility of up to 16 GB of RAM, large image files with multiple layers move at an impressive rate. But do remember that beyond 4 GB or so, that memory is really only of benefit in running further programs simultaneously.

With a PowerMac G5 you have the opportunity to add more disk drives internally, but despite the case size, it only accommodates three drives without recourse to some third-party modifications. You should consider adding an extra drive to provide image storage and a scratch disk to get the best performance from Photoshop. The MacPro with its lower cooling needs can take a second optical drive and four hard drives.

If you are only going to add one extra disk it may well be worth considering partitioning it into two or possibly three volumes. If you add two disks then I would suggest that the first of them has a minimal system loaded first so that it can be used as a startup disk, followed by diagnostic software such as Drive Genius, TechTool Pro or Mac Medic, and your applications. Depending on how you would like to work I would suggest that the other be partitioned so that the first partition was scratch disk around 10 GB, with the remainder for longer-term image storage.

As for the size of drives, this is down to the levels of work you have, or expect to have. Certainly, aim for minimum rotational speeds of 7200 rpm for speed. Do remember that the drives need to be SATA (Serial ATA) drives if intended to be used internally for the G5/MacPro tower. If you only have a single internal drive, this may be because you would prefer to have your data on separate external drives that enable you to lock them up elsewhere overnight.

A point to remember

Partitioning will contribute towards organization, but not speed. If you have a separate drive as Scratch Disk this *will* contribute towards speed.

An editing setup

Here is an example of an editing setup using a G5 Mac and twin monitors, so that the full area of the 30 inch display can be used entirely for the image and Toolbox.

Richard Lewisohn, who created the latest ITN News at ten backdrop, often spends time retouching and montaging his images for clients, and finds the additional monitor vital.

Photo: Richard Lewisohn

Fig. 2.9 Richard uses two monitors, with the larger monitor for his editing and retouching, note also a good chair for those hours spent sitting.

In an editing situation it is essential to be able to control the lighting environment, and if this varies, it can be useful to calibrate for these different conditions, and name the relevant profiles accordingly.

Alternative thoughts

If Dual Processor 2G Hz machines are out of your price range then the iMac G5 or Intel-based iMac with its 20 and 24 inch screens and fast processors are still very workable solutions for editing purposes. The 17 inch monitors whether CRT or TFT will feel cramped when using Photoshop or InDesign for any length of time.

Although high end CRTs may be more accurate then LCD TFTs, their prolonged use is more tiring, due to the lower refresh rate and therefore flickering.

iMac G5, iMac Intel, MacBook Pro and Mac Mini

Like the PowerBooks and iBooks, these are all limited to a single internal drive, and were once limited to 4200 rpm drives, but 5400 and 7200 rpm drives are now available, and can be supplied built to order (BTO) from Apple or Apple Stores. The faster drives will bring major benefits to anyone using Photoshop. The largest capacities tend to be on the slower speed drives.

Where earlier iMacs featured a white hemisphere with an articulated chrome arm and a flat screen, the more recent models featured the simpler angle bracket in brushed aluminum with only a tilt movement, but with a very much smaller footprint, and the entire computer lies behind the screen in clean white plastic for the initial Intel G5 versions, but the later ones are aluminum with a black surround to screen and back. The flatscreen models and all the laptops feature a built-in iSight camera.

The iSight camera in the laptops is there to facilitate video conferencing using Apple's iChat and video Instant Messaging. Due to its impressive speed, and 15.4 inch screen, the MacBook Pro can take on the role of Capture machine. Only the later PowerBooks and MacBook Pros have Firewire 800.

You can add external drives that are either USB 2.0 or Firewire 400/800, and can even be booted from these external drives; though in the case of USB 2.0 only on the Intel Macs.

As mentioned, the Mac Mini, though more powerful with the new Core 2 Duo chips, is somewhat limited, so I would only ever consider this one in a supporting role.

Note

Activation of the Creative Suite is always stored on the startup disk, so bear this in mind if you are loading members of the Creative Suite on external drives.

Hard drive thoughts

Fig. 2.10 Apple System Profiler offers a very comprehensive overview of your setup and is useful for diagnostics.

It is not too difficult to buy and fit extra internal drives to a desktop machine. You will need to check which drives will work on your specific model. Drives could be on the ATA bus, the Serial ATA bus, or the SCSI bus if a card is fitted. You can glean what buses are present in your machine by checking Apple System Profiler under Hardware.

This will state which bus is connected to which drive. So, if you are considering exchanging your startup drive for a larger capacity, or a faster rotational speed, this will show you the relevant technical details (see Fig. 2.10).

The sizes of drives you choose is dependent upon the nature of your work and throughput. Another aspect is whether to install internal drives or plug in external drives. LaCie do a line of d2 high capacity drives with disk caches that could be as much as 8 or 16 MB; ideally you should choose 7200 rpm drives or faster.

Only choose RAID arrays that specify RAID 5 or 0+1, as this will give you both speed and security by using genuinely redundant drives, where if one fails, it can be replaced and rebuilt without loss of valuable data. You could consider RAID 0 as a Scratch disk.

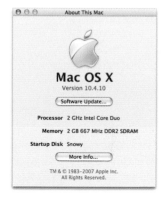

Fig. 2.11 This is the easiest way to access Apple System Profiler.

Apple System Profiler

Click on the Apple menu and choose About This Mac, to see the dialog shown here – the upper button provides an alternative way to access Software Update, the lower takes you to Apple System Profiler. This is a powerful diagnostic tool, because of the information it can provide about your machine.

Note

RAID 10 or 0+1 – an arrangement whereby you mirror a striped set of disks – is something you can now do in Tiger, using version 10.5 of Disk Utility or later.

Ideally you should use four disks of the same size, because in each RAID set the formatting will be limited by the smaller of the two capacities automatically.

The instructions are contained in Disk Utility, and I do not propose to describe it in depth, because the procedure should be followed exactly as detailed within, but provided you have the disks, and want both speed and security, this is a very worthwhile configuration.

In general you cannot use a RAID array as a startup disk.

The case for additional hard drives

Fundamentally it is a good idea to equip yourself with more than one hard drive; the main reasons for this are that photographers deal with large file sizes, and it is a good idea to use a separate disk for scratch purposes. Also most diagnostic and maintenance software needs to run from a separate drive rather than the startup disk, so the secondary disk could hold these.

Additional drives can be mounted internally in G5 towers and ther Mac Pro. Images are your livelihood; backing them up to external drives allows you to remove them at night to a safe or other secure place, even offsite, in case disaster should strike the studio.

The scratch disk (see also page 115) is where Photoshop writes part of the data it is working upon, to disk rather than RAM. If the machine is reading and writing from a separate disk to the startup one, both drives can be spinning simultaneously to carry out the operations. If however there is only the single drive, then each action must take place sequentially, slowing things down. Partitioning can be useful in creating distinctly separate areas for the System and Applications, but since they are rotating on the same spindle, only one operation can take place at a time, a separate drive is therefore far more efficient.

If you keep System files, Applications and Images on separate drives, you should find it easier to be systematic about how you carry out maintenance, backup and general filing. I also recommend that you keep all your application disks and their serial numbers in one place. If an update is downloaded from the Web, then create a disk image of this at the least, and preferably actually write it to a CD or DVD.

Prevention is better than cure

Aim to always leave at least 20% of any hard drive as free space. The reason is that once you go beyond this stage, and keep on saving and deleting files, you dramatically fragment the available free space, making it harder to save files contiguously. It needs only slight corruptions to occur for you to give yourself problems. Also, because your machine is constantly trying to find space when writing, and spending time finding all the fragments when reading, everything will slow down.

Additional drives

Choosing whether additional drives be internal or external is not always a matter of whether the internal bus is faster, but that external drives can be easily detached and stored elsewhere. You need to ensure that internal drives are the correctly matched types for your machine.

G4 machines had IDE/ATA drives, where G5s have Serial ATA (SATA) drives, but with both G4 and G5 machines you can introduce a SCSI card, and then run SCSI hard drives, which can still be the fastest drives available, due to some having rotational speeds of 10,000 rpm, albeit at smaller capacities.

There are also external SATA drives (eSATA), and beyond that RAID arrays with storage capacities in Terabytes. If you go down this route, make sure you specify RAID 5 or RAID 0+1 configurations to give you speed with reliability.

The advantages are the boxes tend to be built as RAIDs and you can install 10,000 rpm drives to give you both speed and storage capacity.

LaCie package a SATA II drive with its own PCI-Express (PCIe) Controller card, which is a two disk RAID drive.

More recently another way to consider how you couple hard drives to your Mac is by using them on your network. The method most likely to be of benefit to photographers is NAS – Network Attached Storage. These are drives which have an Ethernet interface that can be accessed over a network, obviously for there to be a benefit, you need to have a Gigabit Ethernet network with no attached devices of lesser speed.

The latest Airport Extreme using 802.11n has Gigabit Ethernet, making this a very viable way to maintain a hard disk on your network. It also has a USB 2.0 port which can run an NAS drive.

Fig. 2.12 LaCie d2 style external Firewire/USB 2.0 hard drive.

Tip

The little blue light on the front of early LaCie d2 series units above, are also the power switches. If you eject this disk in Finder and intend removing it from the Mac, click this switch off before doing so.

Later models feature a power switch on the back; in this case the blue light is a programmable button, which can become a one-touch solution using the supplied backup software.

Earlier Macs

I have not even mentioned G3 processor machines, but tried to deal with equipment which will still be available for purchase at the time of writing. Fortunately for Mac users the latest operating systems will still run on much older equipment. From a workflow standpoint, G5 and the latest Intel-based machines will give much better service, and allow you to take full advantage of Photoshop CS3 and the rest of the Creative Suite. Earlier Macs do not become totally worthless; many will run much later versions of the operating system than the one for which they were designed. What has happened is that the technology has moved at such a pace that compared to much of your competition, you will be far less productive on the earlier equipment, so for your frontline work, the investment in newer kit will pay off. Now, with the wholesale switch from Motorola and IBM chips to Intel, the upgrade process will become essential.

Some photographers are increasingly using laptops as Desktop machines with large flat screens and digitising tablets. They are then able to disconnect them at night and lock them up, or even take them off the premises. The latest MacBook Pro can even drive the 30 inch Studio Display, and also supports Firewire 800.

Most photographers will have desktop Macs at the studio, use MacBooks, PowerBooks and iBooks for client presentations and on location, which can also be used to take work home. There are two main routes being taken: some use camera backs tethered to a computer, shooting a mixture of single and multi-shot images that could be up to 100 MB, and others use digital SLRs giving 18 MB files; the former may have G5s, or Mac Pros, the latter anything from iMac G5s to PowerMac G4s, G5s and Intel iMacs.

In all cases, there are prerequisites for the amount of RAM, the numbers of hard drives and choices of which writers to consider, CD or DVD, and DVD Dual layer? If you are trying to hold off upgrading the hardware, at least add some more RAM; this will be beneficial in running Photoshop, and adding fast external DVD writers will aid your backing up.

I would certainly try hard to relegate PowerMac computers to the less intensive work, and move to the Intel Macs for sheer processor speed, and in the lowliest, still have the capacity for far more RAM, than PowerMacs.

Leopard note

Leopard will not work on G3 Macs or G4 Macs with CPUs slower than 867 MHz.

Note – Creative Suite 3

G4 is the lowest CPU that will run members of Creative Suite 3, but you will be far more productive in Photoshop CS3 and Lightroom using the latest Intel Macs. If your work is on large files or in great numbers, the new Mac Pros will slice through the work like a hot knife through butter. When you add peripherals such as dual layer DVD writers to the mix, you'll appreciate moving to Intel Macs – these writers will offload 8 GB at a time.

RAM requirements

How much RAM will you need, to work without finding everything seeming slow?

The later G5s will take up to 16 GB, but anything from 1 GB upwards is going to be effective; anything less, and you could meet problems. A point to bear in mind is that in the case of the G5 and Mac Pro, the memory chips (DIMMs) have to be installed in pairs.

You should try to consider you might need the extra slots later, so add larger individual memory values from the outset.

Apple have finally gone over to error-correcting (ECC) memory in the Mac Pro. The DIMMs they use are best as matched pairs to obtain the greatest speed.

Random Access Memory – RAM

RAM is the memory in which all the work of your programs takes place. It lies within the onboard memory chips. Calculations take place here, driven by your CPU; the solutions to those calculations, and many items of data, are stored for use in the various programs you are running.

In Mac OS X each application runs in its own alocated space – this protected memory prevents one program from crashing others.

When the memory space in physical RAM runs out, your Mac uses Virtual Memory (VM), storing data temporarily on the hard disk. Photoshop uses its own virtual memory, and this is what is being used in your Scratch Disks. In its Preferences, Photoshop allows you to set and use extra space, on up to four hard drives.

When making this allocation, go for the fastest drive with the greatest amount of free space. Also remember that what your computer requires is contiguous free space – fragmented free areas will slow it down as it jumps from one part of your disk to the next, trying to find the next free bit.

Currently the maximum physical RAM that can be fitted is 16 GB, but beyond about 4 GB, the gains you make only apply to how many open applications run satisfactorily, since most can only use a maximum of 3 GB or so individually.

Some applications, notably Photoshop, can also specify how much available RAM they use. Do consider leaving a fair amount for the System to use. So, when you are setting the Preferences for Photoshop, never allocate a percentage much above 70 – 80% unless you have 2 GB or more RAM fitted.

To find out whether you need to add more RAM when using Photoshop, take a look at the status bar at the bottom of an image window – you will see a small right-facing black triangle, click this and set 'Efficiency'. If this reads less than 100% fairly frequently, then add more RAM, because what this is telling you is that you are running out of physical RAM and relying on virtual memory on your hard disk/s. Handling chunks of memory from hard disk is going to be very much slower than doing the same in physical memory.

Fig. 2.13 Photoshop Preferences – avoid overdoing the amount allocated – leave enough for the system; between 70 and 80% is a good upper limit.

Virtual Memory and scratch disks

Although most applications can only use 3 GB or so of RAM, some desktop Macs can be fitted with as much as 16 GB RAM. What this means is that since each application runs in its own protected memory space, each program can use the system-limited amount, and thereafter will use virtual memory. This is memory taken from the hard disk.

When a program is in the background and its RAM is not being used, the space it takes can be compressed to provide more for the frontmost application. This is all handled by the Mac operating system.

Photoshop has its own Virtual memory scheme, and this is set up in Plug-Ins & Scratch Disks on the penultimate page of Photoshop CS2 Preferences or under the Performance heading in Photoshop CS3, by the allocating of Scratch disks.

Second monitors

Using an Intel iMac, especially with the 24 inch screen, is a good way to buy into the Intel processor family economically, but be fully aware of where the limits are, since the expansion possibilities are more limited than the Mac Pro.

You can add larger hard drives and more RAM up to a maximum of 4 GB in the iMacs. The video card choices are made at purchase time and cannot be exchanged.

You can work with larger external monitors on the PowerBooks, iMacs and iBooks, though some may be limited to mirrored viewing. Adding second monitors to Macs that allow you to span across both of them gives you a much larger screen area, which can be a boon to those doing montages or using Aperture, Bridge, or Photoshop for working with large numbers of images.

Most MacBook Pros have greater video memory (up to 256 MB), than iMacs which in the Intel model is 128 MB in the 20 inch, but with an option of 256 MB, and in turn they had more than the iBook, which has 32 MB. The newer Intel MacBooks and Mac Minis somewhat muddy the pond, because they have a combined CPU and graphic processor so take part of CPU memory for video processing.

Setting how additional monitors behave is controlled by the Arrangement tab you find in the Displays Preference pane.

Note

In Leopard if you select a computer that has two monitors attached when you use Screen Sharing, you will see both those screens, and in the arrangement set by that computer. Though not as complete a solution as Apple Remote Desktop, you do get more than just a view of the screens – you can interact with the computer to a degree.

I see several scenarios where this facility could offer studio-based photographers some interesting advantages. A client could see work in progress on the Capture station, and conversely the photographer could find that the Mac might become encroached by the set, yet still be accessible from another Mac.

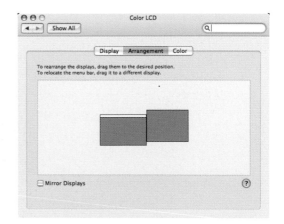

Fig. 2.14 Displays showing mirrored screens - ideal for presentations.

Fig. 2.15 Displays showing where the two screens meet. You can drag the menu bar to the other screen.

Image – Safety whilst on location

At one time I would have advocated the use of the LaCie Pocketdrives for use when away from base, for the storage of digital files, but that was in the days when taking along some form of laptop was the only other way to view the files. Today Epson has come up with a product that is far more functional and lighter than a full laptop – it functions as a means of offloading Compact Flash and SD Cards, and as a viewer or simply an external USB 2.0 hard drive.

When viewing RAW files, they are shown at full frame size on screen, and cannot be zoomed as JPEGs can, but due to the high screen resolution and because it is possible to overlay the histogram, this is not a major drawback. It comes with a 40 GB hard disk in the P-2000; there is also a P-4000 with an 80 GB drive.

You can offload your cards in the field to an iBook or to one of the newer products on the market like the one below. There are other devices from Archos, NixVue, FlashTrax, Jobo and Canon. The quality and size of the Epson screen is very good, however it loses some of its shine when you attempt to use it in bright sunlight – a transflective screen would have made it even better, because the sun would provide the reflective source of image lighting. More recent technologies promise a memory of the last image on screen!

Motion sensors and the MagSafe

In the latest crop of laptops, there is a new protection offered; that of motion sensors. These will react to sudden impacts to switch hard drives into the park position to avoid damage and subsequent loss of data.

There are also some intriguing new uses being found for the motion sensors, mainly by Games producers.

Also, since these machines are often plugged into their power leads in their everyday working environment, Apple has come up with a new means of Power cable connection – the MagSafe – the plug is held in place by magnets, and if the cable is snagged, it falls away easily without dragging the MacBook or MacBook Pro with it! Absolutely ideal in the busy photographer's studio environment!

Fig. 2.16 An alternative to a laptop is a Multimedia Storage & Viewer, such as the Epson 2000, 4000, 5000 or new Canon equivalent.

XServe

Digital photographers nowadays are expected to cover many more skills than was true in the days of transparencies, film and bromide prints. The breadth of your services is largely down to personal circumstances, experience, knowledge and inclination. I have attempted to cover the hardware you might need, what each offers and some of the difficulties you might encounter, and to this end it is probably worth my while mentioning an aspect that may well be beyond the majority of you, and that is that Mac OS X is also available as a Server Operating System, and this can run on any modern Mac or Apple's own brand of hardware server called XServe.

XServe is a rack mounted Industry standard 1U-form Mac Server that differs from its Windows counterpart largely in its licencing arrangement which makes it very competitive over time. You are not faced with licencing that locks you into maintenance contracts to have access to upgrade pricing, and the licence is offered in either 10-seat or unlimited editions. They are now powered by Intel Xeon processors and there is also XServe RAID. Generally Mac OS X Server keeps track with the standard system upgrades, occasionally lagging by a couple of weeks or so.

In a large studio, this could well be a useful solution for long term storage, backup, and more general availablity, and you need not fear that PC connectivity is an issue. You could also use this as a Firewall and Virus Checking station, thereby isolating your individual Macs from direct contact with the Internet.

XServe

XServe Macs can now come with 8 core 3GHz processors and take up to 32GB of RAM, in the same size form as before. They can also feature 1TB SATA drives or 15,000 rpm Serial Attached SCSI (SAS) drives for those interested in seriously large amounts of data.

With the advent of DSLRs with 22 MB raw files, the time for such drives and server solutions may well not be too far off!

Fig. 2.17 Above is the view from above showing the twin G5 processors. Alongside to the right is the XServe front view, with XServe RAID beneath.

(Courtesy of Apple)

Hubs and switches – Ethernet

Mac OS X supports all Ethernet connection speeds, and almost all of the hardware supports Gigabit (1000 MB per second) Ethernet. It can connect two machines directly together, or via a sort of junction box, to several – this is called a network.

When creating an Ethernet network, the best way is to introduce a hub or a switch. A switch is similar to a hub, but is slightly more expensive and can be faster on a busy network. This is because the data traffic passing through is managed in separate streams so they do not slow each other down.

A network links a series of computers so they can pass data between each other, either directly peer-to-peer, or via a central server. It can also be used for connection to the Internet and then sharing this connection to other connected computers. In this role it is considered to be a gateway often with a firewall, performing tasks such as Network Address Translation (NAT) and Port Forwarding.

NAT routes the traffic to a different internal IP address to individual connected computers, so any Internet intruder using your IP address gets no further than the firewall. Some ISPs provide a dynamic IP address, some a permanent one.

Port forwarding is where incoming traffic to a particular port/s is redirected to an IP address on your network. This transaction can take place either at your router or in your Mac. Although Mac OS X has many controls for this configuration, in most cases, you will be making these adjustments via a browser interface linked directly with your router, using its internal IP address. Typically that might be 192.168.0.1 or 10.0.0.1.

Networking terms

IP addresses
Firewall
Network Address Translation – NAT
Port Forwarding

IP stands for Internet Protocol, and addresses are noted as 'dotted decimal' numbers in the form 192.168.0.1, 10.0.0.23 and their like.

A Firewall is a defensive measure to ensure services such as file sharing that your computer may be running are not accessible to those outside on the Internet. This is achieved by providing a barrier between the internal IP addresses that define computers on your Network and those that are available publicly, and it also means that each of us can freely use internal networks with the same numbers without interference.

NAT is a means by which addresses are transposed, so that internally you have a different series of addresses from those you use to reach the Internet.

Ports are the numbered doors through which your various services are accessed when communicating with others on the Internet. For instance Port 80 is used by HTTP for you to reach the Web in a web browser, and Port 25 is used for email.

Port Forwarding is a way that traffic for such a port is directed through your Firewall to your internal network, an outsider simply sees the external IP address of your router. It can also be described as 'tunnelling'. TCP Port Numbers are assigned globally by the IANA (International Assigned Numbers Authority).

Fig. 2.18 Here is my switch showing three connections live on the local area network, and the speed of each connection is shown by the LEDs – the orange lights denotes where only 100 MB per second is being achieved for that port.

Optical media

Most Macs will have CD-RW/DVD Writers, and players, some even using the dual layer media. Although the first MacBook Pros had single layer DVD writers, later models featured the dual layer writer/readers, which can store about 8 GB of data.

The operating system will allow the burning of files to the appropriate media, but before you create your Burn folder, go to System Preferences and the CDs & DVDs item and set what you would like to see happen when inserting a blank (see Fig. 2.25 below). If another application is set to open here, it will intercept your action of inserting the blank media.

As a general rule you will probably obtain faster optical drives in external housings, than the internal offerings from Apple.

Fig. 2.26 Type CD into System Preferences on opening **1**, and this highlights the pane you need, one click later, or hit Enter, and the above window appears, where you can choose the action to be taken on the insertion of various media – provided you have not set another application, you will then be able to use the Burn Folder **2** to write to your media, by dragging files to this folder.

Opening a Burn folder

You create a new Burn Folder from the File menu in Finder, and the window opens with an extra bar at the top, which has a Burn button at its right-hand end.

As you drag items to this folder, you are creating aliases, and when you have added the files for burning to the chosen media, you can hit the Burn button to initiate the burning to CD or DVD. Although this method of burning to CD and DVD is available from the system, I have to say that I prefer the speed and simplicity of using Roxio Toast, but it is handy knowing there is this system level application to hand as a backstop.

A niggle I once had was that because the items that appear in the Burn folder are aliases to the real files, it is not immediately apparent what size the folder is reaching as you add items – the total shown in the bottom of the Burn Folder window related not to the size of the files themselves, but simply the combined size of the aliases, which was not a lot of help in determining whether you are reaching the limit for a CD or DVD. Fortunately this has now been resolved.

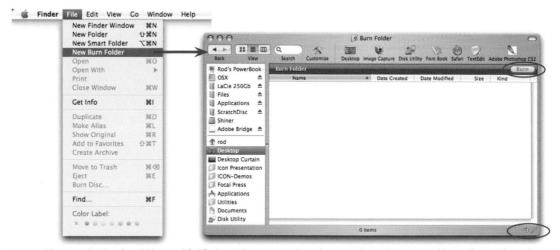

Fig. 2.27 When you select New Burn Folder a modified Finder window appears with two buttons as shown above, as you add items the status bar at the bottom of the window updates, once blank media is inserted press the bottom button to see the total size and the amount free.

USB 2.0 connection

Fig. 2.28 A typical UPS, this one from APC, showing the USB connection and 8 power outlets.

Note

After selecting to shutdown when you cannot see your monitor's screen, you may well have open programs that could halt the process, in these cases the system will have put up a dialog asking whether you would like to save a document prior to quitting, in most cases it would be safe therefore to hit <Return>, so even though blind, you could keep doing this to avoid the stalling of the shutdown process.

A smooth and stable power supply

When trying to ensure your Desktop Mac runs trouble free, one aspect often neglected is the power supply. In an urban environment, there may well be industrial units taking large amounts of power intermittently, such as heavy duty guillotines or electrical saws. Even in agricultural areas, similar conditions may prevail – the voltage may vary and the conditioning of the supply may be poor, with spikes or surges occurring.

Uninterruptible Power Supplies (UPS) are a sound investment to help your Desktop machines avoid possible data corruption due to power loss, or spikes, as they are also stabilised. Immediate corruption may not be apparent, but can accumulate over time.

If you have to leave all the kit running in your absence, you would be well-advised to consider a UPS with several outlets to cover your Mac itself, external hard drives, powered hubs and routers. Your monitor is less of an issue, since it is very unlikely to have any affect on your data, however if your voltage fluctuations are large, then a stabilised supply will certainly help. In a situation where your UPS does not carry out a graceful shutdown, and you cannot see what's on your screen, here is a workaround: hold the Control key and press the Power key; though you cannot see it, a panel has appeared offering you the choice to Shutdown by default, or Sleep, Restart or Cancel. Hit <Return> to shutdown (See sidebar for further guidance).

UPS units contain large batteries offering different lengths of backup time, varying levels of software support, and the numbers of individual outputs sockets. There are often two discrete sets of sockets – one with only suppression on, the other full battery backup.

You should look for AVR labelled items that are Line Interactive, as these will cover the times when the voltage drops or rises relative to the correct value (110 V or 250 V). This would cover what are known as brownouts, which can just as easily cause corruptions to your disk catalogue or files.

Some of the UPS Settings are handled by the System in the Energy Saver Preference Pane, which is able to sense the connection of a UPS device, and open appropriate sections related to UPS operation.

Spikes tend to give rise to cumulative damage to data, that is minor initially, but if not diagnosed or catered for, could result in catastrophic loss at a later date. If you have concerns over fluctuating voltages or you notice lights flickering, then a good precaution to take is a regular visit to Disk Utility, and run the Disk First Aid routinely.

There are various makes of UPS around, but for the greatest protection, it needs to do slightly more than just bring in the battery power when the mains goes down, it should do an orderly power down after a short time, and not simply fail when its own internal battery also runs down.

Not all units are Mac compatible, so do make sure before you purchase that the software allows the Mac to intelligently control this procedure. APC and Belkin are two suppliers who do carry various Mac OS X-compliant products with different output sockets and battery charge duration powers.

Provided the UPS is also connected via USB to the Mac, the Energy Saver dialog is able to detect its presence and allow you to set up how it will respond.

Laptops do not need a UPS

Using a laptop on the mains is less prone to mains supply problems, as effectively its internal battery is a UPS!

Here are some URLs for UPS equipment suppliers:

http://www.apcmedia.com
http://www.riello-ups.co.uk
http://www.tripplite.com
http://www.mgeups.com/mac/
http://www.mgeups.com
http://www.upssystems.uk.com

Fig. 2.29 Energy Saver has detected the presence of the UPS and added a UPS tab with a series of possible user settings.

Fig. 2.30 The Apple LCD TFT Cinema Display family of monitors. *(Courtesy of Apple)*

Monitors

Apple themselves no longer sell Cathode Ray Tube (CRT) monitors. However there are still the two choices in terms of the type of screen, CRT and Liquid Crystal Display (LCD) Thin Film Transistor (TFT) screens, but this choice is beginning to be eroded, as CRTs largely disappear from stores, in favor of the flat screens. Make sure the flat screen you choose can be calibrated.

Sony, Eizo and LaCie still make expensive high quality CRTs, but they are bulky, can get very hot, and though well-screened can still affect digitising tablets and other monitor screens in close proximity. Prolonged working at a CRT can be far more tiring than an LCD TFT screen, and their accurate life is shorter. But, be wary of less expensive screens from unknown manufacturers, they will invariably have very narrow angles where the image can be correctly assessed; both color and brightness can be a problem, and to the degree they can be profiled.

Flat screens have plusses, such as they are less bulky, will remain on-song for longer, can often be in wider screen format, and are brighter. In practical terms they will retain their calibration for longer, and they do not suffer from flicker. They do have disadvantages – you do have to maintain a relatively straight-on view to the screen, when assessing color and exposure.

Be sure that the monitor output connector from your model of computer complies with the one on your choice of screen. You could come across the proprietary Apple connector (ADC) on earlier Macs, for which you may need an adaptor.

Monitors – connectors

If your computer only has ADC, then your choices are going to be limited unless you have appropriate adaptors (such as those from Dr Bott), but fortunately Apple has generally now gone for the DVI connector, which will connect to most flat screens. With most Mac models featuring this connector, they supply a short cable adaptor to VGA, which allows many PC screens to be connected. Not only screens but many projectors can take your Mac output via either DVI or VGA.

Using more than one monitor has long been a feature available to Macs, but is no longer unique. If your Mac has this capability, then you will need to use System Preferences/Displays to arrange how the screens link. A second screen could mirror the first - ideal when demonstrating, or you could span the area across which you operate, by making second or subsequent screens link from one to another. This is handled in the Arrangement tab of the Displays Preference pane.

If you are in the habit of working with a laptop sometimes by itself, and at others attached to an external monitor, then take advantage of checking the box in Displays that shows Displays in Menu bar – this will allow you access far quicker.

You may find that the 16:9 aspect ratios of Mac widescreens, such as the 17 inch PowerBook, may cause you to reduce your laptop screen image when presenting, giving only a 'letterbox' version with black at top and bottom, or vice versa. If you intend to project images, you may have to choose the projector model with care to be happy with the outcome.

Apple have followed Windows keyboard standards to offer a system level toggle for Video mirroring with PowerBooks to larger screens and projectors, which means that you do not have to go fumbling around in Displays to set up this feature. This shortcut works when you are in the Finder, whether you are using an additional screen or a projector. It is F7 (Function Key 7) on the PowerBook, MacBooks and MacBook Pros. Depending on your settings in the Preferences, you may have to hold down the Fn key to access these function keys.

Fig. 2.31 The fairly universal VGA D-type connector, shown here in socket from the Apple DVI to VGA connector.

Fig. 2.32 The DVI connector found on the PowerBook.

Fig. 2.33 The DVI plug shown here from the small converter cable supplied with PowerBooks

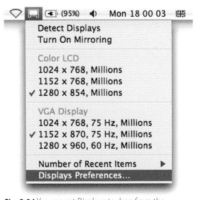

Fig. 2.34 You can set Displays to drop from the menubar, as shown here.

Video card interfaces and connectors

Apple originally had a monitor output all its own, but soon added a more common PC connection called VGA. Soon that changed and you could find Mac users, especially photographers, adding a second monitor to handle all the palettes on one, whilst the main screen remains unobscured and probably full screen with the image you are working upon.

Apple then combined USB with power and the video data for the screen into a single new connector – the Apple Display Connector (ADC).

All changed again when Apple adopted the Digital Video Interface (DVI) connector, and later still the dual head DVI for driving their 30 inch Studio Displays. It is therefore fairly easy to connect to almost any manufacturer's product when it comes to screens for your Mac. To get the best from the LCD/TFT flatscreens you should definitely go for the DVI option, as this will invariably be far crisper.

What can go wrong with monitors?

The answer is very little – in a few instances they may not come back up after Sleep; if that is the case and you instigated sleep mode, then what you try next depends on whether this is an external monitor, and if so, is this a laptop or desktop machine. If it is a desktop machine, put it back to sleep, disconnect the video cable, then reinsert it, and press the Space bar again. If this fails, then a restart is the only option, and it may well be that you need to check whether there has been a Firmware update you have missed. Closing the lid on a laptop and reopening may be worth trying, or, going to the Displays icon if you have put this in the menubar, and choosing Detect Displays will generally succeed. If that does not work, try the same as for a desktop Mac – do a Restart!

Monitors do age, and become less easy to calibrate; this is more true with CRTs than with LCD/TFT flat screens. Regular calibration of your monitor's screen is therefore essential if you want to be able to maintain consistently accurate color results.

Ambient lighting conditions

An equally important point to bear in mind is that the lighting levels around your monitor need to remain reasonably constant, for your assessments to be consistent, otherwise you will not be able to make valid color judgements with any degree of accuracy.

Calibration

You can use Displays to calibrate your monitor and save its ICC profile, but this relies on the 'number one eyeball' rather than direct measurements. You will get far more accurate results from using either a colorimeter or spectrophotometer and the associated third-party software.

CRT (Cathode Ray Tube) monitors can be very sensitive to nearby electric fields, such as power bricks, mobile phones, digitising tablets, or other monitors, so avoid placing these close by. This also applies to any magnets, as any of these can cause localised distortion, ripples or flickering.

Try not to keep changing the positions and angles of CRT monitors as they are sufficiently sensitive to how they are aligned with the earth's magnetic field, and once moved may require 'degaussing' – that is, realigned by applying a magnetic jolt; many monitors have this facility built in, hence that 'burp' at startup.

Although it may seem to be stating the obvious, it is an essential step to take if you are serious about color to calibrate your monitor, this is especially true with a program like Lightroom where all assessments are made with no correlation with color management until export.

Calibration of monitors will be discussed in greater depth in Chapter 6.

Third-party calibration devices

Companies such as X-Rite, formerly Gretag Macbeth, have devices to calibrate monitors alone, printers alone, and combination devices, as well as offering various levels of software to suit the degree of accuracy needed.

If you see on screen what you subsequently see both from your own printer and when in ink on paper in a magazine or brochure, you will be getting peace of mind, and waste less in materials and time.

Color Solutions offer both in variants of their BasICColor i1 Squid, and i1 Pro. Both measure the variances between the file color values and what is displayed, and produce an ICC monitor profile which is then used system wide.

Fig. 2.35 This is an inexpensive monitor calibrating device from Gretag Macbeth. Gretag Macbeth do the Eye-1 Display2, which works for both CRTs and LCD monitors. The accompanying software is very straightforward.

Tiger's Printer Setup Utility dialog boxes

Setting up a printer in Tiger can start in either Printer Setup Utility in Utilities or Print & Fax from System Preferences. In Leopard, it all starts from Print & Fax.

Print & Fax

In Leopard, printer setup has been consolidated into Print and Fax, but some steps are still very similar to those shown here for Tiger, so on the next page I have shown some Leopard dialog boxes. It is certainly much simpler and more informative.

Fig. 2.36 A typical sequence of dialog boxes that you may follow to add a printer in Printer Setup Utility.

Print & Fax (Leopard)

Setting up a printer in Tiger can start in either Printer Setup Utility in Utilities or Print & Fax from System Preferences. In Leopard, it all starts from Print & Fax. The pane on the left lists any drivers already located. Click the + button below to open a new dialog box which finds and lists all others, using Bonjour.

Click on the one you want, then press Add; the window closes and the chosen printer appears beneath any others, and will be seen in Page setup or Print in all application.

The icons along the top of that window offer the range of methods to reach your printers, if not already listed. In Tiger the procedure is rather complex, but just follow each dialog, and you will add any printer without too much trouble.

Problems can occur where the default printer drivers Apple installed are the Gimp ones and these override the printer manufacturer's drivers, such as those for Epson. The solution here is to remove all traces of the Gimp drivers, and ensure you choose the correct path to the relevant drivers. Some Epson printers use their own path via 'Epson USB' as opposed to 'USB'.

When you set up an Airport base station, you can also access your printer wirelessly. The system installer for Mac OS X loads several megabytes of printer drivers at both initial installation and upgrades, removing those you don't need will save space on your startup disk.

In the Leopard screenshots here, you will notice the procedure is simpler, and more information is shown, indicating in this instance the network and the fact the printer is shared from another computer. In the intermediate dialog box, the icons in the Title bar offer other means of connection to reach printers.

Fig. 2.37 Print & Fax opens to **1** – click the padlock and authenticate, then the +; **2** opens, and the search begins. When this finishes, select your printer and press Add – you will now see this in the window of **3**. You may choose this as your default at the bottom. Click the padlock to complete and lock the settings. **4** shows a typical Leopard Print dialog box from Safari.

General Maintenance

To avoid problems with any computer system, it is essential to understand and employ some basic housekeeping procedures, and Mac OS X is no exception. In Mac OS 9.x, one of those, was regular Desktop rebuilding. Invariably the hard drives were smaller capacity, and suffered from fragmentation of the files, and of the free space, so it was necessary to 'defrag' the disks fairly frequently, to ensure the optimum speed from your kit.

Fortunately, Mac OS X suffers less, as it takes advantage of various mechanisms within Unix that inherently avoid fragmentation.

It was very likely that Mac OS 9 users were fairly regularly turning their machines off and therefore starting up from cold with a hard boot. And this actually assisted in doing some housekeeping, but Unix is essentially an always-on system, so it has automatic routines built in to clean up outdated logs and caches in the early hours. Understanding this, you have two options: leave your machine on and running through the night, or manually effecting those Unix routines at times that suit your working practices.

Starting up

When you press the power button to startup your Mac, it will fire up your startup disk, flash a power light, then chime. The next few stages of the procedure will happen from routines held in the Mac's main ROM (Read Only Memory) chip. It is in fact an EPROM (Eraseable Programmable ROM).

The startup procedures are complex, but they go through some checks of RAM, and connected devices and the motherboard, and load the Toolbox, and some items that modify the information held in the ROM are supplied from ROM images held on disk.

During these preliminary stages, the screen will display the Apple logo in silver, a rotating cog, and eventually throw up your designated desktop screen. Up until the rotating cog, most of these operations take place using EFI, Intel's 'Extensible Firmware Interface', which has taken the place of the previous Mac bootup code known as Open Firmware. This used to be accessible by holding down the Command, Option, O & F keys at startup.

Once the preliminary screen has appeared, your Mac is loading the full system into its RAM, and your computer is becoming a Mac.

If your computer fails to startup correctly, note at what step it has reached, this could well help in diagnosing where the fault lies. If it crashes completely anytime after the blue screen has come up, you may well have some faulty software, but this is now rare, since most software publishers now fully understand how to produce efficient and stable 'Kernel Extensions' or kexts.

Poorly crafted kexts were the culprits in crashes that occurred at startup in earlier versions of Mac OS X; by Tiger, even in its early guises, crashes, freezes and kernel panics were already extremely rare, and a good measure of overall stability can be seen by just how many users still happily run 10.3.9!

.DS_Store files

Prior to Mac OS X one repair procedure was to 'rebuild the Desktop' – the nearest equivalent to that Desktop file is a hidden one within most folders that stores the screen co-ordinates of the positions and sizes of windows, icons, etc. It is named '.DS_Store' – the dot at the beginning of the name tells the System to make the folder invisible. The settings you make when you check the 'All Windows' box in View Options is stored within the system as the default, with only different settings stored in the folder when you choose 'In this Window'. The System only creates this file on closing the folder, so the System knows exactly how and where windows and their contents appear, when you *next* open them.

At startup the Operating System searches for all the folder windows you visited during the last Up-time (the time between when last started and last closed) and adds new .DS_Store files to all those folders. If the build up is excessive, things can begin to slow down. Hence the delay you could experience during startup. It would be handy to clear them. Sadly, this is a third-party opportunity – the System has no clearance routine built in.

These files may also be transferred to CDs and DVDs which in fact, is beneficial, as it means folders appear exactly as before, when you open them. You can use this feature to your advantage to ensure that the background of a CD or DVD folder has a picture of your choosing. See Fig. 3.1.

But, let me deal with the downside. The sheer plethora of these files is one aspect, and is one for which there is a third-party product available, 'DS_Store Cleaner', as well as a short command that can be entered into Mac's Terminal application; you type the following into Terminal:

sudo find / -name \.DS_Store -print -delete

Enter your Password and press <Return> Do be aware of the space characters in the line shown.

Another problem occurs when you link up to a Windows or Linux network – these files which are invisible on the Mac are very much visible on these networks and tend to cause consternation and nervousness, with those people wrongly considering these harmless files to be an infection! In non-Mac environments these files are redundant, in exactly the same way resource forks were in Mac OS 9.x days, so their removal is actually entirely safe.

Using a picture as a CD's background

Here I selected a sky that was taken the same day, and made a screenshot to the size of the screen 1024 pixels wide and added the logo as branding, because it is going to be seen on screen. I then converted to the screen profile, even though this would not be guaranteed to match exactly, hopefully it would be closer than using Adobe RGB. I also made the icons as large as possible and used the compact folder mode, to keep things clean. This information was present in the folder stored in the .DS Store file, so when I burned the file to a CD, that is what was read by the Mac at the other end. However, this would be of no use to a Windows PC User.

Fig. 3.1 Here the View Options palette shows where you can import an image to become your background to a folder, and set the icon sizes.

Fig. 3.2 Here is the folder, with a branding and large icons so the client can see what has been shot, without even opening Bridge. As you may notice from the position of the scrollbar to the right, there are further files, and so I did not need to make the sky picture invisible.

Permissions

Mac OS X is a multi-user system: this brings with it the essential necessity for Security. Each user must own a discrete area that does not affect other users. For this to work effectively there must be a 'Super User' who has additional powers to control those users, and have access to the heart of the system. The way this is handled is by controlling the access that a user has to affect parts of the operating system.

At the very powerful end there are Root User and Administrator, and then there are 'Users'. Root is the most dangerous, and will not be the subject of this book. Administrator, more commonly referred to as 'Admin', is the person who has access to the loading and alteration of Applications, the creation of Users and their Passwords and the levels of access they can have.

Permissions relate to the ability:

To 'Read Only' files, that is, be able to open them and look at them, but not change them in any way.

To 'Write' files where you can create and alter files

and

To 'Execute' files. This aspect relates to the ability to 'run' applications. This could be a tiny file that performed some small task, like a Macro, or a full-blown program.

Security is achieved by controlling access by Permissions.

Access applies to Users,

Permissions apply to files and folders.

Permissions are set in what is known as a 'Bill of Materials' – a BOM – which is stored in the Receipts folder within the System. Access is set by Admin for each User or Group of Users. As new applications are loaded onto your Mac, a BOM is lodged with the Receipts folder. When Apple themselves offer updates for the operating system, the same operation occurs. For a variety of reasons, these permissions can become corrupted in use. Within Disk Utilities, it is possible to both verify and repair these permissions, and you will see these abbreviated to: r, w and x when repairing Permissions.

Bill of Materials – BOM

This is the stored item in the Receipts folder that records what has been loaded and the relevant Permissions. It is checked when you Verify or Repair Permissions, and helps Apple's Software Update decide whether a specific item is up to date.

What happens is that the System looks at the Permissions stored in the BOM for each Apple-related application, and if these have been altered, restores them to match those recorded in the BOM.

In earlier versions of Mac OS X, 'Repair Permissions' was considered a valuable remedy for any system problem of unknown origin. I had read of issues that were cured by 'Repairing Permissions', and in particular, to do this both before and after any Application installation or System upgrades. I found this advice to be efficacious, suffering fewer mishaps than seemed the norm amongst my peers.

Verifying and Repairing Permissions

Disk Utility lies in the Utilities folder, inside the Applications folder. In its First Aid tab, you can Repair Permissions for your Mac OS X Startup disk and run Apple's standard disk repair utility on other mounted disks.

In Tiger, it is now possible to verify the disk catalogue on your startup disk. But to carry out repairs you will need to have started up on an alternative drive with a bootable System or from your System Installation disk.

The permutations of Read, Write and Execute form the basis of Permissions. If these are out of kilter, then when you are installing software, an item that should be installed may be rejected, or an installed item may be locked from use, which could mean an incomplete installation or at worst you might get a freeze or crash. Either way your Mac would perform sub-optimally.

Repairing Permissions only deals with Apple-installed items, not those of third-party programs.

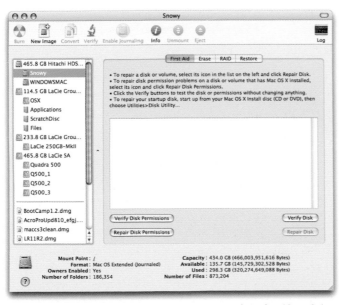

Fig. 3.3 Highlight the Mac OS X System disk to enable the options for Verify and Repair Disk Permissions. Note also that the Startup disk cannot have Disk Repairs carried out.

Repair Permissions Controversy

Much has been written on the Web about the efficacy of repairing permissions, and its use as a remedy for system problems. My take on this is fairly straightforward – in earlier versions of Mac OS X, it certainly seemed to cure many obscure niggling behaviors of the system, but by Tiger, the procedure was redundant and ineffective.

What I will say is that I saw and adopted the recommendations for the procedure of repairing permissions before and after system updates and installs of either a new system or application, and experienced fewer problems than I saw amongst those who did not follow this advice. This was also noted by those who also practised what I had preached in those earlier days.

I no longer make any claims for the procedure.

For those who would like a definitive answer from Apple, go this location: http://tiny.cc/p8hKc.

Keychain and Keychain Access

Apple takes security seriously as can be seen when you notice the Security Updates it offers via Software Download. Mac OS X provides a central repository for all your various passwords. Passwords for your System and User files, for your applications, and for access to certain web pages. They are stored in your Keychain in the main Library folder; you can check on this via the appropriately named 'Keychain Access' program, located in Utilities.

Fig. 3.4 Double-click an item in the main pane to check on its attributes. To narrow your choice, click on the Show Keychains button.

Fig. 3.5 To create a new Password Item, choose it from the File menu, and the above sheet will appear.

Fig. 3.6 Here, I have clicked the Show Keychains button, but for obvious reasons and save myself some retouching, I have stuck to showing all items, but you can now see the other categories.

Fig. 3.7 Here, you see the Access Control tab, since MacJanitor gives access to your system, it is best that access is restricted, and you could also check the box requesting the keychain password for added security.

Keychain First Aid

Earlier in the chapter, I discussed repairing Permissions, explaining that corruptions to these permissions could be cured by repairing permissions from Disk Utility. One other less frequent occurrence could be that a Keychain might suffer a corruption – a symptom of this might be your being frequently asked to enter your user name and password in Mail, even though you had requested this be remembered. If this, or a similar circumstance occurs, the solution might just be to repair your Keychain.

If you suspect that you may have a Keychain problem, you can can see whether this is the case by opening Keychain Access, and in its main menu, go to Keychain First Aid, you will be asked to enter your Admin password. There are two radio button choices open to you: Verify and Repair, as in Disk Utility – I suggest in this instance, you do click Verify first. Click 'Start' to see whether you have a problem. Any problem permissions within your keychain will be colored red. If you do have something wrong, then click the repair radio button followed by Start.

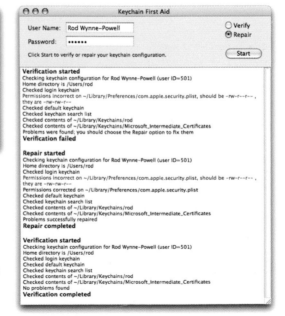

Fig. 3.8 On checking, I found one item had failed the verification, so ran the repair, and as you can see, just like its more general cousin, the Repair mode does both the Repair and Verification when you select Repair, which rather negates the separate options.

Root User and 'sudo'

One significant reason to avoid using Root to access the Mac operating system is that no log is created to store access details. So, any alterations made using Root are untraceable.

You can gain access to the bowels of your system using the 'sudo' command which does create a log, and the authentication lasts for five minutes before lapsing, and requiring reauthentication.

Sudo is defined as Super User Do, and is a command entered in the Terminal Application found in Utilities within the Applications folder.

Unix commands are entered followed by a space, followed by another action or the object to which the action is applied, or other argument, such as 'where from' or 'where to'.

Sudo requires authentication with the Admin password.

Fig. 3.9 I typed 'sudo ls'. Before the Mac allows me to use the command, it insists I type my password, and hit <Return>, only then will it do my bidding – 'ls' which is the command to list the contents of the current directory, in this case the root directory, the first you see when double-clicking the startup disk. The short user name is used before the % sign.

Users and Groups

I think it unlikely that many photographers will be in the situation where Groups play a part, but it is worth mentioning to gain an understanding of the structure. By default normal users are part of the group called 'Staff'. Groups are a way of applying a standard set of privileges to more than one user. If you do not belong to any group and are not designated a User, it may still be possible to offer limited access, and this would be as Guest.

Starting from the most powerful, one user is defined as Root. The Root User has Read, Write and Execute privileges over all files throughout the System. The best advice I can give is never go there! I think it highly unlikely you need ever acquire Root status and use the privilege to alter files within your System Folder. By default it is not enabled. The next most powerful user is Admin – the Administrator – and is the first created; every system has to have one. There is however no reason you cannot have another - it can sometimes be a useful diagnostic tool to create one afresh to check for corruptions in your original.

If you are Admin, then you make decisions as to how many users you declare, you can designate their passwords and what privileges they enjoy, you can load the Applications in the folders that you feel is appropriate. Each User has their own 'Home' folder, to which only you and they have access. Only Admin (and Root) can authenticate the installation of Applications.

Anyone can lock individual folders or files, but this measure is for guarding against accidental erasure or modification, it is set, and is accessible via Get Info. This is very different from Permissions which are about controlling access. To lock an item you highlight its Finder Window and from the File menu or via the shortcut **Command+I**, you select 'Get Info'. In this window you check the 'Locked' box. If you need to restrict access beyond accidental erasure or alteration, then you need to head on down to the bottom of the window to 'Ownership and Permissions'. Here you can either lock/unlock a file, folder or application against any changes, or be given limited access. Only the Owner can unlock these privileges, so remember to click the open padlock to close it, having set these privileges – they do not lock of their own accord!

Get Info

I have described the settings on an individual Mac. Once you have linked several Macs together to create a network, what is set on individual Macs takes on greater importance. If you own the Studio and its Macs, then you need to be Admin for all of them, and you should limit those who have similar access, to avoid possibilities of a disgruntled member of staff ever locking you out of what is rightfully yours, or for that matter, any outsider gaining unlawful access to your images, or confidential material.

There is a wealth of information now stored for every file, and the fully expanded height can often exceed the available screen height. The lower portion, entitled Ownership and Permissions, allows you to set specific permissions for individuals or groups, and provided the padlock is closed, only the Admin User will be able to make changes to these.

The amount of information revealed by this Command is remarkably extensive, and is often so much that you will often have to close some of the reveal triangles to be able to view the specific information you need. If you have been fastidious and named your layers and saved the file in Photoshop native format, you will even be able to search using Spotlight and a named layer within such a file!

Click here to prevent accidental alteration or erasure

Padlock in Unlocked state – Lock this after any changes

Fig. 3.10 A typical Get Info box showing Locking and the Permissions setting. Stationery pad is similar to locking a file – it forces Save into Save As... to ensure the original is not overwritten, so if checked, you are creating a template.

Additional memory

If you want to get good performance from your Mac, having a fast processor (CPU) obviously plays a large part, but there are other factors that contribute, such as RAM and bus speed. Bus Speed is inherent to the model you choose, but RAM is very rarely at its maximum when first purchased unless you specifically order more from the start.

I recommend an absolute minimum 1 GB of RAM for regular Photoshop use by photographers; ideally 2 GB or more will make significant improvement in speed.

If you add extra memory, read the Apple specifications for your Mac model carefully, and note whether chips need to be added in pairs. Buy from a reputable source if you decide not to buy from Apple themselves. Make sure the modules are inserted firmly and avoid any risk of static electricity discharge, by using a wristband and earthing yourself when doing so.

Bad RAM, or poorly inserted RAM modules, can cause instability, loss of speed, or both. So before embarking on the task, it is worth taking some timings of typical operations, and comparing these before and after. You should see a reasonable increase in performance in say a Photoshop routine involving a large file with some layers and an overall Gaussian Blur or similar. If it performs less well, then consider reseating the module/s or swapping them around – if there is still no improvement, it is possible you need to go back to the supplier and request a replacement. Sadly, it is very difficult to check for all the types of fault that can occur with RAM chips, so replacement is often the only satisfactory remedy, but good suppliers are generally helpful over replacing what may seem to be defective chips.

A point often overlooked is employing a second hard drive, and keeping hard drives from encroaching beyond 80% of their total capacity. After that point you start to fragment files and free space, and it becomes harder for the System to do its defragmentation processes. Actually 85% is probably more truthful, but if you start thinking about the issue earlier, it might save you a lot of problems, hence my trying to worry you! The larger the hard drive, the lower the percentage of overall free space can get, for the same average individual filesizes.

Third-party memory

You will likely hear that Apple memory is over-priced, and it is worth bearing in mind some additional information. If you have taken out AppleCare on your equipment, you are covered if you have Apple's supplied memory chips; memory from elsewhere will not be.

Also, do not be tempted to buy from just anybody, three most common suppliers of respected memory are Kingston, Crucial and RAMJet; go by reputation by asking around others for their experiences, make sure that there is a good warranty, and obtain that in writing.

Check very carefully that you are buying the correct specification chips for your machine. Apple have the main source at:

http://support.apple.com/specs/

Look at the complete specification, and double-check this with your intended supplier. If Apple specify that the chips need to be inserted as pairs, then ensure that you do. Sometimes there may also be advantages if they are matched pairs.

If you are not entirely satisfied by the supplier's replies, move on; RAM is too important for you to take any risks.

You can check the existing RAM in your Mac, by looking in Apple System Profiler, which is reached from the More Info button in the About this Mac screen from the Apple menu. But that is once you have the machine!

Ironically when adding RAM, it has turned out that it is not the new RAM, but the originals that were not up to scratch, and this only came to light when the new chips were installed, and then moved from slot to slot! So be thorough.

Caches are created to improve speed... but...

They can also make computers become sluggish; the reason is often an accumulation of redundant data stored in those very caches. The reason data is cached in the first place is to have often used snippets of code readily accessible, but over time, some of it will no longer be of any use. If it is not periodically cleared, it can become a burden; simply sitting there taking up much needed space.

Unix is capable of cache cleaning on a regular basis – hourly, daily, weekly and monthly – and it can be scheduled to do this by what is known as a daemon, called Cron, or more recently Launchd. These small hidden system level files run in the background, and are simply the mechanism used for carrying out timed events. Launchd or Cron can be accessed from the Terminal application in Mac OS X, but there are programs, often free or donationware, shareware or commercial, which add a front end that is more user friendly than the Terminal. You can either setup a schedule or carry out the clearance immediately. It is not only caches, but logs of various activities that become outdated. The third-party programs tend to cover more of these.

The pre-existing housekeeping schedules are normally carried out between 3 a.m. and 5 a.m., so if you shutdown your computer when you are not using it, then you are losing the benefit of those chores. To get around this, use one of those programs to perform any or all the scripts at once on a fairly regular basis. My particular favorite is OnyX.

Others that spring to mind are MacJanitor, Cocktail, Macaroni and Applejack; each has a slightly different set of routines and their interfaces differ, but the core items are those that clear outdated caches and log files, either immediately, or via a schedule that you create.

Online locations for these utilities

http://www.maintain.se/cocktail/
http://personalpages.tds.net/~brian_hill/macjanitor.html
http://www.versiontracker.com/dyn/moreinfo/macosx/20070
http://www.versiontracker.com/dyn/moreinfo/macosx/16593
http://applejack.sourceforge.net/
http://www.bresink.de/osx/TinkerTool.html

Anacron

I recently came across an addition to the Utilities discussed on these pages which performs the various scheduled tasks proactively, by checking whether previously scheduled tasks have been missed due to the computer being turned off or sleeping at the due times.

Once installed it simply gets on with its job unattended.

For details:

http://www.18james.com/anacron.html

Cocktail

Cocktail has some interesting Network tweaks, not found amongst this group of utilities, which probably justifies its cost.

Fig. 3.11 In Cocktail you can change the file format of screenshots to suit your needs, rather than accept Apple's default.

DoktorKleanor

This is a new member to this group, and as it describes itself, it comes in two dose strengths, then mixes its metaphors with Harry Potter, and describes the two strengths as Apprentice and Wizard. The author suggests a possible symptom, if the user indicates this is correct, the Doktor proceeds with the cure!

It is otherwise very similar to the rest in this group.

Some useful maintenance utilities

Mac OS X has enormous power just below the surface. Beyond what is offered to users in the graphical interface is the wealth and complexity of Unix with Terminal as its interface. Fine for programmers and developers, but somewhat daunting for mere mortals. Just behind that door lie several things we would dearly like to use, if we knew were actually there. At least five products tap into this rich seam, by making it easier for us to reach with simple graphical front ends. There are probably more, but here are some I know: Cocktail, Macaroni, MacJanitor, OnyX, TinkerTool and Applejack. Applejack is slightly different; it is a menu-driven addition to Single User mode.

Applejack

Once you have loaded Applejack, you start up your Mac holding down **Command+S**, which puts the Mac into Single User Mode, with an additional line suggesting you type 'Applejack' and hit <Return>. You will now see a menu and the instructions to enter one of the five relevant menu numbers or letters, or 'a' to do all five checks automatically. The last item not covered by most of the others or by Disk Utility, is to clear the Swap files.

Cocktail

This suite of routines covers more than just the standard disk-related tasks: you can tweak the speeds of Network and Internet traffic, and unlock hidden features from Safari, Exposé, and Mail.

Macaroni

Is mainly for running maintenance tasks at times you schedule, like the clearing of caches and logs, similar to MacJanitor.

OnyX and MacJanitor

These two utilities perform some useful housekeeping tasks cleaning up outdated logs and caches, that might be missed through turning off Macs at night, thereby missing the Unix schedules, that could have operated between 3 and 5 a.m.

TinkerTool

Its main claim to fame is in unlocking hidden Mac OS X features; it also allows *you* to set the Permissions of new files and folders.

OnyX, MacJanitor, and TinkerTool

Fig. 3.12 The component features of OnyX.

Fig 3.13 You will need your Admin password when opening **OnyX**, because you are making system level changes.

Fig. 3.14 One of the pages in OnyX, with the three schedules all checked.

The first thing you will notice about OnyX is that it requires your Admin password before it will open. It then provides the toolbar that holds its sheets with the different ways you can access the functions.

Cleaning and Maintenance are the main sections to consider and each can be used directly to clear caches and logs by running scripts that would otherwise have run at daily or monthly intervals. The Unix Utilities can be useful for removing Application Preference files, the com.xxx.yyy.plist files*.

*Where **xxx** is the manufacturer, and **yyy** is the application.

Photoshop's preferences are therefore:

com.adobe.com.Photoshop.plist

Fig. 3.15 MacJanitor interface and its authentication request.

Fig. 3.16 TinkerTool simply enables some of the system features that Apple chose to hide from the everyday user.

Mac slowing down?

Understanding what happens by design using the Mac operating system allows you to sense when something is misbehaving, and also hopefully alert you early enough to avoid a minor mishap becoming a disaster.

If your machine slows down, do not assume this is natural behavior, it is likely to be a precursor to something more serious, so take stock.

Ask yourself whether anything you have done recently could have a bearing.

Symptoms with obvious remedies

You have been working for some time now, maybe without turning the computer off for days, but opening and closing several different programs, and things are seemingly slowing.

This might simply be that your Mac is not over-endowed with RAM memory, and it is clogging up, possibly printing seems a little slower.

Try simply powering down and doing a Restart or choose Shutdown. Leave for about ten seconds then power up again, if this cures the problem, then there is no need to worry; if after a fairly short period the same symptoms occur, then it is worth looking further. If you do have less than 1 MB RAM, I would bite the bullet and buy some more — memory prices are no longer at a heavy premium, but time is money!

If your printer is somewhat sluggish, check out how many programs are open, because all those programs might well be using up large chunks of your RAM, so that the printer driver is not finding the space it needs to spool your file, and there is nothing worse than receiving an alert to say you have lost connection with your printer and your print sits half in and half out of the tray, and you have to restart the printer to retrieve your wasted sheet!

- Have you altered any settings?
- Have you installed more RAM recently?
- Has there been any unusual disk activity?
- Have you recently updated the system?
- Have you updated an application?
- Have you been using the machine constantly for some time?
- Have you run any cache cleaning routines?
- Have you numerous applications open?
- Is your main hard drive fairly full?
- Do you have enough RAM installed?
- When did you last repair permissions?
- Have you run the FSCK routine at startup recently?
- Have you had any mains electricity failures?
- Have there been any electrical storms recently?
- Have you had any unaccountable freezes or crashes?

Any of the above issues can impact on the performance and stability of your Mac.

Apple have developed the system so that applications do run in protected memory, and the applications themselves use individual system extension scripts called kernel extensions (kexts). These are only called by the associated program, so, unlike Mac OS 9, where third parties were making changes which could affect other applications, and therefore crash the entire system, this has largely been eliminated.

Total system crashes, which are known as kernel panics in Mac OS X, are extremely rare, and well worth taking the opportunity to report to Apple.

Operating system stability

I think it fair to say that if you suffer a kernel panic in Tiger or Leopard, it is likely due to a localised problem on your machine or you are using untried or pre-release software, rather than any major player's publicly released offerings.

Whilst touching on this subject, I would suggest that any serious photographer should avoid using their main machine for the playing of games! Games developers are renowned for employing code that avoids any perceived bottlenecks; often communicating more directly either with the main hardware or the graphics cards. Potentially this can have dire consequences, if they have bypassed Apple's toolkit routines for their own ends.

If you sense that things are slowing, the first course of action, is to calmly close all programs, saving the files, then either do a Restart, or Shut Down. When all activity has ceased, leave for about ten seconds and then restart. The reason for leaving for a short period is that starting a machine involves a surge, and doing this too soon can be an issue.

If your machine still seems to be slow, then shut down again. This time, hold down the Command and S keys and press and release the Power On key. Keep both other keys down until the screen fills with white text on a black ground.

The Mac is now in Single User Mode, and is what is known as Verbose mode; it is reporting all the underlying procedures as it is carrying them out. You can now carry out the procedure known as FSCK - File System Check. It is described elsewhere, but probably bears repeating.

You need to type in the following: '**/sbin/fsck -fy**' (missing out the inverted commas, and noting the space between fsck and the hyphen) then hit <Return>. This starts checks validating the disk directory, and what is known as the B-Tree, looking for orphaned files or those that overlap.

It will list all the checks it is making and should finally state confidently 'Macintosh HD appears to be OK' (where Macintosh HD is the name of your startup hard drive). If it reports it has carried out repairs, run the routine again, until it does give your drive a good bill of health, then type 'reboot' and <Return> – your machine will start up normally.

Single User Mode

When you have invoked Single User Mode at startup, your machine will 'bong' then go black all over and start to list a series of checks the Mac is carrying out, and will finally stop with a flashing cursor, expecting some input.

This is the point at which you enter the command - in this case /sbin/fsck -fy followed by <Return>.

'reboot' is the command used to exit this mode and startup normally.

Fig.1.17 When starting up your machine whilst holding the Command and 'S' keys, you will get this verbose mode screen, looking somewhat like the screen shown above.

'Zapping the PRAM'

This is a procedure carried out at startup. But before I go into that, what is PRAM?

PRAM or Parameter Random Access Memory is a separate battery-backed, but addressable area of non-volatile RAM that stores effectively the identity of your Mac. It contains information that defines how your computer starts, your real time clock, what cards you have, how much memory exists, DVD regions, and some security information unique to your machine. It retains the date of manufacture and how long the computer has run. The user has limited access to alter this information. The settings you create when the machine is running are then stored in this area.

Sometimes this can get corrupted, and it may store incorrect information about your computer. This is especially true when, for reasons such as crashes, the computer is not shutdown correctly. As this memory is non-volatile, it means that once corrupted, it will store this corrupted information until you take explicit action to alter it.

The procedure for zapping this area basically clears, then restores, a limited set of these parameters to their default values. You may need to restore those items which are lost by this procedure. If you had Photoshop open and were unable to close down properly, those Preferences may well become corrupted.

The likely System items that may need resetting, are:

- AppleTalk status
- Alarm clock setting
- Autokey rate and delay
- Speaker volume (unplug your powered speakers!)
- Alert beep sound and volume
- Double-click time
- Insertion point blink rate
- Mouse speed
- Startup disk, if not the default
- RAM disk if one exists

On earlier machines the monitor resolution and network settings were lost, but they are no longer stored in PRAM.

Zapping the PRAM

Page 151 describes the keys you need to hold down; turn to page 152 to see the least difficult way to achieve this sleight of hand on the keyboard.

Minor glitches can occur in your system that may take time to show up. Why do they occur in the first place? The reasons are many: some may be minor corruptions that occur through spikes in the mains, that tend to be cumulative over time; others could be due to various log files and cached information building over time, eventually becoming *stale*.

As stated elsewhere, leaving a machine running overnight will allow the operating system to do some regular housekeeping. Alternatively, there are either the third-party options already mentioned, or if you are a glutton for punishment, you could use Terminal to carry out such procedures.

The procedure is to force PRAM to be restored to a factory default, and then to re-enter the data correctly. A sign that for instance, it has been inadvertently put back to its defaults without your interaction, is when it shows a date such as 1970, which is before Macs were around!

Should the incorrect and very early date keep appearing without your machine crashing, it is a good sign that your battery for storing this information is giving out. It is almost invariably a 3.6 volt Lithium battery of some sort, and on desktops this is held in a plastic cradle on the motherboard. In laptops it tends to be a couple of cells encased in plastic with a short lead plugging into the motherboard. The former are readily available the latter less so. Their life expectancy is around 3 years, so if unexplainable mishaps start to occur on an older machine, then suspect failure of this battery – it can render your machine completely inoperable.

How do we 'Zap the PRAM'?

One way is to use TechTool, which is part of the Applecare kit, which can retain a copy of what was stored, to restore it if necessary. The other is to hold down a series of keys at startup – they are **Command+Option+P+R**, press the Power button once, keeping the others down till you have heard the 'Bong' three times, then let them go, and your computer will complete its startup routine. Once up and running, check your Preference panes for any settings that may have defaulted. See a photograph overleaf for a way to hold all these keys down!

Rechargeable Lithium batteries

In MacBooks and MacBook Pros, both the main and PRAM batteries use Lithium batteries, and they have inbuilt circuitry that controls how they charge and also have protection against overcharging and overheating.

The main battery can become exhausted when left overlong in a fully-charged state, if you know your computer is to be unused for a long period unplug the charging lead and shutdown with the battery at 50% of its charge.

It is the exhausted PRAM battery that can cause any Mac to behave erratically, and losing the Time and Date is a good indicator of this condition. A completely flat PRAM battery can cause your Mac to fail to start up at all.

Useful sources of information on Lithium ion and Lithium polymer batteries from Apple can be found at:

http://tinyurl.com/jr2ku
http://tinyurl.com/2dn7uo

Note

Techtool Pro is the commercial product which offers much more than the standard software bundled with AppleCare. It has a full range of diagnostic and repair routines, and along with other products such as Disk Warrior and Drive Genius are extremely useful programs to have to hand when mishaps occur.

AppleCare

AppleCare is a support facility which can be purchased from Apple Computer, which gives you access to technical support technicians, and supplies you with diagnostic software from MicroMat - TechTool.

This can be obtained at the time of purchase or later, and if you are not strong on technical knowledge, this does represent a valuable resource.

The cost is related to the equipment covered.

TechTool, the free component of the commercial product, TechTool Pro, allows you to save the contents of PRAM prior to zapping, and also to restore this data subsequently. This method may well be preferable. Potentially though, you may well restore what you were trying to remove!

Command+Option+P+R and Power Button

Zapping the PRAM. This resets the PRAM, which can be useful in some instances where the stored data has become corrupted. The procedure is to hold all these keys down as you hit the Power button to start your machine, and keep holding them through three startup 'bongs', releasing after the third. Very, very rarely, zapping the PRAM in this manner can fail – removing the small PRAM battery for half a minute or so effects the same end, forcing the EPROM to lose some of its memory.

TechTool

When you Zap the PRAM from the keyboard at Startup, many of the previous User settings are lost. Also, if you remove the battery to return to default, you lose items that can be meaningful, such as the number of hours used by the machine in total, and the date it was manufactured.

Fig. 3.18 Holding down the Command+Option+P+R whilst hitting the Power Key and waiting for the 'Bongs' is most easily done in the manner shown, or have someone else hold down some of the keys for you!

Key combos for use at Startup and Login

- **Option/Alt key**
- **Shift key**
- **C Key**
- **Command+S**
- **Command+V**
- **T Key**
- **Command+Option+P+R keys**
- **Command+Option+O+F keys** (PowerPC only)

Option key

This allows you to start from another drive using Startup Manager. If you hold down the Option key at Startup, in Tiger, you will be greeted with a straightforward blue screen with all volumes with bootable systems present, showing in the top row, and beneath, two buttons; the left meaning rescan, the right the start button. You click on one to select the drive you want to boot then hit the the right-hand button.

This allows you to startup from another internal drive with a valid Mac OS X System, an external hard drive, or a similarly equipped CD or DVD, or to boot from another Mac's drive in Target Disk Mode. See sidebar note related to PowerPC and Intel Macs.

Shift key – Safe Boot

Hold down the Shift key as you start your Mac to boot it into 'Safe' mode - this is where only Apple designated kernel extensions and Apple Login items are loaded from the Library at startup, as opposed to user items you may have set to load. The purpose being to have your computer in a good, clean, known condition for diagnostics.

Startup will also take longer as it is carrying out file system checks upon your disk catalogue, in the way that '/sbin/fsck -fy' does in either Terminal or in Single User mode at startup. It also checks for font caches and dumps these.

Although you could consider this method for your housekeeping, I do not advise this choice, because there is no indication that you are in this mode, whereas it is obvious if you carry out these checks in Single User mode that you then have to restart. You are very likely to have items that would have been in your Login Items, and thus normally have been loaded at startup.

Chip dependent Target Disk Mode

Do remember that Firewire Target Disk Mode booting only works between similarly chipped computers – PowerPC with PowerPC and Intel Mac with Intel Mac.

You may also find that you need to set the Mac whose drive you wish to start from in Target Disk Mode before connecting to the Mac whose Option key you are going to hold down when starting. I have found sometimes this has been the only way for it to be seen, and therefore chosen as the startup disk.

Fig. 3.19 Simulated screen image to show the screen you see when holding down the Option key at Startup on a PowerPC Mac. On the Intel Macs, it is now gray and the layout and style has changed slightly.

Command+O+F keys – Open Firmware

(PowerPC only)

If you hold down this key combination at Startup, you will be booting into what is known as Open Firmware. It is a means of accessing certain parts of the system that controls very low level parts of the system, in particular Open Firmware Password Protection. I do not intend to deal with this in any depth, because even Apple themselves will take no responsibility for any loss of data, and go so far as to state this voids their Warranty.

You can view the list of commands once Open Firmware has been invoked, by typing: 'printenv' without the quotes and hitting <Return>. To continue to boot normally, type 'mac-boot' and hit <Return>, or if you want to shutdown, type 'shutdown'.

One of the uses of these commands after invoking Open Firmware is to restore the default settings type 'reset-nvram' hit <Return> then 'reset-all' and hit <Return> again.

The reality is that Open Firmware is not actually a part of Mac OS X, it is a standard piece of embedded software that Apple and Sun Microsystems both use, and as its name implies is open source, but since it can be a useful last ditch diagnostic procedure, I have included it.

It should be used with great caution - no one makes any claims for its suitability for any purpose, so any action you take is at your own risk.

The Intel Macs use Intel's own EFI, a slightly different mechanism, but Apple have released very little information to those beyond the Developers, and so far there does not seem to be a keyboard shortcut to give access to it, but it does seem to be based closely on the functionality of Open Firmware, and not BIOS, the Windows PC Boot system.

C key

Use this to startup from a bootable CD or DVD. Hold the C key down at startup, until you are certain the CD drive is running, and the system is obviously starting.

Command+S key – Single User mode

You startup using the Command and S keys, holding them down till the screen goes to a black background with white text flowing in, then let go. This mode is known as verbose, since it echoes all that it is doing on screen. When the scrolling stops a small white block informs you that it is ready for input from you. As already discussed, this mode is where we run File System Checks (FSCK). It is an area where various Unix Command Line Instructions (CLIs) can be entered.

The most useful from the Mac standpoint is:

/sbin/fsck -fy

as discussed earlier in this chapter, which carries out disk catalogue checks and attempts to correct any errors it finds. Do not forget to observe the space between 'fsck' and '-fy'. Should you ever forget this exact syntax, just scan through the text filling the screen above and you will see the phrase.

Command+V key – Verbose mode

This is similar to above, but this runs through all the procedures that would normally be hidden from you as it starts, until the Mac OS X is loaded, and you see the familiar blue screen and the normal startup.

T key – Target Disk Mode

Any Firewire-equipped Mac can be treated as just a hard drive. Connect the Mac whose hard drive you wish to see on another computer by a Firewire cable, and hold down the T key as you hit the Power button. Hold the key until a large Firewire symbol starts gently floating diagonally around the screen, bouncing off the sides. You are now in Target Disk Mode. On the host machine, the icon for the disk will be mounted on your desktop, and the contents is now available to that computer.

You can even boot from the disk that is in that mode – first you connect the two computers via the Firewire cable, then on the machine that is targeted, you start it up whilst holding the T key, until the Firewire symbol appears on screen. Then you hold the Option key on the main machine and start this one – keep holding the Option key till the drive icons appear. All the drives with valid systems become available, and you can move the cursor to the targeted one and click the right-facing arrow to boot from this drive. The Intel Macs use a gray rather than blue background.

You may have to authenticate yourself with the Admin account and password when transferring files, but this will depend very much upon how you have set permissions on the individual computers.

Fig. 3.20 The Firewire symbol will slowly bounce around the screen when in Target Disk Mode.

Note

Target Disk Mode is also used very effectively when setting up a new Mac, and in this instance it is done from a button in the Installer setup, to read all the settings such as Network Preferences that you were using in your earlier machine.

Note

Do remember that where before you could boot a PowerPC Mac from another PPC Mac, and in many instances even boot up in Classic using Target Disk Mode, you can only boot an Intel Mac from another Intel Mac using Target Disk Mode.

Conclusions from this chapter

Mac OS X is a maturing operating system. It has been developing all the while in a fast-changing environment: some technologies present at its birth have all but disappeared, and new ones have been absorbed that were hardly envisaged.

Apple Macintosh computers have also evolved both externally and internally: aspects once considered the domain of the high end, have become standard in consumer products – witness Airport and Bluetooth. Much of this has been due to the dramatic increases in speed of the chips in these machines and their lower costs, and Apple's adoption of standards that are common to Windows machines. The irony here being that many have existed for some time in the PC world yet lay dormant until Apple's adoption! Certainly, I have heard comments that Intel have been frustrated by their consumers ignoring their leading edge technologies in favor of tried and tested and low cost features, and they are more than happy for Apple to make use of them and get them established – USB is just such an example – Apple led the way in its adoption, and it is now ubiquitous across both platforms.

Earlier I showed you the underpinning of the interface, the structure, and the intuitive methodology behind the way things work; here I explained how to keep it that way.

Once you have found a way to do some task or other, the chances are that you can find a similar situation, and adopt an identical strategy to tackle the next. If you think to yourself, what I would like to do now that I am here is this... just see whether it will do what you expect – there is every likelihood it will pleasantly surprise you!

Mac OS X is not an interruptive operating system; it is very much an interactive and intuitive system, and because Windows machines have tended to copy many Mac-like features, you might well surprise yourself, and others, by finding your knowledge translates well to operating a Windows-based computer! Especially with the advent of Vista.

Modifier keys

There are conventions that involve the use of the modifier keys:

Command	(⌘ or) key
Option	(Alt or ⌥) key
Control	(ctrl) key
Shift	(⇧) key

I do not propose to create a complete listing of shortcuts – there are plenty out there already, but I do list the most useful for the Operating system and Photoshop in the Appendix, and recommend you try learning them: one of the most useful is **Command+Z** (⌘+Z)!

Whenever you consider there is an obvious opposite or alternative action, consider adding the Option key to the command or menu selection: such an example is the Dodge/ Burn tool in Photoshop – whichever you are in, hold the Option key down and the other applies, so you effectively have an editable undo, or four presets from two tool settings.

The Shift key can add a constraint to a tool, add a link between selections, or join a straight path between two points. So we can make the ellipse tool produce a circle, the rectangle tool a square, draw a line horizontally or vertically or at 45°. We can click with a brush, then holding the Shift key down, click in a second place, and the brush will work along the imaginary straight line between the two clicked points. This convention which applies to Photoshop seems to have been adopted elsewhere.

The Control key provides a contextual menu of items that relate to the tool you might be using at a particular juncture in your work. It can also provide additional control to an action you are performing where other modifiers are already in use. Once you understand the principles of the modifiers, all conveniently placed at the bottom left of your keyboard (some repeated on the right) and the default Express keys on a Wacom Intuos tablet, life at the keyboard will be improved.

Shortcuts

Try to avoid worrying too much about shortcuts – if you are doing something that involves repeating the same two or more operations, or the same one for a series of items in an image, then perhaps a shortcut may be of use, or even the creation of an action or macro. But if it takes longer to rack your brains to remember what the combination is, then forget it.

I have listed the ones which prove worthwhile for many people, it is far from exhaustive, and everyone has different ways of working, so if you feel there should be a shortcut then take a look in the system's Help menu, and if necessary create your own, or if it involves several steps take a look at Automator.

If you have come from the Windows side, then consider the **Command key** as you would the **Control** key. And the Control key on the Mac is the keyboard equivalent of right mouse click. In fact if you have a Mighty Mouse or other multi-button mouse a contextual menu is beneath your fingertips. It is still a right mouse click!

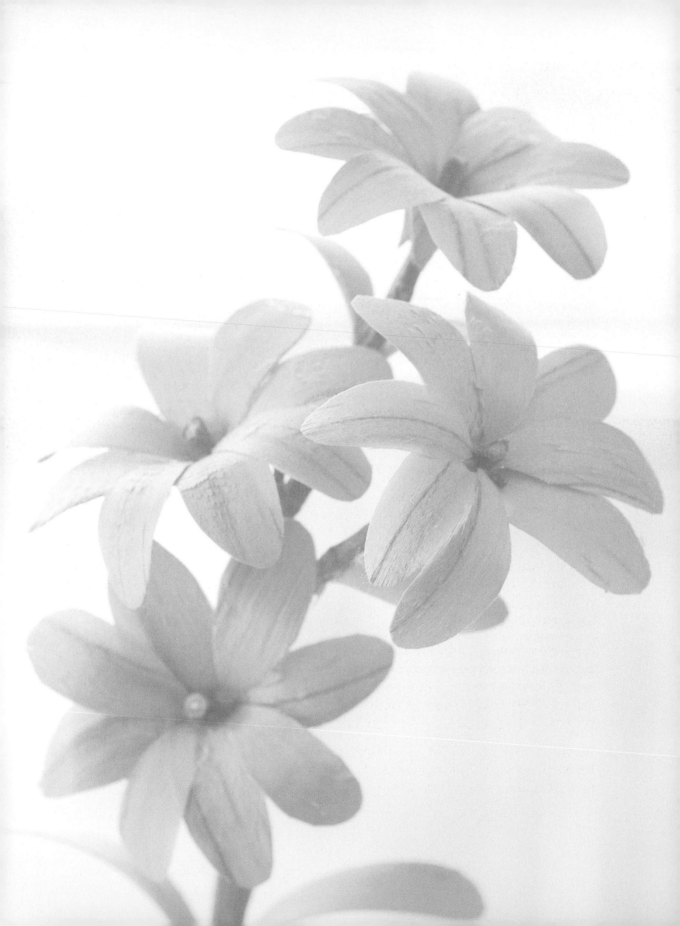

Software Assistance

Apple has gone a long way to provide help, yet this resource is very much underutilised – for instance, many third-party support files can be found from within the System Help menu. Beyond this, System diagnostics can be performed through Disk Utility, which can be found in the Utilities folder. For the more adventurous there is the Terminal, but this can often be too daunting for most photographers.

Fortunately, many of the routines that would be carried out from here have been given a more approachable interface by developers large and small, and several are available as freeware or shareware. You can find these from websites, such as VersionTracker, MacUpdate, MacFixit, Mac OS X Hints, and from magazine articles in the likes of *MacUser, MacWorld, MacFormat and Digit*. Also, for Leopard, take a look at **http://www.apple.com/support/leopard/**.

With Firefox and Apple's Safari both building the Google search engine into their web browsers, it is easy to seek help from the Internet. Mac OS X has brought many more Software Developers to the platform as it has matured.

Installation of software

Some photographers are very wary of loading new software on their machines; however, provided you follow the procedures described here, you should not suffer.

An explanation of some of the ways this is done, should make it a little less daunting. Mac OS X is a multi-user operating system, so firstly, a program can be loaded such that either everyone can see and use it, or only one user may have access to it.

In the former case it is loaded into the first level of the hard drive hierarchy in the Applications folder.

If it is only to be used by a single User, then load it into the Applications folder you find inside that User's Home folder.

Each user has a unique name and password, and as a user you are granted certain privileges; Read, Write or Execute. The highest privileges are accorded to the Root, and the next in the hierarchy is the Administrator often abbreviated to Admin (see also Chapter 3, pages 138/9 and 142).

Some activities can only be sanctioned by the Root User, and this is often referred to as the Super User. You should rarely have to do anything at Root level, and certainly, you should make sure you know exactly what you are doing – at this level, you can do serious damage!

Invariably work carried out at Root-level is done in the Terminal (which can be found in the Utilities folder). To work at the system level, you precede commands with 'sudo' followed by a space character, what follows is the command. A command uses arguments, and the arguments can have parameters; each command is followed by a space.

In other words, you use a language which follows certain rules; these rules are the syntax. A carriage return tells the computer to follow the commands you have issued. If there is a mistake or something is missing, an error message will be returned letting you know either that it does not understand, or something it is expecting is missing. This is not for the faint-hearted!

Fig. 4.1 This shows a Drag 'n' Drop style installation, with the icon dragged from the CD folder to Applications folder, which then appears as shown – the installation really only occurs later when you first double-click that icon, you will then be asked to authenticate the process, by typing in your User name and password.

Fig. 4.2 The background image **1** above is the second screen in the Installation process, where you select your destination disk, followed by authentication **2**, where you enter your Admin name and password.

It is unlikely you will need to have anything to do at Terminal level with commercial software, though some Shareware might need you to do so, though even then most software developers have provided a less intimidating way to interact with Terminal, so take this route to avoid risk and save time.

Every time you load software you will have to authenticate yourself as Admin – there is always a minimum of one user at this level, so that you can load updates to existing software, whether they are for the system itself or applications.

Apple have created an Installer with a standard interface for their own software which is also used by third parties, but you can find programs where all you do is drag from a folder or disk image, into the Applications folder. The application itself may be in the form of a Package which, when you double-click, launches the full installer program to complete the operation.

A Package is a neat device whereby a group of associated files is made to look like a single entity. If you ever need to see what is inside, simply Control+click on the icon, choose 'Show Package Contents', and you will be shown a folder within which is another marked 'Contents': this contains the ingredients for the designated program.

You may well purchase software over the Internet; the Package for your program may then arrive as a disk image (a .dmg file), that when double-clicked mounts on the Desktop and appears like any other disk in the sidebar of a Finder window, with its content in the right pane. You could either enter the true installation from there, or after putting a folder in Applications, launching the program for the first time then does the Install.

What is becoming fairly common is for an alias of your Applications folder to be present in the opened disk image and you are invited to simply click and drag the program icon to the alias. You then launch the program from 'Applications'.

The actual installation will invariably request your user name and password before proceeding, and also get you to agree their EULA – End User Licence Agreement.

Fig. 4.3 Here is a disk image which contains a package which when double-clicked will launch the Updater.

Fig. 4.4 If you hold the Control key down when clicking a package, you get a context menu like the one above.

Fig. 4.5 In the previous figure, choosing to show the Package Contents will show a folder called 'Contents'; in this case it has six components within.

Help

By convention, the Help menu is generally the final item in the left-hand group in the menu bar at the top of your Mac's screen. When you are in Finder, Mac Help will give you access to a plethora of System-related information, and if you are in any of the Mac-supplied applications, you will see to the right of the Home icon a reveal arrow. When you click this, Mac Help is the topmost choice, with a divider line separating it from a long list of available application help files.

You can see the Home page below with a series of general links, and also a window into which you can enter words for searching in its database. I suggest you try single words for speed.

The Help menu, therefore, is available as very much a part of the System. Third-party programs may have their own form of Help, such as Adobe with their 'Adobe Help Center' application which covers their Creative Suite of programs, but some use Apple's Help viewer to access their own information, as can be seen over the page, where the list is shown dropped down.

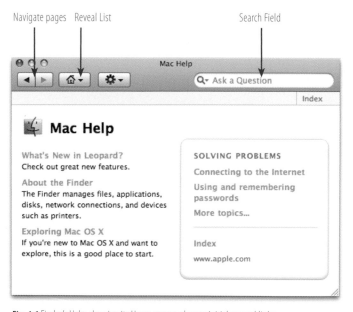

Fig. 4.6 Finder's Help, showing its Home page and some initial general links.

Mac Help

Click the Home icon and you will see a list of applications that you can reach without even opening the specific program itself (see Fig. 4.7).

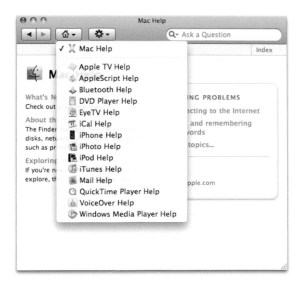

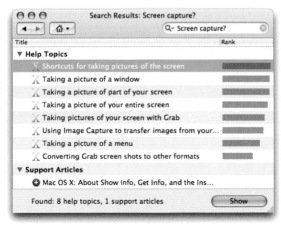

Mac Help

There is a good deal of useful help within Mac OS X Mac Help, but its speed in Tiger lets it down, and for this reason it is less utilised than it should be, and there are many omissions as well.

Leopard sees an improvement in speed, but there seem to be less third-party files. But I do recommend users to look here. Much Mac-specific information is here.

The cog provides a search field within the items displayed and also gives the Print option, as well as controls for the size of the font, these are no longer to be found in the main menu bar, so this facility is a fully self-contained window.

Fig. 4.7 Finder's Help, showing a long list of applications whose Help items can be viewed.

Fig. 4.8 Try to limit the number of words you enter into the search field, as this will keep the speed up.

Disk Utility

If you are in Finder, one of the quicker ways to reach this dialog box is to hold down the Command and Shift keys and tap U, followed by D on its own, then you should see it close by. To make it easier in the future, before you open it this first time, click and drag it to the Dock, and position it to suit your way of working, or when it is open click its Dock icon, and choose 'Keep in Dock'.

The structure of Disk Utility changes to accommodate the information you need, with tabs either disappearing or buttons being enabled.

You can choose to see information relating to the disk itself or to the volume it contains, and the choice you make is reflected in the Title bar. Note also the loss of the Partition tab when changing to the existing volume, as you are within a partition.

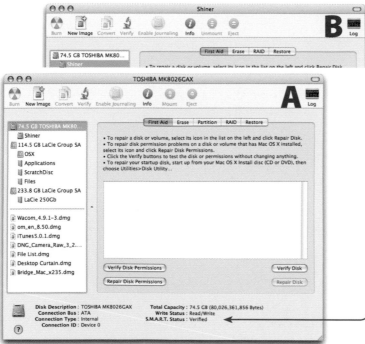

Note

S.M.A.R.T. technology if available on any of your drives, is a new way to get advance warning of possible drive failure, so that you can avoid the costly loss of the data stored on your drive.

Fig. 4.9 In **A**, you can see information relating to the disk itself, in **B** the volume it contains, and this is reflected in the Title bar.

First Aid tab

Any change in selection you make in the left-hand pane will give you corresponding information in the status area at the bottom of the window.

If you select the startup drive then Verify and Repair Permissions become available. Starting with Tiger, you can at least verify the disk, even though you will still have to boot from another drive, CD or DVD, to carry out repairs to any corruption you find.

You will notice that there is a separator line beneath the various hard drive volumes that I have mounted; below this line are various disk images. Disk Utility is able to check these, create empty disk images, and burn disk images to CD or DVD.

Once again note the changes in the Title bar, Tabs, and Status area that have occurred due to the selection made in the left-hand pane of the Disk Utility window.

Fig. 4.10 With the Startup disk contents selected, you will see the above information displayed, note this is a journalled HFS + formatted disk.

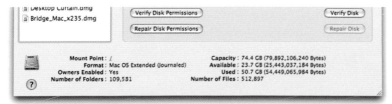

Fig. 4.11 Disk Utility showing the different items displayed for disk images.

Disk Utility combines several functions, from providing useful information about various storage devices linked to your Mac, and giving you access to diagnostic and repair tools, to creating and restoring backups.

One way to run through these functions is to discuss the tabbed features, since these control the accessibility of the button icons which run along the top.. I will describe what you see from the start – the panel to the left lists all the connected drives and the volumes they contain, with the startup disk at the top.

A volume might cover the entire drive, or it could be just one of several volumes on a particular drive. If it is one of several, then the drive is said to be partitioned; you will see from Fig. 4.12 that there are two volumes on my startup disk, and it is named 'Snowy'. The next drive down has several partitions, and these are listed as they are met in terms of the order in which the partitions were created,.

The first item in the second group contains a bootable Mac OS X system as the first partition. I keep this external Firewire drive with a system on, for use both as a standby, and for running diagnostic and repair software from here, to sort out any problems that might arise on my startup disk.

The styling of the disk icons can often give more information such as which software was used to format the drives, the manufacturer or the connection type; the partitions with orange colored icons shown in Fig. 4.12 were created by LaCie, on d2 model drives connected by Firewire.

You can find further information about the drives such as whether the connection was at Firewire 400 or 800 from Apple System Profiler.

Below the separator line are a series of disk images, any of which can be mounted from this dialog box, using the Mount icon.

Once you have made a selection in the left-hand pane, the tab above the right-hand panel can be selected and the relevant buttons for that tab will become available for use.

Fig. 4.12 Note the differing Drive icons, designated by the formatting software, and the separator line, below which are a series of disk images.

Before describing each tab, I will discuss disk Images, and why you might need to create them.

You could be wanting to send several images to a client, and this could be via email*, or by CD or DVD; a disk image is a reasonably compact way to keep several folders together as well as files. It allows you to retain your intended hierarchical structure.

You can create a blank disk image of a specific size, which means you know when it is full. You can create a 650 MB disk image to accommodate exactly, a standard CD, or create one that is 4.3 GB for burning to a single sided DVD.

Also, if you knew your client could not receive an attachment larger than 1 MB, you could create a disk image that was 950 KB, knowing that you could fill it safely and your client is going to be able to handle it.

Disk Images are handy for keeping things together, because you can access their contents fairly easily, and retain the whole, whilst copying out small parts for use.

They can be very useful for backing up when you need to either update the system or change the hard drive.

Erase tab

If you have chosen the drive, then not only can you erase any data that may be present, you can choose the type of formatting to be employed, and how many partitions you are going to need.

If you choose the volume, then you are accepting whatever partitions that may already exist, but you can erase any you find.

You can choose for instance, to create a password protected volume – just remember your password, for without it your data will be lost fairly securely!

Securely Erase means that any pre-existing data will be overwritten by zeroes, and therefore will cease to exist with no chance of retrieval, whereas a normal erase may succumb to disk retrieval software. So, if you should ever inadvertently erase a disk under normal circumstances, you may be able to rescue some or even all of your lost files, by using appropriate software.

***Note**

Windows clients will not be able to understand a Mac disk image, so only use these as attachments when you know the client has a Mac.

File Recovery tab in Leopard

This new tab is introduced in Leopard offering three areas, your Photos, Music, and Movies. The Custom icon offers you a selection of specific modules related to the file types to be recovered.

Fig. 4.13 The three colored icons are buttons that bring down a browser sheet for you to select a destination for the recovered files within those categories.

Fig. 4.14 The Custom icon is also a button, but this sheet asks you to select a recovery module to use in your search.

RAID tab

RAID is the acronym for Redundant Array of Independent Disks, the 'I' was originally for Inexpensive, but this was dropped.

There are now several more RAID type definitions, but for the purposes of the intended readership of this book, those beyond 5 are not relevant, except RAID 10 or (0+1) which mirrors a striped array – for a fuller explanation of RAID see:

http://searchstorage.techtarget.com
http://whatis.com

RAID arrays are a means whereby several disks can be made to seem like one volume, and are configured for either increased speed or security, or both, depending on the arrangement. Mirroring of the data on another drive will offer added safety in the case of a failure of one or other of the drives, but will offer no gain in speed, unless you factor in downtime due to the loss of the data, and its retrieval; this involves a second drive holding an exact copy of the first. Striping, where alternate parcels of data are placed on alternate drives, will give an increase in speed, because one drive can be reading whilst another writes, and vice versa, but a failure of either drive will lose all your data, since no complete copy will necessarily exist on the other drive. A combination of both mirroring and striping will overcome this and give you speed with peace of mind, and RAID 5 is just such a combination, but this is not offered within Disk Utility.

RAID types are normally graded from 1 to 5, with an addition of a non-redundant version designated 0. Tiger offers only two types of RAID – Mirroring and Striping, equivalent to RAID 2 and RAID 0. Under this Tab, Tiger also offers an item called concatenation, which strictly speaking is not RAID at all, in fact is really its opposite – it allows you to designate more than one physical drive to be considered as a single logical volume – it concatenates these drives into a single addressable one as far as the system is concerned.

Tiger offers the following RAID sets:

• Mirroring set
• Striping set
• Concatenated Disk set

Mirrored RAID set

This is where data is stored on two separate drives: this makes one drive effectively redundant, giving you, the user, added security. However, there is no speed advantage when using this mode.

Striped RAID set

This involves writing or reading alternate blocks of data on two drives, which gives a speed advantage, but at the cost of security. In its lowest form, which is what is on offer here, there is no redundancy, but striping can be combined with mirroring (at RAID 5) to add this security and thus redundancy. What Tiger offers is RAID 0. There is a significance in the zero – this level was added after 1 through 5 were discussed, and the zero really refers to there being no redundancy.

Tiger does not offer RAID 5, so use this RAID setting with care, and be aware of the danger that should either drive fail, you will lose data, as you will have incomplete data on both drives when using this setting – ask yourself whether this speed gain is a risk too far?

Concatenated Disk set

There is a third option within this tab, but this is also not really a RAID at all, it allows you to specify a number of separate drives, and then link them such that the operating system sees them as a single, but much larger drive. Concatenation of several disks is often known by another acronym – JBOD – Just a Bunch Of Disks! Be careful to read the particular manufacturer's description of JBOD: some simply mean disks that are not arranged as a RAID, and treated individually, others mean they are concatenated to be seen as a single volume (a less safe arrangement).

Mac OS X is offering a software RAID option, but many prefer to use hardware solutions employing RAID controllers and external boxes with individual bays for the drive units. Often with removal controlled by a key which adds security and becomes a switch which powers the unit down safely prior to removal.

Fig. 4.15 This is a typical style of RAID enclosure where individual drives can be removed by key which combines both a switch and security. ProSATA SS80. (*Courtesy of WiebeTech*)

Note on a new concept

Data Robotics have a new idea requiring no extra software on the Mac that is an enclosure which can take additional drives up to the standard enclosure size for four units. It is seen by the Mac as one drive, and there is inbuilt intelligence to handle hot-swapping and automatic fault recovery. The unit is called Drobo.

Note on RAID

I suggest that the RAID solutions offered in software are too risky for photographic imaging, other than as Scratch disks. This is partly due to the file sizes involved and the inherent value. If you feel you need the speed, I recommend strongly you consider an external hardware solution that is RAID 5 or RAID 10, which then leaves you the option to consider the striping option in software as a Scratch Disk for Photoshop.

Restore tab

This is where you can bring in Disk Images and replace lost or damaged disks from backup. If you have signed up for Apple's .Mac service you may have backed up a series of disk images to iDisk; here is where you can now restore these, because there is the facility allowing you to enter outside URLs where you may have created some offline storage.

The instructions on how to use Restore are well explained in the text: either drag a disk to the field, or browse to it using the button to the right. If you are restoring from an offline source, then I strongly suggest that despite the extra time involved, do not be tempted to check the 'Skip Checksum' box, as the chances of errors are too high.

You can see how handy it is that Apple thought to include Disk Images within the same window to facilitate dragging and dropping.

Context help for Disk Utility

There is a button with a question mark icon in the bottom left of Disk Utility; this will gain access to Help Viewer and offers some guidance in using the various components. It automatically senses the context in general terms, listing further more specific items.

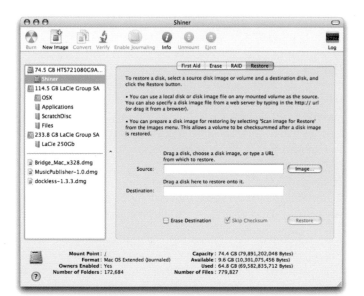

Fig. 4.16 This shows the Restore tab options, complete with full instructions for how to use this facility.

Log

In the top right-hand corner is a button that when clicked shows you the log of the actions you have taken whilst using Disk Utility. The log can also be viewed from Apple System Profiler, or simply by opening the file in TextEdit.

The log file is stored in the User's Library, should you need to find it at a later date.

The controls offered are Clear, which will clear this window of the current log details, Reload, which will open the full log from your disk, and Mark, which will append a datestamp at the bottom of the window. In this way you obtain both the start time for your action and a marker prior to the next you take.

You can limit what is showing by filtering for specific information, this filters in items, in other words searches for specific strings, rather than filtering out.

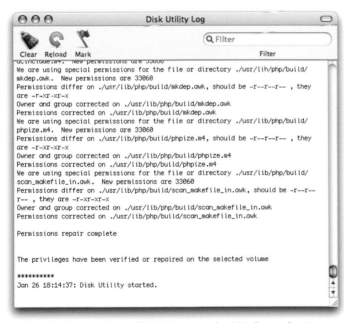

Fig. 4.17 This shows a typical log of Disk Utility activity, when I did a Repair to Permissions on my startup disk. More useful logs to be found are those created when finding a disk problem, and asking the system to carry out repairs.

Other system logs

Logs exist in overall and user level Libraries, and these are files that can be read by TextEdit, they provide useful information of underlying activities with accurate time-stamping.

They can record the installation of specific items, and report crashes or freezes, which can prove essential in tracing the activity that subsequently led to a specific mishap; some of these may make sense to mere mortals such as you or I, others are going to need a long hard look by programmers.

If you start experiencing untoward disk thrashing or freezes, crashes or kernel panics, then locate any relevant logs and send them to the relevant parties, asking what can be done. When for instance, a program you are using crashes unexpectedly and you get the offer to send details to Apple, do take up the offer, it is your chance to improve the stability of the system.

Context-sensitive menus

Despite the belief by Windows PC users that Macs do not have a right mouse click, because they only had a single button mouse, Macs have had context-sensitive help as part of the system for some while. It has even been enabled for those Mac users who had bought multi-button mice. With the introduction of the Mighty Mouse, even Apple sported the 'right-click'! And now there is even a Wireless Mighty Mouse with a scroll wheel.

It is very much a part of the system in the same way Windows users came to expect. The terminology might just be a tad different.

Below is an example of how, depending upon where the mouse click occurred, the help offered differs relating to the context.

Fig. 4.18 Whether you hold down the Control key or right mouse click, it is where you click that defines the different set of context-related options: **1** on a Hard disk, **2** on an Image file, and **3** the Window background.

The illustrated description in the previous page was related to the Finder, but Tiger and Leopard both offer this support of context-sensitive help to all applications, including Photoshop.

When you hold the Control key, the cursor changes to add a small List icon, that some describe as a ladder; when you then click, you will get a list of available options related to your tool setting, dialog box options, or the type of object you click on. Programs like Adobe Photoshop, and others in the Creative Suite, take advantage of this to hide some of their complexity and power, keeping the interface clean and uncluttered.

Modifier keys have established certain properties in the system which have been adopted within third-party programs. You can see an example of this in the selection process; a contiguous selection is made using the Shift key, and discontiguous selections, by using the Command key. As a corollary to this, you deselect selected items individually, by Command+clicking them.

One of the historic ways in which the Mac operating system has helped users, is for all menu items that have a shortcut key associated with them, to display it to the right of the item in the list. This convention is adopted by most third-party developers.

So in Fig. 4.19, the selected item, the Save for Web command, can be chosen using **Command+Option+Shift+S.**

Note also the reveal triangles that indicate the presence of a further set of options. Dependent upon which way you arrived at the menu; that is whether you clicked, or clicked and held the mouse or pen down, that menu can be clicked to appear and stay open or may simply appear.

If you see an ellipsis (...) at the end of an item this means a modal dialog box lies beyond. Modal dialogs are those which ask for information, and only close when that is supplied, or once you have cancelled it.

Fig. 4.19 The Photoshop File menu shows the shortcuts that perform the menu actions described in this list.

Application menu

The first item in the menu bar after the Apple logo is the name of the current application. This menu contains several regular items:

- About *Application*
- Preferences
- Services
- Hide *Application*
- Hide Others
- Show All
- Quit *Application*

About is where the version of the software is found, and occasionally a short description, mostly copyright details.

Preferences

The preferences specific to the current program can be reached from this list, and it is good practice to take a good look here, before using a new program, so that you set meaningful defaults. When I visit photographers, I am often surprised how many have simply never taken a look here, and so find themselves making some simple changes on every file they work upon, because it is not defaulting to their most common setting.

Hiding

Both hiding the program you are using to reach one open beneath or hiding others to keep your workspace clear, are often underused – a shame, since it is often quicker than minimising.

Services

Services is very much underused, but can be very useful. This under-utilisation of Services stems from poor support from third-party programs, as well as Apple itself, as much as a lack of understanding by users.

Adobe has not provided hooks from Photoshop, which might have been handy for photographers, but fortunately several system morsels do make it fairly straightforward to take snapshots of our work, to put into Mail to send to our clients.

Grab in Photoshop would be handy to allow you to take screenshots as you worked, were it activated in Photoshop, but to date its options are grayed-out.

Fig. 4.20 The Application menu, every program has this menu, and certain standard items can always be found here, Quit being the most obvious!

Application menu – Services

I have chosen to show Safari with its Services menu, as it is probably one of the more useful programs to use. You are surfing to find a new technique, or a list of clients. Make a selection, go to Services, down to TextEdit and put it into TextEdit or Mail...

Tip

If you copy white text from a site, it might appear you have not copied anything! In TextEdit Select all, then give the text a color or Black.

Fig. 4.21 Here is the Services menu in Safari, where I have made a selection that I want extracted to a separate file in TextEdit. Note there are still items not available that have been grayed out, though some that are supposedly available turn out to have grayed out submenus.

Screen capture

One area where the Mac is very well-endowed is in the area of screengrabbing, though it is limited at system level to stills, not moving images. For more complex screenshots and movies, Ambrosia Software is king, with its Snapz Pro X.

Apple have a dedicated program, Grab, as well as a series of extremely useful keyboard shortcuts.

Photographers can find many uses for screengrabs, so let's see where it helps in a general workflow. You have been working away at a multi-layer shot putting your client's product into a new background. It is not yet a finished picture, and the client wants to see the stage it has reached for a board meeting with fellow directors in a few minutes. Saving the 120 MB file will take a while in itself, and making a duplicate file and down-rezzing it will also take a while.

No problem: get the screen image to say 25 or 50% (any division by two or multiple of 100%) and hit F on the keyboard, and Tab if neccessary to make enough space, then hold the Command and Shift keys and tap 4. With the new crosshair style cursor, lasso the image, starting and finishing in the pasteboard area surrounding the image.

A new file, '*Picture n*', will appear, saved to the Desktop, where 'n' is the next number up from the last time you took a screenshot.

Open this smaller image in Photoshop. Then apply Image/Trim, and further compress it if necessary, by saving it as a JPEG, and send it to the client. You can then carry on and finish the job.

Now let me discuss some variations, and explain a few tweaks. In the scenario just described, I did not mention how to tidy this image, nor why I changed screen modes – let me explain.

In Photoshop before version CS3, there were three distinct ways to view your image, and tapping F on the keyboard cycled through these modes. Normally you could not move the image within the gray Pasteboard area: the second mode allowed this, whilst removing the window surround. The third mode gave a black surround to the image. CS3 now has four modes, with the second click needed before giving you the freedom to move the image area around to view paths in the Pasteboard area.

Area to be removed

Fig. 4.22 Photoshop's Trim command in the Image menu, and showing what is to be trimmed off – the thin black line shown here will surround the final cropped image.

Fig. 4.23 The Trim dialog box with the options that are available.

Whilst working in Photoshop, the image is in a window; the client has no need of this, hence why I suggested doing the screen shot in the next screen mode, by hitting the F key once. In CS3 you may want to hit F twice, allowing you to manouevre the image more freely. Hitting the Tab key removes the palettes that may obscure the main image. And hitting **Command+R** will remove the ruler if that were present.

Once you capture the screen, open it in Photoshop and if the pasteboard is a darker shade of gray, when you use the Image/Trim tool, you can leave a fine black edge. So long as you take the screenshot as large as is necessary at 25%, 50%, or 100%, the image will look crisp on your client's screen at your chosen size. Save as a JPEG to further reduce its size for emailing.

If you do need the window as well when creating the screenshot, then after using the **Command+Shift+4**, tap the Space bar, and your cursor will become a camera icon. Click on whichever window you highlight to capture that window alone.

The Trim command does not always like working to lose the 192/192/192 RGB mid-gray surround. Using the Paintbucket, fill it with white, then handily, it leaves a neat black border to the cropped image.

Photoshop's Screen Modes

Generally hitting F once should allow you to obtain an uncluttered view of an image, but occasionally at the fixed sizes, it becomes tight, so hitting F a few more times gives you that bit more area. Do remember that if you are still in the standard view, provided you have the window highlighted, overlaid images will be ignored, which if you can live with, or need the window border, is really handy.

Fig. 4.24 The image with part of the pasteboard unevenly around its edges, prior to using Photoshop's Trim command.

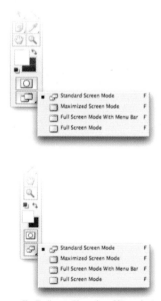

Fig. 4.25 The Toolbox in Photoshop CS3 can be in either 1 or 2 columns, and there are now 4 screen modes; hitting F still cycles through the options.

Capturing a window

When you take a screenshot by using the keystroke combo of **Command+Shift+4**, followed by tapping the Space bar, the System is intelligently using the layered video information to capture only the window you select, and it will ignore any overlaid windows above.

Fig. 4.26 The top image shows the full screen with the particular window that has been highlighted using the camera icon, and you can see that window is partially masked by one above. However, the subsequent capture of that window is complete, as seen here.

Screen capture – color

An important point worth bearing in mind when doing screen grabs is to convert the image to your Color workspace, for accurate matching.

I have glossed over the full-screen mode capture using **Shift+Command+3**; for the very good reason that this mode is really only of use when you need to convey the environment of your image, such as when training. Adding the Control key to this combo places the image on the Clipboard, ready to be pasted into a document, but neither has the flexibility of the previous commands I have discussed.

Grab

The Mac OS X System contains another means of screen capture – it is an application you will find in your Utilities folder, and is imaginatively called 'Grab'. Why didn't I mention this before all these keystroke combinations? Well, quite simply because I find the keystrokes far more straightforward and faster than opening an application to do my captures.

However, Grab does deserve mentioning. It puts its capture on screen immediately, ready to save, and will capture the cursor, which does not happen when using the shortcuts. The type of cursor can be chosen in Grab's Preferences. You can also specify exact crop sizes and to what bit depth the image is captured.

The greater majority of the captured screen in this book were done using the shortcuts; however whenever I needed the cursors, I adopted Grab. It also extends its flexibility by offering a timed delay before capture, which can help.

Fig. 4.27 Grab puts up its captures immediately, and gives you the additional option over the shortcuts – a time-delayed capture.

Color Profiles

Screenshots are profiled with your monitor profile, so you may see this alert on opening, and need to convert if going to print.

Fig. 4.28 Screengrabs are in your monitor color workspace, so will need to be converted upon import if needed for color critical reproduction.

Fig. 4.29 Grab offers you a choice of cursor icon that can be captured.

Fig. 4.30 Grab also offers you a chance to create exact sized capture.

iPhoto

In a book aimed at photographers and about the Apple Mac OS X operating System, it may seem perverse to leave iPhoto to the end of the chapter on software resources. It has been done for a good reason though. There are many professionals who do use iPhoto, and if you are one that finds this has been a successful workflow for you, then Aperture should appeal, because it is built upon familiar foundations.

iPhoto is aimed primarily at the consumer, whereas this book is more for those engaged in photography for whom the operating system is the scaffolding to support various professional programs to handle your digital images. Programs to scan transparencies and negatives, sort the shots that matter, add metadata, color balance, color match, adjust exposures and contrast, crop, resize and prepare for output, then onward transmit them to the client, and manage the archiving and backing up of both the editable work, and the finals.

Aperture

All photographers work in subtly different ways, often governed by the nature of their clients or specialisation. No workflow will be identical — if you know the programs, procedures, and the pitfalls, you will be able to make your own decisions as to which paths you take.

If you are a professional for whom iPhoto provides a good workflow, then Aperture should be a smooth transition, you will be able to import existing Libraries and their Smart Libraries.

iPhoto and Aperture tend to be rather rigid in their structure, and this is how they gain their stability and speed. Both are exclusively Mac programs, which may be a hindrance, whereas Photoshop, Bridge, and Lightroom, are all cross-platform.

It is also important that you consider carefully the links between how you work internally, and how you interface with others, in terms of the file formats in which you save your work.

Various programs that have specialised and become accepted for their roles in digital photographic workflow are the mainstay of a photographer's life, and importantly they scale well and are available cross-platform. iPhoto does many of the tasks, but simply does not scale to the same degree, and because it attempts to cover a wide spectrum of tasks, it has a structure that is often too complex to fit with other accepted programs, such as Photoshop. Aperture, which is an Apple product, but is not bundled with the System, is however more suited to the tasks of the professional photographer, but because it and Lightroom are standalone programs they will only be discussed briefly within this book.

A reason for my reluctance to consider iPhoto as a serious professional tool is because I am a staunch believer in capturing images as RAW files, and I feel that Adobe Camera RAW, Phase1, Bibble and the camera manufacturers' own programs are more suited to the way in which most photographers work. I do know those who work with iPhoto and they are extremely happy, but I just find the filing to be overly complex, and difficult to link with my established workflow.

Not every professional needs to consider shooting in RAW format, though I would certainly advocate the majority of those shooting using Digital Single Lens Reflex Cameras (dSLRs) should try to shoot RAW – it will give you greater latitude when shooting, and will preserve *more data for later*.

iPhoto offers far more to those who have a .Mac account. It has also been furnished with strong links to the iLife Suite, iWork, Mail and iChat, but for me, it is too consumer-oriented.

For those who want to know more, I will run through some of the features that do not require a .Mac account.

A good Mantra – Data for Later!

Shooting RAW means that you have a file that cannot be altered and resaved. If you have used such a file to create your carefully color-balanced, well-exposed and cropped image for a small sized reproduction in a newsletter, this will not preclude using it much larger from the very same file at a later date.

When you need it for a double-page spread in an A4 brochure, you simply go back to your RAW file, and select a different output size. This will create another Photoshop or TIFF image with all the previous settings except it will be at the new size, and again only allow you to Save As... It will not overwrite your RAW file.

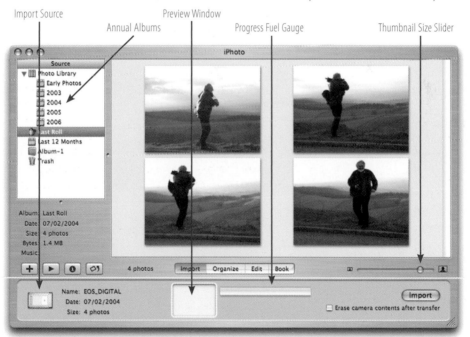

Fig. 4.31 When you open iPhoto to the Import tab, it will look something like the above, as you select each tab, the controls you see below the yellow line I have drawn, will change.

iPhoto now imports RAW, JPEG and TIFF files into albums, and also Smart Albums. Smart Albums can be based on a whole range of criteria, and Apple gives you a series based on years as an example, but you might just as easily create weekly or monthly albums, or based on ranking or location criteria, or any keywords you may have entered.

You create Smart Albums by using the pulldown menus to create a search pattern, which then puts the results into a named album, and as you add images that match your criteria, they will automatically appear in the folder. If you alter say the keywords for an image, so that the criteria no longer matched, that image would disappear from your Smart Album.

If you attend a sports meeting each year, the location might well be the name of your Smart Album. With just a change in the year you could sort images taken at the event in different years, but if you wanted to see all the years, just remove the year criterion.

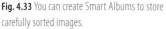

Fig. 4.33 You can create Smart Albums to store carefully sorted images.

Fig. 4.32 Here I have assumed that I have previously created and keyworded a series of photographs taken at the Festival of Speed, and now wish to add any such images to this new Smart Album.

The Edit pane very clearly defines the market this program is targeting, the consumer; the controls are rudimentary and limited. Assuming the images require little or no work, the Book feature is fairly easy to set up, is clean and tidy, with a fair amount of variations on offer as can be seen in the menus below.

iPhoto Pro?

I have stated that the target market for iPhoto is not really the professional, but professionals do use the program, and the remark was not made to denigrate those professionals who do, nor the program itself. Simply, that if this workflow suits, then Aperture is effectively iPhoto Pro.

Aperture's books are of a higher standard in both design and resolution, than can be achieved currently by iPhoto. So for those already going down this route, Aperture is the next progression, but be aware of the restrictions imposed to achieve its ends.

An observation

I tend to advise those I meet that they go for more open standards, because proprietary solutions are hard to escape if your circumstances change.

Examples of this are not difficult to find – photographers who choose a camera and lens combination, and build a system, will be reluctant to change brand due to their prior investment

If the intended type of photography is covered by iPhoto, then this is the program for you, if you need to take things further, then Aperture is the next step.

However, your workflow is very much dictated by these two, if you want greater freedom over the way you work, where you choose the components that most suit, then it is my opinion Lightroom and Photoshop are better routes.

Fig. 4.34 Snapshooters would find this easy and quick. The Enhance tool is a one step process, likewise the black and white and sepia options; the sliders do give added control.

Fig. 4.35 Here I have montaged two menus to show the options available to you when creating a book from an album.

From where does the work come?

The answer to this question has as much to do with Marketing as it has to do with Workflow. Also, the answer may not be straightforward. It can come from many more sources than one, and this may be down to the nature of the work, the background of the photographer, or the location. It can also arrive at a different stage in relation to its final outcome.

The reason I posed the question was to make it blindingly obvious that all of us work differently according to the situation. In most situations, we rarely are at the beginning of the chain – generally someone briefs us as to what is needed, and how it is to be presented. In this age of digital photography, it may even be that we are told about the possibility of the work via email.

Apple is very much aware of the situation and provides Mac OS X with the tools from the very start, with Image Capture to begin the process and allow us to decide what has to happen to the files either from the camera, the card or a scanner.

You have an application that in simple terms can organise your photos, carry out limited image and color corrections, collect them into albums and even print them out individually or into books – iPhoto, or its big brother program aimed at some professionals, Aperture. For some quick work there is Preview.

You also have the Mail program, which allows you to communicate with your clients, and if you want to take that a stage further you have iChat AV, which is even able to offer Conference calls, and in most of the latest machines you have a built-in iSight camera. In Leopard, the Screen sharing and Keynote presentations can also become part of the iChat session.

The iWork Suite has Pages – a Word Processor, Numbers - a Spreadsheet, and Keynote – a Presentation program. The last is a very useful way to promote your work to clients in addition to using the slideshow opportunity offered by Quick Look in Finder.

In Leopard all the programs that are likely to need to link to iPhoto, do, such as Mail, iCal, Safari and the iLife and iWork Suites; it is this level of integration that gives iPhoto and Aperture their strength against stiff competition from third parties.

Bundled programs

Image Capture
Preview
iPhoto
TextEdit
Mail
Safari

and in Leopard
Time Machine

The conversion mechanism for RAW files is built into Mac OS X, which allows all of these programs to benefit from those RAW files for which Apple have provided the translations. This is in addition to those other common formats such as TIFF and JPEG.

So, you can see that Apple has made very sure you can have solid communication right from the start.

Another advantage is that most PC-formatted files are understood on the Mac platform natively, even from PC-formatted media whereas Windows users may have to use a separate program to carry out the initial conversion to allow them to read Mac files. This has been taken a stage further in Leopard, by the inclusion of Boot Camp which will run Windows XP and Vista on the Intel Macs. The drivers that make this possible to access the hardware are loaded via Boot Camp Assistant.

Recording data files to media

Mac OS X can record to Mac and Windows-formatted hard disks, and can burn files to CD and DVD optical media without recourse to third-party applications. This makes it very much simpler to receive and to supply to our clients, many of whom are often on Windows.

Client–Photographer communication

Photographers using Macs are in the fortunate position that for the reasons shown here, they can accept work and discuss it with clients with no more than the operating system and the bundled programs. Add in Photoshop or Aperture and Lightroom, and you can take things even further.

You can write to the PDF format, which is a native element of Mac OS X, so your client can actually see much of your work, without the expenditure of the programs you may have used to create or manipulate their work, because Adobe Reader is available free on all platforms; also you have Quick Look in Leopard and Preview, which are able to read and display a wide variety of image formats.

Why do I keep dropping the name of Preview into the narrative? For the answer, take a look in Chapter 7 – this is a seriously underestimated program!

Earlier in the chapter I discussed screen captures which are a very powerful feature of Mac OS X, and this can be a boon when showing a remote client just how far you have reached with their project, by despatching a screenshot via email.

So, discussions, briefings, clarifications and approval can be carried out to a large degree without either party having necessarily to purchase third-party products. Obviously, Aperture, Photoshop, Lightroom and Snapz Pro will do even more, but the entry-level is low, yet very capable.

You can deal direct with some clients, through Agents, Agencies and Designers, and the means lie within your operating system – Mac OS X.

A useful tip here is that if you have a file or folder of images to send, especially to a Windows-based client, then you can compress the folder to a ZIP archive, using the Contextual menu – highlight the folder, and hold down the Control key (or use the right mouse click) to choose 'Create Archive of *filename/s*' – Tiger's terminology; Leopard uses 'Compress…' – the end result is the same (see Fig. 4.36 to the right).

Fig. 4.36 The Tiger and Leopard dialogs provide the means to compress single or multiple files, a folder or folders into a ZIP archive to simplify their passage via email, but the descriptions are different – Tiger is on top, Leopard below.

Digital photographer's front end

Workflow in Digital Photography will vary from group to group and individual to individual. Sorting, sifting, ranking and naming will come with differing priorities, but for any systematic procedure to be effective, they need speed and ease of use.

iView, Fotostation, Extensis, Phase 1, Bibble, Canon, Nikon, and naturally, Adobe, each offer their own interpretations. Two newcomers have entered this field; from Apple – Aperture, and from Adobe – Lightroom.

I have used the term 'front end' when describing both these programs, but in either case this is somewhat of a misnomer, because they can be 'end to end'. The endpoints for each are however different; in Aperture it can be a book, in Lightroom, prints. Both can export to Photoshop. However, I stand by my heading, as they both basically come at the start of the workflow, before a program such as Photoshop, where major manipulation can take place. To anyone steeped in Photoshop, these newcomers represent a stage before, that had hitherto been the realm of Adobe Camera RAW, Bibble, Phase One, iView Media Pro (now Expression Media) and Fotostation.

Aperture

Apple has, (to my mind at least) come up with a pro version of their popular iPhoto, with many improved portions of the original, such as better book creation by outputting images at higher resolution.

In launching Lightroom, Adobe has effectively produced a new interface for Adobe Camera Raw, that has been created as a standalone program offering non-destructive editing of RAW files, with metadata storage of the edits. The approach they have adopted means that all the searching and sorting is done in a database program based around that metadata – it is much faster than Bridge, and is geared to dealing with multiple similar images at great speed, which is also true of Aperture.

The difference between what at first glance seem very similar and competing programs, is where the conversion from RAW takes place. Apple has made the decision to make this a system-level transaction, whereas Adobe has built Lightroom upon their pre-existing translation engine, Adobe Camera RAW.

Aperture & metadata

Ownership of Edits Metadata

← Aperture and Mac →
Your Mac stores the Edits metadata within the Pictures folder, but access to this, is only from within Aperture.

Fig. 4.37 When you create versions from the master files in Aperture, they only become usable externally once exported into standard image formats.

Note

Both Aperture and Lightroom deal with more than just RAW files, both also can link to third parties who provide print services, they can create web galleries and slideshows, but in these, the differences are acute, with Lightroom definitely producing more sophisticated output.

Aperture and Lightroom have developed rapidly during the writing of this book, and the changes have been substantial. Both products benefited greatly from active involvement with users, though in Apple's case, less prior to release. The architecture in some ways has converged, and the interfaces have matured becoming more individual – Versions in Aperture are equivalent to Virtual copies in Lightroom, but both are only under the control and understanding of their parent programs.

The fundamental difference is that Apple's Aperture retains greater control over the applied metadata, whereas images from Lightroom can have a single interpretation of the raw data embedded within the file's metadata. Aperture stores all the alterations to the master image and subsequent Versions. Only the Virtual Copies and Snapshots remain exclusively Lightroom's.

All members of the Creative Suite have access to the most recent embedded metadata interpretation of a raw file that has been processed through Lightroom. If the raw file has become embedded in a DNG file, this interpretation is understood by Aperture. Lightroom never sees changes made by Aperture until exported, when it is no longer raw, but can be a flat PSD, a TIFF or JPEG file. Bridge however can read the metadata edit settings from Lightroom, embedded alongside the RAW data.

Both programs have loupes, and auto-stacking of images based upon the timeframe within which they were taken. Both these features were originally seen in Aperture, and Apple still has the edge over Adobe here in being able to use the loupe on thumbnails as well as the selected image/s.

Earlier in the development cycle for Adobe's Public beta of Lightroom, it grouped its files into Shoots, but by the time of release, this has become folders that are simply an exclusive subset of the system's folders, that within Lightroom, only hold those images that you have imported. They also added catalogues, thereby becoming more manageable over time.

My preference is for Lightroom, with its modular approach to the tasks involved in RAW processing. Although both programs are RAW processors, both can handle TIFF, PSD and JPEG similarly; Lightroom also imports and export DNGs.

Note

Although the greatest benefits from Aperture and Lightroom accrue to RAW files, they both accept other formats such as Photoshop non-layered files or those which contain a composite RGB layer (obtained by saving with 'maximum compatibility' set), TIFF files, and JPEGs.

Background

The differences between these two programs lie in their roots; Aperture's heritage is that of iPhoto with similarities to Final Cut Pro. Lightroom came from a group of Adobe people who had grown up with Photoshop and Adobe Camera RAW (ACR) and wanted to break the shackles of Photoshop, but extend the power of ACR to provide an end-to-end workflow for those not needing the bells and whistles of Photoshop.

Apple and Adobe realized the power of metadata and the advantages of speed in using a database structure for organising such information.

Apple had underlying technologies within the operating system they could call upon for the conversion of RAW data, Adobe had the engine of ACR. A major difference therefore was Apple's implementation would be tied to Mac OS X, whereas Adobe's could be cross-platform, this difference may ultimately prove crucial to the outcome for Aperture.

Each program faces interesting futures, but their differences are great enough that they can serve different market sectors and therefore both succeed.

Apple Aperture

Apple launched Aperture in a blaze of publicity, with some very slick presentations, and it certainly caught the eye of many a professional photographer. Apple said it was distinctly targeted at the professional photographer, and described it as a program that was entirely based around RAW image formats, and it offered non-destructive editing. It was providing instead a series of versions, which were simply files that contained the edits alone, and since they were small in size, could manipulate the original file very speedily.

It has some very nice features, and a very professional and clean interface. It also has very close links to its forebear, iPhoto, though it handles larger files and provides more facilities. It embraces the files that are imported to its own cocoon, which may well help keep its own workings inviolate, but sadly this precludes much of what a photographer might want to do in other programs with the same RAW files.

When it was launched it worked only within one disk volume, as did Lightroom, which for its target market, professional photographers, was somewhat limiting. By version 1.5, this limitation had been removed. You were always able to open the package that contained the files, but that was hardly 'discoverable', and the links to the Creative Suite overall was more tenuous than Lightroom's obviously.

I suspect ultimately it will be seen more as iPhoto professional, and will not really gain the market share to which it aspires. It will, however, undoubtedly make other software publishers look at their own offerings in a new light. The Loupe tool has very distinct advantages over Lightroom's, in that it works on the thumbnails as well as the Previews, and its auto-stacking of images based on time intervals between images using a slider, is a boon to sports photographers, and possibly portraitists. Lightroom has a similar but more restricted feature.

The Book feature will appeal to certain corporate clients and to wedding photographers, and I gather is already a hit with the families of professional shooters! The cost involved seems very reasonable and the results I have seen have been excellent.

Features that are really useful

The loupe comes into play when you need to place a white point pipette. The loupe operates both in the main and subsidiary windows. For those wanting more power out of iPhoto, then this should provide the answers – the books Aperture produces use a higher resolution and offer greater scope for individual design.

Less useful

The repair tool is similar to Photoshop's Healing brush, though somewhat more cumbersome.

Although the entire program is not all that large, the RAW format converter is not an integral feature of the application, but is a component of the operating system, which means updating when new cameras are launched could prove problematic, though so far using the Software Update feature in the operating system has worked very smoothly.

Adobe Photoshop Lightroom

I find Lightroom has a far less dense interface than Aperture: it will work swiftly on far less highly-specified equipment, and coming out after Aperture will probably fill the gaps in Aperture's feature list of processes. There is a place for both products, but in different sectors or styles of photography.

What Lightroom does to Adobe Bridge must of course be a major concern when deciding how each interacts for a photographer's workflow. It seems ironic to me that in a way Lightroom is the greater threat to Bridge than Aperture, because somehow Adobe need to differentiate the two for photographers, whilst retaining Bridge's essential role to the other members of the Creative Suite.

Aperture uses core elements of the operating system to handle the various RAW formats. Since it does not seem to support a plug-in architecture, it is difficult to see how it can avoid lagging behind, as new RAW files will require system upgrades rather than program or plug-in upgrades to support their RAW file formats.

A faster adoption of the DNG format could come to the rescue, since Apple has taken this Import option as well as the original RAW formats, effectively letting others such as Bibble and Adobe do all the hard work to convert RAW to DNG. Currently Lightroom offers export to DNG, which Aperture does not, thus adding another plus point to Lightroom.

For those photographers who do not tend to manipulate their images, and thus only use a small proportion of its features, Lightroom or Aperture would seem to be excellent choices. For those needing to work in multiple layers, doing cutouts and montages, then Bridge and Photoshop may suit. Lightroom and Aperture both create contact sheets and web galleries faster than Photoshop does currently, but in this ever-changing digital world, do not expect this always to remain so.

Though this book is about the operating system, discussing Aperture and Lightroom was essential, but Bridge therefore needs some space as well, so that follows from here.

Features

Lightroom's loupe is not quite as flashy or fully-featured as the one in Aperture. It is equally fast, but only operates on the image previews, not thumbnails, as Aperture does so effectively.

The modular layout is formed from Library, Develop, Slideshow, Print, and Web with each taking control over the central area for the work each carries out.

The driving of everything in Lightroom is from a relational database in SQLite using metadata and keywords supplied from you, the photographer, and the EXIF data from the camera itself.

The sorting and searching is all metadata driven, but you must build everything in named folders. It is not reliant on the system's folder hierarchy, but does work with it. Searching and sorting in Lightroom is driven by the metadata held within the Images, or the central database. If you create or import to a folder using Lightroom, it is aware, but if you alter or move externally within Finder, Lightroom is unaware, so if you move a folder to a new location at the Finder level, Lightroom will throw up an error message, when you try to access, as it only remembers where it was last.

The Crop and Rotate functions are novel, you move the image within the crop, so what you see of the image is always as it will be after cropping; the alterations for the crop tool all happen about the center, as opposed to seeing the crop rectangle at an angle, and the image still at its original angle.

From version 1.1 Adobe introduced Catalogues, which means you can work with a laptop on location, create a catalogue there and return and import it into your main one back at base. Or, you could base catalogues on Clients, or time periods.

Adobe Bridge

Digital photographers chase ever larger image files, in greater quantities, due to the improved quality and speed offered by DSLR cameras. Now both Apple and Adobe have introduced similar applications to tackle your initial concerns, from choosing the best shots to show your client, the weeding out of those ones that have not worked, the cataloguing of all you have selected, to then showing them to a client either on the spot as Contact sheets, or if remote from your studio, putting them up as a Web Photo Gallery on your website.

So what happens to Bridge? We all complained about the slow File Browser, an integral part of Photoshop, and even as Bridge, now we are being asked to change again to Aperture or Lightroom. I do see this as a dilemma.

There are users of Photoshop who are not photographers. Surprising though this might seem, we are outnumbered by designers and others, so perhaps it is the photographers who have the dilemma, not Adobe, but certainly I think either Aperture or Lightroom offer more scope for those taking a fair number of similar photos using DSLR cameras, where only one image in a series captures the peak moment.

It may well be that Lightroom takes over from Bridge for photographers who then use Photoshop to refine or manipulate their images, once the client has previewed our work. For those closely involved with designers using the rest of the Creative Suite, you may well opt to stay working with Bridge.

Certainly, it has become established. However, some aspects are poorly understood; one such is the Compact mode, which can impact on the efficiency of your workflow, if you need to use say, an InDesign template to show a series of images to a client.

Compact mode sits above all other windows by default, and can be reduced to just its Title bar when necessary. You can drag TIFF images from the window straight into picture boxes in InDesign, then scale them to fit.

This can speed your workflow considerably, because it is intuitive and very visual, as can be seen by the screenshot shown overleaf, where I drag an image from Bridge into an existing picture box in the InDesign template.

Note

Third-party developers produce many programs that due to their mainstream nature give parity to the main operating systems, rather than take advantage of platform specific features. This may well change in the not too distant future as Apple converts developers to the advantages offered by its Core Technologies.

It makes good sense for them to use Core Animation for their interface behavior, to use Automator, and AppleScript to drive batch routines using Core Image and Core Video. If batch changing RGB to CMYK can be accurately handled by the underlying operating system, why waste your coders' time on that aspect when a link to Apple's toolbox can handle it?

Already, in the last couple of years, the offloading of aspects of what had been CPU tasks to Video cards has been very evident, and these trends will continue for other aspects, and this may well see Apple gaining increased acceptance of its Core Technologies by third-party publishers and camera manufacturers.

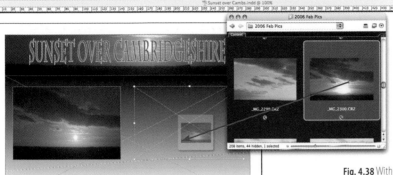

Fig. 4.38 With Bridge in its Compact mode, it remains above other windows – you simply click on the thumbnail in Bridge and without letting go, drag it into the selected picture box, then let go, and resize as necessary.

Adobe Camera RAW

Adobe Camera RAW is very tightly integrated with Bridge and Photoshop, it can be hosted by either, that is, Bridge could be involved with adding metadata to a series of RAW images, whilst you are in Photoshop retouching some other files. Or you could be ranking and sorting images in Bridge whilst Photoshop is opening a series of images.

I am sure this is not well known, however, and as the default is for it to be hosted by Photoshop, most photographers are probably blissfully unaware that you could have Bridge carry out some time-consuming task involving several RAW files, in the background whilst you work away in Photoshop. To host Adobe Camera RAW in Bridge temporarily, you select the files and use **Command+R**.

Note

Bridge and Photoshop working simultaneously, according to which is hosting Adobe Camera RAW, is a good example of programs taking advantage of the Mac's ability to multitask and multithread its processes.

InDesign CS3 Note

If you use InDesign CS3, you can take Bridge's abilities a stage further by selecting multiple images, which can be handled individually by InDesign, pasting into multiple picture boxes – a great boost to productivity! Known as multi-place, this will be especially of value to those who use Wide Format Printers when using templates to fill the sheet with several smaller sized prints.

Fig. 4.39 This is the Preference dialog box for Bridge, and ticking the box shown by the red ellipse changes the double-click behavior from the default, where Photoshop hosts Adobe Camera RAW to Bridge taking control, allowing you to continue working in Photoshop, whilst Bridge carries on in the background.

Initial capture

Almost all the manufacturers of Medium Format Cameras provide software for their own backs. This makes very good sense, because they are catering for a smaller number of end users, and it would simply be uneconomic for third parties to reverse engineer the way the image data was stored to come up with products of their own.The exception is Phase One, with its Capture One software, which is used over a variety of manufacturers' cameras: Hasselblad, Contax, and Mamiya.

Mac-using photographers have been well-served with all the manufacturers supporting Mac OS X, and eventually supporting the Intel Macs.

Hasselblad's Flexcolor software also features the ability to save its files to DNG which offers to retain its raw information and ensure access with other software capable of reading DNG. This gives you the chance to take these files into Aperture. What would be really useful would be if Canon and Nikon adopted the DNG option from their range of cameras.

IPTC info

To maximize the benefits of digital photography, it is essential to make the most of the various ways information can be linked to your images. From the first click of the shutter, there is the EXIF data which contains all the information that the camera can glean from its own settings, such as Exposure, Color Balance, Shutter Speed, Aperture, whether Flash has fired, and if linked to a GPS system, the precise location and time of day. There is also far more specific information, such as the photographer and copyright details, and Client, Subject, Project information.

Some of this more specific data can be entered into the camera, and in the case of certain Lexar cards, can be placed in a private area of a Compact Flash card, and added to all images on import. This feature obviously requires prior knowledge.

Aperture, Bridge, Lightroom, iView Media Pro, Fotostation and others, can all handle IPTC data, which means that the work you do can travel to Agencies and Libraries and be happily integrated into their database systems.

Note

Photographers who shoot for Stock Libraries are aware of providing metadata to aid in the searching of their images by picture researchers, but other photographers fail to understand that if they are equally diligent, they can also gain added promotion from the likes of Adobe.

Adobe have arranged with professional photographic bodies to give access for their members to The Photographers' Directory. This is accessible not only from the Web, but also from Bridge in the Creative Suite. Once images are on the Web, any metadata they contain can be searched; without the metadata, only the filenames will be found.

Although you can at a simplistic level put metadata into files using the Info palette, this is not a practical method for large quantities of images, it is far better done either in a Digital Asset Management program (DAM), or Bridge/Photoshop/Lightroom. That is not to denigrate metadata stored in the Info for a file, as it certainly helps Spotlight to find the files.

Adobe has since 1994, added metadata to the headers of Photoshop images – this was a subset of IPTC IIM* announced some three years earlier. This is like a blank form that you can fill in which then describes the photograph in a more standardised way, so that others can more immediately learn about and search for specific images without necessarily opening the picture itself.

IPTC Core information is stored in panels within File Info accessible using Photoshop: this XMP information can be stored within JPEG, TIFF, PSD and PDF files, making it available in web browsers, page layout and image processing programs on both Windows and Mac platforms.

It is going to be increasingly important to add this information to your images as the haystacks which hold your picture needles grow ever faster with the growth of the Internet. Clients and Agencies seeking images are going to start all their searches using text for speed, and only looking at the images once they have shortlisted likely candidates – if you have not entered details about your masterpieces, they will simply not be seen. If you do not enter your contact details, but they do catch sight of your pictures, then you may simply not receive a call for permission to use the image. Here there are two possible outcomes, your image is ignored, or worse still the image or images are used, but neither paid for, nor attributed.

Keywording your images to effectively communicate the content of your images, and more importantly ensure they are found by those doing the searching, requires skill. You can find help from various sources, such as the Stock Artists Alliance or David Riecks' Controlled Vocabulary website.

A point worth bearing in mind is that you should build yourself a base template for your contact and copyright details, so these can be applied to a batch of images. If you also create standard sets of keywords that typify your most common work, then you will be able to append such details more readily. Undoubtedly this work can be tedious and time consuming, so a little thought ahead of time will make your life a little easier, as well as save you much time later when searching for an elusive image you know you have taken. Take advantage of the opportunity to create Presets for such information, so these can be more readily accessed.

Fig. 4.40 IPTC Info palette in Photoshop. The reveal triangles to the right of the boxes hold previous entries for later use.

IPTC

International Press Telecommunications Council have been laying down standards within the Press industries, this started originally with text information and later image descriptions. Adobe have adopted and extended these standards that help describe the contents of photographic images, and this has been put into a new format called XMP (Extensible Metadata Platform).

* Information Interchange Model

Resources

The digital photographic community is well-served by Internet Subscription Lists such as ProDIG, Pro-Imaging, the AoP List and ProRental, and through other organizations such as the Institute of Medical Illustrators, the British Institute of Professional Photographers, Royal Photographic Society, the Master Photographers Association, the Society of Wedding and Portrait Photographers, and the National Union of Journalists.

And these are only the UK groups! Some are extremely partisan, catering mainly for their own members, but all told, they provide an extremely wide spread of services and information for the practitioners of what we like to consider a profession. They all maintain a presence on the Internet, and many produce magazines. They are a massive repository of knowledge and services, for those connected with photography.

Unconnected with these august bodies are several established and well-respected people who have created dynamic websites covering every aspect of photography. Photoshop News is just one example.

Magazines and periodicals

Magazines, both photographic and computer titles, also contribute to our well-being, as do the software publishers and camera manufacturers.

To make sense of this array of information, try to isolate partisan content in each case, and look at the overall picture; that way you get a measure of balanced opinion and sound technical help.

MacUser, MacWorld and *MacFormat* are general Mac computer magazines, but all have become a good source of digital photographic equipment reviews, but I would suggest that final conclusions are taken only once you have read the articles, since you may find the testing bears little resemblance to real world use of such cameras.

The *British Journal of Photography* in the UK, covers some of the issues and techniques that relate to operating systems involved in digital capture, but rarely to any depth. It concentrates on the images, cameras, lenses and application software in the main.

Personalities

A look at the Web will soon bring a number of names to the forefront, several of whom are authors of paper-based books, some will have well-known websites, and some well-respected photographers and technicians who express their opinions through what are now termed e-zines, or blogs. One especially useful blog is hosted by John Nack, Product Manager of Adobe Photoshop!

Photoshop News is a web-based magazine, the group of photographers behind it are mainly Mac-based, so you will find a distinct Mac slant to what appears, so if a flaw is found in a Mac OS X upgrade or in Photoshop, you'll hear about it there.

Names that immediately spring to mind are Michael Reichmann and Luminous Landscape, Jeff Schewe, the late Bruce Fraser, Deke McLelland, Dan Margulis, Martin Evening, Andrew Rodney, Greg Gorman, Seth Resnick and Katrin Eismann. The list goes on – the point I make is, these people all offer an enormous amount of their wisdom freely, as well as through commercial activities.

I would hope that the future generations who currently benefit from this generosity, give as much.

Fig. 5.1 Just one of the many successful and informative magazines that keep users abreast of the latest equipment, technologies and programs available to Mac using photographers.

Subscription Lists

I shall examine the ways in which you can join these communities and participate in two way conversation with your peers and mentors. I have started this chapter in general photographic terms, but I will be devoting much of the rest with Mac-specific photographic help. It is impossible to be entirely platform specific, but at least in the field of digital photography, the Mac OS is not in the minority position it finds itself elsewhere.

ProDIG, which is an International List that is is very much UK-centric, came about due to a group of photographers who were all members of the Association of Photographers, that were all adopting or about to adopt digital capture in place of film. They needed help amongst themselves and from outside sources and gathered informally in some of their studios.

The founding members included Martin Evening, Dougie Fisher, Mike Laye, Adam Woolfitt, Ed Horwich, and Bob Marchant. In 1996 they put on an exhibition called Digitalis, so named because opthalmologists used this to open patients' eyes, as well as it containing the word Digital.

Martin and Ed later produced the ProDIG List which continues to this day. You subscribe (free) with few restrictions, the most important being that you introduce yourself, giving your interests, and what you can contribute, as well as areas for which you seek guidance. It has proved its worth in providing manufacturers and software publishers with valuable insights to digital photographers' needs, and is watched by the likes of Epson, Nikon, Kodak and Adobe. There is also an impressive website that has links to the archives and up to date information from manufacturers, publishers and photographers themselves.

The ideal way to subscribe is start from the website. Take the opportunity to read through the archives to gauge how a List works, and also read the guidelines from the start. Volunteers take it in turns to oversee the content, but it is not moderated as such, these 'List Mums' are present to offer help and guidance, and if you are unsure about posting, they are happy to discuss what is considered acceptable, and may relax the rules if it is felt to be beneficial to the List's subscribers. See over the page for screenshots of the ProDIG.org site and the route to the List. You can also reach ProDIG via the AoP site.

Fig. 5.2 *Lightroom News*, online magazine, sister of *Photoshop News* from Jeff Schewe and Martin Evening.

Fig. 5.3 A typical article in ProDIG which can open a dialog with the author, and debate amongst the readers, often this brings photographers closer to each other, and allows them to voice common concerns.

Subscription Lists – ProDIG

The ProDIG website can be found at **http://www.prodig.org**

Fig. 5.4 Click here to reach the login and subscribe to the email List.

ProDIG is open to all those for whom digital imaging forms their main source of income. Subscribing is free and merely a matter of supplying your name and email address. Do remember the address you subscribed from, should you need to unsubscribe temporarily or wish to change from receiving each message as they come in, to using the Digest which aggregates the messages each day, you will need to use that same address.

Email Lists are a good way to keep in touch with what is happening, and learning about updates. An offshoot of this list is Pro-Imaging – a list with much tighter entry qualifications, but a broader set of permitted topics – you must earn the major part of your income from professional photography.

Pro-Imaging and ProRental Lists

The Pro-Imaging List with its tighter restrictions with regards who can subscribe, gains many of its members by invitation and the List Owners decide whether to accept you. They do have looser rules on what topics are considered valid postings, but provided you are accepted, this is yet another rich source of information. You may well find some of the same contributors to both this list and to ProDIG.

Other popular Lists are the AoP List (Association of Photographers – who spawned the Digital Imaging Group) and ProRental, which I believe is by invitation. ProRental is another high-end photographic subscription list with fairly strict entry qualifications. This provides help to those photographers using view cameras and digital camera backs. It is sponsored by an American commercial company, unlike the others I have mentioned. All of them cater for differing aspects of professional photography, and each has a following, and style, thereby offering a wide choice.

Various photographic organizations in America and Britain also have email Lists and often archives or FAQs (Frequently Asked Questions), most are restricted to their own members.

What can be said of all these lists, is they are the best way to keep abreast of the technologies and trends in digital photography.

Fig. 5.5 These screengrab images from the respective websites illustrate the subscription procedures for the email Lists that are offered by Pro-Imaging and ProRental.

Keeping abreast

Photography and in particular digital photography has changed dramatically since the 1980s – Sony announced the Mavica in 1981, which basically captured single frames from a video camera and called itself an electronic camera. It took until ten years after the Super Bowl announcement of the Macintosh, for Apple to bring out an equally dismal QuickTake 100 digital camera. As a photographer and salesman involved in the image side of advertising, I was completely underwhelmed with what I saw on both occasions, but I bought a Mac II in 1987, later upgrading it to the Mac IIfx, because I saw the potential.

I was no sage – I was hoping I could be involved with some of what I saw, and still saw film – transparencies particularly – as holding so much more information than any digital electronic media. I well remember someone amusingly ask an electronics-aware photographic audience would they be interested in a product that was less than one inch thick and was five and a half inches by five in overall size, that could store terabytes of information? The audience all agreed YES! He then held up a box of 5x4 Ektachrome!

Yes, I was still interested in electronics producing high quality images, but I soon found that the pace of change was accelerating, and that much as I wanted to be at the forefront, the bleeding edge was always just out of my reach: I was having to keep on learning, and what was true yesterday, was in doubt today. Getting hold of the latest piece of kit with the newest gizmo and understanding how it worked was getting harder: if it broke, no one knew how to fix it, the business model was no longer static, companies sprung up, and just as quickly died. But I hung on. I kept asking questions of others more knowledgable than myself, until they could no longer answer and passed me to someone who could, then I passed on what I knew to others beyond me.

I soon learnt that books were out of date by the time they were out, and that magazines were my source, then along came the Internet, and even the magazines were dated. So how is it I am writing a book? Well, I am trying to provide links and a series of pointers as to how you can keep abreast of what is still a young operating system.

Young and intuitive

Mac OS X is still evolving: it has always approached its tasks graphically, so follow your instincts, watch how a Mac does one thing, and if you find yourself wondering how do you tackle a similar task, try following a similar course of actions – Wow! – it just worked.

You'll generally find that if you want to do something a particular way, it'll most likely allow you. The Mac is malleable and pliant – try adding a modifier key to what you do in one way, and maybe find another.

Apple Inc

Apple has always tended to be secretive, which has been both a blessing and a curse, sometimes both at the same time! It is very hard to second guess what is going to happen next or which direction are they heading. They keep a well-ordered website, both UK- and US-based, and they have a very large Knowledge Base, covering hardware and software that is updated regularly. However, I find that they remain fairly passive over the supply of this information, so the gems it stores might go unremarked. Here is where the Internet and sites that employ robots to scan for site additions come in really handy. So the way to find out what Apple might be adding is to keep in touch with sites that make a point of watching them. I would recommend that you take note of announcements emanating from Apple that appear on sites like Macintouch, run by Ric Ford, or MacFixit and Version Tracker who obviously trawl Apple's pages, and headline them with the relevant URLs (links).

If you want to get an idea of what may or may not be in Apple's mind, then there are numerous Rumour sites, with varying degrees of success in reporting unannounced Apple products. Ones that spring to mind are appleInsider.com, macrumors.com, macosrumors.com, and thinksecret.com, but do not believe all that you read – I think they are used as much for disinformation as anything else!

Apple Software Update

You can use the Apple menu in your Title bar to go to Apple Software Update, and in its preferences schedule these to suit. I would advise that you take the opportunity to go first to the Update menu, and select 'Install and Keep Package' – this will ensure you retain a copy of every item you are installing in case you need to reinstall for any reason later. Or, possibly more importantly, if you learn that a specific update is flawed, you could go back to an earlier version.

What is a shame is that what you set is not 'sticky' in that you must do this before you download each time, the default is simply to download and prepare for installation.

Fig. 5.6 An Apple website headline.

Fig. 5.7 I recommend that you always choose this option.

Bad news travels faster than good news

Let's change that. When you find a good supplier, a good blog, an informative website, put this news about. If we all do that through our own podcasts, blogs or emails to a subscriber list, the digital photographic community will benefit as a whole. In this way we can use the power of the Internet to serve its original intentions.

Fig. 5.8 Mail in Leopard now features an RSS Reader.

Fig. 5.9 A photographic feed from NetNewsWire Lite.

Fig. 5.10 Adobe Lightroom Podcast in Apple iTunes.

Really Simple Syndication – RSS

Websites often publish their headlines, coupled with a short excerpt, in a manner that can easily be read, this is known as RSS. A simple and free RSS Reader is **NetNewswire**, and you can request updates from specific sites of interest at regular intervals, keeping abreast of developments with minimal fuss. If you want to tailor when you receive alerts to new items, or how often you search, or the types of news you seek, whether it be topical world news, local happenings in your community, or specific technology or digital imaging trends, then you might prefer to pay for one of several commercial RSS Readers, sometimes also known as Aggregators. Leopard's Mail includes an RSS Reader.

What happens is that you define a category and possibly a particular source and the aggregator notes when the information has been updated and notifies you according to your schedule. Sometimes the information is commercially sensitive and the subscription has a charge, but for the most part it is free. Many of the Mac-oriented sites have RSS feeds from their website.

Podcasts

A recent innovation in web communication has the potential to bring in spoken help from some sites producing Mac-related podcasts, short radio broadcasts, but so far those I have heard seem of poor quality and too chatty. Apple have also simplified receiving these broadcasts, by adding the ability to subscribe to them through iTunes, bundled with Mac OS X. Names that spring to mind are Photo Talk Radio, which displays a gallery of images on the website then discusses them as the podcast. Podcasts are not limited to sound alone, Photoshop TV conducts interviews which are televised and form part of the podcast file that is streamed over the Internet. For these to be of an acceptable quality you do need a Broadband connection.

Like email lists, you subscribe to these podcasts, and whilst many are free, I am sure that for the level of quality to be sustainable, the better ones will require payment, and Apple has paved the way by providing video clips from record companies and TV shows to be sold at economic, but fixed prices. The way we have worked in the past, and the old business models have changed radically and seem set to keep changing for a while yet, and not necessarily in good ways for the photographer.

Phototalk Radio and Photoshop TV

Fig. 5.11 This site offering podcasts, features the galleries of images on the site, and then discusses them in the streamed audio of the podcast.

Fig. 5.12 This site goes the full distance by offering full streaming video.

Adobe Staffers Blogs

Several Adobe staff have blogs, where they post news about Adobe software, events and technologies, and much of this is photography related. Two names stand out, John Nack and Dr Russell Preston Brown. They are both interesting and fun, and Russell is often somewhat 'off the wall'.

Fig. 5.13 John Nack's Blog. John is the Senior Product Manager for Photoshop in the US, and is extremely active on the Web, and being a keen photographer himself can be the source for a wealth of interesting information, not immediately pertaining to Adobe.

Fig. 5.14 Anyone who has met Russel Brown is never likely to forget him, and his is a website rather than a blog. He is certainly a great evangelist for Adobe.

Camera manufacturers

The major camera manufacturers all have a presence on the Web, and split their software into Mac and Windows categories, and offer upgrades on pages that are generally designated as either Support or Downloads.

Several of the top names may also supply firmware updates that are applied to the cameras themselves, either to address flaws or to add extra functionality. Sometimes these firmware updates are created only for uploading to your cameras via a PC or at their workshops. Fortunately this is becoming rarer, as the process is often carried out from a Compact Flash card (or similar) to which you transfer the software you obtained from the website.

Normally you look in a menu on the camera for the current version of the onboard firmware, the upgrade checks this itself and proceeds. You are advised to ensure your battery is fully charged, and for safety's sake connect to a charger if one is available for your make of camera, as updating firmware should not be interrupted. If the loader detects that you do not need the update it will report this to you.

Visit the major Mac exhibitions and roadshows

Apple, Adobe, and some of the larger dealerships often have exhibitions and roadshows, and I highly recommend that photographers take advantage of these – entry is very often free, and many will also provide seminars from leading exponents of digital photography and color management. Major trade shows are a good way to see, and more importantly handle, the latest equipment.

Shows that spring to mind are **Mac Expo**, **Focus on Imaging**, **Adobe Live**, and shows put on in the UK by **Rapid Group**, **Calumet**, **Hasselblad** and **Nikon**. Due to the changing nature of the way we buy our equipment, using the Internet and 'Box Shifters', exhibitions have become one of the few places that you can actually have something in your hand to play with, and evaluate. More importantly, they are also the place to speak to experts about what is on show. Then there are the User Groups.

Fig. 5.15 Three prominent Mac User Group websites: BMUG is possibly the oldest US User Groups for Mac afficianados. In the UK is the London Mac User Group, and Mac Users UK site.

Mac User Groups

You can locate such groups via the Internet or the classified columns of Mac magazines. User Groups can be another way to get hands-on experience of some of the software and hardware, because if the group has a large membership and is proactive, manufacturers, software publishers, and retailers will often be willing to attend well-publicised meetings. MacUser in the UK has been giving space to MacUser Groups, which has proved to be very effective in boosting their membership, and raising the profiles of those that have been featured. This naturally has led to greater interest from the Trade. So go out and support your local User Group, and you will have found yet another resource.

Apple Solutions Experts (ASE)

Apple has certified ASEs in a wide range of differing disciplines and promotes these individuals or companies via their website and in the Mac magazines. These people have good access to Apple technicians and support beyond what you could glean at User level, and you should consider this as another port of call.

Apple has its own chain of retail stores and you can make appointments with their Genius Bar staff to discuss specific issues which you need to discuss, and this service is free, but do remember these appointments must be pre-arranged with the Concierge. At certain shows some of the Mac magazines offer their staff for similar consultations, and once again these are all appointment based.

I hope you can see from this chapter that there is an enormous amount of technical knowledge freely available to Mac-using digital photographers, but there are also consultants out there who for reasonable fees can help you take things further – I offer my services in this manner to photographers and designers in conjunction with putting on talks with sponsorship from companies such as Apple, Adobe and Calumet. My training has taken me as far as Italy and France in Europe, and in the UK, as far north as Aberdeen in Scotland. Since the advent of Skype, I can do some of this work remotely using Voice over IP, where my charge is not inflated by the addition of telephone charges, provided you have Broadband.

Apple Solutions Experts – ASE

By way of example of individuals in the UK with specialist ASE qualifications, **Alasdair Mellis** of **Foreword** and **Digiturial** is very knowledgable on Networking and helped me to better understand that aspect of Mac OS X.

Color management is covered by **Neil Barstow** who can also be found contributing to the **ProDIG** List.

Fig. 5.16 The Apple scheme that advertises Consultants whose skills have been approved by Apple Inc, and receive the benefits of promotion nationally by Apple.

Links to relevant resources

Rather than rely entirely on you having to reread the chapter, I thought it would be worthwhile to make a list of the various resources with their Web sites. In most cases this should make it possible to find physical locations and telephone numbers.

I am writing from Britain, so my knowledge is necessarily UK-centric, and probably readers may well be more familiar with my name on this side of the pond, so please excuse my bias.

Note

Any list of web addresses can go out of date, but every effort has been made to ensure the accuracy of the URLs presented. I have omitted the 'http://' which is rarely needed by web browsers today, as this is assumed. However, precede an address with this , if in any doubt.

Name	Website

Software publishers

Adobe Systems	www.adobe.co.uk
Adobe/Macromedia	labs.adobe.com/technologies
Alsoft	www.alsoft.com
Jon Nathan Software (AppleScripts)	www.jonn8.com
Extensis	www.extensis.com/en
FileMaker	www.filemaker.co.uk
Microsoft	www.microsoft.com/mac
OpenRaw Discussion Group	www.openraw.org/www.rawformat.com
Panorama Tools	panotools.sourceforge.net
PixelGenius	www.pixelgenius.com
Quark	www.euro.quark.com/en
Realviz	stitcher.realviz.com
Prosoft	www.prosofteng.com
RetouchPro	www.retouchpro.com
Roxio	www.roxio.com
Salling	www.salling.com
Starcoder	www.starcoder.com/xrg
Vuescan	www.hamrick.com
Focal Press	www.focalpress.com

Photographers

Adam Woolfitt	www.adampix.com
Bob Marchant	www.bobmarchant.com
Ian Lyons	www.computer-darkroom.com
Jeff Schewe	www.schewephoto.com
Martin Evening	www.martinevening.com
Michael Reichmann	www.luminous-landscape.com
Phil Askey	dpreview.com
Pro-Imaging	www.pro-imaging.com
Richard Kenward	www.rkdi.co.uk
Seth Resnick	www.sethresnick.com

Name	Website

Resellers

Albion Computers	www.albion.co.uk
Amazon	www.amazon.co.uk
Apple Computer UK	www.store.apple.com/Apple/WebObjects/ukstore
Calumet	www.calumetphoto.co.uk
Cancom	www.cancomuk.com
Color Confidence	www.colorconfidence.com
Color Therapy	www.color-therapy.co.uk
Computer Warehouse	www.computerwarehouse.co.uk
Computers Unlimited	www.unlimited.com
Crucial Memory	www.crucial.com/uk
Dabs.com	www.dabs.com
EPI Center	www.epi-center.com
Fixation	www.fixationuk.com
GBM Digital Technologies Ltd	www.gbmdt.co.uk
GHC	www..ghc.co.uk
Jessops	www.jessops.co.uk
Jigsaw Systems	www.jigsaw24.com
John Lewis	www.johnlewis.com
Johnson-Photopia	www.johnsons-photopia.co.uk
Lastra Imaging (UK) Ltd	www.lastraimaging.co.uk
Media Training Ltd	www.mediatraining.ltd.uk
Micro Anvika	www.microanvika.com
MR Systems	www.mrsystems.co.uk
ProCenter	www.procenter.co.uk
ProRental	lists.prorental.com/mailman/listinfo/prorental
Rapid Group	www.rapidgroup.net
Robert White	www.robertwhite.co.uk
Scotsys	www.scotsys.co.uk
Square Group	www.squaregroup.co.uk
The Solutions Company	www.gotsc.com
TRAMS	www.trams.co.uk

Mac support

Alasdair Mellis	www.digitorial.co.uk
Amsys	www.amsys.co.uk
Inside Lightroom	www.method.co.uk
Keith Cooper	www.northlight-images.co.uk
Malcolm Bryan	www.3rdwavecreative.com
Solutions Photographic	www.solphoto.co.uk

Organizations

Association of Photographers	www.the-aop.org
British Institute of Professional Photographers	www.bipp.co.uk
EPUK	www.epuk.org

Name	Website
Institute of Medical Illustrators	www.imi.org.uk
Master Photographers Association	www.thempa.com
National Union of Journalists	www.nuj.org.uk
ProDIG	www.prodig.org
The Royal Photographic Society	www.rps.org
Society of Wedding and Portrait Photographers	www.swpp.co.uk

Hardware & software

Apple Inc	www.apple.com
Barco	www.barco.com
Belkin	www.belkin.com
Betterlight	www.betterlight.com
Bowens	www.bowensinternational.com
Broncolor	www.sinarbron.com
Bronica	www.tamron.com/bronica/default.asp
Canon	www.canon.co.uk
Carl Zeiss	www.zeiss.com
Contax	www.contaxcameras.co.uk
Creo	www.creo.co.uk
Data Robotics	www.datarobotics.com or www.drobo.com
Eizo	www.eizo.com
Elinchrom	www.elinchrom.com
Epson UK	www.epson.co.uk
Fixer Labs	www.fixerlabs.com
Formac	www.formac.co.uk
Fotoware	www.fotoware.com
Fuji	www.fujifilm.co.uk
Gretag Macbeth	www.gretagmacbeth.com
Hasselblad/Imacon	www.hasselblad.co.uk
Hewlett-Packard	www.hp.com
Hitachi	www.hitachigst.com
Iiyama	www.iiyama.co.uk
Iomega Corporation	www.iomega.com
Jenoptik (UK) Ltd	www.jenoptik.com
Kingston Technology	www.kingston.com
Kodak	graphics.kodak.com/global/product
Kodak – Leaf	http://tinyurl.com/lnrt3
La Cie	www.lacie.com/uk
Leaf	www.leafamerica.com
Leica	www.leica-camera.com
Lexar	www.lexar.com
Logitech International	www.logitech.com
Mamiya	www.mamiya.co.uk
Maxtor	www.maxtor.com
Metz	www.metz.de/en/photo_electronics
Micromat	www.micromat.com

Name	Website
Microtek	www.microtek.com
Netgear	www.netgear.com
Nikon	www.nikon.co.uk
Olympus	www.olympus.co.uk
On One Software	www.ononesoftware.com
Phase One	www.phaseone.com
Rollei	www.rollei.de
Sandisk	www.sandisk.com
Seitz Phototechnik	www.roundshot.ch
Sigma	www.sigma-imaging-uk.com
Sinar	www.sinarcameras.com
Sony	www.sony.com
Tamron	www.tamron.com
Wacom	www.wacom.co.uk
Wiebetech	www.wiebetech.com

Color management

Bruce Fraser	www.creativepro.com/author/home/40.html
Neil Barstow	www.colormanagement.net
Thomas Holm	www.pixl.dk
Bodoni Systems	www.bodoni.co.uk

Mac news

Daring Fireball	daringfireball.net
MacFixit	www.macfixit.com
MacIntouch	www.macintouch.com
MacOSX Hints	www.macosxhints.com
MacUpdate	www.macupdate.com
MacUser	macuser.pcpro.co.uk
MacWorld	www.macworld.co.uk
Photoshop News	www.photoshopnews.com
Photoshop TV	www.photoshoptv.com
Photo Talk Radio	www.phototalkradio.com
TidBits	www.tidbits.com
The Unofficial Apple Weblog (TUAW)	www.tuaw.com
Version Tracker	www.versiontracker.com

Photography news

DC Views	www.dcviews.com/photo
DP Review	www.dpreview.com
George Jardine	www.mulita.com/blog/
John Nack	blogs.adobe.com/jnack
Rob Galbraith	www.robgalbraith.com
Russell Brown	www.russellbrown.com
Thom Hogan	www.bythom.com

Resources – what and why?

A list by itself is of little use without some sort of explanation. What I have attempted to do is put down the web addresses of organizations that provide advice, guidance, technical assistance and expertise that will be of benefit to photographers, retouchers, and designers, in the course of using digital photography, and the manipulation, calibration, conversion, enhancement and storage of images. He takes a deep breath!

There are professional bodies, distributors, publishers of software, generous gurus. You could do worse than spot a name you have never seen before, note the name and visit the site. I have tended to limit the list to those sites that use English as their language, but keen observers will note that by either adding '/en/' many naturally 'foreign' sites take you to their English version, other alternatives use '/uk/' or append '-uk' before the originating country. This strategy also applies to other reasonably common languages. Seek out the standard abbreviations for the countries concerned such as: 'fr' – France 'ch' – Switzerland, 'de' – Germany, 'nl' – the Netherlands and so on.

Another means in common usage is flags, so on a foreign page, look for the Union flag or Stars and Stripes for an English version.

There are sites in the list for individual software programs, for lists of useful links or small utilities that unlock hidden potential in the operating system. Groups of like-minded individuals, special interest websites for the Mac OS as a whole or Mac OS X in particular, and photographic oriented sites, Photoshop sites, digital camera sites – it is by no means exhaustive, but almost all of them have proved useful to me at some time, I have checked them all out as I compiled the list, all were active at that time.

Search engines are another way to find the information you might need, and here is where Mac OS X has been particularly helpful in providing Google within Safari. A small and useful addition to Safari is 'Inquisitor' from David Watanabe. You can find this at: **http://www.inquisitorx.com/safari/**.

When you are in Safari, take a look at Wikipedia.org for a wide range of technical definitions – if I needed confirmation of some details for this book or more accurate explanations, I went there, another useful site was **http://thesaurus.reference.com**.

Fig. 5.17 Leopard Mail brings RSS feeds into your email, with limited global scheduling. NetNewsWire, even in its free Lite version offers a bit more scope. Either is a good introduction to this means of information gathering.

Don't just take...

If you find any free sites useful, then try to understand their motivation, and the benefit you are receiving.

Either actively promote the site at worst, or make a small donation, so that your benefactors can continue their work to the advantage of all.

Many are students and a few dollars, euros or pounds can make all the difference – it could provide a can of Jolt, a jar of coffee, or a few extra megabytes of RAM, you could also offer an improved translation for their interface – anything to keep them from starving; we all need them.

Recommended sites

My home page when viewing the web in Safari, is **Macintouch** by Ric Ford; the reason is that it is very active, provides a wealth of information in a demonstrably simple and digestible format that has improved with time. It is updated almost every day of the year, and provides much more than just information about Macs. He has some very well-informed contributors who supply interesting Show Reports and Reviews, and his links allow a visitor to keep a finger on the pulse of the wider Mac community. He and his team do need donations to remain viable, and US visitors can do this painlessly whenever they need to visit Amazon, by making their connection from his website.

Another site that I visit regularly is **Photoshop News**, which carries information from the Camera Manufacturers and Software Publishers, and notifies its audience of System upgrades, patches, and courses and seminars of interest. Contributions from Photoshop engineers will often appear here first – items from Dr Russell Preston Brown, Thomas Knoll, Marc Pawliger, Scott Byer, Russell Williams, and John Nack will get mentioned here.

If you want news about ways to improve the Mac Operating System, then sites such as Mac OS X Hints, MacUpdate and VersionTracker spring to mind. With the increasing use of RSS (Real Simple Syndication) you can actually set up a program like the free NetNewsWire Lite, so site changes are brought to your notice without you having to trawl around unnecessarily, only to find that nothing new is on a particular site.

There is a plethora of information out there; the problem is finding accurate and reliable information. To succeed you need to find those sources you can trust, and to do this effectively, communicate with other photographers, and this is why I suggest you subscribe to Lists. In this way you can hear from them, as well as let others know what you have found. ProDIG and Pro-Imaging are two such self-help digital photographic lists, but there are others such as ColorSync and Epson lists.

There are User Groups and SIGs (Special Interest Groups), all can be found via Google and other search engines, so before posting questions, always try some of your own searching, especially in the archives of these Lists, this can save everyone a lot of wasted time repeating answers, and so clogging the information arteries.

Note

A new page devoted to Digital Photography has come on the scene recently as sister to *Photoshop News* and it is *Lightroom News*, run by members of PixelGenius, who supply the useful and popular PhotoKit Color.

Yahoo Lists

Specialist Interest Lists are well catered for by Yahoo, where you can easily set one up for your own particular interest.

Fig. 5.18 Going to yahoo.com or .uk allows you to put in a search for your particular interest, and if a group does not exist, you can set one up for yourself.

Color Management

Color management is a subject that seems to fill digital photographers with fear and dread. True, it can become a deep and mystical science, and certainly, it is more than capable of filling entire books on the subject, so I will state right at the beginning I shall not be taking it that far. I can hear the sighs of relief already!

I will leave the deeply technical and time-consuming to the experienced practitioners. But I shall outline the principles and hopefully, put you in a more receptive mood to take the further steps to enlightenment, from the experts. Also, I shall give you the names and details of those who I believe can help you. The very first name is not of a person, however – it is ColorSync. This is the name at the heart of all Mac computers, that handles color for you; it understands the numbers in your image files.

It is all about expectations - you take a picture, you expect to capture exactly what you saw, you expect to be able to retain your vision on screen and in print; to achieve that Nirvana, you have color management.

Color management

What is meant by the term 'color management'?

We need to understand how color is created by a camera, computer, scanner, monitor and printer, and how the color on one is seen and understood by any of the others. Color management is the process that correlates these so that we are talking about the same color or a close approximation of that color in all cases where they should be the same. On a Mac this control is handled by ColorSync.

How do we humans 'see' color? Our eye consists of rods and cones that are sensitive to color at different wavelengths of light in what is known as the electro magnetic spectrum. I am not going to go deeper than this, but hope that it is far enough back to make sense from here on. Frequency and wavelength of light are inversely proportional, that is, a longer wavelength of light is equal to a lower frequency, and a higher frequency is equal to a shorter wavelength. The highest frequency light we see is violet; the lowest is red. light beyond these extremes are known as ultraviolet and infrared, from the Latin for beyond and beneath, with X-rays and microwaves just outside what we see.

Neither film nor the various types of sensors used in cameras and scanners see exactly what we see, and this can bring both benefits and limitations to us as photographers. I will come to those later, so first, why do we see an object as red?

To answer this I have to go back to explain that white light is a combination of all the colors we see in the spectrum (the rainbow). All colors we see are those wavelengths of light that are not absorbed by an object, but reflected from it. This comes about because the object absorbs most of the other colors from the white light, so what we see is only the remainder.

Note

Color management is all about trying to achieve accurate color rendition of our photographed scene in the first place, then retaining this through all the subsequent processes that we put this information. It also extends into non photographic areas where color is generated, and needs to maintain consistent accuracy despite the different characteristics of the equipment and media involved.

Fig. 6.1 This shows the proportion of the whole spectrum that relates to what the eye can see, and to which film and digital chips are sensitive.

How does a digital chip see color?

The true answer should be – it doesn't. At least not without some help. With the exception of the Foveon® design, the sensors see color by being placed behind an array of filters, so that they can provide three signals eventually that correspond to Red, Green and Blue. I say 'eventually' because the filters are arranged to give an array in what is termed a Bayer pattern where there are two greens to one each of red and blue. This cell is what has become known by the shortened version of 'picture cell' – the pixel. One of the reasons for this arrangement is because the eye is most sensitive to green. To arrive at one pixel, which for the most part can be considered square, involves making calculations for the colors of the pixels regardless of the filter. The strategy involved in arriving at the color of each pixel is known as an 'algorithm', where the values of several cells beyond the one under consideration are used in the calculations. Considerable research has gone into these algorithms, and the quality of these has improved dramatically since the first digital sensors arrived.

When an image in a digital camera is focused on its sensor, this is captured, analysed and saved to fast internal memory, and then written to some form of removable storage device; in most professional cases to either Compact Flash card, or SD card. In the case of camera backs as opposed to Digital Single Lens Reflex cameras, the signal can be passed direct to a computer. In this mode, the back and computer are said to be in 'tethered mode'. There are three common methods for this connection: USB 2.0, Firewire and optical fibre.

Most professional cameras are able to store the capture information in an almost untouched format known as RAW, however there is currently no standard for the way in which this information is stored. Although Adobe is trying hard to persuade the camera manufacturers to adopt an open standard format known as DNG, representing Digital Negative.

From this RAW file it may be immediately compressed to a JPEG and stored in that form, and no longer available in the original manner, or it may remain in the native RAW form; either way, it is now in an RGB form. Generally professional and semi-professional cameras allow the user a choice between sRGB and Adobe RGB, with sRGB likely being the default color space.

Fig. 6.2 The Bayer mosaic of filters over the image sensors. From this arrangement you can see that each individual element is missing some of the detail, and in any group of four, the sensors beneath green receives 50% of the information with red and blue receiving 25% each. This is the reason for the necessity to sharpen an image at capture.

Note

What we first saw in the viewfinder or camera back, we now wish to see replicated on screen, in an inkjet print, as the cover of a glossy magazine or inside as a double-page spread. To achieve this we need to manage our color.

The most probable next stage will be importation and storage on a computer. Photoshop, Aperture, Lightroom or iPhoto are the programs then most likely to use this information to show you a picture on screen, for this we will need ColorSync.

ColorSync

ColorSync is the generic name that defines the process that involves two components, the Color Management Module (CMM) and the Profile Connection Space (PCS).

The concept of the PCS is that Input profiles, Display profiles and Output Device profiles can be interchanged within this environment, yet each can be created independently. So the Profile Connection Space is the output destination for Input profiles and the input source for Output profiles.

The Color Management Module is the controlling force, and the ICC made provision for the CMM to be open to interpretation within the standard, so for instance on the Mac, within Photoshop, you can choose the the Apple CMM, Apple ColorSync CMM, or the Adobe Color Engine (ACE). Windows PC users use ICM 2.0, which is a licenced version of the Heidelberg Color Management Module.

Each CMM will have its merits, but from personal observations, it would appear that most photographers leave this at the Photoshop default of ACE. In all cases on the Mac, ColorSync is the glue that keeps it all together! So, unless there is a pressing reason for changing, I suggest you go with the flow and use ACE, on the basis of 'if it ain't broke, don't fix it'.

A point worth noting when using Adobe's Creative Suite of programs is that to synchronise the handling of color across the Suite, you should do the setting up within Adobe Bridge. This will ensure that Photoshop, InDesign, Illustrator, GoLive and Acrobat use exactly the same color settings across the board. In this way the image you create within Photoshop will be treated identically within each application.

You may be surprised at first that Lightroom seems to ignore Color Management. This is not the case: what is happening is that its native color space is a form of Prophoto RGB, a very wide gamut space encompassing most others, and it therefore leaves conversion till the output stage. This means that it relies heavily on a well-calibrated monitor.*

Unlike working color spaces which are gamma-corrected to compress detail in shadows and highlights, Lightroom's color space is linear, to allow for more subtle adjustments.

International Color Consortium – ICC

In 1993, five leading companies came together to form the ICC; they stated:

'The purpose of the ICC is to promote the use and adoption of open, vendor-neutral, cross-platform color management systems.

The ICC encourages vendors to support the ICC profile format and the workflows required to use ICC profiles.'

Those founding members were:

Adobe Systems Incorporated
Agfa-Gevaert N.V.
Apple Computer, Inc.
Eastman Kodak Company
Sun Microsystems, Inc.

Apple called their control mechanism **ColorSync**, and were the first personal computer company to make this a system-wide implementation.

*Note

Lightroom operates in a linear color space internally that is essentially a linear gamma Prophoto RGB, with a monitor conversion to sRGB, with a Gamma of 2.2.

Recently Adobe made its CMM a standalone product so that programs other than the Creative Suite can take full control over their color management in line with that of members such as Photoshop.

A color-managed workflow from camera into computer, onto screen, and later, out to in-house inkjet and ultimately to CMYK and print, follows the path shown below.

This file with its profile will have been seen to be correct for the Photoshop color workspace, thus no change made on import. Within Photoshop the resultant output would pass to your screen via the Display profile with the Adobe RGB profile remaining intact. When instructed to print your image the file will now convert to the appropriate numbers for output to your inkjet printer, and this will involve any specific changes for paper stock characteristics.

Likewise, if the file is to print via InDesign or Quark Xpress, the conversion will take place from the Workspace numbers to those needed for the end result, so if the Page Layout document is going direct to print, then all the RGB files need to be converted to CMYK prior to import into InDesign or Quark.

Note

I make no mention of the input profile here since in most cases professional cameras will have processed the file and applied either sRGB or Adobe RGB profiles, so the true input profile has already been converted for the editing workspace, which would commonly be Adobe RGB.

In the case of RAW files from DSLRs the color space is added after the interpretation of the mosaic information from the sensor has been gathered, and can be set after the event within the RAW Converter.

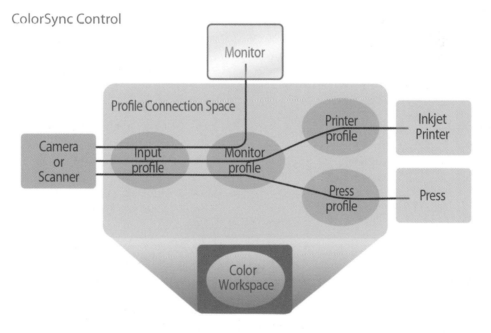

ColorSync Control

Fig. 6.3 ColorSync coordinates the creation of the color workspace, and the conversions between the devices using their profiles in the PCS. The Color Management Module chosen defines how the conversions are carried out in relation to the selected color workspace.

Color management

If you look at the diagram below you will see that the triangle formed by joining the selected positions of Red, Green and Blue for the space defined as Adobe RGB (1998) almost encloses the colors we need to achieve in CMYK.

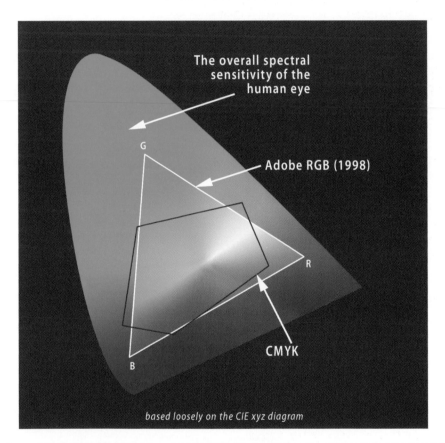

Fig. 6.4 This diagram shows the Adobe RGB (1998) color workspace highlighted in respect to the eye's sensitivity, with the narrower gamut of CMYK shown in black, the sRGB gamut would fall somewhere within the white triangle, and would be wide enough for screen use, but tend to lose even more of the CMYK colors than Adobe RGB (1998).

The Adobe RGB (1998) workspace is a good compromise to capture most of the colors we need in print, without wasting too many values for greens that are simply way beyond the CMYK gamut. For these reasons it has gained general acceptance amongst professional photographers.

The startpoint is to decide upon your color workspace, and this will be governed by how your photographs are to be used. I am making a bold assumption that most of your work will be for print; magazines, brochures, annual reports, leaflets, and newspapers. You will also need to view them on screen over the Internet, or on your website. Based upon this premise, you should choose Adobe RGB (1998) and convert to sRGB when you need to go for the screen and web stuff.

So, within Photoshop* in Edit/Color Settings set your workspace to Adobe RGB (1998). The simplest way to achieve this is from the pulldown menu: if you are US-based, select North America Prepress, if in Europe, choose Europe Prepress.** This will enter the RGB and likely CMYK settings for you automatically.

Once this is set, which means files will be based upon color settings that will provide a wide range of printable colors after conversion to CMYK, the next step is to ensure that what you see on screen is an accurate representation of what the numbers in your file render to the monitor screen. To do this we need to adjust the monitor settings, so that equal values of red, green and blue equate to neutral gray on screen, and for this to be true throughout all the values of each color channel.

This is done either by following the steps in the Preference pane called Displays, or by using a hardware calibrator. The end result although far more accurate overall using the hardware calibrator is nominally the same, and results in creating an ICC profile. This is the Monitor profile and will be taken into account for all occasions an image is on screen. What does all this mean?

It means we can now import an image from our camera, and know that what we see is an accurate representation of the numbers present in the image file, so we can adjust any that are not as they should be, and do so with confidence.

ColorSync ensures that any device that links to your computer to deal with color uses the same definitions for the colors it is handling, in relation to your chosen color workspace. This will not occur naturally, so we need a way to translate what each device, be it a scanner, printer or another monitor, considers is the correct color – this is provided by an ICC profile for each.***

Note

*As mentioned two pages back, if you are using other members of the Creative Suite, make these settings in Bridge to synchronise them across the Suite.

**This is a lowest common denominator setting, not the ideal settings for really top quality work.

***ColorSync stores these and handles all the translations within the chosen workspace. The Color Management Module controls the Profile Connection Space in which this takes place.

ColorSync is a mechanism embedded in the Mac OS X system, the outward user sign of this is ColorSync Utility which allows you to view profiles, compare and repair them. It handles all the transactions between one device and another and any application to any device without you needing to do anything. Its operation is said to be transparent.

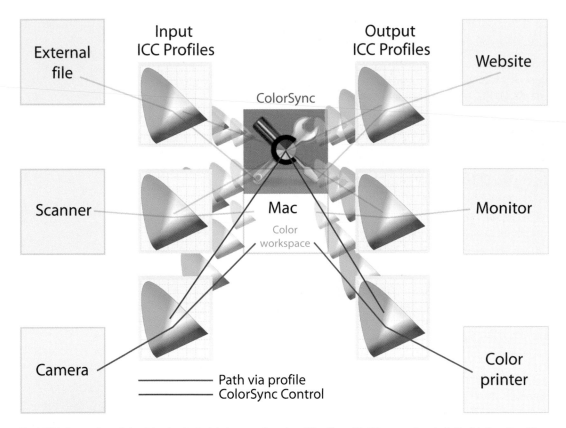

Fig. 6.5 This diagram shows that each input and output device can go through an ICC profile, and that the process is controlled by ColorSync. Everything will be related to your color workspace setting. I have only highlighted one possible route for clarity.

Once you have generated a profile for your monitor, it resides in the ColorSync folder within your main Library, and all color information passes through it to ensure that what you see on screen is an accurate view of what is in the file. The color numbers in an image file now have meaning.

Since all your color transactions are affected by your monitor profile, it is essential that this reflects a true state of affairs. It is important that when you calibrate your monitor, it is under controlled ambient lighting, and that when assessing color at any later time, you are not in a dramatically different lighting environment. Try to aim at having sufficient soft illumination around you that is only minimally affected by changing sunlight or room lighting. Try to keep bright lights from falling directly on your screen and so giving rise to reflections and flare.

Scanners and cameras are not easily profiled, which means on the whole you are reliant upon your choice of color workspace and the accuracy of your monitor profile. You can rely to some degree upon profiles for your printer/s by using the manufacturers' supplied profiles (often referred to somewhat derogatively as 'canned' profiles; however, if you want to retain a consistently high standard of reproducible color, and save money from less wastage of ink and paper, then obtaining a custom-built profile should be the way to go.

There are several people who offer such a profiling service, and it can be done remotely, following their carefully crafted instructions (see Resources, Chapter 5).

In the event you need to show a remote client your work over the Internet, or via email, try to anticipate how your work is being viewed – is your client on a PC? Is s/he using a web browser to view the work? If the answer is likely to be 'Yes' to both questions, then you should consider converting your Adobe RGB files into sRGB. If the client is going to attempt to assess color, then you should really send something tangible – profiled prints.

Safari and Macs are more likely to have color-managed web-browsing, so if you are lucky enough to have a Mac-using client, then Adobe RGB should be fine, but do remember also, that if the final job is to be printed, your files have yet to be converted to CMYK, so if the client needs the ultimate accuracy to the final result, then you do need to convert from RGB to CMYK. This could be as a Soft Proof* or a true Contract Proof.

What component of Mac OS X do you think will take control over this conversion? Why, ColorSync!

Note

It is worth bearing in mind that Cathode Ray Tube monitors are more likely to fade over time than Liquid Crystal TFT flat screens, so they will need reassessing more frequently.

Note

*A Soft Proof is where you convert your file from your RGB color workspace using an accurate profile of the final process supplied by your client's printer, and view the resultant image/s on an accurately profiled monitor.

Remember

For better overall consistency try to buy paper stock in similar batches, because different batches of paper can affect color. You will need profiles for each paper surface and individual printer.

Color management – color conversion

So your client wants to go to print with your masterpieces. You need to know a little more from them about how your work is to be used than, 'It needs to be CMYK'.

CMYK is not universal – one size does not fit all! You need to find out about the processes involved: is it going to be a small brochure on sheet-fed machines using a high-gloss paper, or at another extreme, is it to be printed in the local newspaper using the web offset process?

Why is this going to matter so much? One of the main reasons is due to what happens when ink reaches paper - the more absorbent the paper, the more the ink spreads. The way printing on paper works is that dots of colored ink are laid down as Cyan, Yellow, Magenta and Black and since they are nominally circular, white paper remains. If the dots of ink are spreading, then less of the white will show through and therefore the image will begin to look darker. This effect is known as Dot Gain. Therefore when making a conversion for absorbent paper we need to make our image correspondingly lighter, as well as change the colors, to be able to compensate for this effect.

Although dot gain will occur regardless of the stock, we do need to know about this factor. We need to know whether the paper is coated or not, and whether the white is very clean and bright, as the contrast and saturation of our image will be affected by these characteristics. Knowing these does allow us to make certain general decisions, but nothing beats having a standard to aim for, or receiving an accurate profile for the process.

It is getting a little more common to find a client or printer with profiles, but it is far from the norm. Often the best you can hope for is one of the generic profiles for the region, SWOP coated or uncoated in the US; and Europe ISO FOGRA27, for the UK. If your client is prepared to pay for a proof, this will certainly help everyone, but this is not always possible. A good way you can help is to provide either an AIM Print* or a Soft Proof, either to one of the standard processes or to a client-supplied profile. At least then, some of the more saturated colors you knew would not be as vivid, can be seen and accepted by your client, before going too far down the line.

Note

*An AIM print is simply a print from your chosen RGB color workspace that is printed on a calibrated Inkjet printer, having been assessed and approved by your client using your calibrated monitor.

If in addition to a soft proof, you create a print from your final RGB as an AIM Print, you can ask the printer to make any possible alterations in the direction of your AIM print.

By this means you are saying to the client the AIM print is what we would ideally like to see, but we know it is hardly achievable, and the soft proof is the likely outcome, therefore the client's printer should make any corrections that are necessary towards the AIM print – any result that falls between the two, the soft proof and the AIM print, is therefore acceptable.

ColorSync utility

Before I leave ColorSync, it is worth taking a look at ColorSync Utility. Color profiles can become corrupt, and one of the components in this Utility is Profile First Aid; this will check your ColorSync profiles for any corruptions and repair them where necessary. It also lists all your profiles in their respective device categories. Although much of what it does is very technical, it is still quite interesting to take a look.

Click on the Profiles tab, and select Adobe RGB; place your cursor in the picture window and click and drag to rotate the graph, then drop down to sRGB and click to see the difference between the two color spaces. This will give you hopefully, a clearer idea of what is meant by the term 'gamut'.

Fig. 6.6 This 3D graph can be rotated to describe the range of colors that Adobe RGB (1998) is able to encompass, compare this with the sRGB graph below to gain some insight into the meaning of gamut.

Fig. 6.7 You can see from this screenshot some degree of difference between sRGB and Adobe RGB (1998), but to get a better grasp, click and drag in the real window. You can take this a stage further, by clicking the reveal triangle at the top left corner of the picture, and select 'Hold for Comparison' before selecting the second workspace – this will superimpose the second with the first, keeping them locked together as you revolve them.

Color conversion

If your screen is calibrated, and your workspace is Adobe RGB, you will soon become familiar with what to expect from your images, in much the same way you understood what happened if you pushed or pulled the E6 process in the days of film.

If someone now sends you a file to work with, and they have either never applied a profile or worse still removed one that was there originally, how will you know whether the colors are correct or not?

Well, that is not an impossible task: assume it is Adobe RGB and bring it in un-color-managed – how does it look? If you are really lucky and it looks fine, then Bingo! Assign your workspace profile! However, it is more likely not to be correct – does it look over-saturated and warm? If it does then the two likely options are that it had a monitor profile or was sRGB. These are the most likely scenarios, because in the outside world, these are the likely sources. You could of course be unluckier yet and receive a Wide Gamut or Prophoto RGB file that has had the profile removed in which case, you will be seeing an image that is flat and cold in color that lacks saturation. If that is the case, then try assigning one of these profiles and observing the end result.

What I am saying, therefore, is that once calibrated, you can rely on your monitor to assess un-color-managed images, and resolve the problem. The important point to remember is not to attempt to simply alter the colors in Photoshop, because you are likely to find the image will get worse.

What I have discussed above is related entirely to being supplied with RGB images, in the case of CMYK files, with or without accompanying profiles, the situation is different. They are generally targeted for a particular process, and carrying out conversions is far more likely to end up being detrimental. Try to avoid conversions unless you know the original intended destination. Files that have been prepared for newsprint are going to be very poor when used on high-gloss coated paper for a brochure, and will probably look very washed out. Also, they will have been prepared for a specific size and possibly sharpened for the process – if you enlarge the image, you will almost certainly exaggerate some harsh edges and get a clumpy-looking result.

Tip

My advice is be very wary of altering CMYK profiles, without some good information about their original intended purpose, and possibly get some form of proof done before committing the job to print.

RGB or CMYK supply?

A major question that confronts professional photographers today is whether to supply RGB or CMYK files to clients. This is not an area where hard and fast rules apply, and the subject can inflame passions for proponents of either camp. The best way to come to a decision is to talk to your clients and suppliers. Unfortunately you cannot even categorise clients into neat groups, because much of the response is governed by their previous experiences, and those printers and photographers with whom they have worked. What you must do is try to anticipate what the outcome might be if you supply as defined by the client. Certainly if you doubt their knowledge, try to see whether they will accept a proof of some sort. You need to have closure – a point at which the client agrees your photography was 'fit for purpose'.

If you decide to supply CMYK files, you will need to know how these are to be used, and ideally you need a profile, and you may need to provide a proof yourself. If the client says they are happy with one of the region-standard profiles such as SWOP or FOGRA27, then ask whether they have been down that path before and been happy. If they say 'yes', then fine, but find out whether they intend doing a proof, or whether they will pay for you to have one done. If you are in any doubt they might get things wrong, and end up blaming you, then you could satisfy yourself, and them, by soft proofing.

Soft proofing will never answer all the questions, but will offer a guide to how a picture might look when it finally appears in print. At this point an alteration option you can consider is the rendering intent, where you make a judgement in relation to the handling of out-of-gamut colors. The two intents to consider are Perceptual and Relative Colorimetric. Perceptual looks at the entire gamut, and compresses all the colors to fit within, thereby retaining the relationship between different colors, as opposed to their accuracy. Relative Colorimetric retains the accuracy of all in-gamut colors, then alters the out-of-gamut colors to the nearest in-gamut equivalent. The choice here is subjective, and will very much depend on the number of out-of-gamut colors and their importance to the image. This will be true of the final output, and should be borne in mind when doing the conversion.

Raster Image Processors (RIPs)

It is becoming increasingly common to find printers attached to RIPs for use directly with photographic images, and this new generation is no longer designed exclusively to handle PostScript, but to take more direct control over the conversion process in relation to the very specific handling of the inks. Hitherto inkjet printers were relying on the QuickDraw model in Macs, but this is no longer an appropriate way to deal accurately with printer color management.

This is a very special area of expertise, and I suggest in such circumstances you take advice from an expert (see Color Management Specialists). Sadly, America's finest has passed away, but Bruce Fraser has left behind a lot of very valuable help in his books and on his website, which hopefully will remain available for a while yet.

Another very important factor in your decision as to which color workspace to supply image files, is cost. Are you able to make a realistic charge for the conversion? Because the conversion carries with it responsibility. If you supply targeted CMYK files, you need to be aware of the implications if your conversion is called into question should the print job be less than satisfactory.

You need to understand the processes, so that you are able to argue your corner.

I have found that most photographers do not relish involvement with CMYK, they still consider this to be the Printer or Repro House's remit. I always want cast-iron assurances the client knows what they are getting if I am to supply CMYK files. I have been fortunate that most are more than happy to receive good Adobe RGB (1998) profiled color files. Also, on many occasions I have been able to obtain a custom profile from a repro department when submitting CMYK files, or the company concerned has been entirely happy receiving Euroscale v2 files, and I have been equally happy with the end result. Even when supplying CMYK converted files, if there has been room, I have put the flattened RGB TIFFs onto the CD in a clearly labelled folder, together with a ReadMe explaining what I have supplied, and in which folders.

AIM prints

If I have been concerned that there might be difficulties in judging how to handle the color, I have supplied an AIM print: this is not a print that has been cross-rendered to a particular CMYK profile, but simply a good print from my RGB file on a calibrated inkjet printer, supplied so that in judging any subsequent print, the printer now has a known direction to take from the proof or running proof. The point I make is that any final output that falls between a proof and the AIM print must be acceptable, since one is the standard that the file conversion meets, and the AIM print is a target to which the printer should aspire – the closer the better.

The elegance of an AIM print is in the sheer simplicity, and the economics – any photographer should be able to supply their clients with such a print.

Portable Document Format (PDF)

It is dangerous to predict future trends in this industry, but there is little doubt that PDFs are becoming an acceptable way to supply image data with confidence.

This has come about by the increase in understanding, the improvements made in monitors and their calibration and the rise in the number of digitally captured images.

When you can accept that the color you see on screen is reflected accurately by the file you supply and the printed result, then PDF as a format becomes a very handy way to supply your work, especially if you are also supplying text as well.

PDF is a format that is cross-platform, can be accurately color-managed, is largely 'set in stone', and can be encrypted for safe transfer. There can also be various levels of protection applied by passwords. It can also be compressed and can have digital signatures applied that means it has come from a secure source.

But in case you are worried that embedded mistakes cannot be altered down the line, there is a large third-party industry producing products that can be put to such use!

Also, PDF supports both RGB and CMYK color.

The conversion process

The controls you require for converting between color workspaces reside in the Edit menu of Photoshop, under three headings, Color Settings, Assign Profile and Convert to Profile.

When you first set up Photoshop, set the color workspace that suits in Color Settings, if you are regularly changing workspaces, as opposed to altering files between one workspace and another, then if you can use one of the many presets, do so, but if your settings do not conform, then create your own Custom Preset and save with a meaningful name, so that all you do is swap one preset for another.

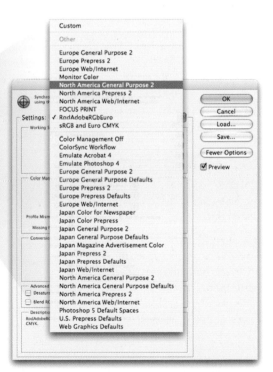

Fig. 6.8 The More Options box has been clicked, which shows the Advanced controls, even though very few people ever need to make any changes here. Should you ever need to alter the CMM or to reduce the monitor saturation, then this is where you do so. The Blend using Gamma 1.0 is there for equally esoteric reasons. Search using Advanced Controls under Gamma in Photoshop's Help menu to learn more.

Fig. 6.9 This is the list of Preset Color Workspaces, you can use any one as a starting point, then as you make an alteration the name will change to 'Custom'. When you have altered your settings to suit, click Save, and give the new preset a meaningful name, and helpful description. At any later date you select that preset, your description will appear in the lowest box.

Color management in Photoshop

When you have defined your Color Workspace, any file you create from that time forward will be saved with your selected workspace profile by default. You can of course uncheck the box that says 'Embed Color Profile: Color Workspace' when you do your 'Save As...' but there are only a few occasions when this is beneficial, as the key to the meaning of the numbers would be lost by such an action.

Assign profile

You would use this command when: either, you have a file that has no ICC profile attached, and you are confident of the correct workspace, or, you have a file that for some reason does not have the correct profile attached. The point to remember is that you are not changing any of the numbers that define the colors within the image, you are simply telling applications that they should consider this file to have been created in your assigned color workspace, and accept or convert those numbers accordingly. To change the numbers you would use 'Convert to Profile...' described on the next page.

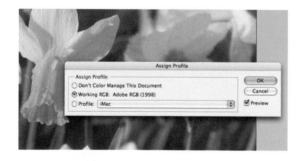

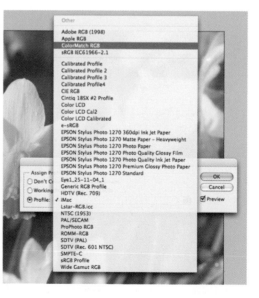

Fig. 6.10 The option working RGB would be the correct choice if this is the correct color rendition now. If however choosing another in the list is an improvement, then select it from the list. You can see the effect a change is making by toggling the Preview checkbox. You may well get an alert dialog box prior to the one above.

Convert to profile

This command *will* alter the values of the numbers in your file to conform to the new reference of the coordinates for Red, Green and Blue, and will attach the new profile which then represents these new values.

If you are using the Convert to Profile command to convert to CMYK, then it is essential you leave the Use Black Point Compensation checked so that your zero Black value in RGB can translate accurately to the correct values in CMYK, the dither function is there to avoid possible banding due to the conversion.

You even get the opportunity to change the CMM engine, but I think this is superfluous, and despite this being a book about Mac OS X, for reasons of maintaining consistency amongst photographers, I suggest this be left at Adobe's ACE setting.

It is always worth toggling the Preview checkbox, because you may find that if the conversion looks poor, you may want the chance to make subtle changes before finalising your conversion.

Note

I have mentioned color workspace conversions in relation to Photoshop, since most of you will do this within that program, but Mac OS X is able to carry out such conversions using Core Image functions. To date access is mainly for Developers and for those for whom Terminal is not daunting – this will change, but for the moment, Preview and iPhoto are ways in which most of us will be able to use these tools.

Fig. 6.12 Color profile handling in Preview.

Fig. 6.11 Here the file is to be converted to sRGB with the rendering intent set to Relative Colorimetric to retain the accuracy of the maximum number of in-gamut colors. Black point compensation should be checked for most occasions and definitely for any conversions to a CMYK. The reason for this is that the profile is constructed to account for the darkest neutral in the RGB to be accurate for the CMYK conversion chosen.

Final thoughts on color management

As you will have seen from what I have written, the control you exercise over color on the Mac is largely done at application level. There is total consistency across all color applications, because of the work done by the system to allow all programs access to ColorSync. You simply work with any application's tools, and it is the program that talks directly to the routines built into the operating system.

The majority of professional photographers and designers use Photoshop and the other members of the Creative Suite, and any color you specify in one application will translate accurately to the others. To ensure this is so across all of the Creative Suite, Adobe have given Bridge the central role to synchronise the color workspace you set for all the applications. GoLive or Dreamweaver can be excepted because in the main, their output will be almost invariably for use on screen, where sRGB is more suitable. However this may change in the future; some day others may follow the Mac web browser, Safari, and be properly color managed.

The ICC color management model relies upon working consistently in a known color workspace, ensuring that your monitor is calibrated regularly, and that your assessment of color in your images is made under closely controlled ambient lighting conditions. Ideally you should be working in moderate rather than bright illumination. Your surroundings should be reasonably neutral, but unless you need the ultimate in consistency, I think you need not immediately go out to an expensive paint supplier to obtain exactly the right shade of gray! You should just avoid bright sunlight and lights being reflected off your monitor screen; being up near a window should be avoided.

Certainly, a hood over the screen can be helpful, but the manufacturer who supplied a black smock with their screens was taking things a tad too far!

Interestingly

Adobe have now offered a standalone version of their Color Management Module (CMM) so that photographers and designers who have used this CMM throughout the Creative Suite can also use the same module with other programs to retain overall consistency. It then ties in with ColorSync.

Monitor profiles

You can resort to outside companies to calibrate your monitor, but buying even the comparatively inexpensive colorimeter devices such as the Basic Color Squid or Gretag Macbeth Eye One Display 2 and using one of these to calibrate and regularly verify your profiling, will be a useful way to understand and appreciate what is going on.

Printing a standard file that you know you can trust, and every fortnight or so comparing this with your screen and your master, will give you the confidence to declare to your clients that they can trust your output. Some color experts will supply such a Reference print.

For anyone selling their own prints, or who supply prints regularly either as AIM prints or proofs, then obtaining a custom profile is a very worthwhile investment. It will save on wasted ink and paper and more importantly perhaps, time. It will also ensure greater consistency and fewer heartaches wondering how an image will fare in print.

Cathode ray tubes or LCD-TFT monitors?

Possibly for the highly critical, an expensive CRT monitor may still be justified, but in my experience, a good LCD-TFT screen with its brightness taken back slightly, will prove more consistent and last far longer. When you add in the smaller footprint, lighter weight, and often sheer elegance of the flatscreen monitors, together with the far easier supply situation, I would definitely plump for the latter.

It is getting more and more difficult to obtain CRTs, and with manufacturers making fewer, it will become harder to achieve consistency, and definitely increase their price; the prices photographers can charge will make it hard to justify the additional expense their purchase entails.

Printer profiles

Having a profile made for different paper stock and ink combinations will undoubtedly give you a fair chance to be able to produce good color consistently, and in doing so will save you frustration and money. There are several companies and individuals who offer this service, and the beauty is that this is something that can be done remotely and with a minimum of fuss.

In the UK, you could consider contacting:
http://www.colormanagement.net

Remote color profiling

The principle is straightforward: you must set up the monitor first, and you print out a test file with all alterations turned off, so that the numbers are being handled with as little alteration as possible. To ensure this, take notes of exactly what settings were in place and make a record of them.

This print, which will contain numerous color patches of known values, is then read by a spectrophotometer, and the discrepancies noted by the profile creation software, that then creates a profile to realign the numbers to within fine limits. This profile can be emailed back to you.

The settings in your print driver are then made to ensure that when you now send a file to your printer, this custom profile is in place. If this is not close enough, a second print from the calibration file can be made and further fine tuning can take place, though this is rarely necessary. Once calibrated you can output a print and compare this to a standard print supplied which you will need to store in a dark and consistently cool place, for future assessments.

Mural depicting scenes at Kew created by Robert Games from original artwork by Terry Thomas

Input and Output

Some photographers still have a considerable involvement and investment in film – either their clients still understand and prefer the medium, or it is the photographer's conscious decision to continue to shoot on either color negative or transparency. If the obligation does not end with handing over a series of prints or transparencies, and these images are to end up on your computer, then your digital door is the scanner.

Should you relinquish this task to a lab or bureau? Or should you invest in the equipment, and ultimately the expertise to carry this out for your client? If holding this data gives you greater potential to benefit your client and offer further services, then buying a scanner makes sense. The quantity of legacy negatives and transparencies coupled with the residue of photographers continuing to shoot on film, means that scanning will be with us for a few years yet.

Regardless of whether you enter digitally or start with film, more knowledge of the subsequent processes has now come within your remit.

Scanning

The options available will vary with the quantity and quality needed from what you shoot, at the high end are the outside bureaux and repro houses, and lower down the scale you could purchase a scanner and keep control in-house. If your throughput is high you could even consider having your own desktop drum scanner, or an Imacon/Hasselblad type.

Mac OS X will communicate with them all, but only offers direct control at the low end, and this is done by a small program called Image Capture, which is found in Applications. It is very capable; able to sense when Cameras, Card Readers or Scanners are attached to the computer by Firewire, USB or Ethernet. It will intercept and respond appropriately, set via its Preferences.

Image Capture

In Tiger, after the initial 'No Capture Devices connected' alert, you go to its Preferences as shown in Fig. 7.1 below. Ticking the scanner box means that when a scanner is on and connected, Image Capture will open the scanner application and do the Overview or Preview scan. All the settings are made in the pull out drawer (see Figs. 7.3 & 4).

Image Capture, as its name implies, does more than offer a scanner interface, so I will complete a description of what it does, before dealing with drum scanning.

Image Capture

Where is it? What does it do?

These are not the actual questions I get asked!

The question is usually asked out of frustration: – 'How come every time I put a Compact Flash card into my PowerBook, iPhoto opens up?'

Or:

'Every time I plug my camera into the USB socket on my Mac, iPhoto is launched – how do I stop it happening?'

The issue is not so much that it happens; it is where is it controlled from, and what should I be looking for? Well, I have the answer for you – it is called 'Image Capture', and the program is quite clever, but Apple are so determined for you to use iPhoto, that it is set to automatically open it for you regardless. Leopard has improved on this approach slightly.

Fig. 7.2 When you first encounter Image Capture in Leopard, this is the newer, improved message; it should be less baffling, since you do now know what is happening.

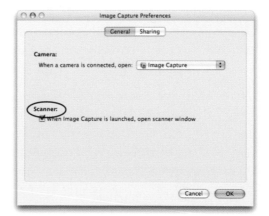

Fig. 7.1 Selecting Image Capture's Preferences will show this window.

Scanner input

The scanner module queries the scanner itself to provide the necessary functions, such as whether you use the flatbed or transparency adaptor, or you are scanning a negative or transparency. All these controls appear in a drawer that comes out of the side of the platen area. Additional settings are made available in a sheet when you click the Options button.

Fig. 7.3 The scanner interface with the drawer open showing the settings you can make.

Fig. 7.4 There is a further set of options available to the Scanner module as shown in the sheet here, which appears when the Options button is clicked.

Image Capture and VueScan

Image Capture shares similarities with Shareware favorite VueScan from Ed Hamrick, they can both be used to access a wide variety of different scanners with a single interface, which can be a boon, since it avoids learning a new interface when changing scanners.

When you click Options, you can set whether you want a custom icon for the file showing a preview of the image, what resolution you want for the Overview image, whether you want to embed an ICC profile, and if so which, and also whether you wish to add details in the Comments file. I shall mention this feature overleaf in Fig. 7.10. The second tab, Buttons, applies only to scanners with Auto buttons that scan using preset parameters, the final tab summarises information about your connected scanner.

Fig. 7.5 Although limited, the scanner driver within Image Capture is a quick way to get scans into your system with the minimum of fuss.

Fig. 7.6 In the Preferences, you can select Sharing, and allow others to share the scanner using Bonjour, Apple's method of allowing devices to link without involving the user in the complexities of IP addresses.

Image Capture – from camera or camera card

Image Capture will not only recognise scanners, it will also intercept cameras, or a card reader, connected via Firewire or USB. If you had iPhoto installed when you first launch Image Capture, then iPhoto would be launched when the camera or card reader was detected. That is handy if you wish to use iPhoto, but this response can be changed to launch another application or Image Capture itself, offering you the chance to decide which images need to be transferred to one of your hard disks. So you have a chance of a preliminary cull of files you don't need.

Note

At the high end, some of the cameras can communicate via Firewire, but many DSLRs use USB, not necessarily USB 2.0. However, most card readers are now USB 2.0, and some are Firewire, even Firewire 800. Since time is money and may even be critical, I suggest you opt for the fastest card reader you can afford. I use a Firewire 800 reader, because the Canon 5D files are large, this means even a full 2 GB card is reasonably fast to access.

Fig. 7.7 This dialog tells you how many files it has found on the card, and allows you to choose where to send either all or some of the images, it retains the last destination by default.

Fig. 7.8 Once you have made your choice, you will see a progress bar with previews of each image as it is saved.

Fig. 7.9 If you click 'Download Some', you will see scaleable thumbnails of all it finds.

Fig. 7.10 When you choose Information, it is about the media card, not the Finder Info about the shots shown. Overlaid – Spotlight gives the correct Image Info!

A drum scan is a file!

Obvious, I know, but in thinking about a scan, somehow this is forgotten. Possibly the reason is because it can come in so many forms, and some descriptions are less than familiar.

Unless you specify clearly what it is you want, it can be a far more cumbersome file than one from a digital camera. Where it differs is in the resolution terminology, the color mode, and the size in terms of megabytes.

Resolution will often be described in the mystical term 'Rez' and yet without a unit of measurement seemingly: Rez25 or Rez80!

Be baffled no more – these are pixels per millimetre. To add to your confusion, Adobe in Photoshop refer to pixels per cm. These sizes also tend to be for RGB files, yet the reason for the scan in the first place is generally for a file that is going to be for print purposes. So, a drum scan from a full 10x8 color transparency at Rez25 might well be roughly a 92 MB RGB file.

I use a rough guide in my head to compare drum scans to original digital capture files that for equivalent detail a 50 MB RGB drum scan equates to an 18 MB digital capture. Or, a good digital file interpolated to 50 MB is equivalent to an average 5x4 drum scan. Please do not take this as gospel, simply a general comparison.

Only go for a CMYK scan if you know the file's final destination. Certainly most photographers deal with designers and agencies, and often have no idea who is to print their work or whether it is to be retouched or planned into pages at particular sizes, so the conversion should only be undertaken when those details are known for certain.

If a bureau is offering a scan that includes a custom ICC profile, the omens are good that they know what they are doing, but ask for a trial scan and proof the first time.

Drum scanning

Drum scans can come to you in any number of ways, and are simply an image file to Mac OS X, it is very likely to be to your specifications precisely, and hopefully spotted and color corrected. There is no recognised standard, and it may well not have an embedded profile, and could be in either RGB or CMYK. You will need to discuss exactly with your supplier, just what you expect. You may well be asked 'What Rez would you like? – See the side panel for guidance on this.

When discussing your needs, get them to ensure cleaning the transparency or negative is part of the price, as there is nothing worse than receiving an oily original back, half-stuck to a sleeve.

Labs dealing with professional photographers regularly will likely offer RGB or CMYK to your specifications and return your originals cleaned, but going to a repro house or printer varies wildly, just remember that cultivating someone local will bring long term benefits if you have a regular need for drum scans.

I would recommend that you ask for your scans on CD, rather than downloaded via Broadband, because you will be able to make duplicates swiftly before you start your work with them, giving you adequate backup for security. You could possibly consider creating an action at this stage to give you the opportunity to rename the images to conform to your own filing system; you could for instance create an Automator workflow that you attach to a folder as a Folder Action.

To create an Automator Action and to attach it as a Folder Action to a specific folder, you need to be careful to create that folder beforehand. You save the Workflow as a Plug In, and that Plug In needs to be attached to the source folder. Then, using the Context menu you click on that folder and choose to attach it to the folder.

If you spend some time setting up and checking your Workflow and the Folder Action, you need to be careful to follow all the steps each time, otherwise you will likely find that your action will misbehave – each time you edit, the link is broken, so you have to re-establish the connection between your Automator Workflow Action, the Folder Action, and the folder to which it belongs.

An Automator workflow for a Folder Action

1. Create the destination folder for the outcome of the workflow.

2. Open Automator and either drag the three actions from the Action pane or double-click each item in the order shown – Get Selected Finder items, Copy Finder items, and Rename Finder Items.

3. Save As a Plug In, choosing Folder Action and the name for that Action.

4. Create the Source folder, and holding the Control key, click the folder to reveal the Context menu and choose Attach Folder Action... It should show the Folder Action Scripts, select the script you have just created.

Remember

It is important that you create the Destination folder, before the Automator action.

In many cases you may also have to consider creating the source folder beforehand; this will not be the case if you create a Droplet.

A Droplet is a freestanding application that will respond to a file, a folder or a selection of either, and carry out the designated steps upon each file encountered.

Fig. 7.11 Highlight the Application (Finder here), drag each action into the Workflow pane in order, click Run to test, then Save As Plug In.

Fig. 7.12 This drop down sheet shows the Save As... action allowing you to name the Action which is a Plug In to be a Folder Action.

Fig. 7.13 Here the Folder is selected in Finder and in its Context menu you choose to attach the Workflow Plug In as a Folder Action.

Scanning images

Scanned images can often require further work before being supplied for use in a page layout program such as Quark Xpress or InDesign; this can stem from small amounts dust and dirt, bubbles of oil in a drum-scanned image, scratches on the film surfaces, and Newton rings. For this reason, I would suggest you save these to a separate folder. Once that preliminary retouching has been carried out, then they can be placed in a folder pertaining to a specific project.

If you are doing a large amount of scanning, you could create a 'Raw Scans' folder, and to make it readily available you could select the folder in Finder and press **Command+T** to place an alias of it in the Favorites section of Finder Windows.

The pitfalls when scanning differ with the type of scanner involved. Drum scanning very often involves a sandwich of a foil taped to the drum's outer surface under which the transparency or negative is placed. A bead of light oil is then run along the back edge and the foil stretched across the film before being squeegied to eliminate air bubbles, then the final tape is applied.

In the case of sheet film, unless the film was roller-processed, it may well have quite noticeable hanger grip marks on the four corners, and this can result in a cluster of air bubbles within the image area. Also, there can sometimes be Newton's Rings due to interference patterns creating a series of moiré patterns like undulating parallel rings often in rainbow colors. Another problem can be small dirt particles trapped within the sandwich.

Any scanner involving glass contacting the film, can be subject to Newton Ring problems, and in 35 mm film in high humidity even without contact this can be an issue. Flatbed scanners without glassless holders can also suffer, however the drier the atmosphere, the less likely the problem.

Severely scratched film will tend to show lines that may have both black and lighter edges due to refraction and shadowing, this is where cleaning and drum scanning using oil can in some cases eliminate this completely.

If any of the above problems exist, then you will have the task of retouching these blemishes, which is often best tackled within Photoshop using the Spot Healing Brush and Clone Stamp tools.

Fig. 7.14 This is a highly enlarged corner of a Drum-scanned 10x8 color transparency showing the clip mark and resultant bubbles in the oil. I had to twist someone's arm to capture this rare occurrence on film!

Fig. 7.15 Dragging the 'Raw Drum Scans' folder below the divider line in a Finder window sidebar, creates an alias that is readily available. This area is called Favorites, and is always easy to find in any application's 'Open' dialog boxes.

Scanning – bit depth

When selecting a scanner, a factor you need to take into account is the number of levels the scanner is able to record in the range between the deepest shadows to the brightest highlights. This is dependent upon the dynamic range and the bit depth it is able to use in its calculations.

Although the files you pass on to others is invariably an 8-bit per channel file, capture should be at a higher bit depth, and the reason for this is that you are likely to make some corrections to the color to achieve the quality you wish to supply. Any color changes you make will involve a loss of data as you ask for the numbers in the three channels to be swapped for others.

What this means is that a color you take away for exchanging, leaves a gap, and the color you move adds to the amount already there. In exaggerated cases this is what gives rise to the gaps and spikes in a histogram. By starting off with more than 8-bits per channel, making the corrections in that larger domain, then converting to 8-bits per channel, you are more likely to fill each possible level, so giving a smoother end result.

Flatbed scanners offer ranges that go from 10 to 14-bit generally, and sometimes you can get access to this level when saving. The format that Photoshop calls 16-bit, deals with all color bit depths beyond 8-bit and up to16-bit. Because it makes good sense to be able to have a mathematical midpoint, they in fact have a 15-bit per channel model, and this still handles the 10, 12 and 14-bits that scanners variously use.

When scanning photographic images, if they are prints remember that the print may have quite large grain, whereas the negative though small was always intended for enlargement, but due to its lower contrast may well still end up grainy, there is a tradeoff here, and the surface of the print may well also have a bearing. A transparency on the other hand, unless the original process was pushed, should give a smoother more pleasing result. A print film transparency from a negative often gives a better scanned result than either a print from the negative or directly scanned from the negative, but the print film needs to be the fine-grained variety, not the display material.

Resolution

Optical resolution of flatbed scanners is often described by two numbers, one represents the vertical travel the other the horizontal travel, so you might see 1200 ppi x 600 ppi. When considering what actually matters go by the lower figure, because what is meaningful to you is identical resolution for both axes, and the lower figure will require interpolation up to give you this, so there is no further detail.

dMax or maximum density

This is the maximum density the scanner is able to read, and unfortunately this is an area where marketeers overstate the figures sadly, but generally 3.6 to 3.8 are good high levels – ignore any blurb that states 4.0 or over, as it is not feasible!

The ability to read detail in high densities and avoid flare in low densities is what you should seek, if a scanner manufacturer tries to gain speed by enhancing shadow detail, it will come at a cost of increased noise.

Digital ICE®
(Image Correction Enhancement)

Primarily a Nikon technology, uses an Infrared prescan to map out surface scratches and dust. It only benefits standard color transparency and negative films, it has no beneficial effect on black and white films or Kodachrome® transparencies.

Drum scanners mainly scan using oil with a similar refractive index to the film which obviates some of the problems of surface blemishes, but one manufacturer, ICG, makes scanners that can work by using centripetal force to press the film against the inside of a revolving drum (this method still using oil, they term 'SlickMount' ®). This method avoids the extra surfaces of the foil. These scanners use vertically mounted drums that can also be used conventionally, mounting films to the outside.

There are a number of high end flatbed scanners, but generally these tend to be aimed at the repro end of the market, they come from Kodak (formerly Creo), Fuji, Purup Eskofot and Scitex, Agfa rebadge the Lanovia from Fuji, so for anyone involved in large numbers of scans, these are the heavyweight players.

Hasselblad Flextight scanners are a breed apart in terms of the way in which they work, in that they use a method that the manufacturer calls a 'Virtual Drum'. By putting a slight compression in one direction across the film, they ensure a very flat surface in the opposite, the arc of the curve corresponding to the radius of the scan. Many photographers support the claims made by Hasselblad that the resultant scans are close to drum scan quality for a fraction of the cost.

For 35 mm and 6x6 cm film there are a wide range of dedicated film scanners, and some employ an infrared scan for dust and scratch removal, and multipass scanning to reduce noise and improve the dynamic range. Photoshop CS3 Extended offers a similar effect using multiple exposures on separate layers.

Although there are examples of scanning software that works for more than one make of scanner, such as Vuescan, Silverfast, and ScanXact, most scanner software is tailored to specific makes, TWAIN driver software does provide a basic interface to many scanners, and may lie beneath software that works on more than one scanner make. Some of the more recent flatbed scanners have transparency adaptors that are capable of producing very acceptable scans, but do not expect comparable results to the dedicated film scanners from the likes of Hasselblad or Nikon.

TWAIN

I have always liked the alleged origin of the acronym – Technology Without An Interesting Name!

This is a common scanner interface, that is used by a number of companies to provide the fundamentals of scanning for use with a wide range of less expensive scanners. Some manufacturers use elements of the technology, without necessarily using the TWAIN interface itself.

It is maintained and developed by a group of leading Industry names, such as Epson, Adobe, Hewlett-Packard, Kodak, Xerox, Fujitsu and others, and is often used for the underlying communication between the scanner and operating system of the computer, especially in many of the more universal scanning softwares.

Remember

The important factors to note are dynamic range (the deepest shadows to the brightest highlights), the optical resolution, and the build quality. The longer the range, the better will be the retention of detail in both shadows and highlights.

Filmscan and digitally captured image differences

Once you have a good scan with correct white balance, good range, and the right resolution for the intended purpose, everything you can do with digitally captured images will be similarly applicable. You will though, likely have a more textured image than an equivalent digital capture, but from this point on the primary difference will be one of metadata content. Unless you spend a small amount of time to apply some information about the image using File Info within Finder, or Photoshop, the file will be less traceable than its digital counterpart.

Adding Spotlight Comments is going to be speedy only if it is a few items, because you do not have to open any application. If Photoshop or Bridge are open, then multiple files can receive the information simultaneously, and can be read in these and other programs, such as iView Media Pro. The Spotlight Comments can be read at system level, but there is no categorisation, and it is not cross-platform, whereas the XML metadata of Bridge and Photoshop is readable on Windows or Mac machines.

Using Comments to aid linking files

Although the example I use is not a scan, the principle is the same, the logo in this case has a descriptive title visually, but has no relationship with the name 'Howarth'.

By making this link in Comments in the Get Info dialog, it is now possible to search using 'Howarth', 'Tim', 'T_J' or 'Logo'.

By locating scans in a folder so named, helps in categorising, and adding metadata in Comments, refines the search.

Spotlight will find the Comments when you search, but the effort and return from Comments will not match what your digital camera, Bridge and Photoshop can achieve. So, although I would like to say the operating system can offer you some help here, Adobe Bridge or Lightroom will still be your safest bet to apply searchable metadata to scanned images at this time.

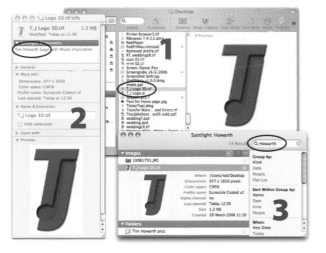

Fig. 7.16 Selecting the file that does not contain 'Howarth' in its name – **1**, and doing a Get Info – **2**, to add the comment shown here, where the name does now occur, allows the file to be found – **3**, using Spotlight and the name 'Howarth'.

Spotlight – EXIF search

Below is an example of a search for images shot using the 12–24 mm lens – I knew that they would all have 'Canon' and '12.0' in the EXIF data from when they were shot, hence the search criterion I chose. The total shown to the left of the Search String box displays the total files found, not the total images, that is only shown against the top of the Images List, which has been scrolled beyond the window.

Fig. 7.17 The total shown indicates numerous .THM and .XMP files located on the drives that essentially contain similar text information.

DNG and metadata

As explained here, Spotlight reads more of the available data in a DNG file, so support for this format is beneficial to photographers in several important ways, so do help in pressurising manufacturers to increase its adoption. You can do this at:

http://www.openraw.org

A more robust way to ensure the EXIF data is found by Spotlight is to convert your files to Adobe's DNG format (see overleaf for more details), as Spotlight finds more of the EXIF data in this format. When you couple that advantage with others such as small file size and an open standard, I can highly recommend that you consider using DNG in your workflow. The more photographers and libraries that adopt it, the greater the pressure on camera manufacturers to improve their support.

Digital capture and metadata

Once you have clicked the shutter of a digital camera, not only have you taken the picture, but you have taken the first step towards the tracking of that shot by adding metadata. How much you have added will depend upon how much preparation you have done both within the camera and on the memory card.

The sensor chip has to capture the information to a buffer first in the most highly efficient form it can, then remove it ready for the next capture. In this miniscule amount of available time it has to transfer that information onto your removable storage, often a Compact Flash Card or SD Card. This information is not in a form you would consider useful, it is simply an array of numbers.

This RAW format varies between camera manufacturer and camera model. There are variations of sensor chips, as well as different interpretations of how the arrays are constructed. RAW is not a standard format that fits every sensor chip or camera manufacturer, because how all this information is dealt with at speed and with high quality is considered a valuable commodity. There is great reluctance to either, part with the information, or to place it in a standard format for the benefit of photographers. Adobe has released a converter that goes a long way towards standardising the storage of all the available parameters in a freely available and well-documented format that it has dubbed the Digital Negative – DNG for short. So far, only a handful of camera manufacturers have made a commitment to support it. There is little doubt that photographers could benefit, if it were possible to save our images directly to DNG.

RAW is fundamentally uninterpreted data of what the sensor captured. Given that our computers have more time and power to carry out that interpretation after the event, it makes sense to make the most of that opportunity. For those times when we do not have the time, we have the option of storing interpreted and compressed files very swiftly so that a sports photographer can send his peak of the action shot of a footballer heading the ball into the net, straight to the picture editor of the newspaper.

Some of the newer Compact Flash cards can be preprogrammed with metadata, that can be applied to the images as they are extracted, which means such information as the photographer's copyright information and location are immediately available.

Note

Since not every flaw or distortion in the computation of a lens can be adequately corrected, but the information about the lens, where it is focused and what aperture is in use can be captured and held in metadata, lens manufacturers can now consider using the metadata in their software to make final adjustments to improve the capture quality. Hasselblad were one of the first, and Nikon seems to be following suit. This is an area where the original manufacturer can tailor its own software more accurately than a third-party, and retain a competitive edge over the competition.

View cameras and camera backs

There is less capture information for photographers using camera backs and View cameras, as there is currently no easy way for the backs to necessarily know what lenses are being used, so EXIF metadata is less complete than for DSLRs.

Another reason is that the proprietary files created by the likes of Leaf, Sinar and Betterlight are of less use because their capture software forms an entirely essential part of the workflow.

The output files are often high bit depth and high dynamic range, and it is only on export that a standard file format becomes available, these are likely to be either TIFF or PSD, and the accompanying profile may well also be custom.

In situations like this almost all the color adjustment has taken place prior to import to a program like Adobe Photoshop or Lightroom.

Digital images

The files from digital cameras have improved in quality; the cameras themselves and the lenses specifically computed for digital imaging have also improved, so fairly naturally the file sizes have increased. This has brought with it a major problem for storage, sorting and searching, and as I have explained, here is the most significant reason digital imaging is more effective, the way accurate information concerning your image remains with the image itself, as metadata.

Sorting and searching your images is reasonably accommodated, but the storage is still an ongoing problem, and each photographer will have different requirements. If images are in regular demand once taken, ready access must form part of the solution. But if once taken and you have received the payment, there is little chance of reuse, then perhaps there is an argument for asking your clients whether they would like you to be the custodian for a fee, or would they like to purchase the primary images for a nominal sum for them to store, as you have decided you will only store the back catalogue free for a limited time, say, one calendar year from date of exposure.

Storage costs. If that is so, you have a right to make a charge. Increasingly the buyers of our photography consider charge for reuse to be untenable, well, it is only fair to lay the burden of storage in their charge, unless they are prepared to pay for storage and retrieval.

RAW and Metadata

RAW data is very much subject to interpretation, and is an area that has seen a great improvement, with updated algorithms improving the image quality obtained from earlier captures. Also the scope for manipulation by the user has become another factor for the transition from film to digital. Metadata can also play a part in allowing software to better understand what can be done to improve or alter the original image, it can play an integral part in later transformations such as correcting distortions in some lens conditions, such as a zoom lens with barrel distortion at the wide angle end of its travel, or when stitching overlapping images, where knowledge of focal distance, focal length and aperture could allow for accurate undistortion of the original images.

Adobe DNG Converter

Adobe have tried to make it very easy for photographers to convert their files to DNG with their free Converter, and even to store the original proprietary RAW file untouched, within that container. This can also still be extracted separately.

Fig. 7.18 The creation of the Converter which is supplied free to Users and Developers is an elegant way to try to future proof the wide range of differing RAW formats that are currently available. Hopefully, its adoption by Hasselblad will spur other camera manufacturers to follow suit.

Shooting in RAW using a DSLR camera

Shooting RAW for the two Apple photo products, iPhoto and Aperture, you need to ensure that your camera's RAW format is supported, and this is an area where there can be issues. So far, Apple has not caught up with Adobe in their support for a wide range of compatible formats. If your RAW format is supported, you will have more control over that image than a JPEG.

In Adobe Camera RAW you will have access to the White Balance, the Exposure, the Contrast and Sharpness, together with the possibility to correct for Chromatic Aberration and Vignetting. There are also controls for Calibration which allow you to make allowances for the possibilities of lenses or cameras that might have a consistent color bias, and this setting could be substituted for the default, or simply be a preset for a lens, or group of lenses. The difference between them is that in the default it will override the original, whereas you can create any number of presets for specific lenses, cameras or particular lighting conditions.

With JPEG, most of those controls are no longer available; the choices were made when you pressed the shutter – the interpretations have been made and frozen in the file, so if any substantial changes need to be made, you will have to carry these out in Photoshop. Some minor changes could be made in iPhoto. Aperture and Lightroom can do slightly better.

At the high quality/minimal compression end, artefacts are likely to be minimal, so here is the first difference, JPEG is not a lossless format, but what is lost is decided by where you set the Compression/Quality slider. For a subject with minimal fine detail, you should be able to set a lower value than would be the case if there is a fair amount of fine detail.

Whether you shoot in RAW or JPEG, the camera captures details of the Camera, Lens, Date & Time, ISO setting, the White Balance, Shutter Speed, Aperture, whether the flash fired, and so on. This specific camera and lens data is stored in a standard format known as EXIF (Exchangeable Image File format). Some of this data is readable by Spotlight. RAW files converted to DNG allows greater access to this data using Spotlight, and this is likely to improve with Leopard.

Fig. 7.19 Although not considered a fully professional camera, the Canon 5D is an excellent workhorse that is light enough to carry around for extended periods, takes the full range of lenses, has a large reviewing screen and has a 'full size' chip. So, for those used to 35 mm film SLRs, choosing a suitable lens for a particular angle of view, is second nature.

Quartz engine – PDF and Preview

Mac OS X uses its Core Graphics to output to screen using Quartz, which is closely allied to PDF, Core Audio for Sound, Core Video for Movies and Core Animation for much of the interface animations. Open GL drives the video card rather than the CPU for 3D work and rendering.

Preview benefits from these to natively open many different graphics and text formats in a very simple interface, it can read PDFs and annotate them in a simplistic manner, without you having to buy the full version of Acrobat.

Core Technologies

Apple has a series of system technologies that allow it and its third-party developers to communicate directly with its hardware, making overall software development more efficient, the latest being Core Animation.

This has two major effects, a developer simply feeds its code into readymade routines, avoiding reinventing the wheel, and often tasks are hived off to specialist onboard hardware rather than hogging the CPU. Many tasks that historically took valuable processor time to put images to screen are now handled directly by the video card, letting the CPU carry out the really meaningful tasks.

Many of the smooth graphic effects that help you understand more about what happens when you are using Finder, for instance, the Genie effect when you minimize a window, or drag and drop a file from one folder to another, no longer tie up the CPU.

The extra RAM onboard the recent video cards makes it a simple task to provide you with transparent icons when dragging a file around, making it more obvious what it is you are doing.

Fig. 7.20 You can annotate any image in Preview with an oval or a text box.

Fig. 7.21 You can also select text within a PDF to copy elsewhere, such as getting an email address or telephone number.

Preview

When time is short and you have captured and downloaded some RAW files that you want to look at quickly, Preview can help you do just that; it opens quickly and if, as I show below, you select five image files and drag them to the Preview icon in the Dock, all five will appear in Preview's Drawer, and the first one is shown filling the window.

Multiple open files in Preview

Fig. 7.23 Multiple selections appear in the drawer, with the first filling the window. The thumbnails are scaleable.

Fig. 7.24 The controls appear momentarily, returning if you bring the cursor onto the screen.

Fig. 7.22 From the Finder you can drag multiple files to the Preview icon in the Dock to open and view your selection.

You now have a range of possible options; you can select each in turn, zoom in on any or all of them, you can put Preview into Slideshow mode. You can save each of them out individually. As the default for RAW files is 16-bit, you can save TIFFs, PNG, and Photoshop files in either 8-bit or 16-bit. PDF is yet another possible output format. The file formats open to you when saving from Preview, will depend upon the original file/s opened.

Interestingly, you can choose to open each image into the same window, and keep adding subsequent files to the Drawer. If you wish to open groups into the same window, then you go to Slideshow mode and choose the Index View. To open individual windows from a series of images, click it from here. So, for instance you could see a slideshow comprising a range of differing file types, or zoom in to check sharpness and detail.

You can add or change color profiles in Preview, and do a range of color corrections, even converting to black and white.

Fig. 7.25 Multiple Images can also be viewed as a Slideshow or Index Sheet view; here the four images are in Index Sheet view. Hover over an image to see its filename appear.

Conversion to black and white

Many people, photographers included, dismiss Preview as something for kids, and not for serious work, but they fail to look just that little bit deeper. Here is a fast-opening piece of free software that can open scores of different format files – a simple example is shown here opening a RAW file, and converting it to black and white.

Preview – a PDF reader

When you do not have the full Acrobat, or simply, that you have Acrobat , but it is not open, then dragging a PDF file onto Preview will be faster to open and show you the contents — in less time than it will take for Acrobat to even open.

But as you can see from this spread, Preview can do so much more. For someone who finds Photoshop daunting and wants to quickly carry out a change to a snapshot, Preview can do a very passable job.

Fig. 7.26 Preview has not got the sophistication of Photoshop, but its simple controls do a swift and competent job of converting this RAW image into black and white.

Color correction

Under Tools/Color Correction you can very quickly achieve a sepia-toned image from any color file that it opens. Imagine that in your hectic life, you suddenly realize that you have twenty minutes before last post goes and you need an idea for a card – Photoshop will do the job, no doubt about it – but as quickly and as easily? Take a more serious look at Preview, before you dismiss it out of hand.

Fig. 7.27 The settings above are all it took to create the sepia print from the shot on the left.

Apple has been altering the underpinnings of image creation in Mac OS X over the last few upgrades, by transferring various tasks from the CPU to the graphics card, and streamlining the entire operation, utilising the power and memory aboard the latest generation of graphics cards.

In Leopard, the original QuickDraw routines will have finally been removed entirely, and even more of the current tasks will be handled by the graphics card. At the heart of all this development are two technologies, Core Image and Open GL – as yet only Apple and a handful of third-party developers use Core Image. Major players may well be reluctant, due to it not being a cross-platform technology, but this could yet change.

Preview uses ColorSync, Core Image and Open GL, as do iPhoto and Aperture, and these all sit well with the likes of Photoshop.

Leopard Note

An added feature to Preview in Leopard is an Auto Alpha feature, which can be useful for the creation of masks around objects for use in Apple's Keynote or Pages programs. It is visualised as red, in a similar manner to Photoshop's Quick Mask.

It does need a fairly good contrast from the object to be effective, but when speed is essential and you need a cutout, it could prove useful, but it lacks the precision needed for high quality work for print production.

Quick Look in Leopard

An interesting addition to Finder in Leopard is QuickLook, which provides all the functionality of Preview without actually launching it. It is accessed speedily by selecting a file in a Finder window and hitting the Space bar, or via the contextual menu (Control+clicking a file or folder) or right-clicking, and choosing QuickLook from the subsequent menu.

In Flow View, the Space bar enlarges one step, from there you can enlarge to full-screen, a boon to photographers.

Spotlight – slideshow

Spotlight has an interesting feature to augment its searching – you can do your search in icon mode, then click the right-facing triangle at the top right of the images pane, this launches the Slideshow module. When it starts the controls appear, and after three seconds without cursor movement, these will disappear.

Using the controls, you can either page through, or run the slideshow automatically. There is also an Index Sheet mode that means you can jump around the search results, and either simply view the selected image, or run the show from that point.

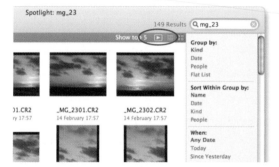

Fig. 7.28 Clicking the highlighted triangle opens the Slideshow feature of Spotlight.

Fig. 7.29 The first image in the Search Results fills the screen, and the controls appear as shown above.

Fig. 7.30 As your cursor passes over the images, each highlights and displays its filename, as shown here. A single click enlarges the thumbnail to fit the screen, and after a few seconds, a higher resolution version appears in its place.

Output

Getting photographs from a digital camera, either by direct connection or via card, via a storage device, or by scanning from an analogue source, negative or transparency, is one third or a quarter of the job. Editing the images by viewing them and manipulating them is the middle bit, but the important part is getting them out, and off to a client. It may well be that this stage is a two part operation, first send a minimally culled selection to the client for initial reaction and their approval. After more whittling down, you work on these, to crop, size, color correct, enhance and tidy up, then you supply finished files either as hardcopy, as flattened files ready for a designer or printer or a combination thereof. You have numerous decisions to make in consultation with your client as to which route you take.

- Does the client want files on CD/DVD?
- Are they to be supplied such that they can be read on Windows and Mac computers?
- What file format is needed, TIFF, PSD, EPS, or PDF?
- Are they to be supplied as RGB or CMYK?
- What size are the files to be?
- Does the client need a proof?
- Does s/he want an AIM print?

Lastly, you'll need to back these up and file them in a systematic fashion for future retrieval.

Probably no two clients will have the same requirements: you may be the one who makes those decisions for them, based on how they plan to use the images. If the client is an experienced advertising agency, the specifications may be really tightly defined, which should make your job far easier.

Certainly, you do need to ask how they are to be used, and this is as much about Rights as about technicalities. It may well be that the image/s chosen may be needed for more than one purpose, and so there will need to be different versions.

Both parties need to be aware of the intended use – at the time you hand over the work.

Photographer's dream!

The client says 'I need these shots for a brochure that is six pages overall; I want a full bleed front cover at A4, a center spread bled A3, and none of the rest will exceed 6 inches or 15 cm over the longest dimension and the bleed on all the images need be no more than 4 mm. – Oh, and supply me Adobe RGB files on CD with hard copy!'

You really do know what is needed, and should have little difficulty supplying files that meet their requirements – rarely are jobs quite so cut and dried!

Even if they did not ask for hard copy, I would allow for them, and provide them.

Some guidelines:

- Never assume you know the use for your images.
- Ask – knowing the client has not decided, is still far better than making a wrong assumption.
- Try to anticipate how an image might also be used differently, at a later date.
- Discuss Rights, charges and other issues upfront.
- Don't be afraid to offer suggestions for other shots, other uses.
- Make sure you know what size image is required.
- If asked for CMYK, ask for a profile – this will often give you a clue as to whether they really understand what is needed.
- If they won't pay for a proof, make sure you at least provide an AIM print from a profiled printer.
- Keep copies, and a record of what you have sent.
- Backup your material, both editable and final copies.

The choice of format for supplying a CD or DVD will obviously depend on the number and size of files you have to hand over. If they will fit comfortably in 650 MB, then choose CD.

As discussed earlier this can be burnt to a CD using the Mac OS X Burn Folder. You create the Burn Folder say, on your Desktop, then put your files inside till you reach the limit you set. Allow room to add a ReadMe file that explains your terms and conditions of supply, and tells the client how you have organised the files on the CD, whether the files are in RGB or CMYK, and what profiles have been applied.

Only leave unclosed sessions if you know the client might need any extra unused space and they have Macs – most Windows users face problems with multi sessions.

If you know your client can handle DVDs and that you would otherwise have to write more than three or four CDs, I would suggest you go for that route, as it will save you valuable time. A single layer DVD will take about 4.3 GB of files. Double layer DVDs will store about 8 GB, but do remember to ask clients whether they are capable of reading the media on which you supply your images.

Size of a folder you are building?

Command+Option click+I on a new folder, and this Info panel will update as you fill the folder, in this way you get an idea of the size prior to burning to your chosen media.

Fig. 7.32 You create the Burn Folder from Finder.

Fig. 7.33 Click the button at the bottom of the window to calculate the size needed.

Fig. 7.31 You can create a branding image for your CD or DVD by using a picture rather than a white background to the folder, and also make a handy and attractive CD cover in place of the nondescript white sleeve. Using some Inkjet printers, you can add branding to the CD/DVD itself, if you get the white coated versions. There is also a very slow method whereby you can with certain recorders using 'DiskScribe®' actually burn an image into the surface of the media.

Output to your printer

Most desktop printers will connect to your Mac using either USB or USB 2.0, although many of the drivers bundled with Mac OS X are what are known as CUPS or GIMP drivers, you would be better advised to search out up-to-date manufacturer's drivers. When setting up many Epson printers, locate the drivers using 'Epson USB', rather than plain 'USB', as those would likely be the GIMP ones, and so would lose you some measure of functionality.

The Setting up is shown fairly fully on page 133 of Chapter 2.

You can also work remotely to your printer using an Airport Express Base Station, which may be more convenient by avoiding untidy and lengthy cabling. You do this by first connecting your USB printer to the USB output from Airport Express and powering it up. Next you create a Network using Airport Setup Assistant, which you will find in Applications/Utilities. Follow the Instructions to setup the Airport Express to a Printer (shown in diagram form on page 123 in Chapter 2).

There is an Airport Assistant program to help you set this up; just follow the simple instructions, by answering the bulleted questions. There used to be a separate Airport Express Setup Assistant, but this has been rolled into a single piece of software covering all the base stations, and there have been numerous firmware updates.

If you have the Airport Extreme 802.11n, this has Airport Utility, which is even more comprehensive, and allows you to connect a USB 2.0 hard disk as Network Attached Storage (NAS) using what Apple calls AirDisk. This allows all Network users access to the same disk drive wirelessly.

Always check that system software is the most up-to-date version, as almost invariably each update has simplified the steps you need to take. I shall show screenshots on the following pages.

On the right, I run through the Reset procedure before the setting up procedure, which is not covered in the instructions for the Airport Express. Simply pressing the reset button and starting again – can often defy all normal procedures to get it working.

Airport Express Base Station

You will need either a spent ballpoint pen, or a straightened paperclip (you know the one that you use to relieve all your stress, by straightening and rebending!)

Plug in, but do not yet power up the Airport Express, this next procedure is more easily done if you use the Express with a lead, as opposed to plugging the unit directly into the wall socket.

Click and hold in the reset button, and turn the mains on, keep holding as the light goes from amber, momentarily to green, then back to a steady amber, keep holding for about a further fifteen seconds till the unit shows green pulsing about four or five times before settling to pulsing amber, you are now in a position to start.

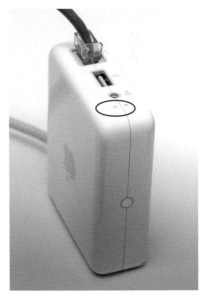

Fig. 7.34 The Reset button on the Airport Express Base Station often requires more than simply a press, and when used with the direct UK three-pin plug is difficult to access as the reset button lies on the underside of the unit.

Output to printer via Airport Express

Airport Express is Apple's entry-level Base Station, and with the later firmware and software will provide you with access to both your USB printer remotely, and AirTunes, so your music can mask the sound of the printer and keep the mood in the studio!

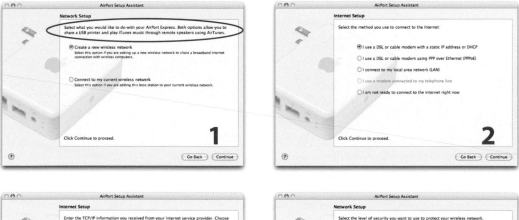

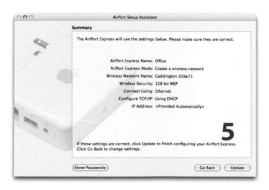

Fig. 7.35 After the initial introductory screen these are the steps you are taken through in the setting up of the Airport Express – you can modify the settings of an existing Wireless Network by selecting the alternative radio button in **1**.

I have shown the likely stages **2** through **5** that you will encounter. You then give the appropriate details that either you get from your ISP, or you create yourself, clicking continue for each completed page.

Selecting the printer is then just the same as any connected physically via USB, and can be shared by any user over the wireless network – provided you check the Printer Sharing box in the Sharing Preference pane within System Preferences.

Outputting image files

If you take a series of images for a client, and you have ascertained what they wish to do with them, they will now be fully color-managed files in either RGB or CMYK, or even black and white, they will be flattened files more than likely, but what file format should they be? TIFF or EPS, or PDF, or JPEG, they could even be DCS 2.0, but what governs the decision? Sometimes the client is not the printer, and may not know themselves, so what are the differences?

TIFF is probably the best, and now possibly the most common. In Quark Xpress, this will generally look best, but many printers prefer EPS for speed. Many of you will have seen your on-screen results at a printers or Repro house looking very pixelated on their screens, well, these are likely EPS files. However, do not fret, they should still print fine, but the first time you see them in this form, your heart will sink! A TIFF in a similar page layout will not look so ghastly, but will probably slow the planner or designer down, hence their choice. Historically, it was only EPS files that allowed for clipping paths to cut out images from the background, and some people have simply not moved with the times. Also, if your images are not for cutout, for other similar reasons where technicians have not updated their software, it is an idea to remove all traces of any paths you may have used in the creation of your finished images*.

In the latest versions of Quark Xpress and InDesign, clipping paths can be understood if using PSD, TIFF and EPS files, but I do not advocate the sending of layered PSD files (saved with Maximum Compatibility checked) or layered TIFF files, or TIFFs saved with ZIP compression, but stick with what the Industry has generally accepted – flattened TIFF and EPS files.

The essential point to remember is not to assume what kind of file is needed; liaise with your client to glean as much detail as possible as to what they are expecting you to supply.

PDF and PDF-X output for files

You might now also be asked to supply files in PDF (the Native format for Acrobat).

PDF and PDF-X are two forms of Adobe's Portable Document Format, and if your images have text embedded within the Photoshop document, this is a good way to ensure that the fonts are treated exactly as you intended, there are distinct advantages of PDF, because you can lock the file from being printed or even viewed until a password is entered, which can be useful.

The variant, PDF-X is where the end process is known, and the client or their printer has supplied a preset Job Definition File (JDF), so that your file is known to exactly comply with their requirements. One other feature of PDF is that images can be supplied compressed.

You can also consider sending files as JPEGs if you can afford to sacrifice detail for the sake of speed of transmission via email or FTP (File Transfer Protocol), but use Save As... not Save for Web to create the file, and preserve your color profile.

*Note

The reason for the removal of paths, basically those that are not a Clipping Path, is that it may mask out most of your image in the page layout program. These paths are likely to have been used to create layers or layer masks, and they may now isolate just that area of your final image.

Terminal

In order to use the Terminal for file transfer using FTP, I recommend you open Utilities/Terminal, and at the prompt, type 'Man' – short for manual – this will display all the commands it understands, and the 'arguments', the items of information it needs to carry out each task. You use a space between each argument.

Fig. 7.36 If you feel the urge to use the Terminal to carry out ftp, then use the Man command to learn more about how to go about it.
1 – shows the line you type, then press <Return> to see the result **2.**

Fig. 7.37 Fetch Softworks, one of the earliest Mac FTP programs is now Universal, and its interface is not too dissimilar to RBrowser, which is free for just FTP use.

Putting images on the Internet

If you want to display your images on the Web in the form of a Gallery, the first stages can be accomplished simply in various versions of Photoshop, Bridge and Lightroom. The engine in Bridge and Photoshop is the same, but it is easier from Bridge.

Once the site has been created all the files can then be uploaded to your webspace, using File Transfer Protocol (FTP). I suggest that unless you are really techie, you do this using software such as Cyberduck, Fetch, RBrowser, Anarchie or Transmit, the last being probably the most popular currently.

HTTP is the protocol for serving web pages. Web browsers use this protocol to download pages from websites, but for getting files and moving them from one server to another, FTP is the way; and with appropriate software, can also be more secure by offering SFTP. Some browsers do also allow FTP downloads.

Using Connect to Server via the Go menu in Finder (**Command+K**), you can access an external IP address with authentication provided by user name and password. If the server is on your machine using the built-in Apache Web Server that comes with Mac OS X, you will be using the Users and passwords you have allocated with associated Home folders. If the webspace is located on an ISP's server, the authentication will have to be arranged with your ISP.

Lightroom and Photoshop can create Web Photo Galleries using templates (editable as well) for ad hoc sites for clients to view the results of shoots, and some can provide you with feedback.

A stage further

If you need a more sophisticated presence than the Web Photo Gallery, then this can be achieved with site building software such as Dreamweaver, GoLive, or Softpress Freeway.

These are primarily desktop publishing programs for the Web, and as such give you more total control over not only the creation of your site, but manage the editing and updating in a formalised way. If the prepackaged look is not to your taste, BBEdit and TextWrangler allow you to get 'down and dirty' with coding and editing the HTML, PHP, Perl and JavaScript – none of which I am qualified to help you with!

Apache Web Server

Apache Web Server is supplied with Mac OS X, and when this is set up on a Mac that is permanently online, you can serve your own web pages which would mean you have total control, but you may well find that using an external ISP is less trouble.

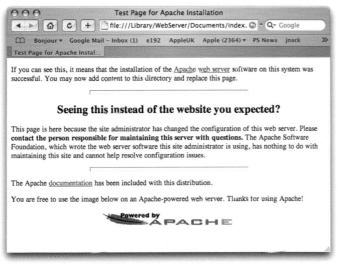

Fig. 7.38 If you have not created your own webspace for Apache to serve, you are likely to find yourself seeing this holding page.

Apache

It is not immediately obvious where Apache resides, or how to use it, but the easiest way to start it is to go to System Preferences, choose Sharing and tick Personal Web Sharing.

At this point a default screen may become available to web browsers explaining that Apache has not yet been setup.

Probably the best place to start to learn what you do next is to look for a file 'FAQ.html' located generally in:

Library/Documentation/Services/apache/misc/FAQ.html

In there you will find the information to get Apache up and running for you.

.Mac

Another option is to consider using the Apple offering – .Mac, which is scalable, and can also be used as external backup for other personal items such as your email, iCal and AddressBook and iDisk.

If you are in the habit of regularly sending largish files to clients, you may well have hit the limits imposed by using email, either at your end or theirs. In which case, you may want to consider asking your ISP for FTP space and the use of an FTP Server, so that you upload files to the server, then simply email your client to say they can be collected, thus removing the pressure of direct delivery to them. This may also avoid problems involved with corporate Firewalls.

iWeb

Another way to get images into your own web pages is actually bundled with Mac OS X. Known as iWeb, this program is designed to work alongside iPhoto and utilise the space that comes with .Mac.

It provides a series of themed design templates for which you supply the images and text. To help guide you Apple provide a link to their site and a series of tutorials. It is not exclusively for display by .Mac, but the links are all there for retrieval of images from iPhoto and uploading to a .Mac account webspace, with the mechanisms for updating the site.

Fig. 7.39 Selecting a basic theme from those in the left-hand column of the sheet shows a subseries.

Handing over images

As a Mac-using photographer, you will have become reasonably familiar with a world that considers that everything you produce is likely to present a problem, whereas the reality is very different. Handing off files to clients is a case in point, so make life easier for yourself – add extensions to filenames. If you are doubtful about the knowledge of the recipient, ask them for precise details over filenaming. If you have color profiles, check whether the client understands the need for them. Always try to make sure clients see hardcopy, ask them to come back to you if they meet a problem.

Essentially, develop a sound working relationship

Make sure you are supplying work that fits with the use they need to make of your images. 'Don't know at this stage' is not a good enough answer. If the job is to be printed, at what size? On what paper stock? Is it coated? Will it be sheetfed or web offset? Do I supply RGB or CMYK? Get all these answers beforehand, or take precautions to cover possible eventualities.

For most photographers images will come as either a series of individual pictures or a collection, they will rarely come as text and pictures; they might occasionally come as cutouts, so file formats are likely to be TIFF, EPS, PSD, PDF, or JPEG probably in that order of likelihood. I generally prefer to supply TIFF, but when dealing remotely, I do often resort to JPEGs (most often at level 12). I do supply a lot of cutouts, and these will invariably be TIFFs unless asked specifically for EPS. Despite general reservations about layered files, I do sometimes supply in this form when I know that certain specialist work is going to be carried out later, but these occasions are rare. If I ever have doubts regarding how images are being used, I write concise ReadMe files in TextEdit. To protect myself, I have even used the IPTC file info to embed a small message relating to supplying a separate ReadMe!

Paranoid? Who, me?

Using the Web for client approval/selection

With the advent of Aperture and Lightroom, it has become possible to really make use of the Web to put up Photo Galleries of a shoot, often in a secure fashion to your own web page where clients have this area to view the images after entering a password that you supply.

They can run through your images and make decisions over selection, cropping and size, and send their instructions via email.

This method adds not only to your efficiency, it puts the onus on the client to get back to you, and adds to your prestige.

Handing over image files – PDF

PDF offers something that other formats do not – Security.

First, it can be password-protected against being opened by just anyone, secondly, the end user can view it in Adobe Reader. An example might be that your client is handing the files to a printer or designer, but he/she only has a Windows PC and without Photoshop, but does have Adobe Reader.

I have had to supply DCS 2.0 files where spot colors and bump maps have been a part of what I was required to produce, but it is rare. Very frequently, I have supplied Adobe RGB, with and without accompanying CMYK files.

One of the joys of working as I do, is that I meet very different photographers and working practices. There seem to be no rules that are sacrosanct. Most photographers will say: 'Only ever supply flat files'. It is often said out of fear, sometimes because the files that are then used by the client may not be as you supplied them, but were they ever? I worked in a London professional color lab, and I can tell you, we often made duplicates for reproduction, some to match, some to improve.

I agree, you rarely, if ever, handed over negatives, but working for some government agencies and on prototype cars and other secret products, it was common practice, so do you never hand over RAW files? Never hand over layered TIFFs? These situations are judged individually. When I work with studios I frequently hand over all my editable files as well as flattened versions, and some of those studios hand on layered files for those last minute client changes.

But invariably, my editable files are simply as an adjunct to the flattened TIFFs which may often have no channels or paths unless Clipping Paths are specified for cutouts. A couple of points here. Clipping paths can be used on subjects that are cutouts plus soft shadows, but pull the path just outside the last remnant of the shadow, this avoids nasty edges (printer willing!). The second is if you have several such images, first fully desaturate the shadows (or reflections sometimes) so then they are grayscale within RGB* or CMYK – it aids consistency.

Note

*I feel this comment needs expanding.

If you are working in RGB, make the shadows neutral here, because provided the correct conversion takes place, the resultant values in CMYK will be correct for neutrality, but the values for CMYK may not be equal, they will likely read something like this:

	C	M	Y	K
1	7	5	5	0
2	10	7	8	3
3	46	39	38	38
4	58	50	50	52

Some printers isolate the black, and only print this for the shadows, but such shadows look very mechanical and lack the richness of a full-color black.

Network, Backup, Archive

Mac OS X, which has roots in a collaborative environment, has good credentials when it comes to talking to other computers, regardless of platform. Couple this with the different means with which it can carry this out, and you soon realize how powerful a tool you have before you.

Those roots are in BSD Unix, which has many established protocols for the entire computing environment including the Internet. Mac OS X can tap into all these. Broadly speaking you can have network connections using Bluetooth, AppleTalk, FibreChannel, Firewire and Ethernet.

The most prevalent network protocol is Ethernet, at speeds from 10 MB per second to 1000 MB per second (Gigabit Ethernet). One aspect worth bearing in mind is that the greatest efficiency and speed will be achieved if each computer on the network is rated at the same speed; as in some cases the speed of a network is governed by the device with the lowest speed. As image files grow ever larger, moving them around and preserving them for further use presents new challenges for the photographer to consider – so use Gigabit switches and Cat 6 cables.

Networks

When you connect more than one computer together, you are creating a network. At the very simplest level, you can connect two Macs together by stringing a cable between them! That cable in most cases would be an Ethernet cable, but could also be Firewire. Computers talk to each other by sending and receiving data from both ends, so that when one is transmitting the other is receiving, and vice versa. At one time this meant when using a single cable between two computers, it needed to crossover from one end to the other. Modern Macs sense this, switching automatically,

Generally, each Mac has only one Ethernet port (as the RJ45 sockets are known), so if you have more than two Macs that need to be linked, they have to have a sort of junction box having at least one port for each Mac. This box can be a hub, switch or router (often supplied with a 4-port switch). A hub is the least intelligent, the router the most sophisticated, but for a simple wired network a switch is ideal. The type of cable you use is known as UTP Cat 5e or Cat 6. The UTP standing for unshielded twisted pair; in layman's terms – fairly uncomplicated wires!

A hub simply passes everything it receives to all its other ports and on to the connected computers. It has no knowledge of who sent the data, nor who will receive it. A switch however is able to learn the computers' addresses, and to which port they are connected, so only passes the data to the specified computer. It learns this from each computer's MAC address (Media Access Control – nothing to do with Apple Macs!) – the term applies equally to both Windows and Mac computers! It can also be referred to as the Ethernet address.

If you have a 100 MB per second network, and are using a hub, the connected Macs share that bandwidth, as it is known. If on the other hand you are using a switch, each connected Mac will have use of the full 100 MB per second bandwidth. A Mac with a low bandwidth card or other low bandwidth device connected to a hub would be limited by the sharing of the bandwidth, whereas that will not be so with a switch.

Note

Do take note of the Ethernet bandwidth/speed of your Macs when choosing the appropriate hub or switch to get the optimum for your network. If you have forgotten, or do not know the rating of your Ethernet connection, for older machines, this can be found from Apple System Profiler – Apple Menu/About this Mac, then click on More Info and down to Ethernet. Most Macs nowadays offer Gigabit Ethernet, that is 1000 MB per second data transfer rates – this can be confirmed in Utilities/Network Utility under Link Speed, you can no longer find this out from Apple System Profiler.

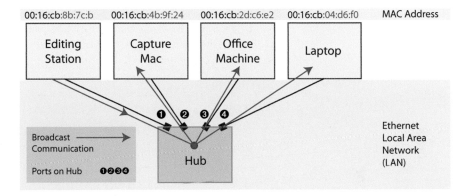

Fig. 8.1 This diagram is similar for both hub and switch, however the switch will perform more efficiently, because it learns to send data to the addressee only, not to all the connected Macs.

In the above diagram a hub is connected to four possible Macs via its Ethernet ports, showing the Editing Station communicating some data to all the others. A switch would be physically connected identically, the difference is that it is intelligent enough to look at the data and extract its destination address, and so pass the data only to that Mac. This makes it easier and swifter for individual Macs to talk to each other.

Communication over a network is done by splitting the data into what are known as packets, with each packet carrying its addressing information. The only knowledge a switch requires is the MAC address of the recipient to be able to function.

In a switch, it initially behaves like a hub, broadcasting to all ports other than the incoming one; it then stores the relationship between the ports and MAC addresses in a MAC Address Table, and uses this information in future for direct transfers.

Your network really only benefits from a switch if there is a large amount of traffic, since less busy ports could still communicate. An even more sophisticated device is a router. These units can be programmed to understand how to deal with the traffic they handle, and can help protect networks by introducing what is called a Firewall, often using a process called Network Address Translation (NAT). It is able to link one network to another, in particular your local network with the wider world, the Internet.

Network Address Translation (NAT)

Let's assume that your Internet Service Provider (ISP) has given you a fixed IP address. This address will be used to connect between your router and your ISP. Inside the router, NAT will then transfer the data to your internal network using an address in a range that is not used for Internet traffic. This means that numerous users can have private networks which use identically numbered addresses.

For example internally I might use 192.168.0.1 for the internal address of my router, 192.168.0.2 for my main desktop machine and 192.168.0.4 for my laptop, whilst across the world another user could use these same numbers in New Zealand, but when communicating with each other we would see the other's ISP-allocated number which is a public number available to the Internet. The private numbers are used for Local Area Networks (LAN) and the ones available on the Internet are described as Wide Area Network (WAN) numbers.

So, in order of complexity and function the devices I have discussed are:

1. A single UTP Cat 5e or 6 cable between just two computers – it can be a crossover Ethernet cable (no longer a necessity).

2. A Hub – this can have any number of ports (most commonly 4, 8, 12, 16 etc).

3. A switch - again in similar port configurations to hubs.

4. A router, this may well be the ISP's incoming port (Wan/ ADSL) and similar configurations of output ports to those of hubs, because they often incorporate 4-port switches.

The most likely router a photographer will encounter is one that connects to either ADSL or Cable, as a Broadband Router, and is often combined with a switch. Recent devices from Apple and others, are those that also have a wireless option (described as Airport from Apple, WiFi from others) Whether wired or Wireless, the router forms a bridge between the Internet, and your internal network, often called an Intranet or Local Area Network (LAN).

The speed at which the traffic is handled is another variable – the earliest used to be known as 10Base-T, and the speeds that have grown from this have been known as 100Base-T, and more recently 1000Base-T, better known as Gigabit Ethernet. 10Base-T operated at 10 Megabits per second, 100Base-T at 100 Megabits per second, and therefore Gigabit Ethernet at 1000 Megabits per second. Try to go for a full-duplex implementation, which means communication goes in both directions simultaneously.

You can create a network to communicate from your laptop Mac to your editing station by plugging into your switch using an Ethernet cable, however, if you are returning from a location shoot, you might well choose Airport. Obviously this presumes that your laptop has Airport. Fortunately, the latest crop of machines all do. This should all be set up and tested well beforehand, so that it is a simple matter of turning on the Airport and logging into the network, then copying from your laptop to the hard disk of your base machine. Using Adobe's Image Processor script you should be able to make this an automatic operation requiring minimal intervention.

Copying Images from camera or card

This operation is sometimes described as ingestion, so if you hear a script described as an ingest script, then this is what is meant.

In Mac OS X this operation is carried out by Image Capture – as soon as a connection is detected as either a camera or memory card, it springs into life and offers to help. Most of the major camera manufacturers and Adobe also offers similar functions, so Photoshop uses the 'Image Processor', which can save both a TIFF and a JPEG from each file encountered, Bridge has 'Photo Downloader', and Lightroom's is inbuilt.

In order to simplify tethered shooting, that is where the camera shoots directly to the computer, Lightroom uses a watched folder, from which files enter Lightroom's library using Auto Import.

A common studio situation involving a router

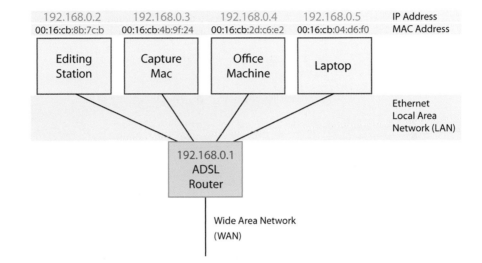

Fig. 8.2 Each computer has a physical hardware address known as its Media Access Control (MAC) address. The first part of the number, indicated in black, is the Manufacturer's code, the second part is the unique serial number. The attached Router can define individual IP addresses for each networked computer, and the built-in switch uses the MAC address to transfer individual packets of data to and from the correct devices. Using Network Address Translation these local IP addresses are only seen as a single public IP address.

A point worth bearing in mind is to rename your computers to correspond to their function when you first set them up. Having them all named 'Macintosh HD' is not very conductive to easy troubleshooting! Trying to change these afterwards is less straightforward, but there is a way in which you can improve the situation. When you first set up a new machine, you are offered a short computer name that is frequently your first name added to your make of computer, such as Rod's Intel iMac.

You can alter this short name in the Sharing Preference pane. So, for instance, my old G3 Pismo PowerBook is 'Blackie', and my newer PowerBook is 'Shiner', and the Intel iMac is 'Snowy'. Many Mac users often have even more esoteric names – you could always name yours 'C Drive'!

Fig. 8.3 AppleTalk itself has a totally different set of protocols and numbering system from TCP/IP, but what you are setting up when you click the 'Make AppleTalk Active' box and leaving it set to 'Automatically' is using AppleTalk over IP which brings it into line with Internet Protocol standards whilst offering Macs their peer-to-peer advantages over your network. Apple is moving towards more strict IP-based networking and 'zero-config.' Leopard shows all published devices under 'Shared' in Finder windows' the sidebar.

Fig. 8.4 Ticking any of these boxes is opening up ports through which particular services communicate. If the next tab is clicked, you will see a repeat of these, because the Firewall closes all ports except these ones you designate here. Often The Firewall is setup at the router, in which case this system Firewall should remain off.

Network – AppleTalk

AppleTalk is a simple peer-to-peer network, where each machine will assign itself a unique identity in the network. Connect your Macs to a hub or better still a switch, using an Ethernet cable.

From the Apple menu or the Dock, select System Preferences and open Network. Select 'Show: Built-in Ethernet', then click the AppleTalk tab and check 'Make AppleTalk Active' on each Mac, and click 'Apply Now'.

In the Systems Preferences/Sharing Preference pane on each of the Macs, you will need to tick Personal File Sharing.

This is not a server situation, it is referred to as a peer-to-peer network – each machine can talk directly to another.

You can have a series of user's Home folders on every machine; this is a fair-sized overhead, but should make it easier to have access to all the files each machine is working on. It will also mean that people can move around from one machine to another and even have two people use the same machine at different times, and for added ease, use Fast User Switching (FUS). This changeover is done from the menu bar at the right-hand end, where the current User name is displayed.

FUS does not force the current user to quit running applications; this user simply logs out, and the next user simply has to log in – this action is signalled by the user's screen seeming as if it is on the side of a rotating cube, that swivels of to the left bringing the next user's login screen in from the right. When switching back, everything is exactly as you left it, unless you had a background task running which might now have completed.

You can alter Permissions to individual folders by selecting them, and doing a Get Info (**Command+I**). In the box that comes up, at the very bottom, you will see a section marked Ownership and Permissions – set the access you feel is appropriate. This is not a true server system, so for maximum access, each user will need to have an account on every other, if not, access will be limited to a folder called Public in the user's folder, possibly in a subfolder called Drop Box. The choice is yours, it may even be that you would prefer each to only communicate as Guests, with more limited access privileges.

It is a good idea to designate one Mac as the main one, and for this one to have a large capacity hard drive, so that you can consider this one to be effectively your server, by making it the central repository of many of the important files. Obviously in a larger concern you could actually have a server, and this could be an Xserve. One handy advantage of using the Mac OS X Server software is that when creating additional Users, they do not all have to have the encumbrance of a Home folder and associated folders, it need only be the means of allowing limited access to any of the Macs, though more than those offered to Guest.

Once you have mounted a remote volume, you can drag its icon to your Dock, or to Favorites; you will then be only a click away from selecting that volume after a restart.

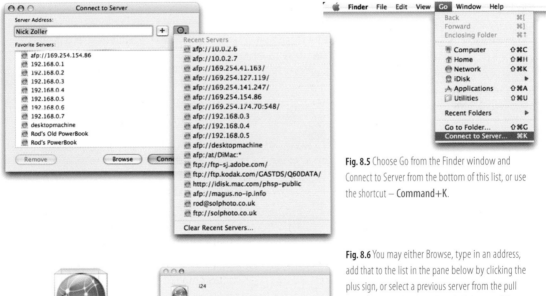

To see the available shares for server "I24", click Connect.

Fig. 8.5 Choose Go from the Finder window and Connect to Server from the bottom of this list, or use the shortcut – **Command+K**.

Fig. 8.6 You may either Browse, type in an address, add that to the list in the pane below by clicking the plus sign, or select a previous server from the pull down menu on the right, then click Connect. When you choose Browse, you are taken to a Finder window and Network, highlight this and you should be able to see the other computers and a cube with a world globe within and a button marked 'Connect'. Click this to see a window listing the Shared volumes available.

Each individual AppleTalk-connected Mac will attempt to acquire itself an address, altering it until it is unique, at which time it becomes assigned. Each user has to go to the Sharing Preference pane, and tick Personal File Sharing. From that time onwards other users can use the Go menu in Finder to select Connect to Server at the bottom of the menu.

Once you have been logged into a server, it is stored at the end of the Recent Items list in the Apple menu, under Recent Servers. Also, there is a similar list of previous servers in the dialog box that appears after Connect to Server is clicked; it is in the top right under the clockface icon (see Fig. 8.5 on the previous page). Clicking this will get you a dialog box with a window of past IP addresses or names. Right at the top of that main window you can either add your newly entered address, select an existing one from beneath that box, or Browse. I would generally suggest you choose Browse, which opens a normal Finder window on that machine, with listed network connected Macs. Each live, connected Mac is listed as an alias. Click on this and you will get a Globe in a box icon with the Connect button beneath.

Public Folder, Shared Folder, Drop Box

Each User has in their Home folder a Public folder, and within that can be a Drop Box. In the main folder is a Users folder in which there is a Shared folder. The purposes of each are as follows.

Items placed in the Public folder are by default available to everyone on your local network, and this can be accessed without a specific user name by using Guest.

In the Users folder at the root directory of a System Disk is a 'Shared folder' – this can be accessed on the local network, by default.

The behavior of these folders can be altered by the Administrator, by changing Permissions in the Info file for the folder.

Tip

When you have made a network connection one action worth taking is to drag the volume* to the Title bar area, wait for the plus sign to appear at your cursor and drop it along the top. It will appear as a globe icon. After you have unmounted it this will revert to a question mark icon, but it is still accessible, and readily so – hovering over it with the cursor brings up the volume's name in the Tooltip.

Provided you are aware of the security implications, if you've ticked the box 'Remember Password' access to that volume is very much faster.

* Remember to ensure you are dragging from the root directory not from the sidebar where all the icons are aliases. As this will simply result in your alias going up in a simulated puff of smoke!

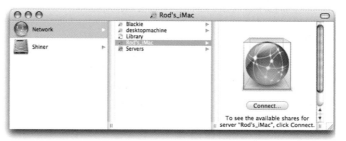

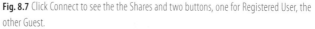

Fig. 8.7 Click Connect to see the the Shares and two buttons, one for Registered User, the other Guest.

Click and you are asked to log in as a Registered User or Guest. If you do not have a User Account on the particular machine, then you will be given only Guest privileges. By default, Guest will only allow access to the Public folder in the User's Home directory. For regular communications between users it is sensible to create users on each Mac, even though each then has a Home folder, which might seem excessive. Once logged in, you will be shown the shared items, and you can select those volumes or folders that you wish to mount on your desktop.

Shared items

Each Mac has control over what is made available to share. You use the Get Info panel for either an entire volume or individual folders within the volume, go to the bottom of that panel, to Ownerships and Permissions, click its reveal arrow, then click the Details reveal triangle.

You will need to unlock the padlock, by authenticating. You will then be able to alter the Permissions defining which User or Group has access to that item. You must do this prior to opening Personal File Sharing in the Sharing Preference pane, so that the user logging in only has access to what you have set.

After this, if you selected a volume, it is as if the other user's volumes you chose is local to you, because it will mount on your Desktop like any of those you already have mounted locally.

When you no longer need the shared volume, you simply click the Eject symbol to the right of its name, in the sidebar section of your Finder window. You can also highlight the item on the Desktop and use your context-sensitive menu (hold down the Control key whilst clicking on the volume, and choose Eject).

Something worth mentioning here, that I discussed in the previous page's sidebar is worth some clarification and this relates to a Finder Window's display in column mode. Unless you have the original Computer disk named icon in your sidebar column on the left, all you have are aliases for your various volumes, which means that as soon as you try to move them elsewhere they simply disappear, what you need is a column that seems like a duplicate, but in fact is the original! How do you get it to reappear? The setting is in Finder Preferences. Click the topmost box under the Sidebar tab (see Fig. 8.8 below).

So long as you are looking at a file or folder on your startup disk, **Command+click** on the name in the Title bar and go all the way back – you are now looking at the computer as a whole, which shows exactly those items.

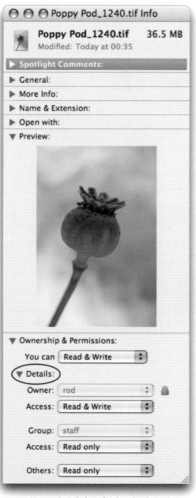

Fig. 8.9 Here is the Info for a file, but the dialog box is the same for File, Folder or Volume. You click on the padlock to unlock it.
You will then be asked to authenticate, and the grayed out items will be turned to full black. Make your changes and click the padlock closed.

Fig. 8.8 Here is how you restore the computer name and icon to Finder's sidebar.

In a studio, a fixed Ethernet network is probably the most effective because of its speed and the lesser likelihood of interference. Cabling can be either UTP Cat 5e or 6; Cat 6 can sometimes benefit GigaBit Ethernet. Due to the narrowing of price between hubs and switches, it is worth implementing switches, but the real gains will only occur when all the Macs are really busy over the network.

The MAC address mentioned is the physical hardware address of devices, there is another important address and that is the IP address (IP = Internet Protocol) and these appear in the form of four numbers in the range of 0 to 255, separated by dots – typically in the form: 192.168.0.x, where x is the unique number for the device, which could be a computer, a router or a printer.

Local Area Networks (LAN)

LANs or Intranets are those that are not recognised by the Internet; they have reserved addresses like the one mentioned in the main text, 192.168.0.x

Other address reserved for private networks is 10.0.1.x with a subnet mask of 255.255.255.0, and this is often found when using Airport networks – similar rules apply in relation to the subnet mask and the available IP addresses.

Dynamic Host Communication Protocol

Better known as DHCP, is the automatic way to assign IP addresses, and in simple networks is likely to be the preferred method. When multiple routers or computers can become DHCP servers, setting up can be more complex, and this is where it is possible to set some addresses automatically and others manually, and I would then suggest you consult an expert.

Note

When linking a router to a switch, never run two cables between them as this will cause a loopback and a total failure of your network.

You can assign these numbers directly to a particular Mac or let the Mac make the decision, using DHCP. Doing it manually can avoid possible clashes where different computers are switched on and connected at different times, but if you do it this way, then make sure that the Macs and their numbers are known, by possibly labelling them. Also, if a router is involved which may be the case where you have a Broadband connection to ADSL or cable, make sure its number is known. It will often be 192.168.0.1.

The IP address I gave earlier is a general purpose number that is not available over the Internet, but specifically reserved for Local Area Networks and it has what is known as a Subnet mask, which is a way of limiting the numbers into defined groups. All you really need to know is that a subnet mask of 255.255.255.0 ensures that the range of possible addresses are masked by the 255s, fixing the first three elements of the address, so only the last number can vary, meaning that the subnet you are using is 192.168.0.x your available addresses are limited by one byte, and in the range of 1 to 254, so your router, may be 192.168.0.1, and the others on the network can be 2,3,4, etc., up to 254.

Rather than get bogged down just understand that where a subnet mask has 255, it will fix that number within the IP address, and where 0 will permit the full range of numbers within the range 1 to 254; any other number in the mask, will limit the possible values for that byte.

Networks – where is all this setting up done?

Having connected your Macs to a switch, what have you got to do to enter the settings and addresses I have mentioned?

The starting point is the Network Preference pane which you will find in System Preferences, however the quickest way to reach this pane is via the Apple menu to Location, where Network Preferences is the very last item.

I have to make an assumption here, that may not apply to everyone, but hopefully explains the principles well enough to translate to specific instances. Most routers nowadays adopt a Browser interface to simplify setting up, and are quite likely to be an easy way to provide the basis of a studio network. They may well take the IP address shown in Fig. 8.11, of 192.168.0.1. The subnet mask shown means that the last part of the address can contain any other numbers from 2 to 254, so if you enter 192.168.0.2 for this Mac, where it currently shows 0.0.0.0, you will have set your first address when you click 'Apply Now' at the bottom right. Don't just close the box!

If you go to each connected Mac and give it the next number – 3, then 4 etc., and labelling each somewhere, then you should have little difficulty when tracing your connections at a later date.

Note

Another way to consider numbering your Macs in a studio environment is rather than 2, 3, 4, etc., number them in tens – 20, 30, 40… In this way you can add numbers in groups, so if the first editing station was 30, and you added another, it could become 31, or you could reallocate 30 to 31 and make the new Mac 30.

If your office machine was 40, and you had grown and needed a second machine there, it could become 41, and so on, if you adopted a manual means of assigning IP addresses. If you chose the DHCP (Dynamic Host Communication Protocol) route, all this would be handled automatically.

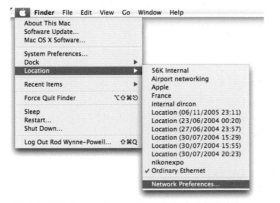

Fig. 8.10 This is the more direct way to get to the Network Preferences.

Fig. 8.11 Selecting Built-in Ethernet from 'Show' and then selecting the TCP/IP tab gives you this window.

Ethernet networking

I did not mention the address numbering method in AppleTalk's own numbering system, but that of *AppleTalk over IP which shares a similar structure, because you simply never need to know them to use the system. The reserved address ranges differ for both. With Ethernet networking, there are two address components that you may need to understand, possibly a third related item, the MAC address (discussed elsewhere in this book).

I am not trying to explain the technicalities, but simply saying accept this, and it should work. If you do wish to take things further there are any number of pages on the Web.

Ethernet networking is totally cross-platform, working over Linux, Windows and Macs relatively seamlessly.

Each of your Macs link in the same way as working with AppleTalk, in that they are connected using the same cabling, the same physical connections; the Ethernet sockets on your Macs.

***Note**

Strictly speaking this is Appleshare over IP, it uses standard TCP/IP numbering for addresses.

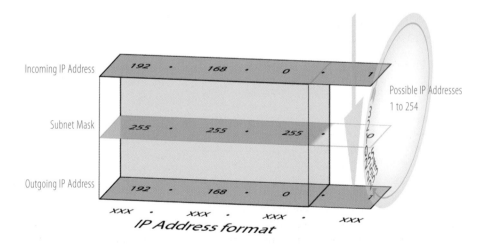

Fig. 8.12 The Subnet Mask when 255 locks the original value, whereas 0 allows every permitted number in the range 0 to 255. The two values 0 and 255 are reserved values, shown in red, and these are not permitted for use as addresses on your network. In a typical situation, the value 1 shown above would likely be that of a router, 2 your first Mac, 3 your third etc. If you enter values for this last slot manually, a tip might be that you allocate 20, 30, 40 etc. You can also allow your router to allocate the numbers automatically; this is done by using DHCP, which you would set in the Network Preferences pane in the TCP/IP tab, after you have set either Show: Airport, or Built-in Ethernet.

IP addresses

The two linked items are firstly the TCP/IP address (often shortened to the IP address) and the Subnet Mask. Ironically the Subnet mask is probably the more important, even though you are rarely going to need to alter it! This defines your network, by locking the elements of the IP address that make the network unique. The part of the address that gives you individual addresses are called the host. The network addresses you will use on your intranet are specifically excluded from being broadcast on the Web. Without going into this subject too deeply, web addresses generally belong to a Wide Area Network (WAN). Those that are used by us that do not belong on the Internet, are described as being on a Local Area Network (LAN).

Where a value in the Subnet Mask is 0, then this will allow all the possible IP address values (0 to 255) to be set for that network, however both those extremes, the zero and 255, are reserved, so the total possible addresses for that network will be 254, that is, any number between 1 and 254.

An IP address is constructed in the following fashion:

xxx.xxx.xxx.xxx

where xxx is a decimal value between 0 and 255.

This notation is known as dotted decimal, because each item is a decimal number, separated by dots. For the technical reader, they are bytes or octets within a 32-bit binary number.

The Subnet Mask defines the range of network addresses available to you within the subnet, for use in your network. The static numbers are effectively your network, and the unmasked numbers are the possible addresses you can allocate and ultimately with whom you can communicate - the Subnet.

You can allocate IP addresses manually or automatically; this is done within Network in System Preferences. DHCP (Dynamic Host Configuration Protocol) is one such automatic process.

Note

Examples of LAN address series are 192.168.x.x, 10.0.x.x and 172.16.x.x.

The lock is performed by giving a byte in the Subnet mask a value of 255. The most likely values for the first two numbers in the IP sequence for a LAN Subnet Mask are 255.255 thereby ensuring that those first two numbers of the IP address are preserved.

Often, the third number of the IP address is zero or one, and the Subnet Mask is commonly 255.255.255.0, thereby only allowing the final number to vary.

254 items of equipment connected to your network at any one time I imagine should be enough.

'Should I allocate the addresses manually or automatically?' There are advantages to both methods, so which method you adopt will depend on the nature of your setup. The advantage of your allocating a specific address to individual machines is that you can make a note of this, making troubleshooting simpler. You may have to learn a little more about the subject.

In any studio there will be times when you need access to the Internet and more specifically, a broadband connection to it. For instance you may need an urgent update for some of your software, or you need to send clients the preliminary or final results of a shoot. You are therefore very likely to have a router, and this could be the wireless variety. The router will almost certainly require setting up via a web browser, and the IP address of that router may well be either 192.168.0.1 or 10.0.0.1. What that means is that the lowest number in the available series for your internal network is that 1, so other computers will be any number from 2 to 254 in either series in the format 192.168.0.2 to 192.168.0.254, or 10.0.0.2 to 10.0.0.254.

I do have a suggestion which might eventually make life simpler later. The suggestion is that instead of actually using 2, use 20, instead of 3 use 30, and so on. The reasoning behind this is to future proof you for when you might expand the network, and say have networked printers that were all in the 30s, or two portables both in the 40s.

Setting up was lightly touched upon earlier when dealing with System Preferences. Select Network from there, select Location which will list a series of previous Locations. I will assume the only one present is one created by the system and somewhat misleadingly named Automatic. Below the divider line in the list click 'New Location...' this allows you to name your network preset. Try to provide a meaningful name that relates to the network you are creating. I mention this because you can setup networking for different purposes and as the name suggests, different locations. So, when on location you may well connect to your Internet Service Provider (ISP) via modem. When abroad, possibly even to a different number, or lastly, from home. Once created, you can simply choose the preset from the list. The list of preset locations can also be found in the Apple menu.

Fig. 8.13 Choosing Location from the Apple menu is the quickest way to reach Network Preferences as well as the preset Locations you can create within Network Preferences. These allow you to create different settings for use under differing circumstances, such as working away from the studio or using an alternative ISP, or in emergencies falling back to a dialup connection when ADSL or Cable fails.

Creating a Location preset

When you have named your preset Location in the sheet which drops from the Title bar of the dialog box, hit OK, the sheet will disappear back into the Title bar, and you can make all the alterations you need in Network, then click 'Apply Now'. For safety's sake click the padlock icon in the bottom left.

In the 'Show' list choose where the network is supposed to be running – Airport, Built-in Ethernet, or Firewire, because the tabs then relate to the medium you are using. If you plan to use AppleTalk, then before finishing select the AppleTalk tab, and click 'Make Appletalk Active'. You can only run AppleTalk over one network medium; say over Ethernet, but not Ethernet and Airport networks. To make the change, click the 'Apply Now' button.

There can be times when past settings seem to override those you are trying to make, if that happens, select 'None' and hit 'Apply Now', then return to the new one, and reapply. Very occasionally, you may find a restart is necessary.

Note

In Leopard, the details you see in the dialog shown in Fig. 8.14 are hidden behind the 'Advanced' button, and a simpler interface for Network is displayed.

Fig. 8.14 When you select 'Manually', 'IP Address' will be blank initially; just enter the number you have decided upon for that Mac. The Subnet Mask and Router address should already be present. If your broadband connection is via the router, then the last two boxes can be left blank, since those settings have already been made via the router's web browser interface and stored within the router.

Allocating addresses automatically – DHCP

In the TCP/IP tab of Network Preferences, under 'Configure IPv4' are two automatic options: Using DHCP and Using BootP, the latter is an unlikely choice for photographers unless they are in a corporate environment. DHCP is the normal choice.

DHCP issues leases for the addresses it sets. These normally last a number of days before renewal, in most cases this will return the same address as before, however, if machines are being switched on and off irregularly, the numbers may possibly change and give rise to breaks in communication. In such cases, try clicking 'Renew DHCP' Lease in the TCP/IP tab of Network Preferences, or if that fails, restart the offending machine.

Assuming that the Subnet Mask is 255.255.255.0, the address that the DHCP Server will issue will be based upon the first three numbers of the chosen series, with itself, the Router Gateway probably set at 1, so: 192.168.0.1, first Mac found 192.168.0.2 etc.

Another option is a semi-automatic setting using 'Manually using DHCP' where on certain machines you set them to individual addresses at higher numbers, so that DHCP deals with the incidental entrants to your network. Under such a regime, it would be convention to set a Network Printer to 192.168.0.10. Most instances I imagine would be that your router was an ADSL or Cable router with a four-port switch, and the address 192.168.0.1 will have been set in the router's browser interface.

In the Sharing pane in System Preferences you can name each computer in your network – as I have mentioned it is best that the name relates to a position or function rather than a person's name, keep it short to save time and effort. When you are trying to connect to a named computer use the style:
 Computer_name.local – 'Retouch.local', 'Capture.local' etc.
This is Apple File Protocol, so the full address looks like this:
 'afp://Retouch.local' or 'afp://Capture.local'.
You can put Users into Groups, using the Accounts pane in System Preferences. The Router connects to your broadband connection. The Macs are connected by Ethernet cabling to a Switch/Hub, or wirelessly to the Router. By selecting Airport in the box marked 'Share your connection from' and then choosing the network you wish to bridge to, in the window headed 'To computers using', you effectively create one larger network.

Dynamic Host Communication Protocol

When you want to have your Mac network create unique IP addresses for each computer or other network device automatically this is the method of choice. The allocations are made either by a computer or router.

It is most likely to be by the router, and if this is the case, those settings may well be made via a browser interface. All the other settings for the router, such as the Firewall and Port Forwarding would normally be carried out from the same browser interface.

This means that most routers designed to work on Windows PCs are just as likely to work with Macs, but if in any doubt, check via the manufacturer's website and from lists such as ProDIG for reports on suitability.

DHCP can operate with fixed IP addresses alongside ones allocated automatically, and so is the most effective way to configure your network to allow for laptops to join and leave with ease.

DHCP is platform agnostic, in that the network can operate with a mixture of Windows PCs and Macs with equal ease.

Note

Should you decide to set up IP addresses manually, then you will also have to set a DNS address, otherwise you will be unable to connect to the Internet, since the addresses will not be resolved.

Talking to Windows PCs

It is all very well connecting a series of Macs together, but another possibility is that your studio needs to connect to a Windows PC. The network structure is the same as for Macs in terms of the connection, the difference is in the interface on the Windows machine. I am going to describe Windows XP Home Edition, but the operating system level you have, may mean the procedure differs slightly from what is shown here.

Firstly, plug an Ethernet cable between the Windows machine and your switch. Once the Windows machine is up and running, go to Control Panel, choose Network Connections in the window that appears, then go to the left-hand side pane and click on 'My Network Places'. Double-click on any of the networked volumes, and after authenticating, you can access that volume.

Fig. 8.15 When you are trying to link to a networked Windows PC from a Mac, this is the box you will be asked to fill in to connect to the PC.

Fig. 8.16 In Control Panel you select Network Connections, and in its window select My Network Places.

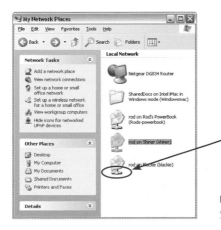

This bar beneath the open folder icon denotes this is a networked folder, in this case rod's Home Folder.

Fig. 8.17 You should now see all the Macs on the Network that have selected 'Windows Sharing' in the Sharing Preference Pane.

Backup and Archive

If the capture of your images is on film, then you are going to have to make some decisions as to what information you enter when scanning the negatives, transparencies, or possibly prints. The task is greatly simplified in some ways when shooting digitally, because as you press the shutter a wealth of detail is embedded in the file. However, the camera does not know your client's name, the product or model, or stylist involved, but it can be told. In the case of Lexar Compact Flash cards, this can be stored so that when the images are imported it can tag along with the other information the camera supplies, and be passed to Adobe Bridge or Lightroom for later use. Some cameras can even store GPS information, so you can record exactly where you were when the shot was taken – with an accuracy of about a couple of metres!

Archive and Backup – Differentiation

I should explain my definition and differentiation of these terms which in some instances seem to be identical.

Backup is a security function, archiving is a means of preserving the images you create and store, with as much additional information as makes it a straightforward task to search and locate them in the future.

Mac OS X creates an Info file for every file, and if you select a file and do a 'Get Info' you will see an item at the top called 'Spotlight Comments'. You can store information here that is used by Spotlight in its searches, and could be used in Smart Folders for easy access at system level. You can even take things a stage further by creating an Automator script. A very simplistic approach to being able to use Spotlight as your own fast keyword searcher is to create this single-step Automator script.

Fig. 8.18 Select the Application from the left pane, then double-click the Action, or drag it into the right-hand pane.

Add Spotlight keywords using Automator

This really is a simplistic use of Automator, but so long as you keep saving it for each change of keywords, it is reusable and is a timesaver. Where it says 'New Spotlight Comments' type in words or phrases of your own choosing and click the box beneath to append your keywords. Then Save As... naming it 'Add Spotlight Comments' and save it as an Application. You can keep it in the Dock for quick reuse.

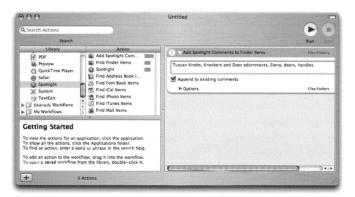

Fig. 8.19 Drag or double-click puts your selected Action in the Workflow area to the right.

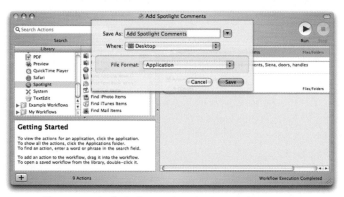

Fig. 8.20 When you save the file the first time choose 'Application', whenever you reuse it just Save, so that the name remains the same.

Fig. 8.21 The strength of this process is that it is quick, but do confirm afterwards that your comments have worked, by selecting one of the files and do a Get Info.

Archiving

The simple use of Spotlight to add a few keywords into the Comments field of the File Info box at System level is not meant to be a substitute for the likes of Bridge, Lightroom, Aperture, Iview Media Pro or Cumulus, it is just to illustrate that there is a simple way to extend the use of Spotlight which is very fast at finding that information. It does not involve a massive learning curve nor a large outlay. Another point is that in this case it only involved a single step in Automator, but you could apply several keywords to an entire folder of images in seconds.

When you want to use that script again, look at the bottom of the left-hand pane, click on the reveal triangle for 'My workflows' to bring it up in the right-hand side. Change the words, save it and then drag another collection of images or an entire folder onto the icon for the Automator script which is often best kept on your Desktop. If you create a similar script for some ongoing project that does not have the wording changed, you could put it into your Dock. Spotlight will find all those files very swiftly and in such a case, you could make your search into a Smart Folder, so though the files were in their correct folders filed away, your project images could all be accessed in that Smart Folder.

The object of archiving is to save your images in a manner that can be easily accessed. At the operating system level, you can file your images by client, by project, job number and by date within the natural folder hierarchy. This is fine if your client asks for the image by saying - 'You remember the Garage Door Roller mechanism you shot in Malvern on the 16th of June 2006?' But what if the question was: 'Do you remember the landscape shot of Door Rollers you did for me for me a while back? Well I need another print from it in the post tonight – any chance?' Obviously any cross-referencing you have from digital files stored on your computer, that mentions 'Garage Door' is going to find something fairly quickly, and you keep a happy client!

Spotlight and Sidecar files

Metadata – data about data – can either be stored as described on the previous page, within the header portion of the file, or stored separately, in a sidecar file – a file of the same name but with a different extension (.xmp is one such method) Adobe Photoshop and Bridge use this method.

Because of the proliferation of RAW formats from DSLR camera manufacturers, Adobe have attempted to bring order to this situation and their DNG format stores metadata as well as the RAW data, in a standard format, with the option to retain the original proprietary form. RAW data is ideal from an archive standpoint, as it is smaller than the rendered TIFF or PSD file, but it is in this instance, the comparatively unretouched file.

Note

If you are in the habit of saving layered files in PSD format, and you name your layers meaningfully, then if the only thing you remember of the file is that it had a layer called 'Lake', Spotlight would find your file if you searched for it using that term as opposed to the actual filename which you had forgotten – 'Windermere Boat'.

Backup

When you take a photograph, it is a record, it has a value, in some cases, it is irreplaceable, but ensuring absolute safety of preservation comes at a cost, so deciding on a backup strategy has to take into account the costs of shooting again, losing a client, losing that sale, losing future sales, and all the associated costs of travel, equipment, and time. Only you can make that assessment, and adopt procedures that ensure that the most valuable images are backed up, possibly off site, in case of fire, theft or flood, at an affordable cost. To have no backup at all is foolhardy, but how far you go will depend on factors such as – will the client want repeat prints in a month's time? Are you sending files to Libraries? Will they be readable in two years' time if they are stored on CD? Are they taking up too much space? Do you need to store the editable files as well as the flattened files? I cannot answer the questions, but you should be asking them.

What medium should you consider for storage? I can give some pointers here – if you are likely to be called on to supply images over a period but short term, though after say three months, rarely if ever again, then keeping files on accessible hard drives make sense until you see no more orders, but it still makes sense to have backed them up originally to CD or DVD (dependent upon size and number), and then remove them from hard drives after a set period. Medium term storage on hard drives is sensible because the files are so readily available and the cost of the hard drives is negligible in terms of cost per megabyte. One hard drive takes up far less space than piles of DVDs or worse CDs!

If you have a .Mac account, then 'Backup' can be your means of backing up remotely, or you can also use 'Ditto' which is part of the System. You use this command to backup individual folders or a volume, from the Terminal application, which is located in Utilities. Open Terminal; at the prompt type 'ditto' followed by a space, then drag the folder you wish to copy into the Terminal window. The pathway for your folder will be typed in! Type a space after that, then drag the destination folder into the Terminal window. You will notice that if your folder name had spaces in it, it will be now be typed within inverted commas. Hit <Return> and the copying will take place.

Leopard and Time Machine

Time Machine automatically backs up data to a destination disk of your choice, it can also backup multiple volumes and disks. You can also limit what is backed up by excluding certain folders and whole volumes to keep things under control. Once set up the process runs in the background without the need for further intervention. Changes to your data are backed up incrementally, and this is done every hour over the 24 hours, for as far back as there is space on your Time Machine disk. If this disk is disconnected Leopard won't fuss at first, but after a few days you will be nagged about the fact that backups aren't current. When capacity gets tight, Time Machine discards the oldest stored data in order to make room for the new. If this way appeals, make sure you get the biggest capacity drive you can afford.

Time Machine shouldn't be seen as a solution to all backup requirements, but it is both very easy to set up and use. Pick a folder window, invoke Time Machine, and you can step back in time to see and access earlier versions of that folder and its contents.

Time Capsule is a combined Airport Extreme and server strength hard disc designed for Time Machine backup.

Note

.Mac from Apple now offers 10 GB of space as standard, making this a good choice for offsite storage of your most valuable files. To help in this respect Apple provides a program called Backup as part of the package, and if this is not enough for your requirements, you can opt to pay for more.

Third-party backup software

SuperDuper from Davic Nanian and ChronoSync from Econ Technologies are other simple ways to synchronise your files to a backup hard drive. If you want something more complex, there are other products – from Dantz, there is Retrospect, and from LaCie, there is SilverKeeper, which often comes free with their hard drives.

Overall strategies

I will repeat the obvious - photographers are all different, so no one strategy for either the way of backing up or archiving is possible. Some photographers shoot subjects for clients who never need repeat orders, others shoot specifically for Stock Libraries where the great proportion of the storage requirements pass to their client. In those cases the critical time is close to the time images were created, so it is crucial that images transfer safely and efficiently from the camera to the computer, and short term storage is more vital than long term. But there can be a sound reason for storing both the RAW file if it existed, and an editable, possibly layered file, should an alternative image for a very large poster, say, or a different crop be needed. Another possibility might be he/she might like to change Library or Agent. It is at that point the photographer would need to decide exactly how the images might be stored and accessed.

Certainly, if you want the ultimate in quality and you shot RAW, then either DNG or the proprietary RAW format file is the earliest file to be kept, but if that was retouched or montaged, it would assume slightly less importance. On a side note, faced with this sort of decision, make your RAW file a Smart Object in Photoshop, so that changes to that file always reverted to the original as the startpoint. If the shots are distinctly ephemeral, then making a decision regarding storage time, and communicating with the clients the length envisaged before disposal, and charging for time thereafter might well be a good business strategy! After all, why should you be burdened by constant purchasing of extra hard drives, DVDs and CDs, and be the bearer of the costs, both of the storage and the retrieval time involved, without recompense?

If constant retrieval directly for the client or for your own purposes is a high priority then keywording, and a robust filing system become really important, and then you need to consider all the costs involved relative to what you keep and how it can be retrieved. Are you constantly having to add more interesting skies? Or extra lawn or roadway? If so, then you might well create Smart folders that keep track of certain keywords you add to Spotlight Comments. You could create a 'Watched folder', by adding a Folder Action to a specific folder that has an Automator script attached and enabled.

Pixel-based vs metadata based editing

What I have discussed here presupposes that we are considering a pixel-based situation, but Aperture, Lightroom, and the ever-increasing numbers of images being created, seem to be taking us into a world of metadata based handling of images.

By this I mean image files are stored in a fixed form, but either the header or an accompanying file known as a 'Sidecar' file stores an Edit list which defines the changes to be made to arrive at a specific end result. Such a file is a text file currently written in XML — eXtensible Markup Language. This makes it economic to create more than one interpretation of the original, which is what Aperture refers to as 'Versions' and Lightroom as 'Virtual Copies', and also has the benefit of offering non-destructive editing.

Yet another aspect of such metadata is that it adds to the opportunities for finding files that may have been edited in a particular way, by searching using such stored metadata in conjunction with the EXIF, keyword and IPTC structures.

Metadata-based strategies

If, as seems likely, more photographers are going to want to shoot RAW, and be willing to accept instruction-based editing of the images they create, then what and how we store will change fundamentally. Already, commissioned photography is being eroded by the increasing use of stock images, and one of the primary reasons for this is due to these images being well-catalogued with carefully chosen keywording. In a Library these are very easily searched and found. Obviously the images are less-targeted, and also by their nature less exclusive, but in this time critical world, the value lies in their being available.

If you have not yet taken the picture you can hardly catalogue it, but, if the work you have done is well-annotated from a metadata standpoint and your style is apparent, and lodged either with an established library or available via your own website, then the Internet can play a part in putting your work on display. Adobe does address this situation by providing access to a wide audience of potential users and buyers of photography in the Adobe 'Photographers' Directory' which gives access to professional photographers from around the world. It does this through being available in Bridge within Creative Suite 2 and beyond.

To give yourself any chance to benefit from this sort of initiative, you are going to have to decide how best you deal with metadata, in particular how you categorise your images, and how you get keywords into your image files fast and efficiently. Already there are businesses providing this facility, and for prolific shooters this may well be the way to go.

Certainly for all photographers, there will be a need for metadata input, if only for internal storage and retrieval. File sizes make storage capacity an issue, and ready access makes demands on online capacity. As soon as you reach your own limit for online storage, you then have to consider both the media you choose and how you achieve efficiency – metadata has to play a part. A folder or file name is no longer enough. Aperture and Lightroom and Digital Asset Management programs all use databases, and without doubt you have to be thinking along these lines. More photographers are going to have to consider servers, to help keep track of all the work you are generating.

Tip

One new way to have central access to a hard drive over a network is to consider Network Attached Storage (NAS). Apple recently added this facility to its Airport Extreme Base Station and called it 'AirDisk' - you simply plug a hard drive into the USB 2.0 socket on the back of the Base Station and using Airport Utility, follow the instructions to share it over the network. You can set all the necessary restrictions for access, but the beauty is it can be readily accessible much like a server to anyone connected to the network. You can also add other drives or computers to the Airport Extreme via Ethernet as there are three Gigabit Ethernet ports as well.

I have been using one such disk to allow me to take screenshots on a Mac running Leopard downstairs, save them to the NAS drive, and readily access them from my office upstairs, where I have been writing this book.

Conclusions

What comes out after all our efforts, has to match our expectations – a statement of the obvious, but, disappointment is a waste of time and money; not simply hurt feelings. Preparation is the key. Examples abound – do all your work in Adobe RGB and fail to convert to sRGB for a web presentation; create a small InDesign leaflet and forget to ensure all the image files are present along with the file – all the links are broken, resulting in pixelated images.

A good discipline when handing off jobs to third parties is to write a specific ReadMe, rather than simply include a boilerplated generic file – the action of describing what is required should alert you to all the necessary components. It may seem to take longer, but doing something twice is both costly, and tedious, let alone time-consuming.

Learning a little more about the operating system that lies behind your Mac, will allow you to work faster and understand what your assistant might be doing better, and how Photoshop, Aperture, Lightroom and other programs might run faster.

It just works...

Mac OS X is a system that has prided itself in 'just working', but that does not mean there is never anything to learn; I'll be honest and say that I have learned things I never knew before whilst writing this book. And, I don't mean worthless pieces of trivia – I mean nuances of behavior that make my work smoother and more rewarding.

You will find that taking a few minutes to ask yourself: 'Are there too many steps in what I am doing?' or 'Can the system do this, or that?' will lead to improvements to the way you work. If you think your Mac is slow, ask yourself – 'Have I got enough RAM in my Mac for the size or number of images I am taking?' 'Is the hard drive large enough or fast enough to store all the images I need to hand?' 'Are the JPEGs in my emails too large for my client to download them quickly and get back to me with sizes and quantities to print by his or her deadline?'* 'Could the pictures I am putting into Keynote be smaller to make a slicker presentation?'

This book should have helped you to answer these and other questions related to getting the most out of whichever Mac you choose to operate Mac OS X. I can certainly say I believe the Mac operating system has really been developed strongly to aid photographers get the best from digital photography, with technologies like USB 2.0, Firewire 800, Bluetooth, the iSight camera, and all the other bundled software such as iChat AV, it really is a system that lends itself to our chosen profession.

Leopard offers a new view in Finder windows which when coupled with the use of the Space bar, links the Flow view to Quick Look in an elegant and straightforward way that should undoubtedly find favor with photographers.

I used to shoot a lot of 35 mm transparencies because I was lucky enough to work at a professional color laboratory, but it soon became prohibitively expensive, and taking my own pictures became a rare luxury; the Mac, its operating system, and digital cameras rekindled my passion for image making, and I will admit Photoshop, Lightroom and Macs are a very large part of my life now, and as I learn something new I am enthusiastic about passing on this knowledge.

*Tip

Look in the bottom right of the page in Mail to reduce the size of the files you send without recourse to resizing them back in Photoshop or Preview.

Beyond the Operating System

In writing a book aimed at photographers about a computer operating system, I have found it impossible not to mention aspects of my favorite program of all time - Adobe Photoshop, which I am fortunate enough to be able to have a hand in moulding and polishing to photographers' needs, so I have added a short appendix that covers the most useful and common shortcuts for that program as well as Mac OS X. I've also included a short example of how just one aspect of Photoshop made a real contribution to editability and ease of amendment whilst I worked in a south London studio helping with retouching watches recently. On that occasion, there were repetitive tasks, but not ones that relied on Actions, but Smart Objects.

Repetitive tasks

Very little of my own work is repetitive, and in visiting various photographers, few have had exactly similar repetitious tasks. The common situations all seem covered by Actions and Scripts that can easily be found from the Web. So my advice for those with specific needs, is look carefully at the steps you take, then get either AppleScript, Automator or Actions within Photoshop, to copy them. Use the resultant script, and see what can be done to improve it over time.

In professional photographic situations I highly recommend the purchase of the whole Creative Suite, because each integrates well with Photoshop, and even if you only use them occasionally, they will help enormously in other aspects of a photographer's work. InDesign will allow you to put together leaflets or even booklets to help promote your business. Illustrator is handy for creating logos, and playing with text to add flourishes to an InDesign flyer. Dreamweaver will allow you to take a Web Photo Gallery created from Photoshop to the next level, and Acrobat will allow you to send some of the output of Photoshop, Illustrator and InDesign to clients via a web page or email without their having to open them in the programs you used to create them.

The operating system is not simply for nerds and geeks, it is the underpinning of how you deal with the programs and all your connected devices such as cameras, scanners, printers, screens and speakers. Mac OS X 'Tiger' showed the way Apple was going and Leopard takes us into some new areas. For those of you who are nervous of early versions of anything technical, you need have no fears: Tiger will prove fast enough and versatile enough for quite a while yet, but if you want to get the best from all the new Intel-based Macs from the Mac Mini to the MacPro, then Leopard and the native applications that form Creative Suite 3, Quark Xpress 7, and Final Cut Pro, are undoubtedly the way forward. Aperture and Lightroom are already Universal, so all the Mac-using photographers can get good performance from PowerPC and Intel based Macs from these applications, with Leopard giving you more in terms of the way in which you work – improving workflow.

Actions, Batch Actions and Droplets

Using the situation in Photoshop as a model, I shall describe a way of coming to terms with repetitive tasks.

Initially you create an Action, a series of steps that carry out an effect or series of effects upon an image, such as crop and resize, change color workspace from say Adobe RGB to sRGB, sharpen, and resave as a JPEG. This strings the steps into one action, hence the name, and applies it just once to a single file.

A next stage is to be able to carry out the same steps upon several images – we create a Batch Action. But this is still filling in a series of details for a particular group of files.

What is far more efficient is to be able to carry out these operations on any group, from a single image to a selection of images, or a folder of images. For this we create a Droplet. It will blindly carry out what has been asked of it, provided it receives the requisite original/s. You simply drop a single image, or a folder of images onto the Droplet and it performs the relevant steps on each file it comes across.

AppleScript Editor creates similar scripts and these can be attached to folders to become Folder Actions, as can Automator scripts. Automator can include AppleScripts. In experienced hands, these can be very powerful, as well as save time and effort in more simple forms.

Appendix

I am loath to fill a chapter with shortcuts, and despite this not being a Photoshop book, I also do not wish to divorce this work entirely from such an essential program to professional photographers; so these pages contain some essential shortcuts for both the system and Photoshop and a few useful tips, to improve the time spent at your Mac.

In a few places in the book I have digressed from the operating system to discuss how I deal with screen captures in Photoshop in conjunction with the system, but here are a few purely Photoshop tips, that I have found invaluable. One such is Smart Objects, which allow you to make filters non-destructive, but which I find more powerful to simplify complex layered files.

Digital photography has made some very fundamental changes to the way a photographer works, and how far he or she takes a project; there are certainly times now when you consider photographing your image with a later, specifically digital manipulation procedure in mind.

I hope this book helps you to decide where your particular boundaries lie.

Shortcut	Action

At startup

Hold T key down	Start in Firewire Target Disk Mode
Hold Command+S	Start in Single User Mode

In most applications

Command+C	Copy
Command+V	Paste
Command+X	Cut
Command+Z	Undo (Command+Option+Z to step back in Photoshop)
Command+A	Select All
Command+O	Opens an application
Command+`	Cycles document windows to the front*
Command+F	Opens a Search Window, can create a Smart folder
Command+Shift+3	Captures entire screen area**
Command+Shift+4, then marquee	Captures a marqueed area
As above, but tap Space bar	Click on any open window to capture it entirely
Command+Option+D	Toggle the hiding of the Dock
Command+Space bar	Opens Spotlight***
Command+H	Hide the Frontmost application (not Photoshop!)
Command+Q	Quit
Command+Option+Escape	Force Quit an application
Command+S	Save current document
Command+Option+S	Save As...

In Finder

Command+Tab	Toggle to last open application
Command+F	Bring up a Find window (More detail in Chapter 1: Pg 55)
Command+N	Opens Root level Finder window (or folder of your choice)
Command+Shift+N	Opens a new Untitled folder
Enter	Highlights selected filename for editing
Command+Shift+?	Apple Help
Command+I	Get Info
Command+J	Call up the View menu for frontmost window
Command+Shift+K	Opens a Finder Window, focussing on Network
Command+L	Make an alias of a file or folder
Command+Shift+A	Opens Applications folder (when in Finder)
Command+Shift+U	Opens Utilities folder (when in Finder)
Command+W	Close window

In Leopard

Space bar	Invokes Quick Look for selected item in Finder window

* The grave accent, not backslash **Saves separate files for multiple screens *** See Photoshop shortcut; same keys, different order

Shortcuts

I have picked out a series of shortcuts which can be used from three main areas, throughout, in Finder and in Photoshop. The intention being to keep the list to a minimum, to try to group them since some form part of a series, and to list them with some measure of importance. The first four should already be known; and I'll make an interesting observation here – the function keys F1, F2, F3, F4, were mapped to Undo, Cut, Copy and Paste, and although I am sure there are those who used them, I have never come across anyone! My own belief is that it is easier to associate the Command key and three or four functions that are related, than remember a function set to a number.

Sometimes the order of the keypresses is important, and here I pick out the Command and Space bar, the combination is the same for the System and Photoshop, notice I have put the Space bar first for Photoshop, this means you can avoid a clash; to use Spotlight, keep to the order as for other applications.

Another in Photoshop, is when creating a circular selection from the center, first, start the ellipse whilst holding the Option key, then add the Shift key to constrain the ellipse to a circle. You can also reposition your circle by temporarily holding down the Space bar, then let it go to continue with the sizing of the circle.

When translating keypresses between a Mac and a Windows PC for Photoshop, the convention is to substitute the Control key for the Command or Apple key, and the right-click is translated to the Control key on the Mac, but there is one time, (and as far as I know, only one) where this is not so – breaking the Snap to bounding box or edge, where you use the Mac's Control key.

Earlier, Apple's system versions took on board global shortcuts that were also popular Photoshop ones, Adobe therefore made it possible for users to alter shortcuts to suit their own workflows; you can now make changes both to System and Application shortcut definitions.

I've seen numerous books that list pages upon endless pages of shortcuts – I wonder who remembers, let alone uses, even 50% of those carefully noted lists. The lists I have given are far from exhaustive, but I have shown ones that are productive, and some that may have been misunderstood, or rarely listed elsewhere.

Altering global shortcuts

Global shortcuts are those available across all applications, and provided one exists by default you can change it to avoid a clash within a particular program, or to suit you for a particular task.

To make such a change go to Keyboard & Mouse in System Preferences, and open the 'Keyboard Shortcuts' tab. Scroll to the shortcut to be changed and double-click in the Shortcut column, which highlights the existing keypress, and enter the new combination. If it is already taken an alert will inform you to the situation, and ask for an alternative.

Fig. 10.1 Highlight a particular shortcut you wish to change, then double-click in the shortcut column and press the new key combination, if this is already taken, as in the case shown, a warning triangle appears, and the error message is displayed below the pane, as shown in the lower picture.

Shortcut Action

In Photoshop

Shortcut	Action
Command+K	Open Preferences
Command+Shift+K	Opens Color Settings
Space bar+Command	Bring up Zoom In Tool***
Space bar+Option	Bring up Zoom Out Tool
Command+A	Select Canvas
Command+D	Deselect
Command+H	Hide Marching Ants and Paths
Command+Control+H	Hide Photoshop
Command+I	Invert Colors of an Image or Mask layer
Command+Shift+I	Invert a Selection
Command+J	'Float' a selection of one layer to a fresh one above
Command+E	Merge layer to one beneath
Shift+Command+Option+E	Create new layer and paste merged visible layers
Command+Control+Click	Select layer via Context menu*
Shift+Command+Control+Click	Add layer to selected layer/s via Context menu*
D	Default setting of Foreground and Background
X	eXchange Foreground/Background (Swap)
F	Toggle through screen views
Q	Toggle Quick Mask mode
Command+G	Group selected layers in Layers palette
Command+R	Add rulers to your image window
Command+S	Save using existing file type, name and location
Command+Shift+S	Save As... allowing you to change any of the above
Control+Tab	Cycle through open images
Command+T	Free Transform
	Subsequently Add the Command key to Distort (free all constraints on anchor point)
	Add Shift key to constrain movement to a single plane
	Add Option key to give equal and opposite movement to Transform
	Use the Space bar to allow a pause in some processes, to allow for repositioning
	Use the Shift key to constrain rotation to 15˚ steps
Command+Shift+Y	Brings up Gamut warning color in image or Swatch**

• Use the Shift key to add to selected areas; and also selected layers in the Layers palette
• Use the Option/Alt key to subtract from a selected area
• Use both the Command and Option keys to intersect with an existing selection
• Use single numbers to move in tens in Layers Palette Opacity sliders

In Bridge

Shortcut	Action
Command+R	Forces Bridge to host Adobe Camera RAW

* Click in the image area for the layer concerned ** Read more over the page *** The order of use is important

Shortcuts have no value if you need to pull a book off the shelf and thumb through it to find the esoteric group of linked keys to carry out your simple task. They should be something that once you have seen, you commit to memory and end up using frequently. There is one here in the Photoshop group that I found out by pure chance and it became a beta tester's special, made it to few books that I ever saw, and became even more powerful after an engineer asked whether we would like to also automatically create a fresh layer when it was invoked – his suggestion was welcomed roundly and unanimously, and made it into either Photoshop CS or CS2 for the very first time. I leave you to find it, in the list on the facing page. I use it all the time to work so far, then simplify the stage reached, before continuing to work on a composite image. It's an absolute boon to those putting together complex images for advertisements.

Some keys are vital when creating Actions. It is important for instance to know whether the Foreground is black or white, so hit D and you are now in a known state – black is the foreground color, white is the background. How do I remember that? Think ink on paper. But suppose what you need is for White to be your foreground color? Hit X – this swaps your known state, so you *still* have a known state. Make sure that for an Action, you always start in a known state.

Another point with Actions is always make the changes in the dialog boxes, never open the box and accept its present state – you have made no change, so the Action has nothing to remember! If the startpoint of an Action is a selection, then make sure your name states this, or if it relies on a particular layer name ensure this will be present. If necessary, create the layer within the Action.

If you need to change your measurement units quickly did you know you need only hold the Control key down as you click in the ruler area? This saves you going into Preferences.

Does your client keep wanting you to revert to an earlier stage? Set your History options to create a Snapshot for each save, and keep keying **Command+S** at intervals. At the top of the History pane will be a series of date-stamped snapshots to choose from.

Out of Gamut?

If you need to create a color in an image and you want to ensure it will convert well to CMYK, then a neat trick is to use the **Command+Shift+Y** shortcut to add the out of gamut gray into your Color Picker.

For an eye opener try this for Green to see just how few saturated colors are likely to translate well!

Fig. 10.2 Applying the Out of Gamut marker to Color Picker gives you a very obvious indication of what is likely to make it in CMYK!

Always working from the original

When making a layered image a Smart Object (SO) allows you to retain all the layers yet have a single object that can be scaled, rotated, and even grouped with other Smart Objects, and the alterations you make are all done from your original files. Your editing is non-destructive.

To create an SO is as simple as highlighting either a single or a group of layers in the Layers palette, and selecting 'Group into Smart Object' from the flyout menu. The layer icon changes to that shown on the right of Fig.10.3 below.

Smart Objects

When montaging multiple images, and those images in themselves are complex, retaining both maximum editability and quality becomes a high priority. Smart Objects comes to the rescue. The concept was introduced to Photoshop at Creative Suite 2. This is undoubtedly a way to deal with what were once considered to be two mutually exclusive attributes. Even though the primary aim of this book is to describe and reveal Mac OS X to the readership, Photoshop plays a large part in a Photographer's life, and this book is in the Workflow series, so I feel it is worth discussing this feature in the Appendix.

Fig. 10.3 On the left is the individual watch with its constituent layers and reflection, as a Smart Object from the master comp which has six, each with its own reflection, the master page is unencumbered with all the layers and masks of the originals, but all are accessible from within each Smart Object.

Smart Objects and a Catalogue Layout

When producing a high quality catalogue of watches, a photographer is presented with numerous challenges that require careful consideration, especially where the requirement is to have several watches together. Each watch has to look its best, the hands need to be set to a consistent time (often say eight minutes past ten), and the smooth bezels need to have slick modelling and reflections, the gems need to sparkle, a leather strap should show its texture, its inner should not detract from the surface, the glass cover should not flare, and so on. And above all no watch should interfere with another.

The answer is often to shoot each individually, not only that each needs to be supported, because often several exposures are needed with different lighting, and all the exposures have to align accurately with each other. The winders need to be photographed pulled out, so the watch retains the time set.

All the watches are shot at the same size, so the correct relationship is maintained, paths are cut to create the needed separate elements, from these masks are made and all the components layered together, with the reflection or shadow separated. The winders are moved to seem pushed in, the supports are lost, blemishes are retouched, inner straps darkened. If the cover glasses were not removed, the subsequent flare is reduced, and the contrast boosted.

This multi-layered file is grouped and a composite watch and strap, and separate reflection are saved and named. A canvas of the exact final size and resolution with a white background is created and opened and given its page number, and if needed a sketched layout is introduced to assist in placing the watches. Each individual watch as a group of watch and reflection are dragged in from their respective layer palettes and dropped on the canvas, then grouped into a Smart Object, named, reduced by a standard percentage, and moved into position.

From this point on, all the individual watches can be moved independently to fit the layout, with the layers organised to suit. Finally, double-clicking the Smart Object in the Layers palette, the reflections can be shortened with a gradient layer mask, and resaved, the composite layout will then update to reflect the change. Any client changes are then easy to make, losslessly.

Altering a Smart Object

Double-click a Smart Object in the Layers palette and you'll first receive an alert warning you to save the file you are opening, so that it is updated in the master file.

This new file is a .psb file that contains all the layers and masks that were present when it was created. Make any changes here and close and save the file, and after a few seconds the master file that contained the Smart Object will update to reflect your changes.

Make any changes to say the colors or contrast of the image as Adjustment layers this will mean that you still retain the ability to alter that image non-destructively.

All the changes you make within the Smart Object will be applied even though in the master composition, that layer had been warped, repositioned, rotated and resized. You can even apply non-destructive filters to the object. You can now have non-destructive sharpening!

There is a gotcha however; you cannot link a Smart Object with its layer mask, but wait! There is a workaround - if you use a layer mask and want to move both around, there are two ways, one is to move the object using Free Transform, then use Transform Again, or simpler still make the Smart Object and its layer mask a Smart Object!

So, you see, complexity and editability can reside happily together in a simple form.

Glossary

A

Activity Monitor A handy utility that shows all the processes going on in your Mac. It is located in the Utilities folder in Applications. It shows the amount of processor time being allocated to each open program and the background tasks your system is running. You do not have to learn all about it, but it can be particularly useful when deciding whether a frozen program is in fact working away all on its own, but do not be too hasty because some times even with what seems like the 'Spinning Pizza of Death' and the red notice saying 'program X is not responding' it is simply rather pushed for time to let you know and is in fact working flat out!

Adobe RGB (1998) A good general purpose **Color Workspace** for RGB work in Photoshop. The color gamut is not so large as to hold numerical data for unachievable colors or too many colors that go beyond what is achievable in CMYK when going to print. There are other color workspaces that hold even more colors than this which can prove beneficial in critical situations, especially when in 16-bit files, or for use with High Dynamic Range (HDR) files. ProPhoto RGB is just such a one.

ADSL (Asymmetric Digital Subscriber Line) This is one of the more common forms of Broadband connections, generally 'always on'; asymmetric because the upstream speed is different from the downstream; it is faster to download to your computer than to upload to the Web or to a colleague, via email or FTP.

AIM An association of companies with Apple that produced the Central Processing Units (CPUs) that drove the Apple PowerMacs, formed by Apple, IBM and Motorola.

Aim Print A print produced by a photographer on a profiled Inkjet printer, using a standard color workspace, given to a client or printer offering a target by which they can assess any proof. As opposed to a proof which shows what *will* be printed from a file without intervention, an Aim print offers an image of what the Photographer/Art Director/Client was hoping to achieve. It offers an inexpensive, effective guidance to a printer as to how to interpret any proof – it might be called an Aspirational print.

Airport *See also* **WiFi** Apple's proprietary name for its wireless communication - now in its second iteration as Airport Extreme, it conforms to IEEE 802.11(was 11b and 11g, is now 11n).

Analogue *See also* **Digital** In our case Film, used to describe a continuously variable dynamic process, as opposed to a stepped process involving discrete levels. Generally used to describe processes using binary or hexadecimal notation in computer operations.

Apple Key (⌘) *See also* **Command Key** and **Modifier Keys** The key generally sited immediately either side of the Space bar. I will always refer to this as the Command key; it will have the Apple Logo and Cloverleaf symbol on. It is used together with other keys to modify the effect of the combination to perform a particular operation. It can be used with other modifiers such as the Shift, Option, Control and Fkeys. It is most often the base function, with alternatives or more specific actions being defined by the additions of any, or all of the others, (such as using **Command+Option+P+R** for zapping the PRAM).

AppleScript A series of actions which can be recorded by the operating system, using

Apple Inc's proprietary scripting language to enable a user to automate these for subsequent replay. They can be recalled via shortcuts or by dropped-on icons created for the purpose (often on the Desktop). They can be called or included in scripts by Apple's Automator, a later addition to the Mac OS X system that simplifies the creation of scripts using predefined routines built into programs by their developers. These programs can be designated AppleScript or Automator aware. AppleScript was designed for the writing of tasks or recording from User input and writing this in English-like language to a script file. An AppleScript aware program has a dictionary of items available for use by AppleScript with which it constructs the desired actions. Photoshop has an extensive dictionary beyond the minimum core requirement.

AppleTalk A proprietary Apple form of linking Macs in a network. A method which involves minimal user intervention to setup, once turned on, the Mac creates a unique address, and publishes its address to the network. Since each individual Mac does the same they are all able to see each other (known as peer-to-peer), and all any one Mac has to do is request via their name and password to share particular volumes, folders, or files.

ATA drives Advanced Technology Attachment (also IDE) drives, 16-bit technology, common base level hard disk drives.

Automator A more automatic process treating individual modules as objects that are dragged from one window to another to build the script items step-by-step. The scriptable components of an application are in the left-hand pane of the Automator application. The right-hand pane is the Editing window. As each object is dragged in, you can edit various parameters. Every block has an input and ouput, so that the result of one operation forms the input of the next. This can be saved as an Application, which for instance can be used as a **Folder Action** or a **Droplet**.

B

Barrel Distortion *See also* **Pincushion Distortion** Some lenses, especially very wideangle and zoom lenses at the wideangle end of their travel, exhibit this form of distortion. It is where vertical and horizontal lines at the edge of the frame bow out, rather than travel parallel to the edges. Photoshop can correct this form of distortion. It is accessed from the Filter menu via Lens Correction.

Bill of Materials (BOM) This is the place where Mac OS X stores the components of an application and the various Permissions available to different users. The BOM is stored in the Receipts folder, which Apple's Software Update program checks to assess whether a particular item requires an update. It is also the reference point when you ask for verification or repair of Permissions.

Binary Mathematical system based upon 2, using noughts and ones – a fundamental basis for use in computers, where each position in the number has twice the value of the next, starting from the right. Decimal is our normal counting method.

Thus:

In Decimal		In Binary
0	is	0
1	is	1
2	is	10
3	is	11
4	is	100
5	is	101

BIOS (Basic Input Output System) This is the code on Windows PC computers that loads the Windows operating System, similar to Open Firmware on PowerMacs or EFI on Intel Macs.

Bit A single binary unit; a byte has eight bits, the position in the byte determines the value of the bit (similar way to decimal), starting from the right, values are powers of 2 (*see also* **Byte**).

Blog A contraction of weblog, an inexpensive form of online journalism (*see also* **Weblog**).

Bluetooth An increasingly common wireless communication protocol invented by Swedish engineers at Ericcson, whose original codeword for the project was adopted on release of the specification. It came from stories of Harold I of Denmark, Harald Bluetooth who preferred communication and negotiation over fighting between warring neighbours. It has good low power idle consumption, and is ideal for narrow bandwidth communication between mice and keyboards to computers, headsets and PDAs. It operates in the same 2.4 GHz range as the more powerful **Airport/WiFi** wireless communications system.

Boot Camp Apple's codename for a suite of programs and drivers that allows the Intel powered Macs run Windows OS on their Macs, first previewed before its incorporation in Leopard; Mac OS X 10.5.x.

Broadband This term covers any higher speed connection than dial-up, to the Internet/World Wide Web, by **ADSL**, Cable or Satellite.

Bridge A means of linking two separate networks together, it can be to link an internal network to the Internet.

Bridge Can also be the circuit/chipset within an external hard drive enclosure that allows an IDE drive to be connected to Firewire.

Bridge This is also the name Adobe gives to what was once the File Browser in Photoshop.

Byte Eight bits make a byte – 1s are blue, 0s are white in this diagram below:

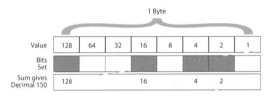

The bits set in the example byte above are: no bit set for bit zero, bits 1 and 2 are set, bit 3 unset, bit 4 set, bits 5 and 6 unset, and bit 7 set. They can also be described by defining the bits as 2 to the power of 1 through to 7 starting from the right as zero, then 1 and so on. In this example the decimal number is the sum of the values set: $(2^1) + (2^2) + (2^4) + (2^7) = 150_{10}$.

C

Cathode Ray Tube (CRT) Fast disappearing as a screen you can buy for your Mac, it is still considered by top professionals in the field to be a superior, more accurate way to view images on your Mac. Certainly, at the very top of the range, this may well be true, but many new flatscreen monitors are now more than their equal.

Chromatic Aberration The color fringing that occurs especially at the edges of wide angle lens images, due to the colors coming to a different focus. In some cases this can be corrected when editing the file in either Aperture, Photoshop, Adobe Camera RAW, or Lightroom.

ColorSync Apple's proprietary name for its color management system, involving overall system-wide representation of accurate color. When combined with Adobe Photoshop's Color Workspaces gives the photographers designers and clients, confidence in the overall control over color fidelity at every stage in the process. It defines, stores and carries out conversions via ICC profiles from Input, via Workspaces, to Output. Its counterpart in Windows is ICM.

Color Gamut The range of colors within an RGB color workspace; the range of colors within a CMYK color workspace; the range of colors that a camera sensor can record; the range of colors a monitor can display; the range of colors a printer can achieve on a particular paper stock – the relation between any of the above. Colors that fall beyond the scope are said to be **out-of-gamut**. How these colors are treated in any situation is defined by the **Rendering Intent**.

Color work space A theoretical work space with clearly defined values for the color co-ordinates for Red, Green and Blue, or Cyan, Magenta, Yellow and Black. The color workspace will have additional parameters such as the Gamma specification. When defining a color image using an ICC workflow, the file will possess an ICC color profile to give meaning to the numbers corresponding to color values in the image. The most common in RGB would be **Adobe RGB (1998)**, sRGB, ColorMatch, and ProPhoto RGB, and in CMYK, SWOP Coated, FOGRA 27.

Command Key *See also* **Apple Key** One of the group of keys known as Modifier Keys, used in conjunction with the alphanumeric keys to perform a specific function, such as short cuts, or Macros.

Contextual Menu Using the **ctrl** key (or right mouse click) and clicking on an item to reveal a menu of opions available to you in the current context of the program or the System.

ctrl The Control key, one of Apple's Modifier Keys, also used as described above as the Mac equivalent of the right mouse-click, (which is also honoured).

Contract Proof A proof that a client is happy to consider a contract between the parties that the final print will accurately match what is on the proof. These will be made by such as Kodak, 3M, Agfa, and Dupont. The two most common are probably Cromalin from Dupont, and MatchPrint from 3M. They will have various color bars and targets that when measured should conform accurately between proof and final printed example. To be really accurate they should be printed on similar paper stock.

CoverFlow The means by which Apple displayed album cover artwork in iTunes. They managed to optimize it sufficiently to introduce it to Finder windows to display the contents of folders in Flow View, which when used in conjunction with Quick Look is ideally suited to photographers when searching folders for images.

D

Darwin The Open Source component at the heart of **Mac OS X**, which allows external Developers to contribute code that can improve the performance of the operating system.

Decimal *See also* **Binary** Decimal is our normal counting system, which is based on Ten, sometimes shown by mathematicians as 14_{10} for our normal 14, which in binary would be 1110. $(2^1+2^2+2^3)$ or $(2_{10}+4_{10}+8_{10} = 14_{10})$.

Digital A term which is over-used, but in most cases refers to anything created by computers using binary mathematics as opposed to more organic, analogue means, such as in our scenario with electronic means, rather than film.

DIMM (Dual In-Line Memory Module) The current type of memory chips, often in the smaller package called Smaller Outline as in SO-DIMM. Another acronym has been tagged to recent chips involved in bringing faster speeds to memory chips. It is DDR – Double Data Rate.

DNG (Digital Negative) An Open Standard Adobe format for storing **RAW** Camera files, based upon the TIFF structure, it is able to store most of the RAW data that is captured by digital cameras at the time of exposure. They also provide a free DNG Converter program that can handle the translation of the proprietary data into a standard format, and its later extraction, including the copy of the untouched camera manufacturer's original data.

Droplets Small executable code snippets that are activated by dropping relevant files on their icons in order to carry out some action. This action could be performed on either single files or batches of files, even folders of files. **Automator, AppleScript,** and Photoshop are all capable of producing these applets.

DTP (Desk Top Publishing) Democratisation of publishing whereby more people could use their computers and a good printer to produce their own printed material at a fraction of the cost of the commercial equivalent.

E

EFI (Extensible Firmware Interface) The Intel based firmware used in the latest Intel-based Macs, similar to Microsoft's BIOS. It is not very accessible as yet, but this is what launches the Mac operating system on Intel Macs in the background, in much the same way as Open Firmware did for AIM-chipped PowerMacs.

Ethernet The most prevalent networking standard available on all Macs. It can be of varying speeds from 10 KB per second through 100 to 1000 KB per second.

EXIF (EXchangeable Image Format) This a standard format that was originally introduced by the Japanese camera industry to provide a standard way to capture the camera settings in place at the time an image was taken by digital cameras. Originally used only for **JPEG** images, it soon became expanded to cover **TIFF, RAW,** and others as well.

F

Firewire, Firewire 400, Firewire Extreme & Firewire 800 Apple's versions of **IEEE 1394,** called iLink by Sony. It was introduced by Apple Computer. It has proved invaluable in taking over from **SCSI** as the main way to connect hard drives to Macs, especially since they are hot-swappable (you do not have to close the Mac down to remove them; simply drag them to the Trash).

Fkeys Function keys Those running across the top of Mac keyboards. On Mac laptops, often need to have a specific fn key used in addition to utilise their functionality. It lies at the bottom left of their keyboards.

Force Quit A means of closing a program unresponsive to the ordinary Quit command. The Hotkeys are **Command+Option+esc**. Also clicking and holding down the Dock icon for

303

the application then choosing Force Quit from that menu, or by opening Activity Monitor and looking for the program that may well be in red text if the operating system is on your side, highlight it and hit the red button at the top left of the window marked 'Quit Process'.

FSCK (File System Check) Unix command used at startup to check the disk catalogue of your startup disk, can also be used from the Terminal application. The common usage is by holding down **Command+S** at startup, which puts the Mac into Single User Mode, then once the screen has completed a series of self checks, it awaits your typing of a command, which in this case is '/sbin/fsck -fy' followed by the Return key. If a message says that a repair has been made, run the same procedure again till the confident message '*Macintosh HD* appears to be OK' is shown. Then type 'reboot' followed by Return.

FTP (File Transfer Protocol) Unix term referring to a standard method of transferring data over a network, often remotely.

G

Gigabyte One billion bytes - 1,073,741,824 bytes – 2^{30} bytes. Abbreviated to GB.

H

HTML (HyperText Markup Language) The computer language of the WorldWide Web – it defines the structure and layout of web pages.

HTTP and HTTPS The two most common forms of communication on the Web; the first is plain text, whereas the second is encrypted between the web server and the user's browser, thus protecting sensitive information.

Hyperlink A link in one document either to another or a different place in the same one. In Web pages these can be either text or images and may be highlighted or underlined. When a user clicks the link, the computer switches to the referenced page, place or image on that page.

I

IDE drives (Integrated Drive Electronics) drives, also **ATA**, most common form of hard disk drive.

IEEE (Institute of Electrical and Electronic Engineers) Often the 'I-triple-E' – the widely known group that oversees many computer and electronics standards.

IEEE 802.11 The computer industry standard for Wireless Communications, 802.11b refers to Apple's 'Airport', 802.11g and n specifications refers to 'Airport Extreme'.

IEEE 1394 The Standard for Firewire.

Intel Apple's latest chip maker. They now make the CPUs that drive all the latest Macs. Intel Macs have not been exactly named, and come variously described as MacTels, MacIntels and Intel Macs.

IPTC (The International Press Telecommunications Council) A consortium of the world's major news agencies, who develop and maintain technical standards for improved news exchange. It is a standard form for detailing metadata storage, which simplifies the sorting and searching of image files.

J

Jaguar Apple's codename for Mac OS X 10.2.x.

JPEG (Joint Photographic Experts Group) They introduced the very popular image compression file format. This works by dividing an image into blocks that it offers to convert a proportion of subtly different image values into close value ones with greater preponderance in that area – the proportion of the section it converts is decided by the user entering a value between 1 and 12 where 1 converts a large number of values, through to 12 which converts few. This results in more efficient Run Length Encoding, and other algorithms being applied, as the number of different colors and exposure intensities is lessened. The choice is therefore between maximum detail at one end, and maximum compression at the other; the user chooses. It is therefore described as a 'lossy' file format.

K

Kilobyte One thousand bytes, or more accurately 1024 bytes – 2^{10} bytes. KB for short.

Knowledge Base Apple has a very large database which stores a wealth of information about Mac hardware, software, issues and tips; it is well ordered and constantly updated.

L

LCD (Liquid Crystal Display) The newer flat panel displays, now used across the range in Apple Macintosh computers.

Leopard Apple's codename for Mac OS X 10.5.x.

Lightroom Adobe's new program aimed specifically at professional digital photographers who shoot many images, often only to use a few – Sport, Fashion, Travel and Event practitioners would seem to fit their target audience, much the same as those aimed at by Apple with 'Aperture'.

Longhorn (*See also* **Vista**) Microsoft's earlier codename for its update to Windows XP.

LZW Lempel, Ziv, Welch Names behind a file compression method, often used for **TIFF** files.

M

Mac OS X The Macintosh operating system, that adopted BSD Unix at its heart, breaking tradition with prior versions that had been in place up to version 9.2.2, which were proprietary.

Megabyte One million bytes, though accurately, 1,048,576 bytes - 2^{20} bytes. MB for short.

Metadata The data about data, the storing of information within a file that describes the file itself. In our case, the storage of **EXIF, IPTC** and other data in image files to make others aware of any copyright issues, to give details such as subject, location, Model Release, Client etc., which helps in the sorting, searching and managing of our assets.

Modifier keys The group of keys that are used in conjuction with the alphanumeric keys as shortcuts to menu items or actions to be performed often on highlighted items, but also on their own. The most prominent is the Command key, then there is the Option key (also known as the Alt key), the Shift key, the Control key. Loosely, the Escape key (esc) and the Space bar could be considered in this group.

An example is the Command key held down with the Option key, then hitting the Escape key to cause a 'stuck' program to be forced to Quit.

N

NVRAM (Non Volatile RAM) An area where certain values are stored which define how your Mac is set up, such as the realtime clock, what expansion slots are populated, and such like. Under certain circumstances, especially due to run-down onboard Lithium batteries, these parameters can be lost. They can be reset; the method varying between Mac models.

O

Open Firmware The built-in firmware that actually loads the Mac operating system, normally this is transparent to the User, it simply does its work behind the scenes. You can actually reach that starting point. Hold down the **Command, Option, O and F** keys at startup. This firmware exists **only** on Apple's PowerMac machines, the newer Intel Macs use **EFI**. Both these items are the near equivalent of the **BIOS** in Windows machines.

Out-of-Gamut Refers to those **RGB** colors not capable of representation in the CMYK translation. Before conversion, a decision needs to be taken as to how to handle those colors beyond the boundaries of the CMYK envelope. This decision is known as the **Rendering Intent** and is often down to subjective taste or individual judgement in specific circumstances. Out-of-gamut colors could be rendered the same as the last color within gamut at that point, or the entire gamut could be compressed to edges of the gamut envelope to preserve the perceived separation of the color values.

P

Panther Codename for Mac OS X 10.3.x.

PDF (Portable Document Format) Adobe's cross-platform means of supplying readable files of text, graphics and images, that can be opened by Adobe Reader and Preview, without using the creating program.

Perceptual The rendering intent that retains the relationship between the various colors in a scene by compressing all to fit the total gamut available.

Pincushion Distortion *See also* **Barrel Distortion** A form of distortion sometimes found at the long end of a telephoto zoom lens, where the sides bow inwards.

Podcast A new means of Web publishing.

PostScript A Page Description language developed by Adobe Systems, primarily introduced for Desktop publishing, now used throughout the Printing Industry along with **PDF**, which takes things further.

Power Mac The previous range of **AIM**-chipped Mac computers before the switch to Intel.

Proof A hardcopy printout from your files to a standard such as Cromalin or Matchprint that is in the final CMYK workspace required by the printer, and will be used to decide that it is fit for use when going to Press.

Prophoto RGB A popular color workspace amongst professional photographers, especially in 16-bit. Used in linear form for Lightroom.

Puma Apple's codename for Mac OS X 10.1.x

Q

Quartz The technology built upon OpenGL and Core Graphics using PDF to display the Aqua user interface and render 3D effects to screen. Currently Quartz Extreme. It requires OpenGL compatible Video cards because these do the work once handled by the CPU.

QuickDraw The drawing technology for Macs prior to Mac OS X 10.x. The basic unit was the pixel, and was therefore less accurate than current means of dealing with text and graphics which is vector-based, allowing for far greater accuracy and scalability. QuickDraw is all but superseded by Display PDF in Quartz Extreme. An immediate benefit is how much better text, graphics, and in particular icons look on today's high resolution screens.

Quick Look Leopard's blind version of Preview, now used system wide to display file contents. Invoked commonly by clicking the Space bar.

R

RAW Although not an acronym, it has popularly been capitalised as the description of the raw data that is embedded within digital images at the moment the shutter is fired. It includes **EXIF** data (referring to capture parameters such as ISO speed, exposure time and aperture, lens focal length, etc.) **IPTC** data and proprietary material from the Camera and Lens manufacturers.

Receipts folder The repository, in the **BOM** (*see also*) for the Permissions to Apple's System files. These are checked when you Verify or Repair Permissions, the BOMs are stored here at installation time.

Relative Colorimetric The **Rendering Intent** which retains the in-gamut colors at the expense of those outside the gamut, by clipping them to the outside edge so they render the same as those just within.

Rendering Intent The decision as to what happens to colors that fall outside of the gamut when converted from **RGB** to CMYK (or any two different gamut workspaces). The two of concern to photographers are **Perceptual** and **Relative Colorimetric**. In **Perceptual Intent** the emphasis is on preserving the perceived differences between all the colors, rather than the ultimately faithful reproduction of each color in the scene. In **Relative Colorimetric**, the emphasis is the accurate preservation of all in-gamut colors, at the expense of clipping those that fall outside (see also **Out-of-Gamut**).

RGB The acronym for Red, Green and Blue, the common color workspace for the editing and montaging of images, as opposed to CMYK which is what is needed for ink on paper.

Rosetta An Apple technology developed from Transitive Technology's code translation software; it translates binary code intended for PowerPC to run X86 instructions for Intel chipped Macs, thus aiding the transition.

S

SATA (Serial ATA) A recent serial connection to hard drives with much faster data transfer rates, first used internally in Mac G5s, now in MacPros also available as external devices, they offer far higher throughput of data than ATA drives.

SCSI (Small Computer System Interface) Once the method of choice for connecting hard drives to Macs, it is now really confined to high end drives, and been largely supreseded by **Firewire,** and more recently, **SATA** drives.

SFTP Secure method of **FTP** (*see* FTP).

Shell Another name for a Command Line Interpreter, like Apple's Terminal program.

Shell Script A series of instructions entered into Terminal to perform a task at System level. Often used to carry out this task for a batch of files.

Spaces Leopard's new multiple virtual desktops feature, to limit clutter by grouping open applications.

T

Target Disk Mode A means of allowing a Mac to have its drive be available on another Mac by using a directly connected Firewire cable, without itself booting up. It is done by holding the 'T' key down whilst starting the Mac whose disk is to be read, until the Firewire logo is seen gently bouncing around its screen. The host machine will then see that Mac's hard drive appear on its Desktop, just like any other external drive.

Terabyte 1024 Gigabytes - 1,099,511,627,776 bytes – 2^{40} bytes. Used as a measure for large capacity storage devices.

TFT (Thin Film Transistor) The technology behind **LCD** monitor displays.

TIFF (Tagged Image File Format) Originally developed by Aldus, the guardians of this file format passed to Adobe when Aldus was bought by them. It remains the most popular open standard file format for lossless storage of still image data. It has two popular lossless compression formats, **ZIP** and **LZW**. In its latest incarnation it can store everything that the .psd format from Adobe can store when used in Photoshop.

Tiger Apple's codename for Mac OS X 10.4.x.

Time Machine Leopard's new automatic Backup/Archiving tool (*see* Chapter 8).

U

UPS (Uninterruptible Power Supply) These units are largish batteries with an amount of circuitry, that will allow them to keep your Mac running for a short while, but close down tidily before the battery itself runs down.

URL (Uniform Resource Locator) The address of the page on the **WorldWide Web**. Although generally assumed, such an address starts with the HTTP protocol: 'http://' or 'http://www.', such as 'http://www.focalpress.com' and may well end as '.htm' or '.html'. The variant address 'https' indicates a secure connection.

USB and USB 2.0 (Universal Serial Bus) An Intel Standard connection that lay dormant until adopted by Apple, and since has become ubiquitous on all computing platforms. USB 2.0 now appears on all Macs. It proves to be an ideal method for connecting mice, keyboards, digitising tablets, rollerballs, modems, mobile phones, PDAs, digital cameras, card readers, scanners and printers to computers.

V

Vista The Microsoft codename for the latest Windows operating system, originally known as **Longhorn**.

Volume Generally this refers to a physical storage device such as a hard disk, a partition on a hard disk, a CD, DVD, floppy disk, or Compact Flash Card.

Volume Also describes sound level.

W

Weblog Often colloquially shortened to blog – an increasingly popular form of creating a web presence to publish your own thoughts and interests on the Internet, often in journal form, leading with the latest paragraphs.

WiFi (IEEE 802.11) The industry standard wireless communication term for Apple's **Airport**.

Wikipedia A free encyclopaedia – a powerful Internet resource that is extremely useful when you need definitions of computing and electronic terms. It can be edited by the General Public.

Windows The *other* Operating system, published and distributed by Microsoft, it also runs on Intel-based machines. There are three versions currently, XP Pro, XP Home and Vista. It is now possible in Leopard to operate various versions using either the built-in Boot Camp or, using virtualisation software you can run these without the necessity for a reboot.

Workspace Not to be confused with Color Workspace, is a definition used by Adobe Photoshop and other members of the Creative Suite to define a saved layout or environment involving the placement and visibilty of palettes, toolbox etc.

Workflows Apple's term for the macros created in **Automator**. The more general term refers to the ordering and components of a pattern of working; the ideal being to maximize this for an efficient, productive and intuitive flow from start to finish of any project. The primary goal of this series of books from Focal Press.

WorldWide Web Often shortened to the Web. The interconnected computers that now span the world providing communication of hypertext-linked files to be seen via a Browser. It was created in 1989 by Sir Tim Berners-Lee, working at CERN in Geneva, Switzerland.

X

X pronounced Ten in **Mac OS X**.

Z

ZIP A popular cross-platform lossless image and file compression format, it can be used in different ways. Mac OS X allows you to archive files, especially folders using this format – highlight a folder and Control+click it or use a right mouse-click to get the contextual menu, and choose 'Create Archive of...' You can also ZIP-compress any **TIFF** file at the time of saving.

Index